The Imperial Museums of Meiji Japan

THE
IMPERIAL MUSEUMS
OF MEIJI JAPAN

Architecture and the Art of the Nation

ALICE Y. TSENG

UNIVERSITY OF WASHINGTON PRESS

Seattle and London

Published with the assistance of The Getty Foundation.
This publication was also supported in part by
The Humanities Foundation of Boston University.

© 2008 by the University of Washington Press
Printed in Italy
Designed by Veronica Seyd
13 12 11 10 09 08 5 4 3 2 1

University of Washington Press
PO Box 50096, Seattle, WA 98145
www.washington.edu/uwpress

Library of Congress Cataloging-in-Publication Data
Tseng, Alice Yu-Ting.
The imperial museums of Meiji Japan : architecture and
the art of the nation / Alice Y. Tseng.—1st ed.
p. cm.
Includes bibliographical references and index.
ISBN 978-0-295-98777-4 (hardback : alk. paper)
1. Museum architecture—Japan. 2. Nationalism and
architecture—Japan—History—19th century.
3. Nationalism and architecture—Japan—History—
20th century. 4. Architecture and society—Japan—
History—19th century. 5. Architecture and
society—Japan—History—20th century. I. Title.
NA6690.T74 2008
727'.70952—dc22 2007044713

The paper used in this publication meets the minimum
requirements of American National Standard for Informa-
tion Sciences—Permanence of Paper for Printed Library
Materials, ANSI Z39.481984.

Cover: (top) Katayama Tōkuma, Hyōkeikan art museum,
detail of central dome and cornice. Photograph by the
author; (bottom) Katayama Tōkuma, Imperial Kyoto
Museum, central sculpture atrium. *Wandlungen im Kunst-
leben Japans,* (1900). Courtesy of the Library of Congress.

To my parents, for introducing me to art and museums

To my brother, for suggesting that I study Japan

To my husband, for keeping me interested in architecture

To my daughter, for making every day a happy day

Contents

Acknowledgments

This book is the end product of seven years of ruminations, discussions, and negotiations—at times with myself, but most fruitfully done with others. From its earliest research phase to its final editing stage, the book benefited from the help, guidance, and financial support of many people and institutions.

Generous funding was provided by the Fulbright Foundation, the Japan Economic Foundation, the Satoh Artcraft Research Foundation, the Tsuchiya Foundation, the Center for Advanced Study in the Visual Arts at the National Gallery of Art, the Harvard University Graduate Society, the Reischauer Institute of Harvard University, the Getty Foundation, and the Humanities Foundation of Boston University.

A stellar group of mentors guided me through the long journey. I first learned to think critically about Japanese architecture under the tutelage of Professor Henry Smith when I was an impressionable undergraduate. His encouragement emboldened me to commit to graduate school, leading me to the door of Professor Cherie Wendelken, who never allowed me to waver in my commitment to the study of architecture and the modern period. No one has given me more of his time than Professor Jonathan Reynolds, who not only tirelessly combed through early drafts but also taught me to appreciate ice cream as the best reward after a long day of writing. Both his work and generous spirit have been true inspirations to me. Another beacon of light for me every step of the way was Professor Eugene Wang. I have been a beneficiary of his wisdom and kindness, and were it not for his always timely advice, I could not have transitioned from dissertation to book so smoothly.

During my research years in Japan, I relied on the good graces of many scholars, curators, and librarians. I made my academic home at the University of Tokyo, where Professor Suzuki Hiroyuki and members of the architectural history group generously introduced me to the excellent resources housed in and around their institution. My deepest gratitude goes to Professor Suzuki, a most brilliant and obliging advisor. Entering his laboratory also meant gaining a sympathetic support group. I am especially indebted to Professor Suzuki's assistant, Ms. Katō Yumiko; Nakashima Tomoaki, Yokote Yoshihiro, and Aoki Yūsuke, who were senior members of Suzuki-ken at the time; and my tutor, Suzuki Maho. And with great sadness I remember the kindnesses I received

from the late Professor Onogi Shigekatsu, a pioneer researcher on Meiji imperial architecture and the works of Katayama Tōkuma. Other scholars who lent me their expertise included Satō Dōshin, Takagi Hiroshi, Namiki Seishi, and Furuta Ryō. Matsuyama Megumi and Yamada Yukiyo, fellow graduate students at the time, generously gave me their time and understanding.

A study on museum history would not be possible without help from curators and the buildings and archives under their care. First and foremost, I would like to thank Mr. Nakamura Yasushi of the Kyoto National Museum, who tirelessly guided me through the full set of extant drawings and models for the Imperial Kyoto Museum during one fine autumn week in 2001. I also have fond memories of scaling to the rooftop of the Nara National Museum with Ms. Hōjō and Mr. Okumura; the daunting climb (in heels no less) yielded new information on the roof structure as well as a spectacular view of Nara Park. Finally, I owe a great debt to Melissa Rinne, who introduced me to the good people of the Kyoto and Nara National Museums.

While in Japan, I enjoyed the warm hospitality of Mr. and Mrs. Atsuhiko Satake, Mr. and Mrs. Kanoh Tokio, Mr. Ryōhei Tsuchiya, and Mr. Tsuji Megumu. In the United States, patient colleagues and friends gave me advice and encouragement: Gennifer Weisenfeld, Carla Yanni, Ken Oshima, Elizabeth Pergam, Jordan Sand, Noriko Murai, Ian Miller, Gregory Levine, Patricia Graham, Gregory Clancey, Chelsea Foxwell, Don Choi, Akiko Takenaka, CASVA members of the 2002-03 term, and the Boston University Art History Department faculty and staff. Last but not least, I thank Christine Guth and the second anonymous reader of my manuscript for their insightful comments. Michael Duckworth and the rest of the team at the University of Washington Press deserve mention for being great people to work with.

Every step of the way, my family was by my side, if not physically then at least once a day by phone. Although they might not all be true fans of the Meiji period or the minutiae of who did what to whom to get museums built, they shared in every twist and turn of my project. For their abundant support and good humor, I am very grateful. This book is as much mine as theirs: my parents, Chris and Iris; my brother, Steve, and his wife, Anne; and my spouse, Derrick Choi. Thanks are also due to my extended family and the many personal and family friends who cheered me on. The most cooperative family member has been baby Clara, who was smart enough to wait until the completion of the manuscript to come into being; there will be no better book than this one to read her to sleep.

Even after years of jostling (or more accurately, being jostled by) throngs of high-spirited school children, senior citizens, tourists, and sacred deer to get to and through the museums, my feelings for these buildings remain as fresh and profound as ever. Each time I stand before them, they take my breath away anew.

The Imperial Museums of Meiji Japan

Introduction

This book examines the Imperial Museums, the first museums of art and history in Japan, as sites of constructed and idealized national self-images. It explores the architecture and art that constitute the totality of these museums and the conceptions of nation and art built into their assembly during the modern period.

A number of major, interlocking factors structured the making of a modern Japanese art historical museum. First was the new relationship, of entwined political, economic, and cultural interests, that Japan entered into with the nations of the West in the 1850s, after centuries of having nearly no diplomatic ties. The abruptly renewed relations with powerful, encroaching forces prompted the imagining of a categorical indigenous self (a notional Japanese homogeneity) in contrast to the foreign other. Second was the new historical consciousness brought about by the changes Japan initiated in order to keep pace with the industrializing nations with which it opened communications. The radical nature and comprehensive reach of the changes led to the conviction, corroborated by tangible upheavals in the structures of the state and society, that the modernizing present was distinctly separate from the feudal past. Third was the emergence of a new patronage and audience for art in the social and political transition from feudalism to a constitutional monarchy. The modern departure from traditional artistic praxis fundamentally involved a shift of physical and intellectual ownership. Many places, objects, and conventions hitherto limited to the purview of the elite were reassigned as the nation's prerogative, to be maintained for national ends. These new conditions and conceptions serve as the key themes of this book and structure its assessment of the merging of art and architecture in the framework of a museum that serves a modern nation.

HISTORY OF THE IMPERIAL MUSEUMS

In 1888, during a tour of the Kinki region, the country's traditional center for the arts, the government official and art administrator Okakura Kakuzō announced the government's intention to design a network of three Imperial Museums as the nation's primary organs of cultural administration:

The museums of Japan will be created through the linking of Kyoto, Nara, and Tokyo. Specifically, the museum in Nara, a city comparable to Rome, will assemble the nation's oldest artifacts that date from the Tenpyō period [729–49] up to the spread of Buddhism; the museum in Tokyo, comparable to London, will specialize in the art of the Tokugawa period and the artifacts of Asia; and the museum in Kyoto, comparable to Paris, will concentrate on the art from the time of Kanaoka [late ninth century] to Ōkyo [1733–95]. It is our highest hope that through this museum triad (*sankan teiji*), Japanese art will be illuminated to the nations abroad.[1]

Okakura's articulation draws attention to three significant features of the Imperial Museum institution that its planners intended: the purposeful configuration of Japanese art after specific Western ideals and models, the allocation of distinct but complementary historical functions to each of the three museums, and, above all, the ambition to create international appeal by amalgamating national resources.

The establishment of the Imperial Museums in the cities of Nara, Kyoto, and Tokyo —successive imperial cities—formally took place in 1889, at a high point of national confidence, most tangibly represented by the recently promulgated Constitution of the Great Empire of Japan (Dainippon Teikoku Kenpō), the first constitution to be drafted by a nation outside the West and its colonies. This book focuses specifically on the formative period of the three museums, which commenced their public commissions as buildings of unprecedented scale and style, and as official showcases of the nation's artistic and historical artifacts, assembled and exhibited for the first time as a unified collection. All who could pay the modest admission fee were able to view this newly constructed narrative of Japan's art historical lineage.

Like the Louvre of Revolutionary France, the Imperial Museums of Meiji-period Japan (1868–1912) were created during a juncture of radical political and social change, but unlike the paradigmatic state art museum, Japan had no existing palatial structure or royal collection readily available for conversion into the nation's museum. The Japanese imperial family made negligible material contributions to the formation of the Imperial Museums, despite the name; instead, the art was purposefully assembled from sources public and private, secular and religious, while newly commissioned buildings served as the architectural framework. Originally fostered in direct response to burgeoning museum and exhibition activities in the Western world, Japan's government-operated museums grew alongside the nation's stature in the Eurocentric world arena and served as an index of its rapid ascension in the global power structure. In the four decades under consideration in this volume, the central government executed plans for four major structures in the three cities to form the museological network of the Imperial Museums. During this time, Japan's representation through these museums may be examined as a process of self-definition heavily informed by a dominant foreign

(that is, Western) influence. Central to this examination are the visual modes of presentation—with an emphasis on the architecture and exhibition strategies—that were crucial to the construction of a Japanese national image as equal to, yet unique from, Western civilization.

While the temporal scope of this book spans roughly the length of the reign of Emperor Meiji, the specific period under examination begins with the coining of the neologism *bijutsu* for "art" in 1872 and ends with the opening of the nation's first permanent *bijutsukan* (art museum) in 1909. An examination of the four main buildings of the Imperial Museums provides both a chronological overview and an ideological register of this institution. Japan's official definition of its artistic heritage at world's fairs and at the Imperial Museums was fundamentally affected by European and American (pre)conceptions of non-Western nations in general and of Japan in particular. The creation of the institutional space of the museum and the category of art in the late nineteenth century can therefore be placed in the broader context of Meiji Japan's difficult and paradoxical search for a new yet historically grounded identity.

Chapters 1 and 2 of this book cover the prehistory of the Imperial Museums. Chapter 1 examines the origins of two terms central to this study: *hakubutsukan*, the translation word for "museum," and *bijutsu*, the translation word for "art." The chapter begins with an investigation of the initial circumstances of Japanese exposure to Western museums and exhibitions in the 1860s and 1870s through the identification of specific models and terms of engagement. Three primary texts from the period set up the discursive arena for the transplantation of the museum institution to Japan. These three sources, authored respectively by government representatives Fukuzawa Yukichi, Kume Kunitake, and Sano Tsunetami after separate investigative missions abroad, cover the spectrum of official interest in and motivation for establishing museums in Japan. The practical and ideological ends that the museum could achieve for Meiji Japan— the dissemination of scientific knowledge and the promotion of art and industry—are scrutinized. The chapter continues on to consider the translation of the fine arts as concept and terminology in relation to the Meiji emphasis on artistic production for display and sale. The coining of the term *bijutsu* in conjunction with Japan's entry into the 1873 Weltausstellung in Vienna situates the birth of the term within the politics of national art display at international expositions. The competitive nature of these events (each nation vying to show itself to advantage) effected shifts and variations in the composition of the fine arts category from one exposition to the next, thereby rendering *bijutsu* an elastic rather than a static heading, responsive to political and economic world developments. The cultivation of an intimate relationship between art and industry in the modern period stemmed from this time and these circumstances. The museum functioned in concert with Japan's participation in expositions overseas by anchoring the two classes of objects as the foci of the institution's collecting.

Chapter 2 studies the institutional forerunner to the Imperial Museums, the museum housed in the permanent building in Ueno Park, in Tokyo, which opened in 1882. Originally named the Museum (Hakubutsukan), it epitomized the Meiji bureaucracy's mission to engage Japan in the international standards and practices of the time. The building, designed by the English architect Josiah Conder (1852–1920), was an early product of the alliance between a foreign expert and the Japanese government. Exhibits composed of the nation's most exemplary production, both natural and man-made, were installed in accordance with the classification system of the earliest world's fairs held in the West in the mid-nineteenth century and the museums that stemmed from them. The architecture of the Ueno Park museum reflected a similar merger of Western design with Japanese stylistics, although it was colored by Conder's personal vision of a new "Oriental" style that he wished to devise for Japan.

Chapters 3 through 5 chronicle the age of the Imperial Museums, from 1889 to 1900. Chapter 3 evaluates the continuities and discontinuities in the institutional objectives and administration that constituted the 1889 reorganization. Two resolutions were most decisive: (1) the installation of two satellite museums in response to the wealth of cultural objects that had historically accrued in the Kinki region around the cities of Nara and Kyoto and (2) the inclusion of the museums in the new art policy, a comprehensive system sponsored, in the main, by the Education Ministry (Monbushō) and the Imperial Household Ministry (Kunaishō) and envisioned by the administrators Kuki Ryūichi, Ernest Fenollosa, and Okakura Kakuzō as linking the preservation, presentation, and production of art. While the organizational changeover under the Imperial Household Ministry has often been portrayed as the true beginning of the age of cultural administration at this institution, due to the shift of collecting focus away from science and industry to fine art and history,[2] the Imperial Museums were in fact just as much a function of the political and economic interests of the state as they had been before, especially under the pragmatic direction of Itō Hirobumi, who served at once as the nation's prime minister and the imperial household minister.

Chapters 4 and 5 examine the two museums in Nara and Kyoto as functions of the new emphasis on art as a link between old and new Japan. While the administrators of the Imperial Museums had initially projected a unified agenda for the satellite museums, the two structures were marked by regional distinctions that arose from each city's historical role as well as the new roles they were assuming in the symbolic topography of a modernizing nation.

Chapter 4 begins with an exploration of the background and career of the architect Katayama Tōkuma (1853–1917), who designed the Imperial Museums at Nara and Kyoto concurrently in the 1890s and the Hyōkeikan art museum in Tokyo in the first decade of the twentieth century. Katayama trained under Conder in the 1870s and, after graduation, enriched his knowledge and design vocabulary through extended, firsthand

investigations of the architecture of Europe and the United States. As a career state architect who specialized in institutional designs of the highest ceremonial order (legations, museums, palaces, mausoleums), Katayama drew upon international sources for the expression of Japan's modern image. His oeuvre shows a consistent use of the high Classicism that dressed comparable institutions in Europe and the United States, and the three museum designs by him examined in this book represent three stylistic variations of this vocabulary. It is possible to argue that at the end of the nineteenth century, Classicism of Greco-Roman origin would no longer define Europe exclusively but developed as a shared language of power, empire, and political legitimation for many nations with global aspirations regardless of actual ethnic kinship.

Chapter 4 continues on to highlight the Imperial Kyoto Museum (Teikoku Kyōto Hakubutsukan) as an institutional signifier of Japanese art as living legacy. Playing out at the site of the museum was the city's ambition to maintain its millennial standing as the heart of the nation's artistic production, in accordance with its active installation of modern infrastructure. The installation of an Imperial Museum fulfilled Kyoto's two-prong agenda, to maintain and to modernize its identity as a metropolitan center for the arts. Anticipated as a precedent-setting design, this museum drew some criticism for not dressing in a uniquely and conspicuously Japanese style. Yet this building made Japan legible through the strategy of visual differentiation, a strategy clarified by comparing the architecture and display method of the Kyoto museum with a parallel national project overseas, the Hōōden, the Japanese pavilion erected for the 1893 World's Columbian Exposition in Chicago. These two projects—planned by the same administrators, for similar functions of Japanese cultural display at around the same period—speak to the necessity of a nuanced treatment of national expression for capturing the desire and respect of an international audience.

Chapter 5 explores the Imperial Nara Museum (Teikoku Nara Hakubutsukan) as a signifier of Japanese art as ancient religious heritage. The intersection of the state's religious reforms, the area's concentrated abundance of renowned Buddhist and Shinto treasures, and the developing museum framework gave rise to an administrative policy on religious art that was arguably the most innovative feature of the Imperial Museums. The chapter investigates the official motivation behind installing a museum in an area already rich with the material culture of the past and the extent to which it was meant to coincide with existing display practices. As much as the museum in Nara was designed as customized architecture for art treasures from regional temples and shrines, it also deliberately asserted itself as a space apart from these religious fixtures. The modern architectural framing and the typological installation of the collection lent an altered visibility to works formerly governed by liturgical or doctrinal specifications. Rather than position the temple and the museum as mutually exclusive places, however, this chapter attempts to locate their physical and practical adjacencies.

Chapter 6 enters the twentieth century and the age of the Imperial Household Museum. At the turn of the century, the Imperial Museums were renamed Imperial Household Museums in order to properly reflect their affiliation with the imperial institution rather than with the nation at large. As an immediate consequence, the museums distanced themselves from practical application and education and placed greater emphasis on preservation. This chapter centers around the Hyōkeikan art museum, a functional monument dedicated to the crown prince, which was conceived and financed by the citizens of Tokyo but supervised from the time of construction by the Tokyo Imperial Household Museum (Tōkyō Teishitsu Hakubutsukan), formerly the main branch of the Imperial Museum located in Ueno Park. This fourth and final major museum structure of the Meiji period takes us back full circle to Ueno Park, no longer the uncultivated wooded grounds of the 1870s but a vibrant center for the arts in 1900. Art practitioners as well as art administrators who were major forces of influence in Ueno envisioned the new museum of art as an exclusive space for exhibiting paintings and sculptures. However, the consensus ended there. Opinions differed over the essential role of art in society, the relationship between the arts of the past and the arts of the present, and the expression of national identity through museum design.

HISTORIOGRAPHY OF THE IMPERIAL MUSEUMS

The histories of the Imperial Museums at Kyoto, Nara, and Tokyo have been documented in detail as early chapters in the centennial retrospective volumes published by their respective successors, the current Kyoto National Museum, Nara National Museum, and Tokyo National Museum.[3] The museums have meticulously combed their own institutional records to unravel the complexity and density of their pasts, and the publications serve as a significant and invaluable source of information for all researchers on the history of Japan's museums. However, no institution is free from the fundamental methodological limitations inherent in writing its own history, and in the case of the National Museums, the methodical thoroughness—and thus, seeming infallibility—of their official self-narratives threatens to hamper, rather than provoke, consideration of their historical function in a new light.[4]

First and foremost, because the story of the Imperial Museums has been separated into three distinct histories, the original function of the three museums as a unified network has been deemphasized, if not entirely submerged. This book retrieves their cohesive beginning by examining the master plan that formed their linked organization and the singular design approach that distinguished their architecture.

Furthermore, the retrospective mode of the centennial histories has been structured to validate the institutions' state, at the time of publication, as vital fixtures of art administration under the Agency for Cultural Affairs (Bunkachō), which was created

after World War II.[5] The narratives unfold as teleological journeys toward current practice as the inevitable and best way of organization, when in fact the stimuli behind the initial operation of the museums and the categories established within them remained exploratory and variable throughout the prewar period. There remains room for further analysis and alternative interpretations, which this book will pursue by studying primary sources in addition to institutional records such as original architectural drawings and models, personal journals and notes of the museum designers, and the popular press and specialized publications of the period.

This investigation of the social and political circumstances surrounding the establishment of the Imperial Museums aims to dispel the idea of a linear institutional development and the attendant notion that developments in the art world were detached from matters of the state and politics. Within the four decades of the Meiji period alone, at least two major shifts occurred in the institutional structure, the collections, and the agency, and sweeping changes repeatedly took place in the period between each museum's founding and the publication of its centennial history. Pivotal moments of transition include the creation of the Imperial Museums in 1889, their reorganization as the Imperial Household Museums in 1900, and another reorganization as the National Museums in 1947, for Tokyo and Nara, and in 1952, for Kyoto. More recently, in 2001, as part of the restructuring of the central government, all three museums were made semiprivate institutions, and the group was officially renamed the Independent Administrative Institution National Museums (Dokuritsu Gyōsei Hōjin Kokuritsu Hakubutsukan). Each reorganization was an unambiguous consequence of a reorganization of the central government, and it should be self-evident that the museums operated within the same orbit of motivations and pressures that animated the political structure as a whole. This method of exploring a direct correlation between art and the state has been used to persuasive effect by two scholars for specific French topics: Andrew McClellan's study of the founding of the Louvre at the height of the Revolution and Patricia Mainardi's examination of the end of the official Salon system in the first decades of the Third Republic.[6] The same method could certainly be applied beyond Japan and France, to investigate the production and enforcement of what Mainardi calls "an ideology of centralized government control of the arts."[7] The history of the modern museum is a shared history among institutions around the globe motivated by interlinked interests and purposes.

THE STUDY OF NATIONS AND NATIONAL DISPLAYS

The Meiji Restoration of 1868 marked the return of the emperor in name to the top of the political hierarchy. The rise of the Meiji regime in opposition to the military government, or *bakufu*, of the Tokugawa family was a direct reaction to the threat of domina-

tion by Western military powers that had arrived on Japanese shores a decade earlier. The decision by the new Meiji bureaucracy to modernize in order to resist foreign domination prompted questions about the appropriate balance between learning from Western paradigms and affirming indigenous methods and forms. In the framework of the Imperial Museums, these tensions played out prominently in the choice of construction method and architectural style for the commissioned buildings and in the organization of the collections within them. The key concern was how modernization could also preserve cultural identity.

After more than two centuries of national isolation, or *sakoku* (literally, "locked country"), Japan needed to define itself within the world order as mapped by the Western powers. Its participation in the international exhibition culture of the time inspired a vision of the Imperial Museums as the illuminators of Japanese art to the world (to use Okakura Kakuzō's words). The world's fair and the national museum were two venues, intertwined by virtue of overlapping administrative intents and purposes, where the staging and performance of Japanese national identity were conspicuously affected by the prevailing practices of Western nations. Studying the representation of Japan during this period of renewed contact with the outside world allows for an understanding of the construction of self-imagery as a relative rather than a solipsistic process.

Japan's engagement with the West through the museum reveals an "other" perspective on the perception and evaluation of cultures during the nineteenth century. The relationship between Japan and the Western powers, though grossly imbalanced at the outset, nonetheless did not render the former powerless or voiceless. The Meiji government's active participation in world's fairs, beginning with the 1873 Weltausstellung in Vienna, spurred the organization of its own domestic industrial exhibitions as well as the eventual establishment of the Imperial Museums;[8] these coordinated efforts at participation and emulation should be understood as deliberate strategies intended to extract the "essence" of Western success for Japan's own application.[9] As discussed in chapter 1, a fuller understanding of the establishment of the museum institution in Japan necessitates an exploration of the two-step process of cultural interpretation: first, Japanese comprehension of the structures of European culture and, second, Japan's reassessment of its own culture in contradistinction to the Western other.

The museum, together with the expositions, international and national, comprised the allied sites of exhibition that arguably cast the widest net of influence in the late nineteenth century. Critical analysis of expositions has directly addressed the issues of art and architecture in relation to nation, race, and identity by employing the theories developed in anthropology, sociology, political science, and postcolonial studies. Works that have focused on architecture specifically, such as Zeynep Çelik's investigation of the self-representation of Islamic cultures at the European fairs and Patricia Morton's study of the imposed representation of the French colonies at the same, have dealt with

questions that also pertain to museum architecture featuring cultures outside the European center.[10] As Jeffrey Auerbach points out in his analysis of the first international exposition in 1851, the "seemingly contradictory ideologies [of nationalism and internationalism] were present from the outset" in the design of this fair—and all subsequent world's fairs.[11] Despite the internationalist orientation of the exhibitions, national imperialist intentions were the continual driving force behind the events, with the hierarchical structuring of the center (Western) against peripheral (non-Western) nations visibly manifested in the physical layout of the fairgrounds.[12] In Çelik's words: "World's fairs were idealized platforms where cultures could be encapsulated visually—through artifacts and arts but also, more prominently, through architecture."[13] Meiji Japan, an avid participant, transferred the techniques of self-exhibition employed at the fairs overseas to the museums being erected at home and was continually responsive to the interests and predilections of Europe and the United States. Although the Imperial Museums stood as monuments to the nation's heritage, the West, as Okakura's earlier quote suggests, was always upheld as a main source of inspiration as well as critical reception. In addition, the actual participation of Western experts such as Josiah Conder, Ernest Fenollosa, and Gottfried Wagener was instrumental to the museums' formation. Therefore, the constancy of Western presence, both real and anticipated, loomed large in the conscious reformulation of Japanese culture at the government-administered sites of the museum and exposition.

In fact, it is no longer unusual to propose that European cultural paradigms formed the foundation of Japan's modern system for art preservation, promotion, and production. Certainly, a main assertion of this volume is that the transplantation of foreign ideas and structures involved a necessarily active and complicated process of interpretation and adaptation on the part of the Japanese in order to fulfill their newly developing "self-visions and aspirations," to use Çelik's words, as a technically as well as culturally advanced nation. This examination of the history and function of Japanese art museums fits under the larger umbrella of current scholarship on the invention of a national art during the Meiji period, launched by the scholars Kitazawa Noriaki and Satō Dōshin more than a decade ago.[14] They have challenged the Japanese art historical field's understanding of its own origins by putting forth the argument that "Japanese art" (*Nihon bijutsu*) as a concept and a category was institutionalized, canonized, and standardized under the auspices of the Meiji bureaucracy through the joint enterprises of the museum, the exposition, and the academy. This comprehensive system of art served as a powerful tool in promulgating a collective history and identity in a time characterized by great social and cultural change, and its influence extended to the government's agenda on commerce, science, public education, and national pageantry. Above all, the realities of international relations and domestic reform, such as securing an export art market in the West and stemming the outward flow of important artworks

from Japan, acted as the most immediate and powerful catalysts for the implementation of a national art policy during this period.

THE STUDY OF MUSEUMS AS COLLECTIONS IN CONTEXT

The growing interest in the history of institutional structures of art has applied to study of the West and Japan alike, and an examination of the origins of Japan's oldest and most powerful set of art museums reveals a moment of intersection between dominant ideals motivating European, American, and Japanese cultures.[15] The formation of the Imperial Museums concerned the development of physical and categorical parameters for a national art in the face of aspirations arising from industrial expansion, cultural enfranchisement, and, later, empire building. What makes the Japanese case unique is the ambitious and comprehensive effort from the top to integrate the multiple facets of art production and cultural preservation. Whether as commercial object, as reformed religious relic, as living tradition, or as innovative practice, the multivalent constructs of art each found a place inside the Imperial Museums.

One scholar who has broken new ground in examining Meiji-period practices of collecting, displaying, and preserving Japanese art is Christine Guth.[16] In addition to foregrounding them as linked endeavors at the official and private levels, Guth has scrutinized the modern formation of a national art canon and the official category of National Treasures (Kokuhō) as resulting directly from the cultural opening of Japan to Euro-America. Her emphasis on specific political and economic factors that spurred the recasting of an eclectic body of works as Art—a stable, invariable status—has led to the logical next step pursued in this book, investigating the physical armature within which Art was emplaced and apotheosized.

The consideration of architecture as an integral part of the holistic construction of the Imperial Museums is essential to an evaluation of these institutions. Extending the scope of research to encompass the site, process, technology, and style of architecture involved in shaping each museum yields a more complex and interesting story than one simply of a burgeoning nation affirming its premodern heritage through the preservation of relics from the past. The architecture tells a story animated by foreign emulation, internecine competition, and even local resistance in the cities upon which the Imperial Museums descended. Although the buildings, in the most general terms, were all Western-style designs, the rapport between the museum as a structure and its respective city varied to a notable degree. The complexity arising from juxtaposing the new type of architecture with the existing city fabric and with the amassed collections of objects registered differently in each setting. Discussions leading up to construction and criticisms voiced after the unveiling of the buildings are crucial to understanding the architecture as a built manifestation of competing government agencies and agendas

and also offer a gauge of local attitudes and politics. This mode of thinking follows Carla Yanni's examination of nineteenth-century British natural history museums, about which she wrote: "the completed building is only one answer to a complex question, and . . . not necessarily the most obvious answer."[17]

Of the four main buildings examined here, the Japanese government has designated the three that remain standing as Important Cultural Properties (Jūyō Bunkazai) in the architecture category.[18] Despite this prominent status, however, the original buildings of the Imperial Museums have not been analyzed as designs for object exhibition. The hermeneutical gap lingers, especially now that two of the three buildings no longer function as regular display spaces.[19]

Within the fields of art and architectural history, some existing approaches to the investigation of museums have precluded a cohesive consideration of the art and architecture of the Imperial Museums. The treatment of content and building as separate events at the museum has proved remarkably persistent within the art historical discipline, with the collection catalog and the building monograph positioned as discrete genres of publication.[20] The continued separation of museum architecture from its function perseveres, in large part owing to the current spate of high-profile, high-publicity commissions for new museum buildings. Impossibly hefty budgets, prestigious international design competitions, and celebrity architects (two prominent American examples being the Getty Center in Los Angeles, designed by Richard Meier and completed in 1997, and the new building of the Museum of Modern Art in New York, designed by Yoshio Taniguchi and completed in 2004) have deepened the perception of museum structures as primarily products of design and further obscured their fundamental role as showroom and storehouse for objects. Although criticisms of and protests against the alienation of art within large-scale, self-aggrandizing architectural masterpieces have proliferated in both specialist publications and the popular press in the past decade, these acknowledgments of architecture's overshadowing of art actually deepen the divide rather than encourage new approaches to thinking about museums as collections in context.[21] It is especially important not to approach a historical study of the Imperial Museums with the current mind-set that art and architecture constitute combating elements of a museum, for this polarization reflects an anxiety of our time, not of the Meiji period.

It would be misleading, however, to imply that there is a scarcity of critical studies on museums and their histories. Notably, art historians exploring museum-related issues have expanded their analytical framework by turning to methods used in other disciplines. In 1980, Carol Duncan and Alan Wallach, using concepts derived from anthropology, called attention to the phenomenology of the museum as shaped by the spatial confluence of art, architecture, and installation.[22] Each continued to pursue this idea in depth, with Duncan developing the concept of the museum setting as a spatial prompter of ritual performance by the visitor (for the purpose of intellectual and even

spiritual enlightenment), and Wallach concentrating on the politics of installation in depicting "American society and the American past" in the art institutions of this country.[23] The transformative potential and the narrative function of the museum are two issues close to this analysis of the strategies in operation at the Imperial Museums— that is, strategies that proffer the museum as an experience different from other sites of cultural experience. Chapters 4 and 5 raise the issue of how the Imperial Museums negotiated competing functions and narratives already in place in long-established cultural centers of Japan.

Another reason that the art and architecture of the Imperial Museums have not been analyzed jointly is the dearth of Western scholarship on modern Japanese buildings, especially those branded as "Western-style" (*seiyōfū*, or *yōfū* for short). What Jordan Sand wrote in 1998 still applies to some extent to the state of Japanese architectural history today: "The Western fascination with Japanese architecture—whether as an object of exotic beauty, an embodiment of Zen spirit, a validation of the universalist claims of modernism, or a sourcebook for craft technique—has encouraged reified perceptions of Japan not conducive to the study of buildings and their makers in historical context."[24] The expectation that Japanese architecture, much like Japanese art, must represent a uniquely Japanese identity devalues as culturally derivative and insignificant those projects that heavily incorporated imported Euro-American technology and styles. Western-style Japanese architecture has occupied an awkward place between cultures and therefore between disciplinary fields, and it has fallen outside the bounds of survey texts that delineate hermetic, cultural-national achievements. Fortunately, since the mid-1990s, two widely used texts have made promising efforts at inclusion; the first edition of Penelope Mason's *History of Japanese Art* and William Coaldrake's *Architecture and Authority in Japan* cover the full historical spectrum and incorporate lengthy sections on Meiji-period architecture rather than concluding the chronological narrative at 1868, the endpoint of the preceding Edo period.[25]

Despite the publication of a number of excellent English-language articles and books incorporating original research and informative sociopolitical framing of major architects and projects of the modern period, there is still a tremendous scholarly void surrounding official projects executed in the mid-Meiji period (around 1880–1900).[26] Primary research on the key Meiji state architects Josiah Conder and Katayama Tōkuma has up to now been the domain of scholars in Japan who have investigated their architectural works within the diachronic progress of the history and practice of Japanese architecture.[27] The emphasis has been on how much these architects broke from indigenous traditions of design and construction and how much influence they exerted over succeeding generations of academically trained architects. This volume expands on the existing understanding of their projects by making a synchronic slice and investigating the Imperial Museums within global design trends in the late nineteenth and early

twentieth centuries, for museums specifically and for state monuments in general. It also takes into consideration domestic developments in the preservation and presentation of national art forms. Understanding the Imperial Museums as designs in dialogue with international and national movements allows for the recovery of the multitudinous actors and factors that facilitated the development of these projects, hence breaking out of both the Western scholarly tendency to view Japan in isolation and the Japanese scholarly tendency to view architecture in isolation. The realities of the Meiji period necessitated integration across national and disciplinary borders, and the study of a Meiji-period subject should properly address these border-crossing conditions.

THE STUDY OF MEIJI

What was Meiji? What is Meiji? Together, these two questions conjure up the thin but essential line dividing historical facts and their interpretations: Meiji was an emperor, a revolution, an opening to the outside world; Meiji is a historical marker, a benchmark, an epistemology. A discussion of the Imperial Museums inevitably requires treading carefully through Meiji self-representations, very often effusive and compelling, as well as through studies of Meiji, which should be all the more cautious of echoing these self-conscious pronouncements unfiltered. The historian Carol Gluck characterizes all who take on Meiji as a subject of inquiry as: " . . . scholarly Houdinis working in different ways to wriggle out of the straightjackets of linear national narrative, essentialized polarities, epistemological and canonical categories—all the restraints created by Meiji's representations of itself, which amount to the restraints of modernity in general."[28]

In short, the line needs to be drawn clearly between the sweeping changes that actually took place during Meiji and the period's characteristic claims to newness and progress. If we define modernity solely as a rupture with the past, and Meiji exclusively as modern, then we risk glossing over the ways and things that did remain constant or only marginally altered as the nation underwent modernization. For example, two primary issues of concern in this book are the primacy of religion to the local identity of Nara and of artistic industries to Kyoto; modernization heightened more than disrupted these identities. A balanced inquiry of Meiji necessarily entails listening to the highly vocal and articulate, but not to the extent of stifling subtlety and nuance.

That said, a study of the Imperial Museums, monumental state organs of cultural administration, appears to be contrary to the spirit of recovering a Meiji that is not synonymous with a monolithic state apparatus. And upon first glance, the Imperial Museums can be taken as evidence of a Japan that had severed its ties with tradition in the attempt to be modern, by embarking on the wholesale assumption of things Western. These apprehensions are assuaged if we assume two particular theoretical positions, now shared by many historians of Meiji: first, that the state can no longer be portrayed

in a one-dimensional way nor can modern history be encapsulated by a master narrative and, second, that the concept of "Western" assumed various linguistic forms and inflections, and to analyze something encoded as "Western" during Meiji entails dealing with both objective features and subjective perceptions.[29]

The Imperial Museums were very much a part of the Meiji state's self-representation as novel and progressive, although dealing directly with the matter of the nation's cultural heritage required a more nuanced treatment that attempted to harmonize modern innovation with the ancient origins being celebrated and preserved. The lack of consensus and the general fragmentation among the groups of state bureaucrats and state-hired experts involved offer evidence that no single, easy solution was available. Several ministries did pool their resources to see through the preparation and creation of the Imperial Museums, although this in no way implies that they approached the project with one mind. Even within the same ministries, not all the participants entertained the same visions. Tellingly, for the buildings examined in this book, there was a consistent and evident disconnect between the ideal and the actual installation of the collections. Furthermore, local administration and organizations in Kyoto, Nara, and Tokyo reacted to these state-managed institutions with less enthusiasm or approval than anticipated. Certainly, in the context of the formation of the Imperial Museums, it is not possible to speak of an overarching entity in the guise of "the state."

Similarly, this book tries to resist reading "the West" as an undifferentiated homogeny and attendant things labeled "Western" by Meiji Japanese as a transparent category. The aim is to unpack the tangible attributes of the Imperial Museums—such as an architectural element, an interior room scheme, or a mode of access—that fulfilled Meiji imaginings of Western-ness. This of necessity implicates a study of the flip side of the coin: what satisfied Meiji imaginings of Japanese-ness (and sometimes of the broader "East"), a cultural-national uniqueness by invention essentially distinct from Western-ness. Were the Imperial Museums fashioned as representations of one or the other? Or, more ambitiously, as a complex merger of these constructed opposites? In asserting the latter, this volume acknowledges the fact that the museums were, and still are, accepted with difficulty as persuasive symbols of both native Japanese tradition and Western-inspired modernity, for they have fallen prey to precisely the absolute barrier erected between Japan and the West. Critics then and now tend to review on separate terms if not in separate frames altogether the collections that embody the perceived Japanese-ness and the architecture that embodies the perceived Western-ness. Almost too true to the underlying spirit of opposites, one is usually found to be satisfactory while the other is deemed deficient: many a Meiji critic marveled at the architecture while reserving sharper words for the collection. Interesting, too, enthusiasm for the Euro-American-inspired architecture dimmed perceptibly from the first to the last building examined in this volume, not because of a surge of nationalistic pride but because of the plethora

of such designs skillfully implemented by Japanese in Japan during the three decades in between. From which arise the questions: What made this last museum Western all the same, if a Japanese architect designed it to house Japanese artworks in a building styled to resemble contemporary museums around the world? Why was it, at the same time, expected practice to house art encoded as Japanese in a space encoded as Western? The following chapters attempt to answer these questions.

I · Encounters and Translations

The Origins of *Hakubutsukan and Bijutsu*

We do not stimulate the sense of sight through museums. We do not introduce new things through exhibitions. To excuse ourselves by saying that it is because we are of a different habit of mind is not an honest argument.

—Kume Kunitake (1872)

Two terms integral to this study on the formation of the Imperial Museums are *hakubutsukan* (博物館) and *bijutsu* (美術). Both were translation words created in the early Meiji period to capture larger concepts from the West: *hakubutsukan* for "museum" and *bijutsu* for "art." This chapter investigates the initial circumstances of their creation and the fairly separate processes of their conception. While the term *hakubutsukan* was generated from long-term visions of scientific and technical training for the Japanese, *bijutsu* was invented as part of an immediate plan of action to enter the world economic market through artistic, manufactured objects. The two terms and their respective ideological orbits did not converge until the middle of the Meiji period, when fine arts became a major collecting department at the Imperial Museums. One legacy of this institution would be the molding of the nation's museum to be synonymous with its fine arts.

HAKUBUTSUKAN: TRANSLATING MUSEUM

To reflect on the historical circumstances of the formation of a national museum in Japan requires, at the outset, examination of the contemporaneous models in Western Europe and the United States that inspired it. Although a diversity of intent, scope, and function prevailed among the large number of museums operating during this time in Europe and the United States, it is still possible to broadly define the nineteenth-century museum as an integrated system of collection, classification, and display that served to provide knowledge (and, secondarily, entertainment) to an extended general public. Essential to its discourse—that is, its operative reason and logic—was the relationship between the object and knowledge and the way in which, and the extent to which,

material culture served as an index to human culture. Some of the major assumptions at work can be found underlying the museum's fundamental operations of *collecting*, *classifying*, and *displaying*.

The first and foremost assumption was that of the object as a site of knowledge, or what the historian Steven Conn characterizes as an "object-based epistemology."[1] The object not only possessed inherent meaning in itself but also acted synecdochically to evoke an encompassing category of related objects and metonymically to conjure up a larger elusive whole. To form a collection of objects, in essence, was to form a microcosm, with each specimen acting as a constitutive block of that world.

A second assumption was that of the commensurability of knowledge. The meaning residing in the objects was likened to commensurable, hierarchical units; meaning was revealed through the proper systematization and arrangement of the objects. Furthermore, such a classificatory system, in the words of Donald Preziosi, presupposed a "universal standard or measure against which the products (and by extension the people) of all times and places might be envisioned together on the same hierarchical scale or table of aesthetic progress and ethical and cognitive advancement."[2] Classification therefore rendered the world into a system of objects, the ordering of which yielded some larger meaning or reality.

A third assumption was that of the object as a medium of communication. Construed as an evidentiary artifact, the object was charged with the function of successfully communicating to the beholder its meaning, to be yielded by means of *visual* inspection. Applicable to the objects housed in the art museum and the natural history museum alike, meaning was thought to rest within the objects' observable features; the objects were valued for the evidence of original time, place, and circumstances of production they could provide. To display was not only to grant visual access to an object but also to provide an ordered viewing framework for a greater narrative.

The operations of collecting and displaying—and, tacitly, classifying—remain fundamental to the definition of a museum today.[3] The immediate and ardent reaction of the Japanese to the museums they encountered was a testament to the efficacy of this object-based, ocular mode of communication. Even as foreign visitors who were limited by language and cultural comprehension, they were able to recognize the effectiveness of the museum's fundamental operations and its vital position in the larger scheme of a nation's administration of knowledge and culture. Based on the reports submitted by officials sent on government missions to the West in the period from the 1860s to the 1870s (to be examined in detail in this chapter), the following functions of the museum were recognized as the most efficacious to a developing nation-state: directing contemporary visual culture (i.e., its relationship to other modes of public exhibition), defining allied fields of practice and disciplinary study, and fabricating and maintaining the nation's visual imagery and master narrative.

The earliest efforts to investigate, implement, and disseminate the Western museum models in Meiji Japan were initiated at the behest and with the sponsorship of the central government. It launched this ambitious enterprise without the benefit of any one individual's prevailing vision, expertise, or largesse. The imperial family was unable to contribute a collection or a palace to the cause. Bureaucrats, rather than keen art administrators such as Henry Cole in Great Britain or ambitious private collectors such as William Wilson Corcoran in the United States, were responsible for founding a national museum.[4] The absence of a comparable Cole or Corcoran figure to spearhead the museum movement in Japan was apparently in step with the overall approach to the implementation of Western-inspired institutions and policies at the time, as W. G. Beasley articulates:

> Policy decisions [in the early Meiji period] did not so much depend on detailed knowledge of the West, or training in its skills, as on an awareness of problems and possible solutions to them. The "experts," whether Japanese or foreign, had their place in advising on policy, or implementing it, but the men who decided it, at least in the first generation of the Meiji leadership, were politicians, especially those who had traveled in the western world enough to form a view of its virtues and defects. They had not usually studied there in any larger sense.[5]

Therefore, rather than focus on the advocacy of one or two prominent "experts," this chapter pools together some of the most influential judgments formed by Japanese delegates who encountered Western museums firsthand and examines the rationale behind their recommendations.

THREE EARLY TEXTS DEFINING *HAKUBUTSUKAN*

The earliest recorded visits by a Japanese to museums and exhibitions in the West date to the 1860s. After the political and economic opening of Japan in 1853, the Tokugawa *bakufu* sent envoys to North America, in 1860, and to Western Europe, in 1862, for the purpose of negotiating and ratifying trade treaties. The Meiji government, which overthrew the Tokugawa regime in 1868, also sponsored several missions, combining diplomacy with fact-finding, to the West. The earliest Japanese exposure to the museums took place when the envoys visited the public exhibitions held in the Western capitals (fig. 1.1).

One way to begin to assess the Japanese comprehension of Western museums is to examine the terminology they invented to describe what they were seeing. Since the time of earliest contact, the term *hakubutsukan* has been the closest Japanese equivalent for the English term "museum." It was an informal creation that first appeared in the

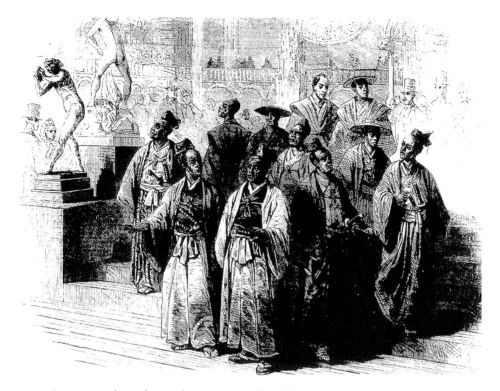

1.1 Japanese ambassadors at the International Exhibition, London, 1862. *The Illustrated London News* (24 May 1862). Courtesy of the Library of Congress.

diary entries of members of the 1862 mission to Europe.[6] The term, however, did not gain widespread acceptance and usage in Japan until the publication of the book *Conditions in the West* (Seiyō jijō) several years later. Because of the book's popularity, the word *hakubutsukan* overshadowed several others that were invented at the same time—*hyakubutsukan* (百物館), *hakubutsusho* (博物所), *shūkokan* (集古館)—all coined to convey the meaning of a centralized place housing a diverse range of objects.[7]

Hakubutsukan is not merely a translated word or a translated concept. It belongs squarely within Japan's larger project of translating the West at the end of the nineteenth century. Historian Douglas Howland has studied the transmission of Western concepts through the invention of Japanese terminology, proposing that the translation of Western concepts during this time necessarily involved extensions and modifications of meaning due to the dissimilarity of language and usage specificity between Japan and the culture of origin.[8] Offering more than a phonic transcription, as does the term *myūziamu* (ミュージアム), a transliteration that reproduces the sound of the English word "museum," *hakubutsukan* is a translation word that approximates the meaning of Western museums as perceived by the first Japanese who encountered them in the 1860s

and 1870s. The term *hakubutsukan* is composed of three Chinese characters 博 (*haku*), 物 (*butsu*), and 館 (*kan*), which combine to mean literally "hall of diverse objects." It sacrifices the classical European etymological root *mouseion* as well as the rich, complex intellectual lineage lodged in this term; it privileges instead one dominant feature—the universal scope of this institution's material holdings. [9]

In their diaries and records, the Japanese envoys conflated many functionally differentiated and specialized places under the heading of *hakubutsukan*—natural history museums, art galleries, international exhibitions, zoological parks, botanical gardens, and even the Patent Office in Washington, D.C. These venues shared one prominent feature, display of a diverse range of objects for visual edification and spectacle within the confines of a specified physical space. Beyond noting the physical attributes of museums, the Japanese visitors also made mental associations between the material object and rational knowledge, acknowledging the importance of providing that knowledge to the general public for the betterment of the nation. Greek Muses and Alexandrian intellectualism submerged, the translation word maintained a steady emphasis on the tangible reality of the collection and its utility in the service of popular enlightenment.

Three primary texts from the Meiji period set up the discursive arena for the transplantation of the museum to Japan: Fukuzawa Yukichi's *Conditions in the West* (1866–70); Kume Kunitake's *A True Account of the Ambassador Extraordinary and Plenipotentiary's Journey of Observation through the United States and Europe* (Tokumei zenken taishi: Beiō kairan jikki) (1878); and Sano Tsunetami's *Report on the Austrian Exposition* (Ōkoku Hakurankai hōkokusho) (1875). Together, these three sources capture the basis of official interest and motivation in establishing museums in Japan and offer the impressions and recommendations of three major intellectual figures of the Meiji period.

Conditions in the West

Fukuzawa Yukichi (1835–1901) joined the first Japanese mission to the United States in 1860 as well as the first to Europe in 1862.[10] His three-volume work *Conditions in the West* is a compilation of observations he made on these visits to the United States, England, France, Holland, Portugal, and Prussia, and it describes the institutions and customs of the West in plain, concise language. A best seller in its time, *Conditions* was an attempt by its author to relay to his audience—his countrymen, who would have had little prior exposure to the subject matter—the essence of the West, or what Fukuzawa believed differentiated the West from Japan. The book is organized in encyclopedic fashion and contains entries on distinctively "Western" concepts and inventions as diverse as *kokusai* (national debt), *gaikoku kōsai* (diplomacy), *shinbunshi* (newspaper), *hinin* (poorhouse), *tenin* (insane asylum), *jōki kika* (steam engine), and *gasutō* (gaslight). The description for the term *hakubutsukan* appears in the first volume:

A museum [*hakubutsukan*] is a place where the world's material goods, ancient artifacts, and rare objects are gathered and exhibited for the sake of propagating knowledge. A mineralogical museum is a place where minerals are collected. Approximately all of the world's metals and rocks are gathered and displayed, each labeled by its name. A zoological museum is a place where animals, fish, and insects are collected by type. For animals, their insides are stuffed so that the outer skin layer keeps its shape; for fish and insects, chemicals are used to dry and harden them in their original forms. All appear to be living. There are also instances when small fish and insects are soaked in spirits.

Also there are places called zoological parks and botanical gardens. In a zoological park, living animals, fish, and insects are kept. Lions, rhinos, elephants, tigers, leopards, bears, brown bears, foxes, raccoons, monkeys, rabbits, ostriches, eagles, hawks, cranes, geese, swallows, sparrows, snakes, toads, all of the world's rare and fantastic creatures are here without exception. In order to nurture them, food should be given according to their disposition, and the temperature prepared as appropriate. Fish are put in glass, and once in a while given fresh sea water so as to be kept alive. In a botanical garden, the trees, flowers, and grasses of the world are planted. For tropical plants, a large glass room is built, the inside laid with iron pipes to give out steam for warmth. The inside of the glass house even in the dead of winter is above eighty degrees so that the tropical plants can flourish.

A medical museum is devoted to the practice of medicine. It gathers specimens such as dissected human bodies and bones, fetuses, or the bodily remains of those dead from rare maladies as records for the future. This kind of museum exists in many hospitals.[11]

To today's reader, whether Japanese or Western, Fukuzawa's entry appears to be an incomplete, or highly unbalanced, characterization of a museum, specifically for its emphasis on the sciences to the exclusion of art, history, and culture. Yet more than an expression of the author's personal bias in favor of Western science, the definition in *Conditions* typifies the general sentiment among the Japanese intelligentsia in the 1860s and 1870s that privileged practical knowledge as a key Western value useful for the development of Japan.[12] From Fukuzawa's description, the museum's defining characteristics are the comprehensive range of its collections, its rational systemization of specimens, and its positivist grounding for knowledge; the overarching aim of the museum is the pursuit of knowledge for knowledge's sake. In this model, universal principles trump sociocultural values as well as aesthetic ideals.

The museum, in conjunction with the other institutions featured in *Conditions*, represented a rational, accessible machinery for knowledge production and dissemination that Fukuzawa found lacking in his own culture. It was potentially vital to facilitating the nation's pursuit of what the early-Meiji elite perceived as "civilization and enlightenment" (*bunmei kaika*), which was at the time measured by a Western rubric

and thereby derived from principles of Western culture. Because Fukuzawa believed that civilization could be measured by man's progress in knowledge, the advancement of Japanese civilization would therefore greatly benefit from the authority of absolute, empirical values that the museological institution could generate.[13]

A True Account of the Ambassador Extraordinary and Plenipotentiary's Journey of Observation through the United States and Europe

While Fukuzawa spoke from personal conviction, Kume Kunitake (1839–1931), the author of *A True Account of the Ambassador Extraordinary and Plenipotentiary's Journey of Observation through the United States and Europe*, was recording the collective observations and thoughts of the members of his mission, led by Iwakura Tomomi, under whom Kume served as private secretary for the journey.[14] From December 1871 to July 1873, the group, composed of many of the highest-ranking officials of the Meiji bureaucracy, visited Austria, Belgium, Denmark, England, France, Germany, Holland, Italy, Russia, Sweden, Switzerland, and the United States. The five-volume publication is organized as a daily log of the sites and sights encountered during the mission's eighteen-month sojourn and serves as a docu-commentary on Western society based on firsthand examination of its public institutions, national landmarks, productive industries, and technological innovations. Among these, the delegation paid recurrent visits to museums (fig. 1.2). The Iwakura mission's travel diary—titled a "true account" (*jikki*) in order to emphasize the trip's fact-finding function—served as an instrument by which the government could indoctrinate the public on the Western-aligned changes it aspired to undertake. After returning to Japan, Kume continued to be employed by the government for five years as he prepared the diary for publication. Multiple printings were issued, despite the high cost of the multivolume set.

The places the Iwakura mission specifically named as *hakubutsukan* include the British Museum in London, the Altes Museum in Berlin, the Uffizi Gallery in Florence, and the Capitoline Museum in Rome. Kume distinguished other comparable places, which are considered museums today, by using different terms, such as labeling the South Kensington Museum in London a *jō-hakurankai* (permanent exhibition), the Smithsonian Institution in Washington, D.C., a *gakkō* (school), the Louvre in Paris a *hōko* (treasure repository), and the Pinakothek, both the Old and the New, in Munich a *zōgakan* (painting archive). Although Kume did not clarify the distinctions among the various labels, the places he named as *hakubutsukan* housed collections of comprehensive diversity in type, genre, and place of origin.[15] Making more than a simple correlation to the linguistic denotation of the term *hakubutsu* as "diverse objects," Kume observed the international scope and edifying influence of the *hakubutsukan* collections. For example, in describing the museum in Florence (certainly the Uffizi, as indicated by his mention of the Arno River, which flows beneath this four-story edifice), the author

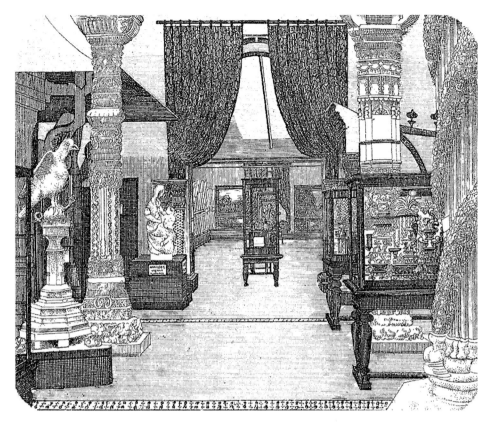

1.2 South Kensington Museum, London, ca. 1870s, view of exhibition gallery. *Tokumei zenken taishi: Beiō kairan jikki* [A true account of the ambassador extraordinary and plenipotentiary's journey of observation through the United States and Europe] (1878).

remarks that "art historians" (*bijutsu gakka*) and "artists" (*gashi*) come from every nation to see and copy the museum's masterpieces, including "Greek statues," "paintings new and old from every nation of the West," and "European artifacts of flawless beauty in precious metals."[16]

In comparison to Fukuzawa's definition, which considers scientific collections only, Kume's definition of the museum is distinguished by the diversity, accessibility, and didacticism of the collections, inclusive of the art, scientific, archaeological, and anthropological types. Moreover, *A True Account* provides context for its readers; it delineates the space and atmosphere of a museum (overlooked in Fukuzawa's writing) by supplying informative descriptions of the architecture, physical organization, and visitor activity. The entry for the delegation's 27 September visit to the British Museum is a particularly good example:

At eleven in the evening [morning] we went to the British Museum. . . . This is Britain's national museum, a vast building renowned throughout Europe for its size. Its hundreds of rooms are all filled with exhibits. All who aspire to learning or who wish to improve their professional skills, whether men or women and whatever branch of learning they are interested in, will derive some profit from a visit to this place. Its collections are so large that it was of course impossible to see them all in a visit of a few hours.

The museum is in the central district of the city, so that it is easy to get to from all parts. It is open from ten o'clock in the morning till six o'clock in the evening on Monday, Wednesday and Friday of each week. . . .

The library contained 750,000 volumes, shelved in a circular book-stack called the "vault." This surrounded an area in which desks were provided at which books, issued to users of the library in return for call-slips, could be read. This reading-room is a magnificent structure. The extraordinary engineering skill which it exhibits and its sheer size dazzle the eye. Around its periphery are curved galleries where ancient, rare and foreign books are kept. Here are the writings left by the greatest sages and wisest men of all the ages: Sanskrit works from India, Buddhist scriptures written on pattra leaves, and ancient books from Greece, Rome, Egypt and Persia. Some have bloodstains on them; some have been retrieved from the embers of fires. Even remnants of incomplete and damaged books have been collected and are kept in glass cases.[17]

After expressing more amazement at the breadth of the minerals, fossils, and archaeology galleries, Kume then provides a rare and lengthy commentary based on his observations of this institution:

When one looks at the objects displayed in its museums, the sequence of stages of civilization through which a country has passed are immediately apparent to the eye and are apprehended directly by the mind. No country has ever sprung into existence fully formed. The weaving of the pattern in the nation's fabric is always done in a certain order. The knowledge acquired by those who precede is passed on to those who succeed; the understanding achieved by earlier generations is handed down to later generations; and so we move forward by degrees. This is what is called "progress". . . . Nothing is better than a museum for showing clearly the stages by which these processes happen. "Seeing but once is better than hearing a hundred times," said the ancients, and *truly the sense of sight is more important than the sense of hearing in enabling people to absorb information.*[18]

Kume's writing both concretized and individualized the Western museum. He presented museums, not as a generic feature replicated in every major metropolis of Europe and America, but in terms of the scope and complexity of each individual institution, whether by nature of its collection or its close association with another cultural institu-

tion, be it a library, zoo, school, or palace. In fulfilling one of the major aims of the Iwakura mission, which was to systematically assess the achievements of Western society, these records situated the museum within the concentric cultural frameworks of the host city, nation, and geographical continent.

Report on the Austrian Exposition

The Austrian Exposition Bureau (Ōkoku Hakurankai Jimukyoku) sent a delegation that overlapped with the Iwakura group in Europe in 1873. Members of the exposition delegation were responsible for administering the nation's participation in the Weltausstellung held in Vienna that year (figs. 1.3, 1.4).[19] The group was charged with the weighty assignment of absorbing as much information as possible from the assembly of international participants at the event. Specifically, the agenda entailed (1) the promotion of Japan's natural and man-made products for political and commercial purposes; (2) the evaluation of those products exhibited by European nations; (3) the study of the latest manufacturing and engineering technology from these European nations; and, finally, (4) the compilation of intelligence pertinent to erecting a museum in Japan. The results of the investigation were recorded in the *Report on the Austrian Exposition*, which the Exhibition Bureau's vice director, Sano Tsunetami (1822–1902), submitted to the central government in 1875; it consisted of sixteen parts and was bound into ninety-six volumes. A section in the *Report* focuses on the museum and includes recommendations from Sano and Gottfried Wagener (1831–1892) for a new museum in the city of Tokyo. Gottfried, a German technical consultant employed by the Meiji government, was a key figure in facilitating the planned activities of the Japanese exposition delegation.[20]

The section on the museum contains separate subsections, beginning with Sano's proposal, which sets up the ideological framework for the establishment of a museum in Japan. This subsection is followed by Wagener's recommendations on the organizing principles of the proposed museum. Two other major subsections titled "A Chronicle of the South Kensington Museum in London since Its Establishment" (Eikoku Rondon funai "Sautsu Kenshinton" hakubutsukan setsuritsu no raireki) and "A Guide to the Administration of the 1851 English Exhibition" (Eikoku hakurankai shimatsu: Senhappyakugojūichi nen Eikoku hakurankai) provide the reference data for implementation and operation.[21] Together, these essays build up a holistic vision for the new museum in Tokyo: it was to be modeled after the South Kensington Museum (renamed the Victoria and Albert Museum in 1899), as an institution in continual collaboration with industrial exhibitions, for the joint objective of promoting Japanese arts and industries.[22]

Sano's proposal begins with the following sentences, very similar in language and sentiment to Kume's: "The aim of the museum is to promote man's wisdom and craft through teaching the eye. The power of vision stirs emotions in the heart and inspires

1.3 Hall of Industry, Weltausstellung, Vienna, 1873. *Kunst und Kunstgewerbe auf der Wiener Weltausstellung 1873* (1873). Courtesy of the Fine Arts Library, Harvard College Library.

comprehension and discernment from the greatest number of people possible. . . . The ancients have a saying: 'Seeing is believing.'"[23] Defining the museum by its primary mode of transmission—the visual—Sano articulates a total scheme for the first museum in Japan. He refers to the South Kensington Museum as the most appropriate model for Japan to follow, the aim being the stimulation of good craftsmanship and design through the preservation and exhibition of exemplary samples of such art. Specifically, Sano envisions the Ueno area in Tokyo as an ideal site for housing a composite museum. The spacious, undeveloped park grounds would accommodate an accompanying art school, zoological park, and botanical garden and also serve as exhibition grounds when such occasions arose. Lastly, Sano explains the intimate connection between the temporary "exhibition" (*hakurankai*) and the permanent "museum," or *hakubutsukan*, as two endeavors with the same aim, which was to serve as the source of "the nation's enrichment and the people's enlightenment."[24]

1.4 Japanese national display at the Weltausstellung, Vienna, 1873.
Tokyo National Museum, TNM Image Archives.

Although he is better remembered today as the founder of the Japanese Red Cross Society (Nihon Sekijūjisha), it was Sano's involvement in exhibitions and museum-building that initially exposed him to the Red Cross pavilions in Paris and Vienna, which later inspired him to set up the medical organization in his own country.[25] He had attended both the 1867 Exposition Universelle in Paris as a representative of his native Saga domain, and the 1873 Weltausstellung in Vienna as a representative of the Meiji government; both times, his responsibility was to observe and study the purpose and procedures of an international exhibition. Like Fukuzawa and Kume, Sano felt he comprehended the West primarily through the eye, through the visual communication that the displays facilitated—in spite of, or, just as likely, because of, the differences in the linguistic and cultural qualifications between the observer and observed objects. But unlike Fukuzawa and Kume, Sano, in addition to firsthand observation and experience, also acquired knowledge through the self-representative literature published by the museums (such as those by the South Kensington Museum included in the *Report*) as well as through the cognitive filter of a Western specialist, namely, Wagener. The resulting master plan for the museum proposed by Sano and Wagener, therefore,

attained a level of clarity and feasibility that the earlier definitions by Fukuzawa and Kume lacked. Sano and Wagener's proposal was a definitive plan of action, specifying in explicit detail the site, organization, and function for the first comprehensive museum in Japan. They had taken the first step toward the transplantation of the museum from the West to Japan by creating the physical and ideological place for it within the Japanese cultural fabric.

Shared Observations

Why did the museum appeal to the Japanese? Why was it considered appropriate for Japan? What need did it fulfill in a country embroiled in the revolutionary transition from nearly total isolation to full participation in the Eurocentric world arena? The similarities in the perception and definition of the museum in these three accounts of the West merit some analysis. The earliest scrutiny of the museum was undertaken within the context of Japan's investigation into the sources of Western strength and prosperity. In defending Japan against encroachment, pro-Western scholars including Fukuzawa advocated examining the whole way of thinking and learning in the West that produced its institutions and practices, rather than mindlessly transplanting its military and scientific technology without the epistemological roots. He and like-minded intellectuals were proposing that, in contrast to the Western view, the traditional, Confucian view of learning in Japan lacked practical education based on a thorough comprehension of the natural sciences. This chapter's epigraph captures their frustration with the dearth of visual and intellectual stimulation in Japan for scholars and laypeople alike and recognizes museums and exhibitions as universal solutions (not culturally specific approaches) to the problem. According to Fukuzawa, rationality and practicality of thought were directly responsible for raising Western civilization higher than his own on the ladder of progress:

> Western scholars studied [the laws of nature] for many years and found that everything in the world was reducible to fifty elements. Then after further research they found that there were sixty, and then eighty. They examined their properties and expounded their uses, and then went on to turn the immaterial forces of heat, light, and electricity to practical use in developing productive industries. It was sad indeed that while all this was going on the scholars of the Orient should have rested content with the theories of *Yin* and *Yang* and the Five Elements, given no thought to progress and relegated industry, manufacture and suchlike to the lower classes of society. In the education of our samurai there was certainly dignity, refinement and high moral principles of which they had no cause to be ashamed, and indeed in which they were far superior to the West. But in the one matter of physical laws our Confucian scholars, despite all the learned tomes they read, knew no more than an ignorant housemaid.[26]

Fukuzawa believed that a reform movement in support of useful and practical knowledge was necessary, beginning with the systematic comprehension of the external world. In his eyes, the museum would be an effective tool in facilitating this new learning.

Fukuzawa, Kume, and Sano shared one observation, that of the museum within a larger matrix of visual representational practices operating in the late nineteenth century.[27] Consistently defined as part of an ensemble, with the exposition, the zoo, or the botanical garden, the museum was recognized as part of a greater communication system. The museum as purveyor of knowledge, as an authority of "showing and telling," was the essence of the Western museum as understood by the first Japanese visitors. If Steven Conn is correct in asserting that "knowledge was *always* understood to be what museums had to offer but also that knowledge was what they were charged to create and what they were obligated to provide to a visiting public," then it served as the most accessible and direct source of information on the material goods, cultural values, and scientific erudition of the West that the Japanese encountered.[28] The museums functioned efficiently and effectively by sidestepping much of the language and time restrictions inhibiting Japanese inquiry. This is especially true given the daunting scope and ambition of the early missions, which, for example, in the words of Takenouchi Yasunori, leader of the 1862 mission to Europe, was to carry out "investigations . . . on the conditions abroad and on *anything besides* that may be of value to Japan"[29] (emphasis mine). On the flip side, however, Japanese visitors perceived the museum as having very little to distinguish it from the other venues of display, whether by its organization or its content. The term *hakubutsukan* could well apply to any and all centralized places housing a wide range of objects. It is little wonder that in this period of initial contact, the Western museum was commonly understood as no different from a "permanent exhibition," or *jō-hakurankai*.

All three reports also shared another outlook, that the British model was superior to all other European models. Whereas the Dutch had been the only Western source of diplomatic contact for the Japanese during their two centuries of isolation, the significance of Holland for the Japanese dimmed once overseas travels and direct observations enabled closer comparative studies of European nations and the United States.[30] Victorian Britain elicited arguably the most interest from early Japanese travelers to the West, especially in view of its prominence in promoting world's fairs and innovative museum practices—both roles being reflective of the vast extent of British political and commercial influence in the second half of the nineteenth century. For Fukuzawa in particular, Britain was the yardstick against which the other nations of the West could be measured.[31] The sheer quantity of pages devoted to this one nation in *Conditions in the West, A True Account*, and *Report on the Austrian Exposition* attests to its premier status in these assessments of foreign practices worthy of emulation.

Fukuzawa, Kume, and Sano also observed that the museum belonged in a matrix of

institutions that linked knowledge to progress and national strength. In taking the image of Victorian industrial progress and commercial prowess as a model for development, the museum was part and parcel of Japan's aspiration to be the Britain of the East. The pragmatic and commerce-driven ideology of the South Kensington Museum (rather than the elite conservatism of the British Museum) therefore dovetailed neatly with the early-Meiji policy of developing technology and expanding trade. One significant consequence of London's 1851 Great Exhibition of Works of Industry of All Nations and its museum offspring at South Kensington was an emphasis on the substantial place the decorative arts could occupy in a nation's economy. Moreover, the nationalist mise-en-scène of the international exhibition culture cannot be overemphasized. In the late nineteenth century, competition in the industrial arts generated explicitly political and even bellicose responses among rival nations—particularly England, France, and Germany; success in the fields of commerce and industry was often cast as an affirmation of the nation's martial prowess.[32] Japanese government officials learned from London's Great Exhibition and South Kensington Museum paradigms that art production could serve as invaluable sources of income and national pride in the international competitions of the time. Notably interlaced with this pursuit of improving craft design and production for trade were discourses on the perpetuation of national heritage, the attainment of a unique national style, and the embodiment of national self-image. The same issues would also pertain to the architecture of display, as the next chapters will explore.

BIJUTSU: TRANSLATING ART

In addition to the word *hakubutsukan*, another key term for this book is *bijutsu*, the translation word for "art" coined during the early 1870s. As examination of the etymological roots of *hakubutsukan* has suggested, the early visitors Fukuzawa, Kume, and Sano did not consider art to be a natural or particularly intimate partner to the museum at the outset. What is significant here is the eventual importance of art as a collecting category within the Imperial Museums as well as the later merger of the two terms at the turn of the twentieth century to form the new concept of the *bijutsu hakubutsukan* (art museum), or *bijutsukan* for short.

Fine Arts at the Exhibitions

Bijutsu was one in a set of terms related to art created by the central government in the Meiji period in the effort to graft existing European terminology and classification onto Japanese works for their entry into the international market. Two terms crucial to the organization of *bijutsu* were *kaiga* (絵画) for painting and *chōkoku* (彫刻) for sculpture. The creation of each can be directly linked to the establishment of an official event or

institution: *kaiga* debuted in the name National Painting Fair (Naikoku Kaiga Kyō-shinkai) in 1882, and *chōkoku* was the name of a course in the newly opened Technical Fine Arts School (Kōbu Bijutsu Gakkō) in 1876.[33] Although the scholarship of Kitazawa Noriaki and Satō Dōshin has laid the foundation for investigation of the transcultural conditions compelling the creation of all three terms, the semantic variability of the European model as well as the Japanese derivative are still in need of clarification.[34]

Because the coinage of the term *bijutsu* distinguished painting and sculpture as fine art endeavors separate from the other arts, the meaning of "fine arts" and "beaux arts" is explored here in the context of their original languages and in conjunction with the new meaning generated in the Japanese context. Douglas Howland asserts that language is always bound by its own particular historical framework and that "[the] work of translation [in late-nineteenth-century Japan] . . . involved both the description of a received world and the construction of a new one."[35] In other words, the Japanese translation words invented to engage in the foreign concepts of art were subjective interpretations of timely concepts rather than objective transmissions of universal, fixed ideas. Such translation words may be examined by augmenting Howland's analytical framework and applying a three-part assessment of the context in which the original term operated, the nature of the Japanese encounter that yielded the new term, and the implementation of that new term in a Westernizing Japan.[36]

Paul Oskar Kristeller has defined the history of the formation of the modern system of the arts in Europe as a gradual culmination of familiar yet fluctuating concepts accumulated from the classical period onward:

> The grouping together of the visual arts with poetry and music into the system of the fine arts with which we are familiar did not exist in classical antiquity, in the Middle Ages or in the Renaissance. However, the ancients contributed to the modern system the comparison between poetry and painting, and the theory of imitation that established a kind of link between painting and sculpture, poetry, and music. The Renaissance brought about the emancipation of the three major visual arts from the crafts, it multiplied the comparisons between the various arts, especially between painting and poetry, and it laid the ground for an amateur interest in the different arts that tended to bring them together from the point of view of the reader, spectator, and listener rather than of the artist. The seventeenth century witnessed the emancipation of the natural sciences and thus prepared the way for a clearer separation between the arts and the sciences.[37]

It was not until the nineteenth century that a defined concept of the fine arts came into being, refined most recently by the wealth of eighteenth-century French, English, and German philosophical writings on the arts. Grouped as a set of pursuits separate from the sciences and crafts, the fine arts were at the outset distinguished by French writers

1.5 The Crystal Palace, Great Exhibition of Works of Industry of All Nations, London, 1851, detail of transept. *The Art Journal Illustrated Catalogue: The Industry of All Nations, 1851* (1851). Courtesy of the Fine Arts Library, Harvard College Library.

such as Denis Diderot and the other authors of the *Encyclopédie* for having pleasure rather than usefulness as their end and, subsequently, by German writers such as Alexander Baumgarten and Immanuel Kant for having the notions of beauty and taste as their basis.

In practice, the fine arts were governed by professional organizations and standards separate from the mechanical (or useful) arts. Significantly, in the nineteenth century, what Patricia Mainardi has called "the dialectic between art and industry" played out in vivid relief at the national and, subsequently, the international expositions of Europe.[38] Within this arena designed to encourage industry and trade, the fine arts had consis-

1.6 The Crystal Palace, Great Exhibition of Works of Industry of All Nations, London, 1851,
detail of main avenue. *The Art Journal Illustrated Catalogue: The Industry of All Nations, 1851*
(1851). Courtesy of the Fine Arts Library, Harvard College Library.

tently occupied a small but critically visible place. Since the inaugural international
exposition in 1851, in London (figs. 1.5 and 1.6), the category of the fine arts—identified
with the visual arts alone—had generated attention for its composition and installation.
As a category, it was noticeably inconsistent with the fair's classification system, which
was divided into the three main sections of Raw Materials, Machinery, and Manufac-
tures, representing the three stages of the manufacturing process. Fine Arts, having no
place in this master schema, became the stand-alone fourth section. Critical reactions
to the Great Exhibition attest that neither the English nor their continental neighbors
had reached consensus on the classification of exhibits. Tellingly, even the jury of the
Fine Arts section admitted to instances of indecision of judgment "owing to the neces-
sarily uncertain limits of the several classes." As a result, there were many occasions when
an object garnered awards from more than one jury.[39] Furthermore, French critics lam-
basted the London organizers for showing celebrated sculptural masterpieces alongside
textile and biological specimens and for excluding paintings altogether at this event.[40] At

the next international exposition, held in Paris in 1855, the French would stage the prominent Palais des Beaux-Arts as their riposte to the British.

Even at the end of the nineteenth century, almost fifty years after the first international fair, consensus on the proper place and classification of art was yet to be reached by the majority of participants at the European expositions. The French artist Emile Gallé, who wrote for the *Gazette des Beaux-Arts* a review of the objets d'art shown at the Salon in Brussels in 1897, challenged the prevailing system dividing the fine and decorative arts, denouncing it as arbitrary and absurd:

> A tenet generally prevails that the quality of the substance is the basis for classifying glyptics, the art of stonecutting. Engraving on stones: precious, hard, even ordinary stones—works of art! *Worthy to enter* into the International Salon of the Fine Arts at Brussels in 1897 and into the one in Paris in 1900. Stonecutting on soft materials, amber, crystal, glass paste, shells, plastic on metal and pliable substances, tin, wax, wood? You will not enter the International Salon of the Fine Arts at Brussels. Such are the specifications without exception due to favoritism which proves the rule.
>
> Here is the academic criterion; here is the official aesthetic of the day; *the density of the material!* The piece which is presented, is it a *work of art* or an *object*? Is it hard, or is it not hard? "Ask the question of the day!"[41]

The place of the fine arts in industrial exhibitions had been ambiguous from the start, upheld as categorically separate from, yet integrally related to, industry. The category underwent redefinition from exhibit to exhibit but was consistently supported by the underlying conviction that it represented an idealized pursuit above and beyond the dexterity of facture and ingenuity of process. In the words of the 1851 jurors, the fine arts should be distinguished by "the embodiment of ideas, thought, feeling, and passion, not for the mere imitation of nature however true in detail, or admirable in execution."[42]

However, national and economic interests, more than contemporary philosophical constructs of art and aesthetics, were the immediate driving forces behind the definition of art at the international exhibitions. The taxonomy structuring each event—the painstaking matrix of groupings and subgroupings—was intended to illuminate the logic of the existing world order, as understood by each host city and nation. The language of domination and authority resonated in the meticulous and prescriptive classifications, rules, and regulations. While fair planners intended little room for variability and uncertainty, the event's enormity of scale and diversity of participation inevitably spawned disruption and defiance. Changes also occurred from exhibition to exhibition. Sites changed, contents changed, classifications changed, terminology changed; above all, loci of cultural, economic, and political power changed.

The inclusion of works from countries outside the Western European center—the Americas, Asia, and Africa—was not the only catalyst for change and uncertainty. As much as these other cultures represented alternative values, practices, and systems, much disagreement and strong biases already existed among members of the dominant Western nations: England, France, Italy, and the United States. Fine art as a category was not immune to changes and challenges, as its composition was noticeably adjusted at each exhibition. As mentioned, painting as a category was not even included in the very first international exposition in London, a determination the French quickly reversed at the next event. It should not be a surprise, then, that the type or genre that showed the host nation in the most favorable and profitable light was inevitably included under the heading of fine arts. This calls attention to the function of international exhibitions as competition, for the various prizes awarded and for the greater, long-term benefit of commercial and political gain. Art as an exhibition category was not intended to be a cultural equalizer or mediator of cultural gaps. It was maneuvered, more often than not, as a tool for cultural advantage, which led in turn to economic and political advantage. Representatives of the Japanese government were initially compelled to conceive the categories of art and industry in this context of commerce and competition.

Birth of Bijutsu

Kitazawa Noriaki has asserted that the term *bijutsu* was coined in 1872, on the occasion of Japan's participation in the 1873 Weltausstellung.[43] Specifically, the term first appeared in the Japanese translation of the original exposition program, in which the description of exhibition group 22 read "Darstellung der Wirksamkeit der Kunstgewerbe-Museen." The program also included English and French versions of the same description, "Representation of the Influence of the Museums of Fine Arts applied to Industry" and "Exposition des Musées des Beaux-Arts appliqués à l'industrie." The European-language originals were rendered into Japanese as:

美術〈西洋ニテ音楽, 画学, 像ヲ作ル術,
詩学等ヲ美術ト云フ〉ノ博覧場ヲ工作ノ為ニ用フル事.

Kitazawa points out that this translation contains at least two potential discrepancies. The first concerns the precise European term to which the Japanese term *bijutsu* corresponds. The syntax of the Japanese description closely reflects the English and French phraseology, but not the German, as Kitazawa suggests, and in so doing offers *bijutsu no muzeumu* (the translator originally inserted ムゼウム in superscript above 博覧場 to indicate the pronunciation for this term) as the word-for-word translation of "museums of fine arts" and "Musées des Beaux-Arts." This interpretation—equating *bijutsu* with "fine arts" and "beaux-arts" rather than with "Kunstgewerbe"—would also resolve

Kitazawa's second concern over the definition of the newly coined term. The explicatory remark inserted by the Japanese translator explains *bijutsu* as "music, painting, sculpting, poetry, etc.," and once again this group clearly refers to the contemporary European concept of the fine arts and not the applied arts.

Locating and parsing the etymological construction of the term *bijutsu* discloses some important features of its original formulation. First, the attribution to Japan's participation in an international exposition reveals the primacy of the link between the fine arts and industry (translated here as *kōsaku*) as early as the fourth year of the Meiji period. Reading the creation of the word *bijutsu* literally, art was conceived as an aid to industry. This documents the beginning point of a relationship, vital to the nation's entry into the world market, that would continue throughout the period. At the same time, art was also being differentiated from industry as a much wider set of pursuits encompassing visual and nonvisual works. That the translator conscientiously provides this definition ("in the West, music, painting, sculpting, poetry, etc. are called the fine arts") points to a second significant revelation. As much as the coining of *bijutsu* was official, foreign induced, and market driven, on the occasion of Meiji Japan's first participation in a world's fair, the translation from the outset proposed that *bijutsu* could operate *outside* the realm of industrial exhibitions (that its primary place did not even appear to be there). To call attention to this distinction is to allow for a broader analysis of the shaping of art in Meiji Japan so that its changing definitions and branching purposes throughout the period can be fully investigated. In other words, after its coining in 1872, *bijutsu* continued to develop as concept and practice in the realms of instruction, creation, display, marketing, collection, and preservation; understanding the original conditions of its creation offers but an entry, not endpoint, to the process of illuminating the role of art in the Meiji period. Each of the following chapters builds on the definition of art by exploring additional facets of its implementation beyond its service to industry.

2 · The Museum in Ueno Park

Styling the Nation

Gentlemen, when looked at practically, there is really no question of choosing between two rival styles, one indigenous and one foreign; it becomes a matter of deciding between the obsolete and the modern; between what was suited to the wants and customs of the days of the Bakufu, and what is required by the needs and habits of the times of Meiji and of parliamentary institutions. It is a question whether the modern cities of Japan are to have an architecture or no architecture; whether you are to possess educational, social, civic, and commercial institutions arranged with modern conveniences, and fitted up in scientific and sanitary ways, or are to be content with imperfect makeshifts for these essential things.

—Josiah Conder (1891)

After their tour of the United States and Europe, members of the Iwakura mission shared the sentiment that Japan was not hopelessly behind the West in its state of development. Kume Kunitake summarized his thoughts after visiting Britain's South Kensington Museum as follows:

> We learnt . . . that European agriculture, industry and commerce had all three reached their present flourishing condition in the space of no more than a few years. . . . Britain was the first country to discover its own individual style in the industrial arts and to show that the crafts of countries other than France were worthwhile. This gradually brought about a dawning awareness in the peoples of other countries, and the industrial arts in Europe are now . . . an orchard in which many different trees, from every country, blossom in profusion, filling the air with fragrance. And all this is owed to the Kensington exhibition [sic]. *We should examine the records of these events and consider what implications they have for Japan.*[1] [emphasis mine]

In the simplest of terms, if the West had made the change in "no more than a few years," then Japan could very well catch up to the most advanced nations within the short span of one generation.[2] Perhaps the most remarkable of Kume's interpretations of Western prosperity was his crediting one exhibition, the Great Exhibition of 1851, for the flour-

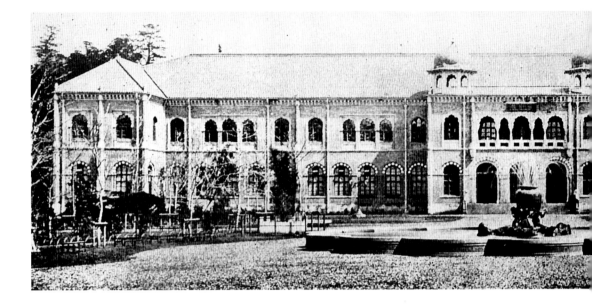

ishing of agriculture, industry, and commerce in, not only Britain, but all of Europe![3]
It is no wonder then that the South Kensington Museum, understood as the permanent
adaptation of the temporary Great Exhibition, figured prominently time and again in
the itinerary of each wave of Japanese delegates and was copiously recorded and analyzed
in the respective writings of Kume, Sano Tsunetami, and Machida Hisanari (1838–1897),
another key governmental figure in the early Meiji institution of museums and exhib-
its.[4] It is important to note their confidence in the inevitability of Japan's success, the
upshot of following the winning South Kensington formula. This confidence as well as
their apparent clarity of vision, however, belie the turns and detours on the road from
proposition and planning to the implementation of a national museum.

 With great resolution, the Meiji government realized its own version of South Ken-
sington in Ueno Park, Tokyo. This new park hosted the first of a series of large-scale
domestic expositions, the National Industrial Exhibitions (Naikoku Kangyō Haku-
rankai), in 1877, and unveiled a permanent museum building to the public in 1882.
British influence was apparent in the architectural design of the museum as well, due
to the involvement of the London-trained architect Josiah Conder. His employment
rendered the project an unprecedented alliance of foreign and native forces. The
completion of the building, designed by Conder in collaboration with his Japanese
students and local workmen, signaled the successful implementation of European
technology and professionalism in Japan. Yet viewed more critically, the building's
design treads the delicate line between importation and imposition. In many ways, it
embodies the complex power relations between a non-Western nation struggling to

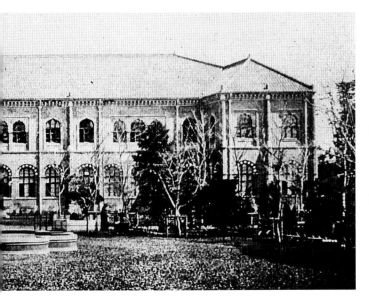

2.1 Josiah Conder,
the Museum in Ueno Park
(demolished), Tokyo, 1878–81.
Kondoru Hakase isakushū
[Collection of the
posthumous works of
Dr. Josiah Conder, F.R.I.B.A.]
(1931). Courtesy of the
Architectural History
Laboratory, Architecture
Department, University
of Tokyo.

maintain its independence and a host of Western nations encroaching on this right. The central government's promotion of the museum institution necessarily entailed a negotiation of the extent to which it should borrow from another nation and another culture in order to highlight its own. It also constitutes a vivid illustration of the government's dualist policy of preserving the past—both ancient and recent—and adopting new ways of organizing that past so as to benefit the present. At this point in time—the formative period of a museum meant to be as broad in scope as possible in order to promote the nation's agriculture, industry, and commerce—debates on the role of art within this institution were not yet prominent. A greater concern was the way in which the museum could serve as national expression and promotion just as the museums of Europe represented each nation's best countenance.

A RIVAL MUSEUM IN UENO

The trajectory from Sano Tsunetami's 1875 proposal for a national museum to the grand opening of the Ueno Park building in 1882 was neither unswerving nor uneventful. A rival museum, the pedagogical museum sponsored by the Education Ministry, also intended for Ueno Park, was a major cause of the complications and drama. This chapter focuses on the museum of art and industry founded under the Home Ministry (Naimushō) and eventually housed in the building designed by Conder (fig. 2.1).

The origins of the two museums were closely intertwined in the early 1870s. The period of March 1873 to February 1875 saw the short-lived merger of the Museum Bureau

(Hakubutsukyoku) and the Museum (Hakubutsukan)—both founded, in 1871 and 1872, respectively, under the Education Ministry—and the Exposition Bureau (Hakurankai Jimukyoku), founded in 1872 under the Grand Council of State (Dajōkan). The merger also included a library (*shosekikan*), and a medicinal garden *(yakuen)*. Together, these five previously separate entities formed the museum commonly known as the Yamashita Museum (Yamashita Hakubutsukan), located within Tokyo in Uchiyama Shitachō. This large composite institution was not open regularly to the public but held temporary exhibitions only twice, once in 1873 and once in 1874. A decisive split in 1875 separated the Yamashita Museum into two independent museums, one under the Education Ministry and the other under the Home Ministry. While the Education Ministry was the first to designate its institution a *hakubutsukan* and erect a building for it in 1877, the Home Ministry ultimately won the battle for the name and site originally sought by both ministries.[5]

Sano had suggested in his 1875 proposal that the site most suitable for a new freestanding museum was a northeastern district of Tokyo known as Ueno. A similar proposal had been made in 1873 by his colleague Machida Hisanari, who believed that the open expanse of Ueno would be ideal for protection against fire hazards and accommodation of large crowds.[6] Sano and Machida were not the only ones inspired to build a museum in Ueno, for the promoters of the pedagogical museum also realized the site's advantages. Thus, the Home Ministry and the Education Ministry engaged in an animated struggle for the best plots on the Ueno grounds. The specific zone of contention was the former grounds of the Tokugawa family temple Kaneiji, which had been lost in 1868 as the result of revolutionary battle fires. After the Meiji Restoration, the new regime requisitioned the Ueno area for the city of Tokyo, to be developed as public park grounds, the first to be opened in modern Japan, in 1873. The Education Ministry was already aggressively petitioning for an area of 64,262 *tsubo* (roughly more than 52.40 acres) to use as educational facilities, including a pedagogical museum, when, in 1875, the Home Ministry initiated a fierce tug-of-war by putting in a bid to place its composite museum of art, industry, and science, in this park.

In December 1876, the Home Ministry won the battle for the two choicest parcels within the former Kaneiji grounds (where the Tokyo National Museum and the Grand Fountain currently stand) owing to the strong political clout of Home Minister Ōkubo Toshimichi (1878–1952) and the determination of the eventual museum director, Machida Hisanari.[7] Together, they triumphed over the rival ministry, which at the time was weakened by an inopportune vacancy in its top position and by the waning status of pedagogy in the government's immediate plans for nation building.[8] Consequently, the Home Ministry secured the northern apex of Ueno Park for its permanent museum, effectively elbowing out the pedagogical museum to a peripheral site.

Preempting the Home Ministry's victory in Ueno, the Grand Council of State declared on 24 February 1876, at the request of the Home Ministry, that the museum under its jurisdiction would be named the Museum, or Hakubutsukan, while museums under any other administration, national or provincial, would be required to affix geographical or classificatory prefixes to their names.[9] By insisting on the use of *hakubutsukan* as a proper name rather than a category, the Home Ministry was steering its museum as well as all others in the nation in a new direction. This semantic domination resolved more than the nominal equivalence (and confusion) that had marked the Education Ministry Museum and the Home Ministry Museum since their inception. Exclusive right to the name secured the latter's ascendancy over the former and all other existing and future museums. As a typological epitome, it became the standard against which all other museums must measure themselves, both in form and in function.

The Home Ministry envisioned the definitive Museum as a centralized place for the maintenance and exhibition of the nation's arts, artifacts, and manufactures. Its purpose was to enrich the minds of the general public and educate designers and manufacturers by providing an exemplary collection. The new site held great promise for implementing this vision, providing not only the high visibility afforded by its elevated location but ample open space for a large-scale building and surrounding greenery. Rather than strictly following the South Kensington model, the Museum showed the broader influence of London's Great Exhibition of 1851, which prompted the "now-forgotten organizational schema, in which science, industry, and art were presented together, almost as fluid categories."[10] Furthermore, like the permanent museums in Europe that had risen from the paradigm of the Great Exhibition, it was to appeal to the public on more than one level. This 1866 description of the Edinburgh Museum of Science and Art (an institution founded shortly after 1851) could just as aptly apply to Japan's Museum: "It is meant not merely to please, but to instruct; not less to charm the eye than to enrich the mind."[11]

The assassination of the home minister Ōkubo, who had championed a museum for commerce and industry in the heart of Ueno, brought more changes for its ambitious yet indeterminate program. Ōkubo died in May 1878, two months after construction of the new permanent building began, and he was succeeded in his ministerial position by Itō Hirobumi (1841–1909), previously the minister of public works.[12] Itō, a close colleague of Ōkubo's, shared the latter's dedication to Westernizing the nation and continued the drive to develop the nation's industry and trade. Machida, who was instrumental in the fight for the Ueno site, was appointed museum director in January 1876 and remained in this post until the completion and opening of the Museum in 1882.

BUILDING FOR EXHIBITION: AN EARLY EXAMPLE

In early 1877, the stage was set for the erection of a freestanding building for the Museum. Overseeing the construction was the Public Works Ministry (Kōbushō), which had just entered into a five-year contract with the English architect Josiah Conder in January of the same year.[13] The Grand Council of State formally approved the request to execute a design for the museum on 27 December 1877. No documentation remains, however, of Conder's commission for this design. Most likely, he was given the project in the first calendar days of 1878, as the groundbreaking occurred on 14 March of the same year.

Before construction began, the First National Industrial Exhibition had occupied the site for more than three months in 1877.[14] One of the buildings raised for the occasion, the Art Gallery, or Bijutsukan (fig. 2.2), remained standing to serve as a permanent extension for the future museum complex. The designer was Hayashi Tadahiro, a Japanese who had trained as a carpenter but learned Western-style masonry construction at the foreign settlement in Yokohama.[15]

Hayashi's Art Gallery shared two important characteristics with Memorial Hall at the Centennial Exhibition held just one year earlier in Philadelphia.[16] First, both were built as permanent structures among many temporary ones.[17] Second, both were art galleries whose comparatively elaborate design stood apart physically and symbolically from that of the surrounding buildings. While Memorial Hall protruded conspicuously outside the protracted main axis of the Centennial Exhibition, the Art Gallery was situated even more prominently, at the apex of its event's triangular plan. Maeda Ai has characterized this position as "the pivot point of a folding fan" and suggests that "art, in other words, was thought to embody the essence of the 'power of vision' that formed the fulcrum that would propel industrial production."[18]

The Art Gallery, a red-brick, one-story, one-room structure (fig. 2.3), was by no means an ornate building in comparison to Memorial Hall. The small gallery's volumetric simplicity, composed of a gabled top and boxy body, calls to mind the form of a *kura*—the traditional Japanese storehouse for valuables—rather than a contemporary European museum. Since safekeeping is a vital function for a building that serves as a repository for precious objects, whether it be a *kura* or museum, the use of brick rather than heavily plastered wood frame was an endorsement of Western masonry construction, at the time held to be the best technology for fire and earthquake resistance.

The oversize imperial chrysanthemum crest affixed on the pediment of the entrance portico was another feature that simultaneously engaged the old and the new. Although the floral crest had a long history of association with the Japanese imperial family, it held "no exclusively national or imperial meaning until the modern era," when it was made the exclusive insignia of this institution.[19] The prominent use of the sixteen-petal crest along with another recently appropriated national emblem, the rising sun flag,

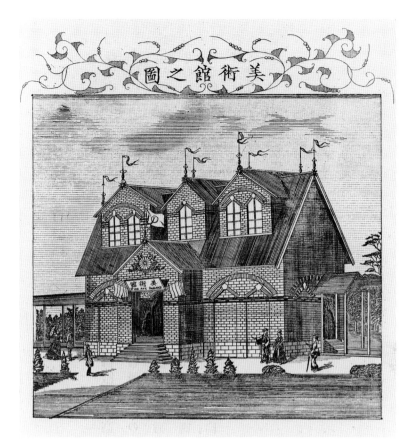

美術館之圖

2.2 Hayashi Tadahiro, Art Gallery (demolished), First National Industrial Exhibition, Tokyo, 1877. Tokyo National Museum, TNM Image Archives.

2.3 Hayashi Tadahiro, Art Gallery, First National Industrial Exhibition, Tokyo, 1877, elevations and plan. Drawn by Derrick Choi.

2.4 Utagawa Hiroshige III, *Art Gallery at the First National Industrial Exhibition*, 1877. Woodblock print. Tokyo National Museum, TNM Image Archives.

highlighted the importance and visibility of the structure as the amalgamation of familiar and unfamiliar conventions.

Hayashi's building was innovative not only in material and decoration but also in function. The Art Gallery featured several architectural attributes derived from museums in Europe and the United States. The walls were left entirely solid so that light would come exclusively from above, through an elevated row of dormer windows. The uninterrupted wall surface allowed maximum space for hanging pictures, just as the open interior accommodated the unwieldy dimensions of the display cases. Extant photos and a detailed woodblock print by Utagawa Hiroshige III (fig. 2.4) reveal a stark

interior embellished with a pair of Ionic columns and a vaulted ceiling. Both traditional Japanese ink paintings and newfangled Western-style oil paintings were framed and mounted on multiple registers on the walls. Glass cases and cabinets housed objects such as lacquers, bronzes, and porcelain. Although the majority of the painting subjects were traditional—birds and flowers, landscapes, and beautiful women—the format and method of display were completely new, consciously replicating the way Japanese works of art were being exhibited abroad at international expositions (fig. 2.5).

Accounts of visitors to the First National Industrial Exhibition indicate mixed feelings about this format. An Anglophone writer for the *Tokio Times* described the building as small and unsuitable to "any full display of pictures or other art treasures" and faulted the architecture, the art, and the installation for their experimental nature.[20]

2.5 Japanese national display in the Main Building, Centennial Exhibition, Philadelphia, 1876. *The Masterpieces of the Centennial International Exhibition Illustrated* (1875–76).

On a more positive note, a lay observer, the American adolescent Clara Whitney, declared the building to be "perfectly fascinating to [herself] and appeared to be most attractive to the Japanese also."[21] The two observations, while expressing opposing sentiments, acknowledged in common that the exhibition design of this gallery was conventional in neither Japan, Europe, nor the United States.

The Art Gallery not only engaged unprecedented modes of displaying and viewing art but also brought about cultural commingling and innovation among the visitors—some came in traditional dress, some in Western dress, still others in Chinese dress, and a few in varied combinations of the three (see depiction of visitors in fig. 2.4). In one woodblock rendering of the fairgrounds by Kawanabe Kyōsai (fig. 2.6), the Art Gallery, a giant windmill, and an elevated clock tower stand in relief as the most prominent markers of the event, as conspicuous symbols of the technological progress the exhibition was designed to facilitate. In the foreground, the emperor is depicted in motion, dressed in full Western military regalia and borne in his horse-drawn carriage, with great pomp and dignity, into the heart of the celebrations.

One salient attribute of the Art Gallery is distinctive to exhibition architecture of Meiji Japan: the use of brick construction to signal both permanence and innovation in building. This imagery is in marked contrast to the status of masonry building in contemporary Europe and the United States, especially in the three decades after Joseph Paxton's Crystal Palace, the main building of London's 1851 Great Exhibition. The differentiation between permanent and temporary building, in both material and "character," was a well-known dichotomy at international exhibitions. The permanent structure was seen as architecture and the temporary one as engineering: "Architecture presumed more of a familiarity with the art of building and the functional arrangement of space [and] engineering with the design of long-span structures based on a more precise knowledge of building science."[22] While architecture held the responsibility of physically withstanding and visually signaling "permanence," engineering provided an efficient, low-cost solution to presenting large-scale, impermanent structures for exhibition.[23] This dichotomy first arose at the 1851 Great Exhibition, when the original proposal for the exhibition building, essentially a colossal brick pile, was deemed unwelcome as an enduring presence in Hyde Park, while Paxton's executed design of iron and glass, described as "light, airy, novel, and temporary," captured the public's imagination.[24] Similarly, the architectural press posited the expansive stretch of the Centennial Exhibition's main building and the enclosed shell of its Memorial Hall as antipodes, representing the contrast between the transient but timely and the permanent but (out)dated.[25]

The signification of masonry construction as exhibition architecture in late-nineteenth-century Japan was distinct from the import of such construction in Europe and

2.6 Kawanabe Kyōsai, *Famous Places of Tokyo: The 1877 National Industrial Exhibition in Ueno Park*, 1877. Woodblock print. Tokyo National Museum, TNM Image Archives.

the United States, in that brick and stone represented newfangled materials for building, as opposed to the traditional timber frame. Endorsed by the Meiji government as vital to the literal strengthening of Japan, masonry structures not only were pragmatic solutions for solid, fire-resistant construction but took on cultural stature as embodying the aesthetics of newness and enlightenment. A leading intellectual of the day, Nishi Amane (1829–1897), even used the tectonics of brick construction as a metaphor for strength and moral righteousness:

When traveling in Europe, I saw brick buildings five to six stories high and six hundred to a thousand feet wide. Moreover, they are so firm and strong that they cannot be rocked or bent, and they are formed on four sides by magnificent high brick walls. . . . Fineness and strength as well as squareness and uprightness is the nature of bricks, and protecting human rights is the nature of man. Once their natures have been altered in the least by rounding off the brick or by compromising sycophancy among men, there will be no room for the builder or the statesman to exercise their powers even though the builder exhausts his arts and the statesman fully exerts his talents.[26]

Nishi's conception of brick resonated with the dominant attitude of the Western engineers and architects hired by the Japanese government in the first two and a half decades of the Meiji period. Propounding the invincibility of masonry in contradistinction to timber construction, especially against the destructive jolts of earthquakes, this group of foreign experts was responsible for developing Japan's urbanism and civic infrastructure. The British dominated the coterie of foreign engineers and architects hired by the Public Works Ministry, established in 1870 to galvanize the process conventionally termed the "Westernization" or "modernization" of Japan. Among the foreign experts, the architect Conder acted as a principal force in laying the foundation of Japan's new architecture. Although he believed in the artistic and historical significance of traditional Japanese architecture, he also believed in the superiority of brick and stone as an absolute requisite for "sound architecture."[27] The dichotomies of West versus East, structure versus decoration, architecture versus non-architecture were frequently called into play to support the British experts' undeniable racial reading of their indomitable Western technology in service to the insubstantial native tradition.[28] While Conder was not an extremist in upholding a Eurocentric view of world architecture, his premise for expressing Japanese national character in the architecture of the Museum in Ueno was anchored in his subjective position as a Westerner and an architect. His design for the museum was his way of addressing what he perceived as the "lack" and "failings" of indigenous Japanese architecture.

JOSIAH CONDER, FOREIGN ARCHITECTURAL EXPERT

Historians today commonly refer to Conder as "the father of modern Japanese architecture."[29] He first entered the service of the Public Works Ministry as an instructor and architect and spent the rest of his career and life in Japan. Although Conder's official assignment in Japan was to institutionalize the architectural profession according to extant Western models, his motivation for accepting it paradoxically hinged on his interest in traditional Japan. During his pre-Japan years in the 1870s, he, like many English artists and architects of his generation, had developed an ardent admiration for Japanese design and workmanship in response to art objects circulating in Europe. However, it was not until he took up residence in Japan that he became familiar with the country's architecture. His appreciation of the traditional Japanese arts in combination with his professional commitment to the "advancement" of Japan through European building materials and techniques engendered the ambivalence that colored his view of this nation.

Because fairly little has been published in English on Conder, an extended discussion of his background and design philosophy is in order here.[30] Born in London in 1852, Conder descended from the artistic lineage of his great-great-grandfather, the sculptor

Louis François Roubiliac (d. 1762), and his paternal grandfather and namesake, the writer-poet Josiah Conder (1789–1855).[31] Although it appears there were no architects in his immediate family, young Josiah secured a promising start to his career at the architectural office of a distant relative, Thomas Roger Smith (1830–1903).[32]

Between the ages of sixteen and twenty-four, Conder underwent his education and training as an architect.[33] His background was unusual in that he was one of the few in his generation to receive instruction in the classroom as well as in an architectural office. Consequently, he was conversant in both the theory and the practice of his profession. Conder apprenticed in Smith's office for four years. During this time, he also attended lectures at University College and drawing classes at the South Kensington Art School. In 1874, he moved to the office of William Burges (1827–1881) on Buckingham Street, and his first task as an assistant was to work on a new design for Trinity College in Hartford, Connecticut.[34] In the evenings, Conder fine-tuned his drawing skills at the Slade School of Art. One year later, in 1875, he transferred to the studio of Walter Lonsdale, a stained glass artist who was working with Burges on the latter's ecclesiastical designs. Conder's eight-year architectural training culminated in two remarkable events. On 13 March 1876, his design for a country house won the prestigious Soane Medallion Competition held by the Royal Institute of British Architects (RIBA).[35] And on 18 October, he signed a five-year contract with the government of Japan as technical consultant to the Public Works Ministry and professor at the Imperial College of Engineering (Kōbu Daigakkō).

Conder matured in a decade marked by the displacement of the dogmatic Gothic Revivalism by the eclectic, uninhibited Queen Anne style.[36] The rigor of the former was replaced by a new relativism in the use of historical and "exotic" styles and a general gravitation toward aestheticism and pragmatism. Conder shared many of the convictions of his peers, and especially those of his mentors Smith and Burges, concerning the cultural signification and function of architecture. A few of the fundamental beliefs arising from this background greatly animated his practice and teaching in Japan, specifically his understanding of architecture in relation to history, art, and Japan.

First and foremost, the contemporary phenomenon of historicism made a deep impression on Conder's approach to design. His design for a country house, which garnered the Soane Medallion (fig. 2.7), is the only extant record of his professional work before he traveled to Japan. The drawings confirm Burges's strong influence on his assistant and Conder's confident command of the master's Gothic vocabulary. The country house displays an exuberant massing of asymmetrical volumes and is painstakingly elaborated with symbolic sculpture and stained glass designs. The drawings also appropriated Burges's signature pictorial contrivances, such as the insertion of lettering in Old English script and figures in period costumes. More than an exercise in historical accuracy, Conder created a rigorously artistic and totalizing vision of medieval times.

2.7 Josiah Conder, winning country house design for the Soane Medallion competition, 1876. *The Building News* (21 April 1876). Courtesy of the Library of Congress.

This propensity to view a past era with romantic reverence would also fuel his desire to visit Japan, a place where, according to Burges, the European Middle Ages could be experienced in the nineteenth century. Throughout his career, Conder remained at his most expressive and adroit when designing in the Gothic idiom, although his repertoire was not limited to this style. He, like many of his contemporaries, ultimately made use of the full palette of historical building styles in his design.

J. Mordaunt Crook has characterized the tension built into the relationship between Victorian architects and the past as dilemmas revolving around choice and contemporaneity: the architect faced not only a panoply of historical styles with which to work but also the challenge of putting the chosen styles in the service of a progressive age, particularly in light of the changing demands born of new building technology and types.[37] For Conder, this challenge was heightened in his work for the Japanese govern-

ment, for his position as a foreign expert obligated him to spearhead the adoption of advancing technology above all else. Furthermore, the experience compelled him to carefully consider the purpose of reproducing past European styles, Greek or Gothic, in the context of a nation that claimed no cultural roots in Europe.

Conder also brought to late-nineteenth-century Japan the belief that architecture should be the reconciliation of science and art. In an 1878 lecture to his Japanese architecture students, he made this opening statement:

> It is necessary that you should master . . . the rules and results of all scientific investigations, so far as they concern the strengths of materials, and mechanics of structures, in connection with buildings. . . . You must not however forget, that, although the education necessary to an Architect is partly a Scientific education, it is equally necessarily an Artistic one. The utilitarian age in which we may be said to live is one in which there is a tendency to disparage the value of the Arts. . . . The Fine Arts, appealing as they do to the emotions and senses, their causes and effects cannot be clearly reduced to mathematical proofs and limited laws.[38]

Calling attention to the duality of architectural practice, the talk posits a separation of architecture's scientific and artistic components. As the lecture progressed, Conder betrayed his bias for the artistic education of an architect when he relegated scientific construction to the observation of predetermined laws and rules while elevating architectural art to the cultivation of "certain feelings, considerations, and passions." Once again, the influence of Burges looms large in this notion of the artist-architect. In Burges's words: " . . . it ought to be as disgraceful for an architect not to know the [human] figure, as it would be not to be able to design a piece of tracery."[39] Conder's own training in general stressed the integration of architecture with the other arts, as demonstrated by his continuous enrollment in drawing classes and his apprenticeship in stained glass design. Later, during his years in Japan, he would continue to pursue his architectural design in conjunction with his studies of Japanese costumes, landscape gardening, painting, and, of course, traditional architecture. His membership in the Asiatic Society of Japan and the Meiji Art Society (Meiji Bijutsukai) fueled his interest in the arts; an active participant, he regularly presented papers or lectured at these organizations, sharing his findings and knowledge on subjects that were more than passing hobbies.[40] In addition to researching Japanese arts, he practiced traditional ink painting with the artist Kawanabe Kyōsai (1831–1889). Kyōsai frequently recorded his delight in his English pupil's artistic skills and refined character in his diary and sketches.[41] No doubt Conder's greatest contributions outside of architecture were his publications *The Flowers of Japan and the Art of Floral Arrangement* (1891), *Landscape Gardening in Japan* (1893), and *Paintings and Studies by Kawanabe Kyōsai* (1911).[42]

Conder was not the first foreigner hired by the Public Works Ministry to design and build in Japan.[43] He did, however, contribute something crucial to its new Western-aligned architecture: a sense of artistry in the design process. He promoted architecture as more than the pragmatism of Western technology and technique and instead fashioned it as an "artistic conception" originating in accordance with rationality, convenience, and economy of construction. Conder has been recognized as the father of modern Japanese architecture because he established a viable profession by providing a comprehensive approach to architecture. Following the credo of his mentors, he trained his own students to appreciate the significance of artistry, scientific precision, and historical awareness in architectural design.

A third factor in Conder's initial approach to instating modern Japanese architecture was Japonism, or the cult of Japan in Britain. His most direct link to designers who were collecting and drawing inspiration from Japanese arts were Burges and Burges's close friend E. W. Godwin.[44] The two were pioneer collectors of Japanese prints and works of art in Britain, their interest having been propelled by the 1862 International Exposition in London. Burges and Godwin wrote and lectured on the subject of Japanese art and its affinity with European medieval craft, and they ardently incorporated Japanese motifs, forms, and finishes in their designs. Conder's exposure to Japanese arts at the office of Burges was inevitable.

Precisely what and how Conder learned about the arts of Japan through Burges is undocumented, although it is easy to speculate that he absorbed it while studying European medieval and other "Oriental" arts and architecture. Conder's receptiveness to Japanese arts is indicative not only of Burges's comprehensive influence on him but of the place Japonism held in the pursuits of the nineteenth-century British art world. By the 1870s, Japanese art, mostly lacquer and porcelain pieces, had begun to enter museum collections in steady quantities and was shown in international and domestic exhibitions; the growing number and accessibility of scholarly English-language books on this subject and lectures by prominent designers such as Burges, Godwin, and Christopher Dresser (1834–1904) established Japanese art as the subject of serious study, not mere objects of curiosity.[45] The comparison to medieval Europe at once familiarized and exoticized Japan for the modern designer. Conder's sketchbooks exhibit this conflation of the feudalistic and fantastic East and West, with the free juxtaposition of drawings of Japanese decorative objects, Gothic cathedrals, and Islamic ornamental patterns, the varying subject matters frequently sharing the same volumes and pages (fig. 2.8).[46] Japanese people, scenery, and design patterns interwoven with Gothic and Islamic forms epitomize the knowledge base that informed his view of Japan prior to his arrival there. This way of seeing Japan, as disembodied design motifs or as part of an idyllic, homogeneous, other time-place remained firm, despite his later firsthand observation and experience of Japan. His familiarity with only the applied arts and not the architecture

2.8 Josiah Conder, three details from one volume of the Josiah Conder Sketchbooks.
Top left: "Design for the top of a sideboard, adapting details of Japanese Temples," ca. 1877;
top right: "Cathedral Pisa, stained glass," 1876; *bottom*: "St. Marks, Venice, Pavement," 1876.
Courtesy of the Architectural History Laboratory, Architecture Department, University of Tokyo.

of Japan during his formative years in England would also affect his perception of traditional Japanese architecture and his vision for a new architecture.

On 28 January 1877, Conder landed at Yokohama Bay to begin the formidable task of "modernizing" Japanese architecture. His professional experience in Britain is especially relevant because the Museum in Ueno was the maiden commission of his career in Japan. At this early juncture—the first year of his professional duties—the modes of thought and practice that had shaped him as an architect in England were being converted into a practicable approach to building in Japan. Together with his winning Soane competition drawings and volumes of sketches from a just-completed minitour of Europe, Conder carried with him to Japan the ideological baggage of a Victorian architect.[47]

The unique combination of values and practices that engaged Conder in Britain directed his practice in Japan; likewise, another foreign expert, depending on his country of origin and prior professional experience, would have been equipped with a different set of tools for the job. It remains a mystery why the Japanese Public Works Ministry invited Conder, a relatively young Englishman without a single built project on his résumé, to be the primary instructor responsible for educating a new generation of Japanese architects. What is clear is that Conder fully recognized the weight of his position; his Japanese students later remembered him fondly for his unstinting devotion to their academic and professional progress.

CONDER'S DESIGN

As part of the preliminary preparation for designing the Ueno building, the Home Ministry once again consulted museums in Western Europe and the United States. Rather than undertake an inspection tour—time and finances most certainly being the prohibitive factors—the ministry conducted the survey by correspondence. As early as January 1876, Home Minister Ōkubo had sent official requests to Japanese ministers situated in Austria, China, England, France, Germany, Italy, Russia, and the United States, soliciting architectural drawings, pictorial documentation, and catalogs of the museums in these respective nations.[48] Extant records show that materials on museums in Austria, Berlin, France, Italy, Philadelphia, and Russia were sent in response; however, because, for the most part, the names of the museums were not recorded, the institutions and the types of materials submitted cannot be clearly identified.[49] One exception, a record of drawings procured by the English ambassador in Japan at the time (presumably Harry Parkes), depicts the Natural History Museum designed by Alfred Waterhouse, a building then under construction in London. By January 1878, all of the items submitted—copperplate prints, photographs, illustrations, and explicatory text—were

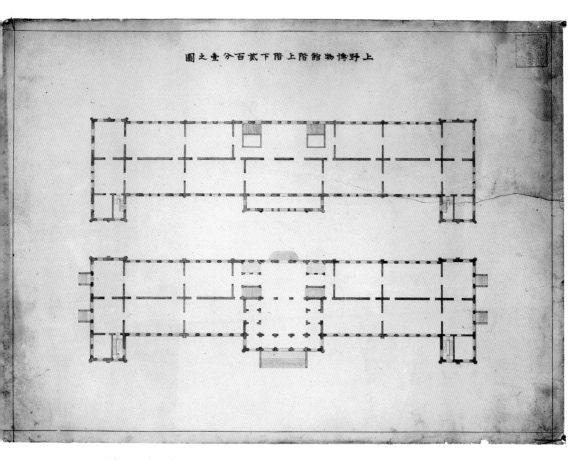

圖之分百貳下階上階館物博野上

2.9 Josiah Conder, the Museum in Ueno Park, plans of upper floor and ground floor.
Tokyo National Museum, TNM Image Archives.

assembled at the Home Ministry, where they served as reference materials for the architectural design of the Museum.

As mentioned earlier, although no documentation remains of Conder's commission to design the Museum, he certainly was assigned to the project some time between his arrival in January 1877 and the building's groundbreaking in March 1878. However, a number of extant sources suggest that initiation of the design process preceded Conder's participation. Conder may have been asked to work with a preexisting set of floor plans (fig. 2.9), and it is not known for certain whether Giovanni Vincenzo Cappelletti (in Japan from 1876 to 1885) or Antonio Fontanesi (in Japan from 1876 to 1878) drew those plans. Both were art instructors from Italy employed by the Public Works Ministry at the Technical Fine Arts School.[50] But once Conder assumed full design responsibility, no other foreign expert appears to have taken a role.

When the Museum was on the verge of completion, in 1881, it served for approximately three months as the art gallery of the Second National Industrial Exhibition (fig. 2.10).[51] Printed guides for this event informed visitors that after the exhibition closed, the building would become the permanent home of the national museum collection and that its debut as the exhibition's art gallery was a preview of its long-term function.[52]

The Museum opened officially in March of the following year. The inauguration ceremony was a grand affair, marked by fanfare from two military bands and the attendance of ranking statesmen, aristocrats, and the Meiji emperor, who graced the occasion with the following speech: "Nothing equals the establishment of the museum for advancing human knowledge and promoting industry. Today, we witness the opening ceremony for the Main Building as evidence of steady progress toward the establishment of a wealthy nation."[53]

At the time of its completion, the official name of the building designed by Conder was the Museum, but it was popularly referred to as the Ueno Museum (Ueno Hakubutsukan) or simply the New Building (Shinkan) or the Main Building (Honkan). From its opening day, the new museum was touted as an institution of conspicuous national significance. In its heyday, it was more accessible to the general population than any other public institution in the nation.[54] In providing easy access to a centralized collection of the nation's artifacts, manufactures, and arts, the government aimed to accomplish a twofold objective: to enrich the minds of the general public and to evoke a sense of shared heritage. Above all, the building epitomized the Meiji bureaucracy's mission of engaging the nation in the international standards and practices of the time.

Although the Museum was lost to the great earthquake of 1923, it is still possible to reconstruct the original form and configuration of the building through an examination of existing pictorial and textual documentation. The archives of the Tokyo National Museum currently contain sixty-three sheets of construction drawings, photographs of the exterior and interior, and a perspectival rendering in watercolor executed by the architect himself (fig. 2.11), and the National Archives of Japan holds three sheets of presentation drawings.[55] Moreover, the building, as the focal point of the Second National Industrial Exhibition, was a popular subject of woodblock prints, usually done in the triptych format to emphasize the building's horizontal expanse (fig. 2.12). These artist renderings help to situate the building within the layout of the park grounds and illuminate the ways in which the Meiji population interacted with it.

Its location at the apex of a spacious park separated the Museum from existing historical neighborhoods, and its distinct architecture intensified the idea of its newness. The two-story brick structure, with windows punctuating the full horizontal length of the exterior wall, was distinguished by the combination of its exceptional size, material, and style. The central entrance bay and the two end pavilions formed shallow projections in the otherwise perfectly rectangular floor plan. The interior was composed

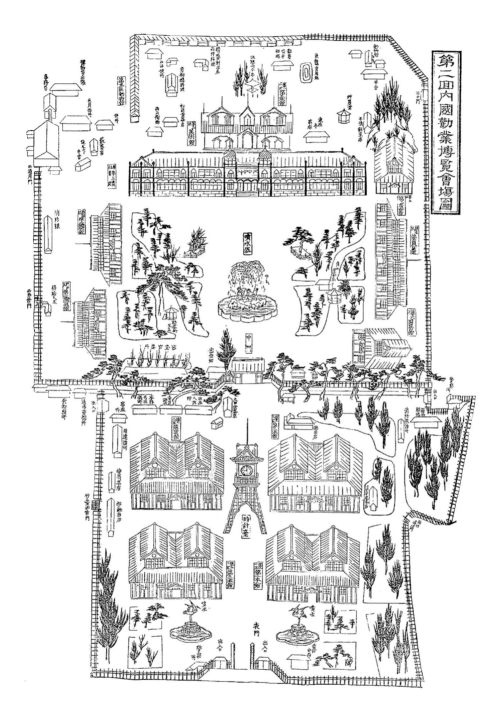

2.10 Map of the Second National Industrial Exhibition, Tokyo, 1881.
Dainikai Naikoku Kangyō Hakurankai reppin zuroku [Illustrated catalog
of the Second National Industrial Exhibition] (1881).

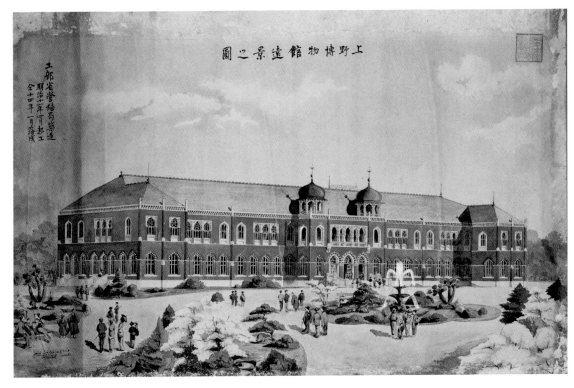

上野博物館遠景之圖

工部省營繕有葉達
期治十一年四月起工
全十四年一月落成

2.11　Josiah Conder, *Perspective View of the Museum in Ueno Park*, ca. 1881.
Watercolor on paper. Tokyo National Museum, TNM Image Archives.

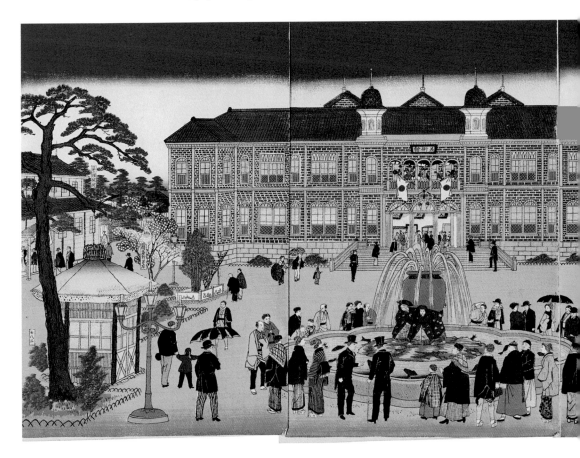

exclusively of exhibition rooms, configured as enfilades that set out a fixed, linear circulation path. The most conspicuous feature was a set of decorative bulbous domes crowning the front facade. The architect himself characterized the overall style of the building as "pseudo-Saracenic," his painstaking solution to expressing Eastern character through Western masonry construction.[56] The elements that Conder labeled "Saracenic" (a term to be examined later in this chapter) were forms entirely alien to the architectural traditions of Japan. The unprecedented decorative program, together with the striking location and material (especially the juxtaposition of the red brickwork with the green, wooded surrounding), marked the museum as an unmistakable symbol of a new institution and a new architecture that had no conspicuous indigenous links.

The most famous examples of institutional designs by Western architects that attempted to express "Japanese character" all postdate the Ueno Park museum. These include proposals for the Imperial Diet Building and Law Courts (1887) by the German architects Hermann Ende and Wilhelm Böckmann (fig. 2.13) and the executed design of the Imperial Hotel (1913–23) by Frank Lloyd Wright.[57] Previously, European and

2.12 Utagawa Hiroshige III, *The Fine Arts Museum and the Shōjō Fountain at the Second National Industrial Exhibition in Ueno Park*, 1881. Woodblock print. Museum of Fine Arts, Boston, Jean S. and Frederic A. Sharf Collection. Photograph © 2006 Museum of Fine Arts, Boston.

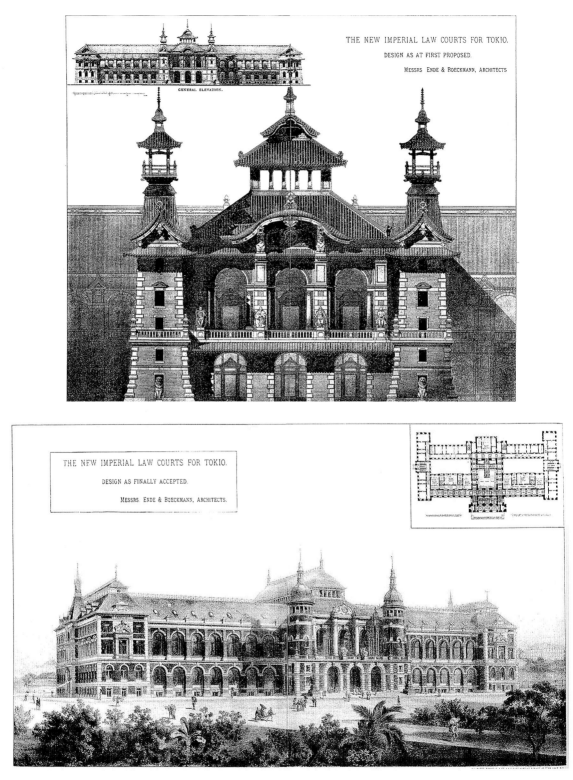

THE NEW IMPERIAL LAW COURTS FOR TOKIO.

DESIGN AS AT FIRST PROPOSED.

MESSRS ENDE & BOECKMANN, ARCHITECTS

GENERAL ELEVATION.

THE NEW IMPERIAL LAW COURTS FOR TOKIO.

DESIGN AS FINALLY ACCEPTED.

MESSRS ENDE & BOECKMANN, ARCHITECTS.

2.13 Hermann Ende and Wilhelm Böckmann, proposed designs for the Law Courts, Tokyo, 1887. *Top*: rejected scheme; *bottom*: approved scheme. *The Builder* (London) (15 April 1893). Courtesy of the Library of Congress.

American experts customarily employed the techniques and attendant styles with which they were already familiar, adapted to the materials and skills available in Japan. The Japanese government had engaged them for the expediency of implementing existing expertise rather than for the challenge of adopting indigenous traditions of carpentry and joinery. Conder, who was contracted for the same reason, also stressed the incompatibility of Japan's traditional styles with the new requirements of modern institutions such as colleges, assemblies, and hospitals. Nonetheless, the museum was an exception. Although it is possible to argue that the very idea of this institution represented an intrusion of the foreign and a break with existing modes of organization and expression, Conder approached the architecture with more nuance, in consideration of framing Japan's historical and cultural lineage. While the collection objectified the nation on a literal level, the architecture presented an opportunity to do the same on a metaphorical level.

TRANSNATIONAL DESIGN LINKS

As museum architecture, the Ueno Park building established a visual link to a body of well-known contemporary designs in Britain and the United States. It was an homage to the line of mid- to late-nineteenth-century British museum projects that departed from the classical tradition: the Trinity College Museum in Dublin (1852–57), the Oxford University Museum (1854–60), and the Natural History Museum in London (1868–81), to name three prominent examples.[58] As a young architect growing up in London, Conder would have been acquainted with the prolonged Natural History Museum project; in addition, as mentioned earlier, the English ambassador provided the Home Ministry with a set of the drawings of this museum. Conder participated in this turn toward the Gothic manner, his preferred style, in the animated use of constructional polychromy (alternating colors of stone or brick) on the facade and carved ornamentation for both exterior and interior articulation. This was the only noticeable link between his fanciful entry for the Soane Medallion and his museum design, the project that immediately followed his winning country house entry.

While the Museum can also be counted as one of the many such institutions that display the strong influence of the South Kensington Museum, it is unique for being an Anglo-Japanese example. This museum had its start at the same time as two of the most influential art museums in the United States—the Metropolitan Museum of Art in New York and the Museum of Fine Arts in Boston. All three were founded in the 1870s, emulating, to various extents, the South Kensington model, both institutionally and architecturally.[59] The permanent buildings of the South Kensington Museum, designed by Francis Fowke (fig. 2.14), as well as the three aforementioned British examples inspired the penchant for color and detailing that distinguished the Metropolitan Museum of

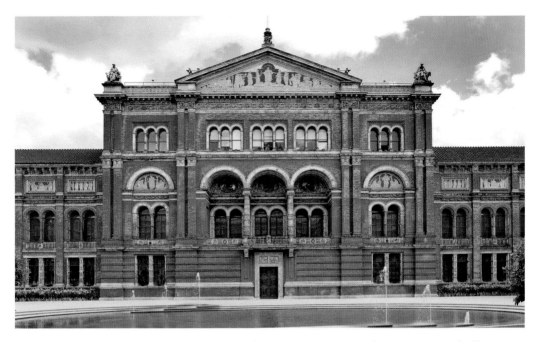

2.14 Francis Fowke and Henry Scott, South Kensington Museum (now Victoria and Albert Museum), lecture theater, London, 1867–69. V&A Images/Victoria and Albert Museum.

Art's first buildings (1874–80), by Calvert Vaux and Jacob Mould, and the Museum of Fine Arts' first section (1870–76), by John Sturgis and Charles Brigham (fig. 2.15).[60] Apart from the prominent bulbous domes, the Ueno museum externalized many similar stylistic features, including the use of red brick with stone and terra-cotta dressing and pointed, banded arches.

It is no coincidence that Conder designed his building with the distinctive philosophy and visual attributes of the South Kensington Museum in mind, for the application of the arts to architecture formed the core of his education under Burges, who called architecture the mother of all the other arts.[61] Moreover, Conder's four years of attendance at the South Kensington Art School honed his aptitude and appreciation for ornamental design (not to mention the prominence of Oriental arts as decorative motifs under Owen Jones's influence at that school). His experience also intersected with that of the architects Sturgis, Vaux, and Mould, who all trained in London, and he shared with them a similar interest in the English picturesque and the Gothic Revival.[62] Just as the Boston and New York museums have been described as "small, American versions of the South Kensington," the museum in Ueno Park could claim kinship as the small, Japanese version.[63]

Aside from the stylistic resemblance, however, the Museum did not share some of the practical features distinctive to Euro-American museum designs of the time.

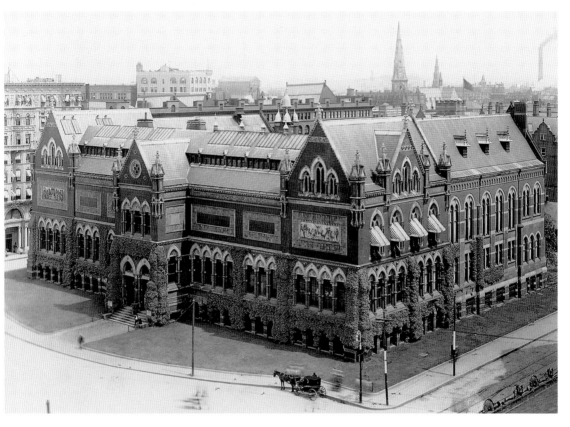

2.15 John Sturgis and Charles Brigham, Museum of Fine Arts, Boston, Copley Square Building (demolished), view of building as enlarged by 1879. Photograph © 2006 Museum of Fine Arts, Boston.

Although Conder later characterized the institution as "a Museum of Treasures for the Far Eastern Arts," it housed a collection of much greater diversity.[64] The six collecting departments—natural products (*tensan*), agriculture (*nōgyō*), horticulture (*engei*), industry (*kōgei*), arts (*geijutsu*), and history (*rekishi*)—are more appropriate to a museum of science, art, and industry. Although much of the existing scholarship on museum architecture tends to overlook the difference, Carla Yanni has rightly pointed out the need to recognize the display of art and natural history as parallel but distinct endeavors, dealing with discrete sets of objects, exhibition requirements and objectives, and visitor expectations.[65] The exhibition spaces of the Museum were used for a diverse range of objects, from ink painting scrolls to ossified animal remains, yet twenty-five of the thirty exhibition rooms were nearly identical in size, allowing no special distinctions or accommodations. The identical configuration for the upper and lower floors sets out linear series of rooms, each lit from only one side with the exception of corner rooms, which were lit from adjacent sides. The building lacked both a central court to

2.16 Josiah Conder, the Museum in Ueno Park, view of art displays. Photograph taken before 1923. Tokyo National Museum, TNM Image Archives.

serve as a spatial focus and a partially glazed roof to provide additional sources of illumination—two features found in many customized museum designs overseas.[66]

For displaying artworks, the building did not differentiate the illumination of paintings from that of sculpture. The arrangement and lighting of displays had been two primary concerns driving the design of art museums and galleries in Europe since the inception of this building type in the eighteenth century.[67] Competing theories demanded precise positioning of windows and skylights and exact angles of illumination, although the consensus on the best setup dictated the placement of sculpture on the ground floor, lit from the side, and paintings on the higher floor, lit from above. As mentioned earlier in this chapter, art at the First National Industrial Exhibition in 1877 received top lighting, and the painted works hung directly on the walls. In comparison, all works of art in the Ueno museum, regardless of medium, were placed behind glass (fig. 2.16). This transition of display method could be attributed to the difference in approach to temporary and permanent exhibitions as well as to the difference in the value of the items in the respective events—the former available for sale and the latter strictly for viewing.[68] Contemporary photos of the Museum's interior show no hint of the overcrowded

2.17 Josiah Conder, the Museum in Ueno Park, view of science and anthropology displays. Photograph taken before 1923. Tokyo National Museum, TNM Image Archives.

displays and visitors that marked the temporary exhibition. The Museum's permanent national collection allowed more space between the vitrines as well as between the objects within them.

Natural history displays used similar vitrines (fig. 2.17). This practice contrasted with recent developments for science displays in Britain, namely the implementation of ferro-vitreous construction on the roof, which created maximum lighting from overhead. Joseph Paxton's Crystal Palace inspired the ubiquitous use of glazing for display. Permanent museum structures such as the Oxford University Museum and the Edinburgh Museum of Science and Art (1861–89), which featured spectacular double-story arcades covered with iron and glass, represent the period's characteristic setting for promoting visual identification with natural and man-made products. Material, technical, and budgetary limitations must have deterred the extensive use of iron and glass in Ueno, where there was neither a glass roof above nor a corresponding large hall beneath.

Without the appropriate human and material resources, Conder could not have been expected to implement ferro-vitreous construction. The Museum could, nonetheless,

lay claim to several technical innovations for masonry construction in Japan, although none were directly related to museum design.[69] As Onogi Shigekatsu points out, Conder used reverse arches in the wall construction as a means of countering the uneven ground conditions. He also incorporated steel beams within the brickwork of the second-story floor plate for reinforcement. Both techniques were unprecedented for brick construction in Japan.

STYLING JAPAN

Although the newspapers fully reported on the debut of Conder's building at the Second National Industrial Exhibition in 1881, as well as its 1882 reopening as the Museum, the Japanese press did not comment on this monumental structure as a work of architecture or art. Toshio Watanabe has offered two very plausible reasons for this omission: first, that since, "at this stage there was no tradition of media criticism of such government buildings . . . a less-than-favorable comment would probably have been regarded as *lèse-majesté*," and, second, that "architecture was not yet regarded as properly pertaining to art [and therefore] there was no tradition of discussing buildings in aesthetic terms."[70] Furthermore, there also was no professional opinion available, for the modern architectural profession was in its infancy, being fostered by none other than Conder himself. Conder's professional progeny went on to found the leading association Zōka Gakkai in 1886 (renamed Kenchiku Gakkai in 1897) and its journal *Kenchiku zasshi* in 1887, but even decades later, members in general spoke of the profession's founder and his work only with the utmost respect.[71]

Conder himself, however, offered revealing commentary about the Museum in 1920, at the end of his career and shortly before his death at the age of sixty-seven.[72] The Kenchiku Gakkai had organized an award ceremony to honor Conder's lifetime achievements.[73] His acceptance speech was brief, but he singled out the Museum, out of the more than 130 buildings in his oeuvre, for special attention. His remarks are especially significant in light of his customary reticence about his own work and his ardent tone in addressing a project so distant in time:

I have always remembered Baron Hamao by the predilection he was kind enough to bestow upon me for my design for what is now called the Imperial Japanese Museum at Uyeno [*sic*]. . . . Now, a foreign architect arriving in this country imbued with the idea of the continuity of a national style, generally first attempts to find some way by which he can perpetuate the national architecture, whilst giving it the modern improvements of arrangements, solidity, and scientific advantages. So far as my studies of the national styles went (and I was an enthusiast in the beauties of Japanese art) there were no decorative or ornamental forms, or forms of outline or contour, which lent themselves construc-

tionally to a ligneous or wooden style, and it became necessary to seek in Indian or Saracenic architecture for forms which, having a logical treatment in brickwork or stone-work, would impart an Eastern character to the building. Hence this first effort to impart a character not too much at variance with a Museum of Treasures for the Far Eastern Arts. I do not know whether or not some other person has ever properly understood my motive in introducing a pseudo-Saracenic style of architecture in Japan, but I have always remained grateful to Baron Hamao for reminding me of my first and, in his opinion, successful attempt.[74]

Clearly, Conder's overwhelming concern with the museum design was its style rather than its function or construction, even though at the time the innovative building type (museum) and construction method (masonry) would have been equally challenging concerns. The high visibility of the Museum as a public, monumental statement of the central government's modernizing ideology must have impressed Conder deeply. The crux of his argument for designing in what he called "a pseudo-Saracenic style" is his assertion that Saracenic forms are more "logical" than Japanese ones for imparting Eastern character to a brick and stone building. Conder appears to have been offering a materialist explanation, echoing the position, originally put forth by the architect A. W. N. Pugin, that form and style must be generated by structural utility and, there-fore, ornamentation derived from wooden construction had no legitimate place in a masonry structure; however, Conder's explanation glossed over deeper, more complex issues of architectural representation.

Conder's conceptualization of Japan in this speech reveals the base of logic and seman-tics from which he was operating. First is his assertion of an existing, homogenous "national style" or "national architecture" and the need to both perpetuate *and* improve it. Second is his deliberate semantic fusing of the terms "Japanese," "Indian," "Saracenic," "Eastern," and "Far Eastern" as equivalent signifiers of Japan. Third is his definition of these non-Western styles solely by their ornamentation and architectural fragments. Underlying these constructions is the notion that his interest was not in architecture that was Japanese but in architecture that he believed *represented* Japanese-ness.

At the most fundamental level, Conder's use of the Saracenic reflects the contempo-rary European attitude that homogenized the geocultural diversity of the so-called Orient. The very label "Saracenic"—derived from the noun "Saracen," a deprecatory term used since the time of the Crusades to distinguish a Muslim as "a non-Christian, heathen, or pagan"—begs for a careful dissection.[75] Here the Saidian framework appears applicable, namely, the assertion of an "Eastern" or "Oriental" image as the diametric opposite of the "European" self, and the essentialization and immobilization of this Other as complement to the complex, progressive West.[76] Conder shared the worldview of his contemporary Basil Hall Chamberlain (1850–1935), the influential Japan special-

ist and a fellow Englishman who spent most of his life in Japan. Despite the extraordinary length and breadth of their exposure to Japan, they, like Said's Orientalists, still saw their world as divided clearly between West and East.[77] (Remarkably, at the turn of the century, a similar worldview would be endemic to self-representational writings on Japanese culture by native writers such as Okakura Kakuzō. Ironically, the strategies of colonial control Said identifies—cultural essentialization and polarization—became common approaches for asserting Japanese uniqueness and conscious markers of difference from the West.[78])

Conder's attitude toward his own discipline sets off his Orientalist vision with the most clarity. In his 1878 paper "Notes on Japanese Architecture," he maintained an inviolable boundary between wooden construction and masonry construction as the basis of differentiation between Japan and the West as well as between past and present.[79] He would eventually present four papers on Japanese architecture for English-speaking audiences, and he remained resolute in enforcing the polar categories of what he called "the ancient style of building"—in essence the whole chronological range of architectural works in Japan up to 1850—and the "modern, revolutionary" contributions of Europeans and Americans like himself. Thus, he joins Chamberlain and many other European and American scholars of Japan in "praising selective aspects of the Japanese past while denying relevance for the future to any but Western practices."[80]

When Conder eschewed the direct quotation of Japanese architectural forms and turned to the Saracenic, he was able to maintain an inviolable line between the Japanese past ("fantastic," "elegant," and "fragile") and the Western-inspired present ("rational" and "solid").[81] His knowledge of the Saracenic style as a classification and as terminology most likely derived from the architectural historian James Fergusson's *A History of Architecture in All Countries* (1865), a survey book of Western and non-Western architecture.[82] Fergusson's *History* did not include a section on Japan; in fact, at the time, no major architectural publication, including Owen Jones's *Grammar of Ornament* (1856), offered a visual index of Japanese architecture. In designing the Ueno museum, Conder appears to have relied on European sources on "the East" and given form to modern Japan based on material devoted to Islamic architecture that was available to a British architect.

Conder's assertion of the difference between Indian, Japanese, and Saracenic architecture in the classroom, teaching all three as discrete sections in his lecture course "History and Art of Architecture" at the Imperial College of Engineering, adds another layer of complexity to his use of Saracenic architecture in his design for the Museum.[83] In addition, he had been conducting research on traditional building types, specifically religious and domestic architecture, since his arrival in Japan; his sketchbooks contain numerous pages of elevations and plans of temples and houses recorded and labeled with attentive precision. He displayed a deliberate eagerness to assume the position of

2.18 Swinton Jacob, Albert Hall Museum, Jaipur, India, 1881–86. *Handbook to the Jeypore Museum* (1895). Courtesy of the Library of Congress.

Japanese expert among his professional peers in England.[84] A set of his sketches illustrating Japanese architecture was exhibited at the RIBA in December 1877, and his aforementioned paper "Notes on Japanese Architecture" was read on 4 March 1878, at the same institute.[85] Both the exhibition and the lecture took place before the groundbreaking for the Museum. Conder could have drawn on his specialized knowledge of Japan in the museum design, but he chose not to.

The prominence of the "Indo-Saracenic" style being developed by the British Raj in the 1870s also made the Saracenic style a conspicuous choice for a British architect working overseas; the Albert Hall Museum in Jaipur, India (fig. 2.18), is one particularly striking example. The historian Thomas Metcalf has proposed that this architecture "proclaimed the supremacy of the British as they sought to reshape India" and that "by drawing together and then melding forms distinctly labeled 'Hindu' and 'Saracenic,' the British saw themselves, the self-proclaimed masters of India's culture, as shaping a harmony the Indians alone, communally divided, could not achieve."[86] Museums erected under the Raj, Metcalf points out, "were invariably housed in Indo-Saracenic-

styled structures" because the museum institution and this style of architecture were both powerful manifestations of the colonial ruler's organization and classification of India's past.[87] Conder's mentors Smith and Burges had designed for India, although their involvement predated the rise of the Indo-Saracenic style by a decade and neither employed such forms. Burges is best known for what was dubbed by the *Ecclesiologist* "a kind of quasi-Orientalizing Gothic" design for the Bombay School of Art (fig. 2.19), while Smith is remembered for his advocacy of blending "essentially European" styles with features of the "best Oriental styles."[88] Their designs and writings grounded contemporaneous debates on the suitability, adaptability, and legibility of European versus indigenous forms in the East.[89]

Conder's characterization of his design as "pseudo" signals two levels of substitution, or separation, from Saracenic architecture—that is, his recognition of his work as a nineteenth-century European derivative of historical models and the deliberate use of this derivative as a stand-in for Japan's national identity. The prefix "pseudo" is not pejorative but, rather, underscores the architect's knowing imposition of an unusual model for modern Japan. The so-called pseudo-Saracenic forms composed the Museum's ornamental features (fig. 2.20). Most prominent are the flanking *chattris*, or open pavilions, atop the central bay of the facade. Pointed arches and floriated windows line the full horizontal expanse on all four sides and two stories of the building. A decorative balustrade and intermittently placed finials crown the base of the roof structure. Column bases and capitals, visible in one detailed drawing of the central bay, are decorated with animal and plant forms. Polychromatic masonry construction of contrasting red brick and light-colored stonework highlight the varied window shapes and tracery patterns. These details on an otherwise classical body resonated with prevalent British architectural modes of the time, that of the Gothic Revivalist styles and the later Queen Anne style. Rather than working from rigorous, firsthand examination of original Islamic architecture, Conder's fairly simplified composition could have been inspired by a study of Fergusson's books, illustrated travelogues, or even other buildings in the neo-Islamic mode. As Smith indicates, a European of the time with some knowledge of art or architecture would have been acquainted with elements of Saracenic architecture even if he had never traveled to the Orient.

While architects and architectural historians of the period might have folded India and Japan under the same classificatory heading—"non-Christian," "non-historical," or even "non-architectural"—the two cultures were obviously sustaining very different political relationships with Europe.[90] Because Japan maintained its sovereignty in the late nineteenth century, British building in Japan and British building in India operated under distinct sets of patron-architect power dynamics (or simply put, Conder was acting on the authority of the Japanese government to build for the Japanese). After all,

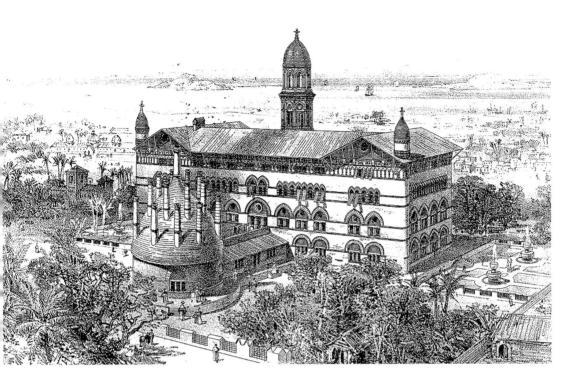

2.19 William Burges, proposed design for the Bombay School of Art, Bombay, India, 1865–66. *Top*: exterior perspective; *bottom*: section. *Sessional Papers of the Royal Institute of British Architects* (16 December 1867). Courtesy of the Library of Congress.

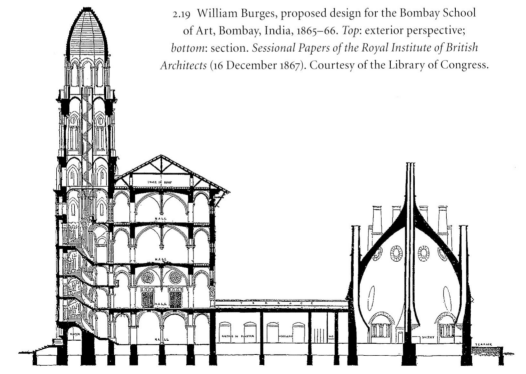

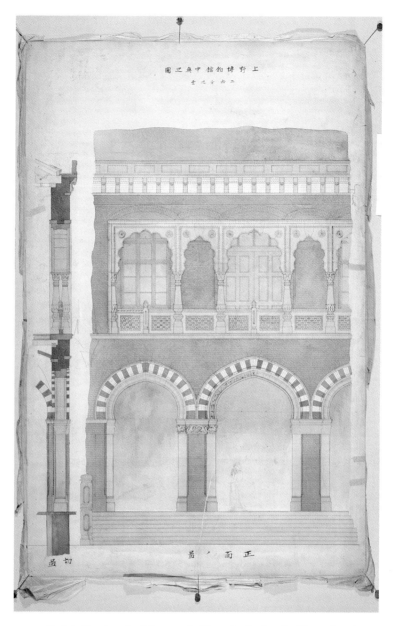

上野博物館中奥之図
二六分之一堂之

切図　　　正面之図

2.20 Josiah Conder, the Museum in Ueno Park, detail of front facade.
Tokyo National Museum, TNM Image Archives.

Japan was never part of the Orient of Said's Orientalism; in addition to not falling under the British or any other colonizing power, it did not have the history of geographical, cultural, and religious adjacency to and contention with Europe that ignited the specific structure of power struggle analyzed by Said.[91]

However, the West's "abrupt, massive, and menacing" penetration of Japan in the 1850s was a powerful catalyst that activated the island nation's self-preservational imperative to modernize and form a unitary polity.[92] As Marilyn Ivy succinctly puts it, "Japan is literally unimaginable outside its positioning vis-à-vis the West. . . . The articulation of a unified Japanese ethnos with the 'nation' to produce 'Japanese culture' is entirely *modern*."[93] Although Japan had to endure extraterritoriality and unequal treaties, it had the freedom to appropriate select Western institutions and structures and retain select elements from its own past as common strategies for maintaining an autonomous sense of self.

British employment of the Saracenic style in the colonies was, in the most simplistic terms, a mechanism of control by the colonizer over the colonized, as Thomas Metcalf and Mark Crinson argue; G. Alex Bremner also contends that the use of this style in Britain was a display of imperial triumph.[94] Nevertheless, this style did not carry the same oppressive overtone in Japan. Baron Hamao Arata (1849–1925) offered one response, given at the 1920 ceremony held in Conder's honor.[95] Hamao, an honorary member of the Kenchiku Gakkai and former president of Tokyo Imperial University, was not an architectural expert, although he figured prominently in the promotion of a national art for Japan through his leadership positions with the Fine Arts Commission, the Imperial Museum, and the Tokyo School of Fine Arts. A member of the cultural elite, Hamao was joined by the well-known art critic and historian Okakura Kakuzō in seeking to link the pre-Meiji past with the modern national-cultural identity.

In his speech, Hamao made emphatic mention of the "pains" (*kushin*) Conder had gone through in order to make a building appropriate to the site—Japan in general and Ueno Park in particular. He lauded Conder for forgoing the design of a "typical Western building" (*junjō naru seiyō no tatemono*) and attempting one in Western style mediated by "Eastern taste" (*Tōyō shumi*). Hamao praised the suitability of Conder's design to its function as a museum and to the surrounding topography, in contrast to the recently executed Hyōkeikan (examined in detail in chapter 6), completed in 1909 and standing adjacent to Conder's building. The Hyōkeikan, according to Hamao, in its "pure Western style of white masonry" (*shiroki ishizō no jun seiyō no sutairu*) not only failed to harmonize with the style and material of the older building but made no attempt to address its specific purpose and location. Hamao, like Conder, believed in the importance of showing some tangible sign of alterity from Western forms in the museum

design and the need to associate the architectural style with the collection of Japanese objects inside. Hamao appeared satisfied with the insertion of Saracenic elements to signal a generalized Eastern identity, and this perhaps reflects the intellectual trend at the time that asserted Japan to be not only a strong, independent nation but the leader of the greater geocultural region of the East.[96]

Conder undertook the task of expressing Japan's national character in the Museum, and in that respect, he did not succeed in what he set out to do, for his design encompassed a much wider region—the East or the Orient as an elastic, relative construct of the West's opposite. While the Japanese administration approved of the executed design, the ambiguity of expression was undeniable, to the extent that Conder himself openly doubted whether anyone other than himself found it legible. As a style in the mid- to late-nineteenth century, the Saracenic represented something distinctly separate from the Greco-Roman tradition, although Conder's peers building in British India had manipulated it as a non-European style under European control. In choosing to participate in the use of this established style, Conder forfeited a major opportunity to innovate by incorporating his unique, firsthand knowledge of Japanese architecture, structural and ornamental, as the means of signifying difference from the West.

LEGACY

In 1893, the World's Congress of Architects invited Conder to give a paper on the architecture of Japan. Speaking as an authority on—rather than a representative of—this nation, he said the following about the difficult search for a modern national style:

> The desire to perpetuate national characteristics of style in modern works is a most laudable one; it is one which has been pursued with some success in India; and is one which must inspire every art-architect on commencing work in a strange country. It is therefore a pity to see the failure of attempts in this direction unfairly ascribed to fickleness on the part of the employers, as was done in the English periodical, the *Builder*, of April 15, 1893. To design a civil building in masonry having all the characteristics of the classical styles of Europe, and to crown it with fantastic lanterns, roofs and turrets of timber in imitation of portions of Japanese religious constructions, is not adapting the national style to modern purposes—it is to create a bizarre and hybrid *ensemble* as revolting to Japanese taste and common sense as it is wanting in the permanent and fire-resisting qualities which are the first conditions of the programme imposed.[97]

The so-called failed design discussed in *The Builder* was the proposal by Ende and Böckmann for the Law Courts in Tokyo.[98] Conder dispensed this thinly veiled invective

against the German firm, no doubt out of a mixture of personal frustration and professional conviction, for he had vied unsuccessfully with Ende and Böckmann for the gargantuan commission, a suite of bureaucratic offices just south of the Imperial Palace in Tokyo. The other two architects had offered several designs that vigorously incorporated "fantastic lanterns, roofs, and turrets" as allusions to Japan's architectural lineage (see fig. 2.13). The fantastic elements in question, such as the bow-shaped gable (*karahafu*) and plover gable (*chidorihafu*), were recognized forms from Japanese religious architecture (albeit stripped of any historical specificity) and arguably were more legible as symbols for Japan than the Islamic arches and domes Conder implemented in his own museum design.[99] Evidently, the English architect had definite ideas as to what *not* to do for Japan's public architecture but provided little direction on what to do. His own students, the first generation of Japanese architects who became the leading state architects responsible for the countenance of modern Japanese architecture, had no strong stylistic legacy to follow, and each went in his own direction for the answer.[100]

From 1886 to 1889, less than a decade after the completion of the Ueno museum, the institution was reorganized as the Imperial Museum (Teikoku Hakubutsukan), and Conder's building was criticized for several deficiencies specific to exhibition, namely, inadequate natural lighting, insufficient display space in the individual rooms, and ambiguous spatial differentiation among the various departments.[101] The South Kensington model as a whole was deemed passé in the eyes of the new Imperial Museum administration,[102] which also decried the commingling of art, industry, and science under one roof.[103] The two museum structures sited in Kyoto and Nara, commissioned as part of the reorganization, now catered exclusively to art and history. Stylistically and organizationally, the new buildings designed by Katayama Tōkuma, one of Conder's students, did little to acknowledge their predecessor. Rather than make use of the Victorian Gothic style that he learned under Conder, Katayama turned to Classicism, the shared language of "cosmopolitan modernity" among world powers and aspirants to that status at the end of the nineteenth century.[104]

After its debut at the Museum, the Saracenic style was not explicitly used for a project of equal national stature, not even by Conder.[105] The Kaitakushi Sale and Reception Hall (1881) and the Rokumeikan reception hall (1883), designed and constructed at roughly the same time as the Museum, used Islamic and Venetian Gothic detailing, although no extant record suggests that the architect considered them specifically "Saracenic." Two later buildings by other architects displayed floriated windows similar to those of the Museum: a building for the Third National Industrial Exhibition in 1890 (fig. 2.21), which at one point stood adjacent to the Museum, and the Prefectural Exhibition Hall for Nara Products (1900–1902) (fig. 2.22), located east of the Nara Imperial Museum.

2.21 Takayama Kōjirō, Sankōkan (demolished), Third National Industrial Exhibition, Tokyo, 1890, detail of windows. Courtesy of the Architectural History Laboratory, Architecture Department, University of Tokyo.

2.22 Sekino Tadashi, Prefectural Exhibition Hall for Nara Products (now Research Center for Buddhist Art), Nara, 1900–1902, detail of windows. Photograph by the author.

Nonetheless, the Ueno museum undeniably established the precedent of monumentality—of scale and of style—as national architecture and as museum architecture. As the first project designed by Conder, the single most influential practitioner and instructor of architecture in Meiji Japan, it served as the archetype for institutional building for the new era and exerted considerable influence on the developing public face of the government. Every major museum after Conder's was placed within a wide park space, where it served as the prominent endpoint of a main axis. Other sustained features include perfect symmetry and simple massing. Most significantly, the idea of expressing the nation's identity through ornamental forms and fragments continued to influence public projects. Even after the toppling of masonry structures in the strong earthquakes of 1891 and 1923, the tendency was to follow Conder's example of asserting meaning through facade treatment without altering the overall formal and structural integrity conferred by European building technology. Likewise, in the next three projects to be examined in this book, the architectural gesticulation of national difference and national identity would for the most part operate at the surface and ornamental level, not the structural or programmatic ones.

3 · The Age of the Imperial Museum

Everyone knows that each of the countries of the world which maintains its honor has its own
special style. The style of course exists spontaneously, but it is an indisputable fact that all
the people will put great effort into cultivating and preserving it. . . . I think the basis for
Japanese education, or the element of education necessary for being Japanese, lies in the
preservation of the spirit peculiar to Japanese from ancient times. . . . The more one is
acquainted with the customs, civilization, and political systems of foreign countries, the more
one feels the need [for knowing the Japanese spirit].

—Sugiura Jūgō (1887)

In 1881, before the completion of Conder's museum building, the government trans-
ferred responsibility for administering the Museum from the Home Ministry to the
newly created Agriculture and Commerce Ministry (Nōshōmushō).[1] The change was
nominal, for the Museum upheld the same primary agendas: education of the public in
the natural sciences and promotion of industrial and craft production. From July 1881
to March 1882, the collection made the move from the Uchiyama Shitachō site to the
new main building and two auxiliary buildings adjacent to it (one of them being the
Art Gallery from the 1877 National Industrial Exhibition).[2] The collection was reorga-
nized into the following six departments: natural products, agriculture, horticulture,
industry, arts, and history. During the approximately five years that the Agriculture and
Commerce Ministry administered the Museum, the natural products and industry col-
lections dominated the museum's holdings; the arts collection was the only one of the six
that recorded a decrease in holdings during this time.[3] When the government reorganized
the Museum once again in 1886, this time transferring it to the Imperial Household Min-
istry, the strong focus on science and industry did not carry over.

In December 1885, in anticipation of the promulgation of a constitution, a German-
inspired executive cabinet replaced the Grand Council of State in the central govern-
ment, and this change led to a restructuring of the ministries and their responsibilities.
As a result, the Agriculture and Commerce Ministry relinquished its jurisdiction over
the Museum—but not over the Exhibition Bureau—to the Imperial Household Min-
istry. The latter ministry, created in 1869, was reorganized in 1886 for the purpose of

handling all state matters of the imperial house. It was designated as the only ministry outside of the new cabinet and its authority so as to enforce a clear separation between state politics and the imperial court.[4] Although actual political power resided in the ministries and the cabinet, the highest veneration was reserved for the emperor as the locus of national pride and lineage. In 1889, the Constitution of the Great Empire of Japan, or Meiji Constitution, proclaimed the exalted status of the emperor to be law by pronouncing him "sacred and inviolable"; he and his family would be above the constitution, for they were to observe a different set of rules, the Imperial House Law.[5] Their contribution to the state was nonetheless invaluable. The intellectual Fukuzawa Yukichi in 1882 portrayed the imperial household as an entity that "brings sincerity to the moral education of the entire nation, sets the example of honoring letters and esteeming scholars, makes Japanese learning independent, *rescues the arts from their abandonment*, and promotes the prosperity of civilization"[6] (emphasis mine).

While no records remain to clarify the official motive for establishing a link between the imperial household and the existing museum, the upshot was evident: the new ministerial association with a majestic institution "unbroken for ages eternal," rather than with farm and industrial products, commanded unprecedented cultural authority and refinement.[7] The administrators of the museum, now a group distinct from the antecedent regime, took immediate steps in preparation for the reorganization. The Fine Arts Commission (Bijutsu Torishirabe) and the Temporary National Treasures Investigation Bureau (Rinji Zenkoku Hōmotsu Torishirabekyoku) were most instrumental; the fruits of their investigations, conducted both at home and abroad, launched the Museum on a new trajectory.

ART IN THE NATIONAL FOREFRONT

The Museum's separation from the Agriculture and Commerce Ministry, its Exhibition Bureau, and their scientific and industrial bent appeared to spell a clear separation from the pragmatic virtues of Europeanization advocated by members of the Iwakura mission a decade ago. This separation was registered most conspicuously in the changed name. In 1889, three years after its transfer to the Imperial Household Ministry, the museum in Ueno received a new name: the Imperial Museum, or Teikoku Hakubutsukan. It also acquired two satellite institutions: the Imperial Nara Museum, or Teikoku Nara Hakubutsukan, and the Imperial Kyoto Museum, or Teikoku Kyōto Hakubutsukan.[8] Referring to the emperor rather than the empire (which would come later), the prefix "imperial" (*teikoku*) affixed to the names of a vast array of institutions, both government-run and private-run, during this time signaled a new collectivity under the emperor and the new constitution. The museums, by bringing focus to the former

capitals, conspicuously confirmed a new interest in linking this institution to imperial culture, specifically the aesthetic culture fostered under imperial patronage before Westernization.

A political justification is commonly cited for the rise of nativist sentiment and the general turn away from Western influence in mid-Meiji. Historians pinpoint the year 1889 as pivotal. Japan had entered its imperial age, its beginning marked by the promulgation of the Meiji Constitution (and its end by the collapse of its authority in 1945). The Meiji Constitution activated a modern emperor system that proffered the emperor as a political and cultural anchor for the sake of instituting political and social order as well as generating a sense of unity among the citizenry.[9] During this time, "the outburst of nation-mindedness included explorations of national character, reassertions of indigenous ways, and projections of Japan into the world order as the nineteenth-century West defined it."[10] The focus of the moment was on what made Japan uniquely Japanese, no longer on what it needed to learn from abroad.

The creation of the Imperial Museums appears to fit neatly within the burst of nationalism that occurred at the dawn of Japan's constitutional monarchy. The advent of this museological institution has been recorded in its official history and confirmed by art historians and museum scholars as the beginning of the age of cultural administration at the site of the nation's museum.[11] The transition is identified as a clear shift of focus from science and industry to fine art and culture, or from the practical to the aesthetic. This shift supports the general historiographical division of Meiji-period culture into two chronological halves, with the earlier two decades characterized by the emulation of foreign ideas, techniques, and institutions and the latter two decades marked by the return to indigenous roots.[12] This familiar generalization posits the assertion of Japanese identity through the (rash) embrace of wholesale change in the first half, as opposed to the (perspicacious) reconnection with long-established traditions in the second half—an all-too-neat division that this volume proposes to challenge.[13]

Acknowledging the unprecedented emphasis on art—and, specifically, pre-Meiji art—is indeed crucial to understanding the thrust behind the reorganization of the nation's museum into the Imperial Museums, but to see this as a radical departure or a conscious rejection of the foregoing museum and exhibition policies would be misinterpreting a tactical shift for an about-face in mission. Under the Imperial Household Ministry, the museum took new form by implementing change *and* maintaining continuity. This holds true for the administration as well as the configuration. The period from 1886 to 1889 constituted a watershed moment for not only the nation's museum but its traditional art. The transfer of the Museum to the Imperial Household Ministry in March 1886 launched the flurry of art-related activities that reached fruition in the year 1889: the establishment of the Imperial Museums, the opening of the Tokyo School of Fine Arts (Tōkyō Bijutsu Gakkō), and the publication of the scholarly art journal

Kokka (国華) (literally, "national glory" or "national flower" and, significantly, a homophone for *kokka* [国家], or "nation"). As this new, totalizing schema for art administration (preserving, producing, publishing) was being instituted, the museum maintained its involvement with international and domestic exhibitions and the political and economic interests of the state. In this moment, art—physically old as objects, conceptually undeveloped as a national collection—garnered unprecedented visibility as a vehicle for nation building.

THE ADMINISTRATORS: KUKI, YAMATAKA, FENOLLOSA, AND OKAKURA

The age of the Imperial Museum has to a large extent been written as synonymous with the achievements of the cultural administrators Kuki Ryūichi (1852–1931), Yamataka Nobutsura (1842–1907), Ernest Fenollosa (1853–1908), and Okakura Kakuzō (also known as Okakura Tenshin) (1862–1913). In striking contrast, Sano Tsunetami, Gottfried Wagener, and Machida Hisanari, despite their pioneering status, have received comparatively less scholarly attention for being the visionary figures who first launched the Meiji museum movement. The difference lies in the portrayal of Kuki and his group as more than agents of state interest. Instead, they have been glorified as revolutionaries whose prescience and determination rescued traditional Japanese culture and aesthetics from the oblivion brought about by two decades of frenetic emulation of Western ways. Fenollosa and Okakura were largely responsible for creating heroic images of themselves as champions of traditional Japanese art. Not only were they charismatic figures who were highly respected during the peak of their careers, their appealing styles endured through their authoritative writings about art as a cultural-national imperative. Later scholars who took them at their word perpetuated the heroism, apotheosizing them to varying degrees as reformers, saviors, even prophets of Japanese art.[14] Autobiographic and hagiographic exaggerations aside, one of their great contributions, the orchestration of a comprehensive national system linking the enterprises of preservation, presentation, and production of art, deserves recognition. However, rather than swimming against the pro-Westernization tide, their involvement and interest in culture and the fine arts were more rooted in, and connected to, the museum and exhibition activities of the 1870s and 1880s than both they and existing scholarship have conceded.

The professional credentials of Kuki, Yamataka, Fenollosa, and Okakura prior to 1886 suggested little of the path they would take with the Imperial Museums. The only common factor in their backgrounds was some form of training in a specialized Western discipline; they did not share either an expert knowledge of art or a deep devotion to pre-Meiji culture.

Kuki, who became the director general of the Imperial Museums in 1889, had been with the Education Ministry since its establishment in 1871, after training under the "civilization and enlightenment" advocate Fukuzawa Yukichi at Keio University. He was one of the top officials in charge when this ministry lost its battle with the Home Ministry over the Ueno museum site in 1876 (see chapter 2). Kuki was dispatched as a government representative to the 1878 Exposition Universelle in Paris and instructed to travel around Europe after the event, studying the educational facilities of each country. During the four years prior to his appointment as director general of the Imperial Museums, he served as an ambassador extraordinary and plenipotentiary (*tokumei zenken taishi*) to Washington, D.C.

Similarly, Yamataka Nobutsura had received a progressive Western-style education, at the Higher Engineering Training School in Yokosuka, modeled after the École Polytechnique of France. His early career, first as acting director of the Imperial Museum in Tokyo and later director of the Imperial Kyoto Museum, began with an extended research visit to France. Later, he entered the Home Ministry, serving in the departments promoting industry and agriculture. Concurrently, he was an official in the commissions overseeing Japan's participation in the 1876 Centennial Exhibition in Philadelphia as well as the first two National Industrial Exhibitions in Ueno in 1877 and 1881.[15] Like the earlier generation of museum administrators, which included Sano Tsunetami and Machida Hisanari, Kuki and Yamataka had consistently worked for the central government, had traveled and conducted research abroad, and had been directly involved in overseeing activities at international and domestic expositions. Because of their work with the exhibitions, Kuki and Yamataka also had been involved with the art organization Ryūchikai (literally, "Dragon Pond Society"), precursor to today's Japan Art Association, since its founding in 1879; the association's membership comprised government bureaucrats interested in the study of traditional art for the promotion of contemporary art production.[16] Counter to Fenollosa's suggestion that he and Okakura opened Japanese eyes to the importance of old temple treasures, active interest in pre-Meiji art was by no means a new or radical turn for the central government in the mid-Meiji period. Officially sponsored investigations of art holdings in temples and shrines had begun almost immediately after the Meiji Restoration; in fact, Machida Hisanari, at the time with the Museum Bureau, led a survey to Kyoto and Nara as early as 1872.

The scholar Murakata Akiko has credited Okakura and Fenollosa specifically as the masterminds behind the linked museum-school enterprise for the arts in the late Meiji period.[17] In their cases as well, personal interest rather than professional experience in dealing with the arts led to their involvement in this visionary project. In fact, they would become pioneers in the professionalization of the discipline of art history in Japan by setting precedents for the administration, connoisseurship, and historical

study of art. Much has been written on the lives and work of Fenollosa and Okakura, and only some of the relevant details are necessary here.

Okakura was the linchpin that secured the connection between the Japanese official Kuki and the American professor Fenollosa. Okakura had studied under Fenollosa at Tokyo University (renamed the Imperial University in 1886 and then Tokyo Imperial University in 1887). After graduating with a degree in philosophy and English literature in 1880, he began to work under Kuki at the Education Ministry, first in the department of music and later in the department of art. More than his aesthetic sensibilities, his proficiency in English was his main asset at this early point in his career. His ability to expertly mediate between the English-speaking and Japanese-speaking worlds made possible his career-long role as a popular and respected spokesperson for Japanese art.[18] Even after being edged out of his governmental positions at the museum and the art school in Japan, he was able to apply his expertise abroad by curating the Asian collection at the Museum of Fine Arts, Boston, from 1904 until his death in 1913.[19] His influential books *The Ideals of the East* (1903) and *The Book of Tea* (1906) were written in English and were not translated into his native language until decades later.[20]

Fenollosa had embarked upon an undefined career path as a young man in Boston. While he was pursuing undergraduate studies at Harvard University, his interests gravitated toward philosophy, poetry, and music. He graduated in 1874 and ambled from studying philosophy at the Unitarian Divinity School to studying painting at the Museum of Fine Arts in Boston, until an unexpected employment opportunity presented itself in 1877. At the recommendation of Edward Morse (1838–1925), a Harvard-trained zoologist whose expertise in the natural sciences had recently won the confidence of Japanese education authorities, Fenollosa traveled to Japan to teach political science and philosophy at the nascent Tokyo University in 1878.[21] Unlike Josiah Conder, Fenollosa had no particular interest, cultural or otherwise, in Japan before his employment with the Japanese government. (His biographer cites the generous salary of the teaching position and the sudden death of his father as the two main reasons behind his decision to accept a job in a place as distant and unfamiliar as Japan.)[22] His reaction to the Japanese display at the Centennial Exhibition in Philadelphia just two years earlier, in 1876, betrayed casual and uncritical concern, bearing no hint of the discerning connoisseur of traditional Japanese art that he would later become. In the diary he kept during his visit to the exhibition, he recorded but one line on the Japanese display, in the entry for Friday, 29 September: "The Japanese exhibit is a mine of wonders. Bronzes of most exquisite workmanship and immense size, in the shape of animals, men, dragons, temples, vases, etc. In the Chinese the ceramics were almost/equally wonderful, and the wood carvings were stupendous, carvings in three dimensions, one carved bedstead being worth 1700."[23] Later, as an Asian art expert, Fenollosa had no such positive com-

ments for export ware, which he identified as evidence of the ruin of Japanese and Chinese work. Although he had briefly taken courses at the School of Drawing and Painting at the Museum of Fine Arts, just as Okakura had taken lessons in literati painting, neither he nor Okakura became professional or dedicated practitioners of art; their real interests lay in connoisseurship and administration. Victoria Weston has aptly dubbed them "full-time promoters" of art, a new breed born of the Meiji period.[24]

MUSEUM CONCEPT

With no experience in the history or connoisseurship of Japanese art, Fenollosa and Okakura learned on their own initiative and later while serving on the special government commissions, accumulating knowledge from the patchwork of leading artists and experts they enlisted or visited throughout Japan, Europe, and the United States. Beginning in the early 1880s, Fenollosa and fellow Bostonians Edward Morse and William S. Bigelow (1850–1926) went on acquisition sprees throughout the Kyoto and Nara regions—with Okakura in tow as interpreter—in search of art and antiquities. Fenollosa and Okakura were also members of the Ryūchikai, but in 1884, they seceded to form the Kangakai (Painting Appreciation Society), in pursuit of their own ideas of art preservation and promotion (a primary agenda being the close mentoring of contemporary artists in the production of a unique national art). These ideas took concrete form in their proposals for organizing the Imperial Museums and the Tokyo School of Fine Arts, for which they had, in the words of Fenollosa, formulated a "total system of government administration of fine arts . . . all working together harmoniously in pursuance of a single organic plan and under . . . a single management."[25]

Fenollosa's vision for the Imperial Museums is extant in a handwritten outline; it closely mirrors Kuki's initial draft and the eventual bylaws for this institution.[26] Fenollosa's informal writing reveals what the terse language of Kuki's official submittals do not—the circumstances, motivations, and aspirations driving the direction of the museums. Fenollosa proposed an imperial fine arts museum, which he named the "Imperial Tokio Art Museum," distinct from the existing Ueno Park museum, which would focus exclusively on "true art history, criticism, [and] classification." Fenollosa cites four main reasons for establishing the art museum: (1) loss of art treasures to their owners' mismanagement and hardship, (2) difficulty of performing comprehensive study of these treasures, (3) foreign interest in them, and (4) Japanese interest in them. He believed the central government was responsible for assuaging these conditions and desires by managing the preservation and study of art. Fenollosa outlined the primary functions of the museum as "exploration and collection," "presentation and exhibition," and "compilation and publication." Under the first function, he urges regular examinations of public and private collections (especially those in temples) and provides strate-

gies for taking, purchasing, or copying the works. More disquieting than the suggestion of absolute governmental authority over important treasures is his proposal to expand the exploration to neighboring countries: "Eventually Japan ought to do this for China, Corea, Mongolia, etc as German and French museums are doing for Greece and Egypt." Under the second function, Fenollosa advises proper cataloging and classification, and the presentation of an ordered, comprehensible display to the public. A short exhortation in parentheses calls for "specimens" to be exhibited in rooms "decorated in the style of their period" so as to show "as many concrete relations as possible" between the object and its original surrounding. (Chapters 4 and 5 investigate the extent to which this dictum influenced the museum designs in Kyoto and Nara.) Under the third function, Fenollosa devises a combination of art historical study and diplomacy; the fruits of research and writing on objects in the museum should be compiled in publications to be used as information exchange and advertisement with foreign museums. He also emphasizes the importance of eliciting the participation of art school students and faculty in these efforts.

The blueprint for the Imperial Museums, in the form of Fenollosa's proposal and Kuki's similarly structured official submissions, cast all art holdings in Japan, whether public or private, as a collective, as *Japanese* art. Subsequently, under such classification, the administration of this art would become the responsibility and prerogative of the nation.

PREPARATION AND CONFIGURATION

Since Fenollosa, Kuki, Okakura, and Yamataka, the leaders of the Imperial Museums, did not come from the preceding museum administration, they were essentially inventing their new roles while drafting the institution's bylaws. Two special commissions, the Fine Arts Commission and the Temporary National Treasures Investigation Bureau, performed the majority of the preparatory work. The Education Ministry created the Fine Arts Commission to devise plans and policies on the fine arts. From 1886 to 1887, the commission, headed by the education official Hamao Arata and with Fenollosa and Okakura as members, carried out a twelve-month research tour of the art schools and museums of Europe and the United States.[27] Pertinent to the future Imperial Museums were the specific investigations of the administration, exhibition, preservation, and architecture of the art museums. The Imperial Household Ministry played a secondary role in sponsoring the Fine Arts Commission, since the museum was but one piece of the greater artistic whole that the commission had studied abroad; the other areas of interest were art schools, artist associations, art exhibitions, art production and reproduction, and art history.

In addition to studying foreign models, the same group of men began to explore

domestic treasures in September 1888 when the Temporary National Treasures Investigation Bureau was established under the Imperial Household Ministry. Headed by Kuki, the bureau carried out surveys nationwide in order to register and evaluate the material holdings of temples and shrines. The investigations continued for almost a decade, from May 1888 to October 1897,[28] and committee members were top officials drawn from the various ministries and institutions of the central government. On the whole, this project was not the single-handed endeavor of the Imperial Household Ministry but was made possible by the alliance of this ministry with the Education and Home Ministries. The lengthy survey formed the basis for the classification and preservation policy for national artistic treasures, enacted by law in 1897, and for the collecting guidelines at the Imperial Museums in Kyoto and Nara.[29]

Rather than cater to the concerns and interests of the imperial household or the ministry, the Imperial Museums continued to serve pragmatic pursuits and general state interests as had the preceding museum regimes. One major reason was the person heading the Imperial Household Ministry at this time: Itō Hirobumi. Itō had headed the Home Ministry when it administered the Museum less than a decade before. From 1885 to 1887, he held a power monopoly as both the imperial household minister and the nation's first prime minister, and he continued to see the stimulation of industries within Japan to be of greater importance to the nation than the establishment of a museum of art.[30] Fenollosa himself, while working under Itō's instructions, conceded that "the whole question of art schools, museums, and buildings [was] only a preliminary to the great future economic desideratum."[31]

The most immediate consequence of the surveys was the decision to establish two satellite museums, in Kyoto and Nara. The two cities, both former imperial capitals of Japan,[32] contained the greatest concentrations of temples and shrines in the nation and, not surprisingly, were home to the largest number of objects of historical and artistic import. The Imperial Kyoto Museum and the Imperial Nara Museum were to act as repositories for local temple and shrine treasures that were in danger of damage and dispersal. In return for surrendering their objects to the museums, the original host institutions received government subsidies and a percentage of museum ticket proceeds. (The procedure, meaning, and ramification of placing religious property in the custody of the Imperial Museums, and, in effect, in the custody of the state, is discussed in greater detail in chapter 5.) The promptness with which museum administrators and treasure surveyors acted is significant. Less than one year into the survey work, they laid down the plan to use the Imperial Museums as centralized, regulatory places for objects, both secular and religious, that were representative of the nation.[33]

The original draft proposal (dated 27 March 1889) and the formal charter of regulations (dated 16 May 1890) for the Imperial Museums announced their joint mission to

be "the advancement and promotion of the knowledge of history and art." In addition to the organization and maintenance of object collections, other important pursuits included continuation of research conducted at home and abroad, publication of findings on existing collections and from research expeditions, and education of art and technical school students. Past, present, and future are linked in the configuration of each museum. The Imperial Museum in Tokyo was restructured into five new departments: history (*rekishi*), fine art (*bijutsu*), art industry (*bijutsu kōgei*), industry (*kōgei*), and natural products (*tensan*).[34] The Imperial Kyoto Museum had four departments (history, fine art, art industry, and industry), and the Imperial Nara Museum had three (history, fine art, and art industry). Clearly, the main concern was not preservation alone but also the satisfaction of current needs and the promotion of future growth. By phasing out the natural sciences (which had no place at all in the Kyoto and Nara museums), the primary narrative at the Imperial Museums became the emphasis on art as the link between old and new Japan.

As discussed in chapter 1, during the nascent stage of establishing a national museum in Japan in the 1870s, the effort to classify, catalog, and exhibit the country's riches, both natural and man-made, for preservational and educational purposes, dominated the concept of the museum. The administrators of the Imperial Museums from 1886 to 1889 added a new dimension to the task—by registering the past as the basis for molding national identity. Yet as much as the new emphasis was on the ideological construction of nation and shared cultural experience, the original emphasis on art and production, competition and internationalism remained integral to the museum enterprise. The Imperial Museums continued to work in concert with Japan's participation in international expositions by providing objects, models, and written catalogs for Japanese national displays.[35] The same administrators—Hamao, Okakura, and Fenollosa—founded the Tokyo School of Fine Arts in 1887 to promote a new art that incorporated traditional and Western methods of painting and sculpture.[36] Okakura, who acted simultaneously as the director of the Tokyo School of Fine Arts and the head of the Fine Art Department at the Imperial Museum, both located in Ueno Park, sustained a close tie between the two institutions. The museum provided historical models of unprecedented breadth and variety for the art students, making it an essential resource for the new *bijutsu gakkō* (public art school) education in contrast to the traditional *juku* (private atelier) education.[37] In turn, museums and expositions benefited from these students, who made copies of masterpieces for display at both venues.[38] The age of the Imperial Museum was therefore not simply a time of self-rediscovery or, in more biased language, the "re-nationalizing of Japanese art in opposition to that pseudo-Europeanizing tendency so fashionable [at the time] throughout the East."[39] The new administrators were savvy students of Western training, not reactionaries. Their desire for creating

a national art assumed the significance of Western approval and appreciation, and the same concerns over Japan's national standing in the modern international arena persisted. The visible difference was the new focus on old, traditional objects to represent the spirit of the nation. In the words of the art historian Christine Guth: "Although Japan's cultural nationalism included efforts to protect its artistic heritage, its primary thrust was not retrospective but rather animated by the belief that traditional arts could serve as agents of modernity."[40]

4 · The Imperial Kyoto Museum

Locating the Past within the Present

The experience of a nation suddenly emerging from the isolation of centuries into the noon-
day glare of the nineteenth century undoubtedly presents picturesque features. To a people
so situated, however, ambitious and self-respecting, not ashamed of their ancient civilization,
but eager to secure the benefits of modern progress, and above all, determined to maintain
their national prestige, the situation is one of stern reality. They cannot live in the past, and
if they have a high ideal, they must perform in decades what it has taken other nations
centuries to accomplish.

—Tateno Gōzō (1893)

In 1895, Kyoto experienced three great events celebrating the long historical and artis-
tic lineage that had come to distinguish this city from all other major cities of Japan.
From April to July, the city hosted the Fourth National Industrial Exhibition (fig. 4.1),
in October, construction for the Imperial Kyoto Museum (fig. 4.2) was completed, and
from October to November, it celebrated the 1100th anniversary of its founding by
Emperor Kanmu (737–806). Each event was unprecedented in scale and scope, and the
three together presented an extraordinary opportunity to reaffirm Kyoto's prominent
position in the nation. The planners went to great pains to align the three events seam-
lessly within the span of a single year, and this string of well-publicized celebrations
sharpened the visibility of Kyoto vis-à-vis Tokyo as a modern metropolitan center for
the arts.[1] The significance, however, went beyond the announcement of local distinc-
tion and achievements; the occasions served as purposeful rehearsals for the national
role to which Kyoto aspired, that of custodian and promoter of the Japanese cultural
legacy.

In 1868, by imperial edict, the city of Edo was renamed Tokyo. The edict not only
created a new capital on the eastern coast of Japan but, more important, appointed it
the site of the nation's new governmental center. As a result, Kyoto became the capital
to the west of Tokyo rather than the absolute point of reference its name proclaimed,
as *kyōto* literally means "imperial capital." The new name and political power given to
Edo compromised the Kyoto's symbolic significance as the imperial center of Japan, as

4.1 *Famous Places of Kyoto: The Fourth National Industrial Exhibition
and the Daigokuden of the Heian Shrine*, 1895. Woodblock print.

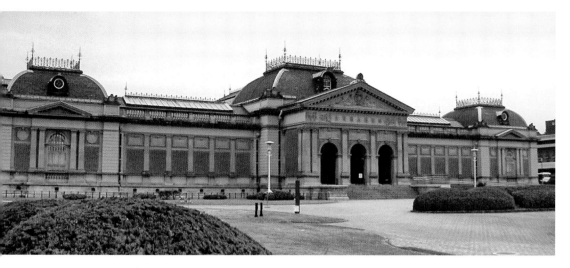

4.2 Katayama Tōkuma, Imperial Kyoto Museum (now Kyoto National Museum),
Kyoto, 1892–95. Important Cultural Property. Photograph by the author.

did the physical departure of the emperor, one year later, to reside permanently in Tokyo. In the next two years, the majority of the Kyoto nobility followed him. Consequently, the imperial capital commenced the Meiji period as an empty signifier.

The leaders of the new central government did not intend to diminish Kyoto's historical and symbolic significance.[2] Although there was no immediate consensus after the Meiji Restoration as to the proper role for Kyoto in relation to Tokyo and the new political regime, by 1889, both cities acquired more definitive assignments. In January of that year, the emperor's move into the newly completed Imperial Palace designed by the master carpenter Kigo Kiyoyoshi secured Tokyo's position as a political *and* imperial center. In the following month, the Imperial House Law upheld the continued importance of Kyoto by mandating that all future enactments of the two major rites of imperial accession—the *sokui* and the *daijōsai*—take place in this historic capital.[3] The preamble to the Meiji Constitution, promulgated in the same year, clearly enunciates the symbolic order being constructed.[4] Although Japan prided itself on being the first nation outside of the West and its colonies to draft a constitution, this document began with a reference to the mythical origin of the emperor as the descendant of the Sun Goddess Amaterasu. The new Japan was being defined as much by its myth-historic origins as by its modernizing objectives, and the two capitals were to be two faces of the same coin—Tokyo representing the secular, progressive countenance of Japan, and Kyoto representing its sacred, historical countenance. The creation of Japan's symbolic topography in the Meiji period, and specifically Kyoto as representative of Japan's historical past and Tokyo as representative of its progress, is a central argument in Takashi

Fujitani's *Splendid Monarchy*. Defined with more nuance, however, the symbolism of each city and the relationship between them may be seen as slightly more complex. Within Tokyo and Kyoto, the respective symbolic ideals of "progress" and "tradition" were also playing off against each other so that each city could fulfill the ideological role being assigned to it by the central government.

Kyoto was already home to a rich accumulation of imperial artifacts—palaces, mausoleums, temples, shrines, and the material holdings inside these structures—and the Meiji government highlighted this facet of the city by designating it a repository of the nation's cultural heritage. In accord with this ideology, the Imperial Household Ministry, three months after the promulgation of the Meiji Constitution, formally announced the government's intention to establish the Imperial Kyoto Museum and the Imperial Nara Museum. Unlike the Imperial Museum in Tokyo, the Imperial Museums in Kyoto and Nara were site-generated institutions. While the museum in Ueno Park served as a centralized place for objects from all geographical regions of Japan, the museums in Kyoto and Nara dealt chiefly with the historical and religious relics from their own host regions. Therefore, just as the establishment of the Imperial Kyoto Museum represented the state's endeavor to redefine the city in keeping with its new symbolic construct, the museum was equally defined by the city.

The Meiji administration appointed the architect Katayama Tōkuma to design the Imperial Museums in Kyoto and Nara at approximately the same time that it was revising its general position on the emulation of Western culture and values. Following the end of the so-called Rokumeikan era, a short period in the 1880s when cabinet ministers such as Inoue Kaoru exerted tremendous energy on Westernization without securing enough tangible advantages for Japanese at large, a new consciousness arose, on the specialist as well as the popular level, that indigenous arts and architecture should be set apart from imported Western models. In 1889, the year the constitution was promulgated and the Imperial Museums created, the Tokyo School of Fine Arts opened, the first government-sponsored institution established after the Meiji Restoration devoted to training in the traditional-style arts, to the deliberate exclusion of Western-style equivalents.[5] Also in 1889, the Architecture Department of Tokyo Imperial University first included courses on Japanese architecture in its curriculum.[6] At this historical juncture, unprecedented attention was being paid to the cultural distinction, in both art and architecture, between the indigenous and the foreign. In the nativizing climate of this time, the studied Western Neo-classicism of the Imperial Kyoto Museum must be recognized as a deliberate statement—the conceptual and architectural design of the Imperial Kyoto Museum was influenced equally by contemporary global standards of visual representation and by the position the city occupied in the symbolic topography of the Meiji period. The Kyoto museum was neither an unmediated reproduction of a Western institution nor a preservation scheme narrowly conceived to protect the

nation's "old wares." It was as representative of Japan's adaptation of a foreign culture as of the modern period's appropriation of Japan's past.

SITE

The Imperial Household Ministry considered three building sites for the Kyoto museum. The first option was inside the Imperial Garden, which surrounded the palace, and the second was within the grounds of Nijō Castle, the former residence of the Tokugawa shogun. The ministry managed both properties, which were of sufficient size to accommodate the anticipated scale of the new museum and a large volume of visitors.[7] The third and eventually successful option lacked the high prestige of the other sites. It was farther south, on Seventh Avenue (Shichijō), away from the city's historical-political center, and there was some initial uncertainty due to its proximity to a housing district for the poor (*hinmin sōkutsu*). In the end, the consensus was that the museum would provide a much-needed incentive to redevelop the overcrowded area.

Located in the Higashiyama, or Eastern Hills, district, the building site was surrounded by an assembly of renowned religious institutions. In the late sixteenth century, the site itself was a part of the large temple complex of Hōkōji, best known for its Great Buddha Hall (Daibustuden). Erected by the warlord Toyotomi Hideyoshi (1537–1598) to rival the eighth-century Great Buddha Hall of Tōdaiji in Nara, this great hall, which had housed a monumental sculpture of the Vairocana Buddha, and no longer extant during the Meiji period, would have stood to the north of the museum site.[8] The Toyokuni Shrine (also read as Hōkoku Shrine), Hideyoshi's mausoleum, would also have been to the north. To the east of the museum site was the Myōhōin, originally a religious retreat for the retired emperor-monk Goshirakawa (1127–1192) dating back to the late Heian period (1086–1185). To the south was the famous thirteenth-century Sanjūsangendō, a hall thirty-three bays long that houses 1,001 Kannon images. The former site of the Kyōmyōgū, a temporary Buddhist worship hall for the imperial household from 1870 to 1876, was to the west.[9]

When the Imperial Household Ministry selected this site in the fall of 1890, it controlled only the western half occupied by the Kyōmyōgū. The eastern half was privately owned and served as the residential quarter for the Myōhōin temple complex. The government purchased the eastern half and merged it with the western half to form a total area of 52,892 *tsubo* (approximately 43.13 acres). The museum's main entrance would face west toward the Kamo River and be reserved as the imperial entry. The Meiji public, in contrast, was to enter from the back, on the mountainous eastern side. Despite the proximity of the religious landmarks, the museum was designed to stand isolated, completely closed off by iron gates and fencing and buffered from the immediate neighborhood by landscaped grounds.

EXPECTATIONS

When Kuki Ryūichi, Ernest Fenollosa, and Okakura Kakuzō designed the master plan for the Imperial Museums, they regarded architecture as an integral part of the "rationally organized whole" that a museum should be. The Fine Arts Commission had investigated the two intersecting but separate areas of art museums and their architecture during its research trip to Europe and the United States. The commission's 1886–87 research mission and the resulting findings were documented in the notes and reports it submitted. Once again, Fenollosa's articulation of the agenda grants more access to the group's thought process than does the concise language of the official instructions.[10] Whereas the latter merely lists the subjects of inquiry, Fenollosa elaborates on the motivation and objective behind the commission's pursuit of each subject of investigation:

> The second important matter which it became [the Fine Arts Commission's] duty to consider was European Art Museums and their administration. Here again it was not with the intention of copying outright any such Western institution, building, organization, and arrangements, but of learning as much as possible what was vital and universal in these regards, for the purpose of realizing it later in a new form adapted to the peculiarities of Japanese needs. In other words the Japanese government wished to benefit by the experiments, failures, and successes of the West before facing its own special problem.
>
> The third important matter was connected with the question of a future possible use and development of Japanese architecture. It was true that the government had seemed to declare itself irrevocably in favor of foreign styles for public buildings but it was equally clear that the mass of the people who had any comprehension of the aesthetic in architecture at all, had nothing but words of condemnation for the new work. Moreover, there were several young Japanese architects, who had become proficient in both styles, and who distinctly asserted the possibility and desirability of utilizing the Western scientific knowledge in developing Eastern styles. In virtue of this possibility, the members of the Commission were expected to ascertain something of foreign professional opinion upon this subject and to render themselves capable, if called upon, of taking a rational attitude toward it in the future. That their views would have to be consulted in the question of new buildings for a future Fine Arts Museum, and for art schools, was not the least of the reasons for their making as close a study as circumstances permitted of the architecture problem.[11]

While Okakura kept a diary during this journey, his observations were slapdash and patchy, written half in English, half in Japanese, and supplemented with diagrams and doodles.[12] It was clearly meant to be no more than his private notes and not the basis for a lucid formal report. In contrast, Fenollosa's report, drafted after their return

to Japan in October 1887, conveys the group's findings with comparative clarity. It included the following twelve-point summary in regard to architecture:

1. That the earlier styles of architecture, Greek and Gothic, though beautiful, are unsuitable for modern life.

2. That the only style of architecture which Europe has developed in modern times is the Renaissance imitation of the classic, which is degenerate in form, incapable of further development and crushing originality.

3. That the distaste for these styles in recent years, has led to a new study of all the world's ancient styles, and many attempts to recombine their features.

4. That the greatest vanity of styles, and the greatest success in developing something new are to be found in America.

5. That the future of Western architecture will be determined by American experiments and tastes.

6. That by far the greatest variety of materials, decorative features and scientific applications is to be found today in America; and it is probable that these American architects are about to introduce Japanese style for wooden buildings.

7. That the great evil of European architectural practice is the separation of the two functions of "construction" and "decoration."

8. That all healthy and permanent development of painting, sculpture, and the fine art industries in every civilization of the world has been in the subserviency to architecture.

9. That the possibilities of decorative effect, and the use of fine art products therein, have hardly begun to be developed in modern European architecture.

10. That American architects are most eager to introduce Japanese products into their work, if they can rely on the fulfillment of their orders.

11. That brick and stone architecture is quite unadapted to damp warm climates, on account of the retention of moisture by its walls and of the relative smallness of its openings which do not admit enough light and air.

12. That brick and stone architecture cannot be built to withstand serious earthquakes, and the Italian Government has forbidden it in earthquake districts.[13]

The dominant idea running through the commission's aspirations and recommendations was that Japan should look to its own traditions and to the United States' innovations in developing its own architecture. (This is in remarkable contrast to Josiah Conder's opinion, expressed roughly a decade earlier, that modern Japanese architecture had nothing to learn from the United States and pre-Meiji Japan.)[14] While Fenollosa left the mechanics of the proposed union of Japanese and American architecture tantalizingly vague, the suggestion is not a surprise coming from an American most famous

for advocating a modern Japanese art that could command international attention without compromising its native ingenuity. Using both artistic and scientific arguments, Fenollosa challenged the use of European architecture in Japan: "There is great harm in introducing into Japan foreign architectural forms . . . since these are already in decay and chaos, and it is Japan's prerogative to show the way out by producing better."[15] Clearly, this American saw Japan's Imperial Museum as an institution that could and should transcend the cultural weight and specificity of Old Europe. As he articulated in the commission's agenda, the intent was not to copy any one Western institution but to learn from their collective successes and failures.

Fenollosa's summary for architecture included similarly strong proclamations. His condemnation of the Greek, Gothic, and Renaissance styles on the grounds of their unsuitability and degeneracy was highly inflammatory, but it was his objection to brick and stone architecture for its seismic liability that drew a swift rebuttal from an architect who thought otherwise. That architect was Josiah Conder. In a letter submitted to the editor of the *Japan Weekly Mail*, Conder warned against the "absurd" assertion made in a Japan Art Commission report that the Italian government "had forbidden the construction of solid buildings and decided in favour of wooden structures."[16] In addition to challenging the rationality of the claim that "a civilized European country possessing some of the most solid architectural monuments of antiquity had at length in this nineteenth century determined to resort to a ligneous style," Conder decisively quashed the idea by stating that he had found no mention whatsoever of the Italian government's decision to adopt wooden construction in the relevant reports and regulations issued by the Italian Earthquake Commission. Perhaps his expert rebuttal indeed won over Fenollosa, for the American changed his mind about masonry construction that very year, when he made an architectural proposal for the Imperial Nara Museum; he advised a building "made of the best brick" as the first condition of construction (see chapter 5 and the appendix).

This exchange between Fenollosa and Conder reveals once again the multiplicity of opinions and expertise that informed the designing of the Imperial Museums. No one person was able to dominate a project of this scale and significance. Divergent opinions and changing political and cultural sentiments forced a cautious approach to adapting Western standards. The tone of this debate over wood and stone in the late 1880s contrasts to that of ten years earlier when the Ueno museum was under construction. In the new cultural-political climate favoring the revitalization of traditional architecture and the arts, masonry provoked skepticism rather than admiration. Now the use of brick and stone for a project of high cultural significance required a vigorous expert defense.

The merits of masonry construction were put to a rigorous test when the Nōbi Earthquake struck in 1891. The quake affected the central region of Japan near Kyoto and Nara,

and according to various accounts from the scenes of disaster, buildings made of brick and stone appeared to be no less susceptible than traditional wooden architecture to the violent tremors and fires. The earthquake ignited a stream of conflicting reports on how well the buildings, both brick and wooden, withstood the catastrophe. The 7 November 1891 issue of the *Japan Weekly Mail* published as many as three reports by three different investigative eyewitnesses.[17] While one report claimed that "brick buildings and the old [wooden] structures stood the shock the poorest,"[18] another noted that the post office and cotton-spinning factory, two well-known brick buildings in the area, were reduced to "little more than a heap of ruins" whereas the Japanese houses nearby sustained little damage.[19] Taking more care and time in making his official assessment, Conder once again prepared a public defense of brick construction, this time in the form of an extensive report published in the *Seismological Journal of Japan*.[20] His main conclusion was that shoddy materials and sloppy workmanship, rather than the integrity of the material or method, were to blame for the greatest damages sustained. Notably, more than one published source in 1894 asserted that this earthquake prompted the architect of the Kyoto museum to drastically alter his design from a three-story building to a one-story building.[21] No material evidence of this three-story design exists today.

Had the architectural objectives Fenollosa outlined been followed, the Imperial Kyoto Museum would have been a revivalist project that made use of traditional Japanese architecture "in organic relation with" native-style painting and sculpture as the decorative program—the type of collaboration he and Okakura were promoting at the Tokyo School of Fine Arts. As a project, it might have been similar to the Japanese national pavilion, the Hōōden (figs. 4.3–4.5), constructed in Chicago for the World's Columbian Exposition of 1893, or the commemorative Heian Shrine (Heian Jingū) in Kyoto (fig. 4.6), also of the same decade. In his initial 1886 outline, which formed the basis of the Imperial Museums bylaws (discussed in chapter 3), Fenollosa had already advised creating exhibition rooms in the period style of the objects. The executed design of the Kyoto museum deviated from such purposeful revivals of historical Japanese architecture, most notably by being a Western-style design that assumed the traditionalist forms of Old Europe rather than of Old Japan. There were no attempts to harmonize stylistically or contextualize the objects with their surroundings. The museum also did not appear to acknowledge the innovative technological and stylistic potential that Fenollosa believed to be bubbling forth from the United States.

By the time the two new Imperial Museums were designed and built, Fenollosa was no longer acting as an expert consultant for the nation's fine arts master plan.[22] His close collaborator Okakura, however, continued to serve as the head of the committee on the construction of the Kyoto and Nara museums. Because Okakura was simultaneously teaching and handling curatorial duties in Tokyo, his involvement with the two

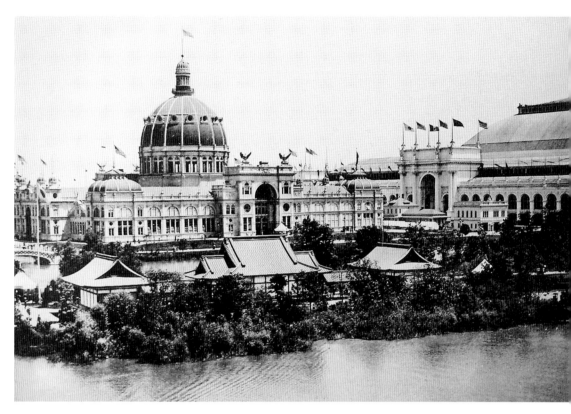

4.3 View of the Hōōden, the Japanese national pavilion (foreground), and the Government Building (background) at the World's Columbian Exposition, Chicago, 1893. *Official Views of the World's Columbian Exposition* (1893). Courtesy of the Library of Congress.

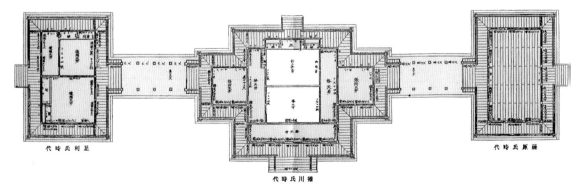

4.4 Kuru Masamichi, Hōōden (demolished), World's Columbian Exposition, Chicago, 1893, plan. *Kyōto Bijutsu Kyōkai zasshi* (November 1892).

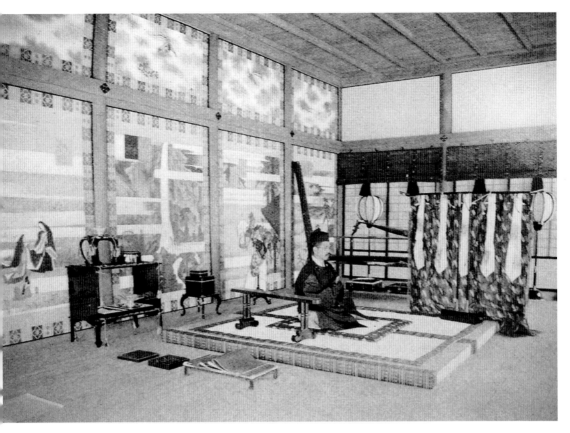

4.5 Kuru Masamichi, Hōōden, World's Columbian Exposition, Chicago, 1893,
view of Fujiwara wing. Courtesy of the Fine Arts Library, Harvard College Library.

4.6 Kigo Kiyoyoshi and Itō Chūta, Heian Shrine, Kyoto, 1893–95.
Photograph by the author.

satellite institutions likely was no more than nominal. Records show that he inspected the future site of the Kyoto museum with the architect Katayama in February 1892 in order to finalize authorization of construction. His seal of approval, along with that of the director general Kuki Ryūichi, is also visible on a set of three undated architectural drawings depicting a design comparatively more ornate and European than the realized scheme.[23] It is difficult to know whether Okakura had a hand in either version of the design. In two other instances of Okakura's participation in the design of Japanese art display (one immediately before and the other more than a decade after the design of the Kyoto museum), his preference was, in accord with Fenollosa's, to re-create an object's original architectural context.[24]

Fenollosa was not the only person who looked forward to a new style of architecture for the Imperial Kyoto Museum that would incorporate both new and old traditions. In 1898, one year after the museum's opening, a lengthy critique of the building written by Mamizu Hideo was published in the most prominent architectural journal of the day, Kenchiku zasshi.[25] The Kyoto museum project generated as much excitement in the architecture world as in the art world, and the same journal had been reporting on the building's construction progress for several years. Mamizu's essay, a rare example of critical professional evaluation for that time period, served as Kenchiku zasshi's final review of the long-anticipated finished product. Through the author's examination of the building's "style" (yōshiki), "design method" (shuhō), and "character" (shinjutsu), the essay expressed in lucid terms the concerns and expectations Katayama's professional peers attached to this project. Mamizu's points will be considered in the next section.

The Kyoto museum was a prominent project for many reasons, including Katayama's high standing in the profession and the patron's imperial affiliation and budgetary largesse. Beyond the prestige, the project was conspicuous for the innovations it would require. A museum of this scale was unprecedented in the city of Kyoto, just as its function was distinctively modern for its historically rich site.[26] Furthermore, the planned collection of historical, religious, and artistic treasures differed distinctively from the predominantly industrial and scientific one assembled previously for the Museum in Ueno Park. Additionally, the institution would be called upon to impress a large and diverse body of visitors, including the Japanese public, imperial personages, and international dignitaries. Given all of these factors, expectations ran high that this building would take museum design to a new level.

KATAYAMA TŌKUMA, IMPERIAL ARCHITECT

The three major Imperial Museum buildings in the Meiji period all fell under the charge of Katayama Tōkuma. He executed the Imperial Museums in Kyoto and Nara simultaneously in the 1890s and the Hyōkeikan art museum in Tokyo in the first decade of

the twentieth century. When he received the commission for Kyoto and Nara, he was at the midpoint of his career. Although these two projects preceded his masterpiece, the Palace for the Crown Prince (Tōgū Gosho) (1898–1908), better known as the Akasaka Detached Palace (Akasaka Rikyū), by more than a decade, he was already an established leader in the profession, as both a practitioner and an instructor. His family and professional roots set in motion his career-long standing as a government architect.[27]

Katayama was born in 1854 into a family of low-ranking samurai in Hagi, a castle town of the Chōshū domain. He grew up in the immediate aftermath of Commodore Matthew C. Perry's landing in Japan and was roughly one generation younger than the pro-imperial revolutionaries who orchestrated the Meiji Restoration. Katayama's Chōshū origin proved significant for his future as an architect to the nation. When he embarked upon his career, the highest stratum of the political bureaucracy was dominated by men from this domain, including fellow Hagi natives Itō Hirobumi, Kido Takayoshi, and Yamagata Aritomo. Through his older brother, Katayama also secured a personal connection to Yamagata,[28] who had steadily assumed key positions in the Meiji administration, including his successive roles as war minister, home minister, and prime minister. Unlike their elders, however, Katayama's generation ascended to top government positions through practical skills rather than military might.

At age nineteen, Katayama entered the "architecture program" (*zōkagaku*) being offered at the School of Technology (Kōgakuryō) in Tokyo, along with four other students, all from families formerly of warrior rank. The School of Technology became the Imperial College of Engineering in 1877, the year Josiah Conder arrived to join the faculty. Conder began teaching Katayama and his classmates during their fifth year in the college, when their training would be devoted to practical work for their final two years.[29] Therefore, from 1877 to 1879, Katayama and classmates of his graduating year participated in Conder's building projects, which consisted of the Museum in Ueno Park, the School for the Blind, and the Kaitakushi Sale and Reception Hall. Students accompanied Conder on visits to the sites and also learned by assisting with construction drawings.[30] Katayama's signature is not visible on drawings for these projects but appears on a sketch for a book shelf for Conder's office at the college.[31]

For graduation, Katayama submitted a design project and a written thesis.[32] Of the three possible design projects, he chose the school of art (fig. 4.7).[33] Just as Conder's winning Soane Medallion drawings strongly reflected the influence of his mentor Burges (see fig. 2.7), Katayama's graduation drawings closely followed Conder's preferred style. Conder had allowed his students freedom in selecting a style for the design, and of the four graduates that year, only Katayama emulated his mentor's quixotic handling of the Gothic idiom.[34] Katayama was the only student who took pains to include a variety of stained glass designs and a sculptural program, although interestingly, all the human figures he inserted were Japanese, mostly in fighting or laboring poses. The graduation

4.7 Katayama Tōkuma, design for a school of art, graduation project for the Imperial College of Engineering, 1879, detail of facade on right wing. Courtesy of the Architecture Department, University of Tokyo.

design project is remarkable, for none of Katayama's subsequent, executed designs would make use of this style. Likewise, in his thesis "The Future Domestic Architecture," Katayama demonstrated his attentive absorption of his mentor's lessons.[35] Conder's written commentary reveals that this was precisely where he found the essay flawed. He criticized Katayama for fluently reciting the general principles of building without offering suggestions for architectural improvements and changes. Both in design and in research, Katayama's capacity to innovate would be proved after his student days.

One month after graduation, Katayama entered the Building and Repair Department (Eizenkyoku) of the Public Works Ministry as an engineer of the seventh rank. Such was the stipulation for a student who enrolled as a government cadet in the Imperial College of Engineering: he received the six-year education free of charge and then served seven years under government contract after obtaining his engineering degree.[36] Katayama's early career was galvanized by his participation in designing the palace for Prince Arisugawa, a project headed by Conder. The palace was the most luxurious Western-style residence in Japan at the time of its completion (fig. 4.8). The furnishing of this palace led to Katayama's first visit to Europe and the United States, where he traveled for eighteen months, starting in June 1882. The first building Katayama designed and oversaw on his own was the Japanese Legation in Beijing, completed in 1886 (fig. 4.9). For this project, he remained in China for two years. In 1887, he once again visited Europe, staying for almost one year in Germany, where he oversaw the production of furniture for the new Imperial Palace in Tokyo. When he was assigned to design the Imperial Museums at Kyoto and Nara in 1889, he had already transferred to the Bureau of Construction (Takumiryō) of the Imperial Household Ministry, where he remained for the rest of his career.[37] In 1904, he rose to the rank of Takumi no Kami, the highest position in this bureau, which had till then been reserved for bureaucrats, not technicians. Katayama held this prestigious post until his retirement in 1915.

From 1888 to 1891, just before designing the Kyoto and Nara museums, Katayama was also teaching, writing, and lecturing, the only time in his career that he publicly disseminated his knowledge. He taught architecture courses at the Engineering College of Tokyo Imperial University (the reorganized configuration of the Imperial College of Engineering since 1886) and the new "trade school" (*kōshu gakkō*) for workmen in architectural construction.[38] He published three articles in *Kenchiku zasshi*: "On Brick Construction" (Renga kō) in March 1889, "On the architecture of the new hospital at Heidelberg University" (Haideruberuhi daigaku fuzoku shinbyōin kenchiku tekiyō) in September 1889, and "The Interior Organization of Chinese Imperial Palaces" (Kando ōuchi no sei) in July 1890. And overcoming his dislike of public speaking, he gave two lectures at Zōka Gakkai meetings: the first on the history of domestic decoration in Egypt in January 1888, and the second on contemporary interior decoration in September 1889.[39] Katayama also served the association as secretary from 1886 to 1897 (and,

4.8 Josiah Conder, palace of Prince Arisugawa (demolished), Tokyo, 1884, view of ballroom. Decoration and furnishing supervised by Katayama Tōkuma. *Kondoru Hakase isakushū* [Collection of the posthumous works of Dr. Josiah Conder, F.R.I.B.A.] (1931). Courtesy of the Architectural History Laboratory, Architecture Department, University of Tokyo.

4.9 Katayama Tōkuma, Japanese Legation (demolished), Beijing, China, 1886.
Kenchiku zasshi (January 1887).

later, as vice chairman, from 1900 to 1906). This flurry of activities outside of his main employment at the Imperial Household Ministry culminated in August 1891, when he received his doctoral degree in engineering. He became the second person after his former classmate Tatsuno Kingo to hold this title in Japan.

Katayama's architecture was international, not only because of the Western methods and history he learned in Japan, but also because of his travels in Europe and the United States. His education at the Imperial College of Engineering under Conder's instruction laid the foundation for his design skills and sensibility; his travel, research, and service overseas in China, Europe, and the United States greatly expanded this horizon. Although Conder's influence was strong during his student days, in his professional work, Katayama relied more on his direct observation and investigation of foreign architecture. Best known for his work on aristocratic residences and imperial palaces, Katayama traveled to the West for inspiration and investigation for each major project.[40] Unlike Conder, who never really established a style of his own, Katayama consistently designed in an academic, classicizing manner. One way to account for Katayama's stylistic consistency is to recognize that while Conder's projects fell into the three primary categories of institutional, commercial, and private architecture, Katayama's projects fell predominantly into one single category, the institutional.

Despite the fact that Katayama's works—especially the Imperial Kyoto and Imperial Nara Museums and the Akasaka Detached Palace—have been included in nearly every survey of Meiji-period architecture, only one scholar, Onogi Shigekatsu, has published comprehensive studies on Katayama's architecture.[41] Onogi examined Katayama's museums under the larger heading of Meiji imperial architecture, specifically the projects executed by successive construction bureaus administered by the Imperial Household Ministry. He characterized Katayama's architecture as inspired, in the main, by buildings of the early Italian Renaissance and the French Baroque periods, citing Katayama's multiple overseas tours and the large quantity of architectural books the architect acquired from abroad as the main sources of inspiration for his designs.[42] However, emphasis should also be given to the international and amalgamated nature of Katayama's experience and inspiration. In addition, his designs were unified by the constant and exclusive patronage of the imperial household, symbolic keeper and cultivator of the nation's culture in the Meiji period. The buildings Katayama studied and designed belonged to a nation's most emblematic and materially opulent class of architecture. The patron, more than the specific styles, were his main inspiration.

The records of his official travels show that he took four trips to the West and visited the United States and every major country in Europe more than once. From 1886 to 1887, just before his museum projects for Kyoto and Nara commenced, he embarked on a prolonged eleven-month stay in Munich.[43] It is surprising to consider that Katayama's personal exploration of the architecture of Europe and the United States was wide ranging and lengthy compared to the limited travel experience of his mentor Conder, who, after moving permanently to Japan at age twenty-four, made only two short trips, back to England. Furthermore, Katayama's overseas travel was not limited to the West. As already mentioned, he had lived in China for two years for the Beijing project just before he began his extended stay in Munich. He was the first Japanese architect of his generation to build in a foreign country.

The collection of reference books Katayama formed for the Bureau of Construction covered the architecture and decorative arts of a diverse range of cultures and periods. A catalog of the more than seven hundred book titles reveals no concentration on any particular place or time (such as the Italian Renaissance or French Baroque, as Onogi suggested). A few noteworthy subcategories include technical manuals on the latest construction technology (for example, reinforced concrete, steel construction, heating and ventilation, electrical wiring), American architecture (such as architects' monographs, new building types, city planning, interior decoration), and Japanese art and architecture (all in Western languages by non-Japanese publishers). The current tendency to label Katayama as devotedly Franco-centric, as the scholars Onogi and Fujimori Terunobu have done, should be reevaluated.[44] No evidence from his education, travels, or reference library supports this claim. In order to realize a complete portrait of Kata-

yama as an architect, it is necessary to consider his appreciation of design and technical innovations alongside his grasp of historical forms and traditional methods as well as his study of non-Western arts (especially Japanese and Chinese) alongside his use of European architectural elements, old and new.

KATAYAMA'S DESIGN

The Bureau of Construction of the Imperial Household Ministry supervised the architecture of the new Imperial Museums in Kyoto and Nara, and Katayama was the architect in charge of both projects. His principal team of assistants was composed of four engineers who worked under him in the same bureau—Adachi Hatokichi, Yamagishi Shimesu, Shibata Katsuji, and Hara Chūji—and one recent architecture graduate of Tokyo Imperial University, Sō Hyōzō.[45] Although the Imperial Household Ministry hired an outside contractor, Nihon Doboku Kaisha (forerunner to today's Taisei Kensetsu), the company reneged three months after signing, leaving the ministry no choice but to supervise the entire project directly.[46] This partly accounted for the protracted construction process, which began in June 1892 and did not end until October 1895.

In addition to the building itself, the archives of the Kyoto National Museum hold an invaluable resource that greatly informs research on the architecture of the Imperial Kyoto Museum. More than seven hundred sheets of the original construction drawings and twelve scale models of the building are extant, and they offer a rare chance to examine the design and construction process of a Meiji-period building in great detail.[47]

Upon its completion on 8 October 1895, the Imperial Kyoto Museum stood as a one-story building of brick construction with iron bracing and stone facing. The built area covered more than 960 *tsubo* (roughly 34,100 square feet), consisting of seventeen rooms arranged symmetrically in three nearly identical wings around a central atrium. Although the exhibition space was only half that of the Museum in Ueno Park, the final cost of construction for the two buildings was about the same.

Newspapers and journals reporting on the newly completed building recognized its architectural style as the most distinguishing feature, especially in relation to the historical site it occupied. Beyond describing it as a Western-style brick building,[48] several articles, including those in the *Kyōto Bijutsu Kyōkai zasshi* (the journal of the Kyoto Art Association) and the Osaka *Asahi shinbun* referred to the style specifically as the "French Doric" (*furansu no dorikku*).[49] These labels are obviously not adequate for capturing the eclectic variety of stylistic details that distinguish the building. The most conspicuously "French" elements are the seven mansard domes capping the front center and main corners of each of the three wings. Each dome is pierced with a square skylight,

covered by glass and bordered by decorative cresting. These distinctive roof structures account for nearly half the total height of the building. The central bay of the facade, augmented by a raised entrance portico, features a triangular pediment, three arched portals, and quarter-pilasters of the Composite order (fig. 4.10). Embellishing the rest of the building facade are Doric half-pilasters and cartouches, both circular and rectangular. Overall, the exterior boasts a dramatic and monumental silhouette. At the same time, the detailing is comparatively restrained, featuring moldings and carvings in very shallow relief. Extant drawings, including the set stamped by Okakura and Kuki, show several earlier, more animated versions that feature even more dramatic rooflines punctuated by an extravagant number of trophies and flags. The moderation exercised in the realized design is not as evident without a comparison to the unrealized versions.

In his 1898 *Kenchiku zasshi* essay, the critic Mamizu Hideo called attention to the style, or *yōshiki*, of the museum as one of its major failings.[50] He was less interested in discussing what that style was than in detailing what it was not:

> As a museum in the spirit of protecting the treasures of the nation and sited in a blessed spot [the Hōkōji site], this pure Western architecture does not completely satisfy the visitor. As a space to highlight the arts and crafts of Kyoto and the historical integrity of the Old Capital as well as the treasures of our nation's past, Katayama's museum needs a certain something to truly express these functions. Neither a pure Western nor traditional Japanese style would suffice for this task. This was a very good opportunity for Katayama to create a new type of architecture to represent our nation's history and art and to serve as an inspiration to future designs, but he failed to do so.[51]

Mamizu was arguing for a stylistic innovation that would reflect the unprecedented function and symbolism the Imperial Kyoto Museum as an institution represented—sentiments similar to Conder's when he spoke of his pseudo-Saracenic design for the Ueno museum. Like Conder, Mamizu envisioned a direct stylistic correlation between architecture and site, architecture and object collection, and, ultimately, architecture and nation. The museum's architecture should necessarily address both the new and the old, and not just one or the other.

It is surprising, however, that Mamizu condemned the building wholesale as "pure Western architecture" and did not acknowledge some of the highly visible and innovative attempts at representing traditional Japan. One example is the prominent sculpture group on the facade pediment (fig. 4.11). It consists of the sixteen-petal imperial chrysanthemum crest flanked by two supine figures: Bishu Katsuma (fig. 4.12), the god of sculpture, on the left and Gigei Tennyo, the goddess of the arts, on the right. Both are majestic, robust figures strikingly clad in voluminous, flowing robes. Unfortunately,

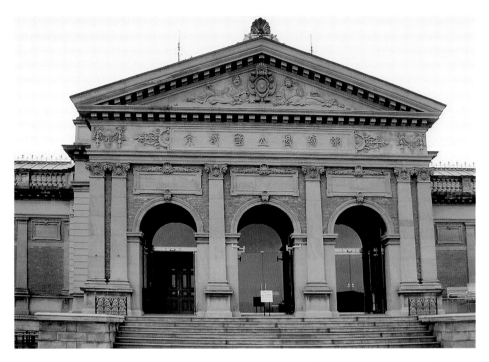

4.10 Katayama Tōkuma, Imperial Kyoto Museum, detail of front facade, central bay.
Photograph by the author.

their large frames are gracelessly squashed so as to fit within the triangular tympanum. The bearded, mustachioed god wields a hammer in his right hand, while the plump, bejeweled goddess holds a writing brush and a roll of parchment. Despite the ostensible Asian derivation of the two deities, their physiques, postures, attire, and facial features refer to no existing examples, ancient or modern. The designer of these two figures is not recorded, although the sculptor Takeuchi Kyūichi (1857–1916), at the time a professor at the Tokyo School of Fine Arts, was very likely their creator.[52] (Takeuchi had recently completed a monumental polychromatic wooden sculpture of the same goddess Gigeiten for exhibition at the 1893 World's Columbian Exposition.) The name of the museum, Teikoku Kyōto Hakubutsukan, was inscribed in calligraphic form on the frieze below, reading in the traditional manner from right to left; the inscription and orientation have been changed twice since.[53] The imperial crest serves as part of the floral motif bordering the two sides of the inscription, but the bows, ferns, and scrolls are stylistic forms hitherto unknown in Japanese architecture. This central pediment is the most visible emblem of the creative mediation between old and new, foreign and native, for which the museum as an institution stood; the art deities within the pediment and the calligraphy on the frieze are *inventions* of traditional Japanese motifs (much like the imperial crest) fitted into the armature of Classical Western architecture.

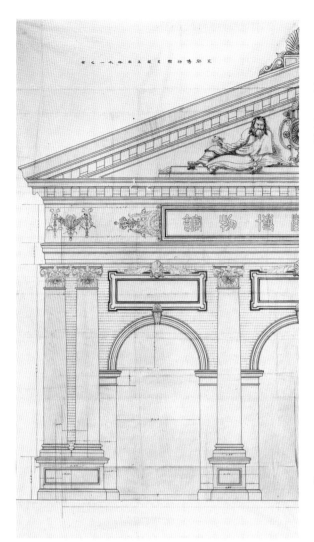

4.11 Katayama Tōkuma, Imperial Kyoto Museum, detail of decorative program on front facade. Kyoto National Museum.

4.12 Katayama Tōkuma, Imperial Kyoto Museum, study model of Bishu Katsuma (God of Sculpture) for facade pediment. Kyoto National Museum.

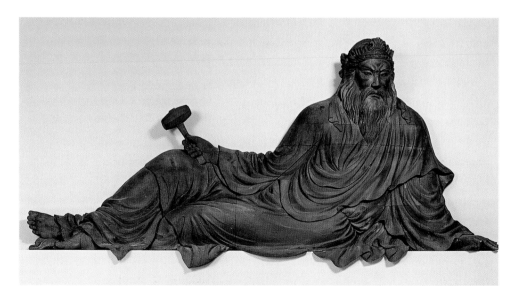

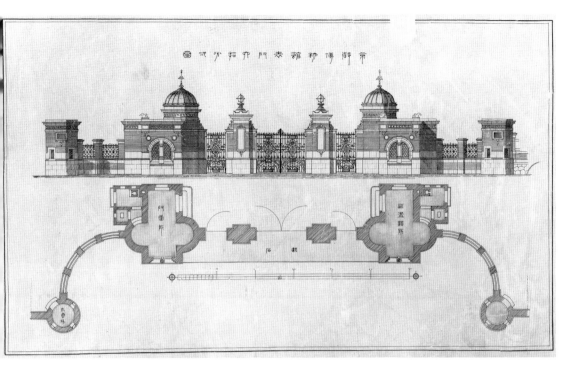

4.13 Katayama Tōkuma, Imperial Kyoto Museum, main gate structure, elevation and plan.
Important Cultural Property. Kyoto National Museum.

The main gateway, an elaborate entry pavilion, is another visible innovation (fig.
4.13). This symmetrical structure is built of the same brick and stone as the main build-
ing. It consists of a central double gate of florid iron latticework, with flanking pillars,
each faced with a vertical cartouche bearing the name of the museum and topped by a
glass and iron lantern. Moving outward from the central gate, slim panels of iron lat-
ticework lead to enclosed structures, the gatekeeper's offices.[54] In plan, the shape of each
of these identical offices is formed by the intersection of an ellipse and a rectangle; in
elevation, it is accented by a miniature turret topped by a copper dome. Next to each
office is a ticket booth. The entire gate structure displays little of the restraint that
distinguishes the main building. Some of the most playful features include the place-
ment of curved cartouches above the window cutouts on the ticket booths, the embel-
lishment of the front windows with fish-scale latticework and Ionic half-columns (fig.
4.14), and the repeated application of round medallions, large and small, and oversize
scroll forms (fig. 4.15). Originally functional architectural elements are converted into
lighthearted decoration, in columns and scroll brackets that do not act as supports and
cartouches that carry no inscriptions. The entire gate structure—now designated an
Important Cultural Property in its own right, independent from the main museum

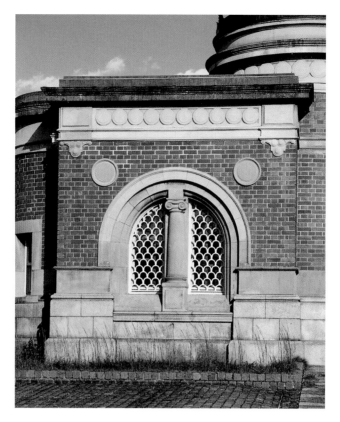

4.14 Katayama Tōkuma, Imperial Kyoto Museum,
main gate structure, detail of window in gatekeeper's office.
Photograph by the author.

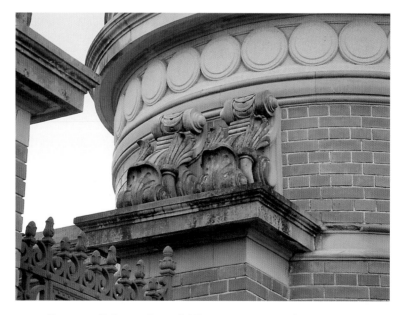

4.15 Katayama Tōkuma, Imperial Kyoto Museum, main gate structure,
detail of decorative scrolls. Photograph by the author.

building—distinctive in form and function, does not observe any obvious type, style, or model, indigenous or foreign. The building makes no apparent use of traditional Japanese architectural forms, although condemning the building by classifying it as "pure Western" or accusing it of a lack of invention is unjustified.

Mamizu also found fault with the museum's design method, or *shuhō*. In particular, he was dissatisfied with the plan and massing:

> Architecturally speaking, achieving variety is a merit in design and the repetitive use of a given shape lacks uniqueness. The *hin* (品) shape of the museum consists of six identical domes. And the center one, although larger in size, is essentially the same in design. It is as if Katayama had in mind an aerial view of this building when he designed this museum. . . . This design method really did not add any freshness to the schematic of the museum, and Katayama seemed to be overly miserly with expressing his design talent.[55]

Mamizu did not recognize the original logic the architect attached to the layout of the rooms because there seems to have been no coordination between the architect and the curators. The key to understanding this logic is the correlation between the illumination and the arrangement of the collection, a relationship corroborated in extant drawings in the archives (fig. 4.16) as well as a plan published in the April 1893 issue of the *Kyōto Bijutsu Kyōkai zasshi*.[56] The building's seventeen exhibition rooms are essentially of three types: (1) square corner rooms with top and partial side lighting, (2) rectangular connecting rooms with top lighting only, and (3) the central atrium with top lighting from the roof lantern and side lighting from the interior courtyards. The first type is labeled on the plans as rooms for "ancient vessels" (*kokibutsu*), the second type for painting (*kaiga*), and the last for sculpture (*chōkoku*). In addition, the building expresses externally the interior functions of the rooms: the voluminous mansard domes indicate the rooms for ancient vessels, the rectangular cartouches on the horizontally extended walls indicate the rooms for paintings, and the tall, uninterrupted roof volume behind the central mansard indicates the atrium for large-scale sculpture. This is in marked contrast to Conder's Ueno museum, where spaces for the various categories and types of display objects were not differentiated architecturally.

Visitors to the Kyoto museum, including the critic Mamizu, would not have realized the clarity of association between the form and function of the rooms because when the museum opened to the public in 1897, the collection was not arranged according to the architect's plan. The inconsistency arose from three assumptions Katayama made in his design. First, he assumed that the collection would be limited to three types of objects: two-dimensional works (e.g., paintings and historical documents), small three-dimensional works (e.g., ceramics and lacquerware), and large three-dimensional works

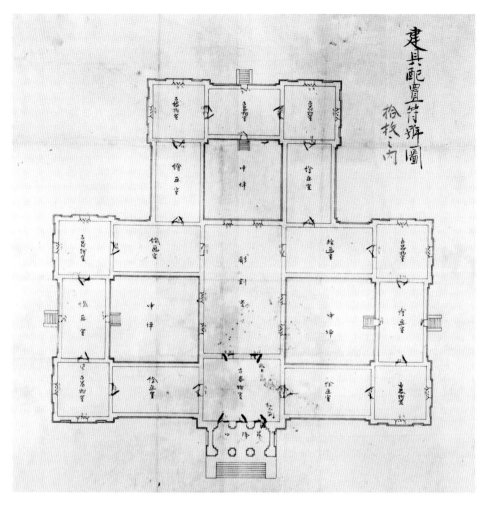

4.16 Katayama Tōkuma, Imperial Kyoto Museum, plan showing rooms labeled
by object medium. Kyoto National Museum.

(e.g., Buddhist statuary). Second, he assumed that objects of the same category or the
same type did not need to be placed in adjoining rooms. And third, he assumed that
objects of different media would not be exhibited in the same room. None of these
assumptions was carried through in the completed museum. According to detailed
reports published in the local newspaper and art association journal, the museum's four
departments—Fine Art, History, Industry, and Art Industry—each occupied a separate
block of conjoining rooms (fig. 4.17). The actualized layout does not show the corre-
spondence between object medium and exhibition room articulated in the architect's
plan. The Fine Art Department disregarded every suggestion, placing paintings in the
side-lit square rooms, sculpture in the top-lit long rooms, and paintings and sculptures

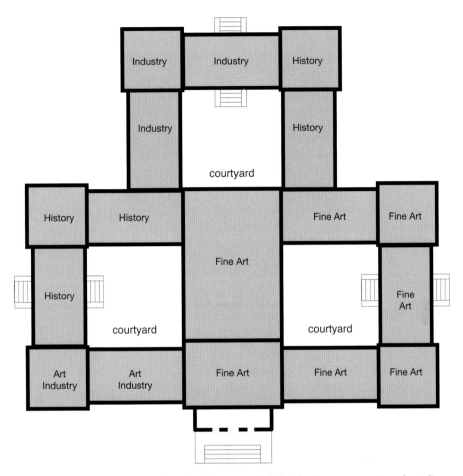

4.17 Imperial Kyoto Museum, plan showing rooms labeled by department. Based on diagram published in *Kyōto Bijutsu Kyōkai zasshi* (July 1897). Drawn by the author.

together in a single room. The other departments exhibited objects such as musical instruments, clothing, and books, which had no place at all in the architect's original plan. Without the coordination between the objects and the custom-designed rooms, the museum's plan and formal massing would have appeared arbitrary and incomprehensible to the visitor, as it apparently did to Mamizu.

The critic's last grievance was the museum architecture's character, or *shinjutsu*:

Some have suggested that this museum has a very heavy-set feel like a storehouse or prison, the squat proportion being at fault here. The dearth of windows and the indifferent, repetitive use of the dome shape have also been criticized.[57]

As with his criticisms of the museum's style and design method, Mamizu did not consider the technical determinants that may have affected the overall form and character

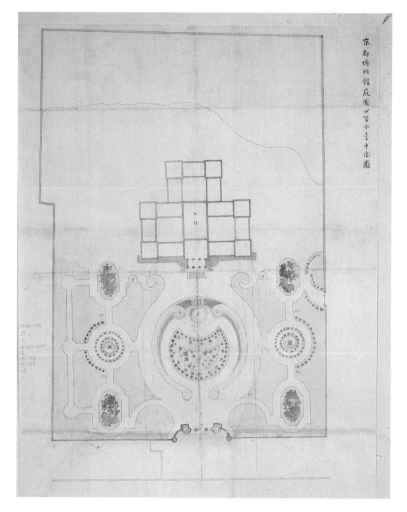

4.18 Katayama Tōkuma, Imperial Kyoto Museum, site plan of museum and gardens. Kyoto National Museum.

of the building. The attempt to control the level of natural lighting was in part responsible for the "squat proportion," "dearth of windows," and "repetitive use of the dome shape"; the need to protect against seismic vibration, with the memory of the 1891 earthquake still fresh, would also account for the building's horizontality and the modest size of the wall perforations.[58]

However, the architectural critic was correct in pointing out that Katayama's overall planning and composition relied heavily on symmetry and repetition, and that this design strategy extended beyond the main building to the formal garden and the front gatehouses (fig. 4.18). The architect envisioned the Imperial Kyoto Museum as a unified composition of building and landscape, in the same vein as the Imperial Museum in

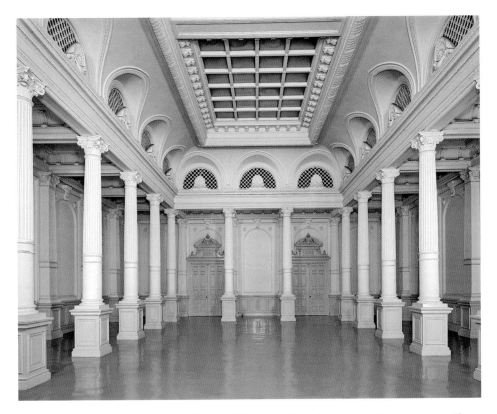

4.19 Katayama Tōkuma, Imperial Kyoto Museum, view of central sculpture atrium. The atrium was intended to serve as the throne room for imperial visits. Kyoto National Museum.

Tokyo. The museum complex, physically demarcated by a continuous iron and brick fence, consisted of the main building overlooking a formal garden of geometric and arabesque patterns, a small reflecting pool, and a circular driveway for the imperial carriage.[59] Mamizu did not point out, however, the effect of the picturesque produced by Katayama's highly exacting design. Making use of the ascending topography along the east-west axis, the entire complex unfolded before the visitor in a crescendo of shapes and colors.[60] According to a familiar anecdote, the architect had consciously aligned the curvature of the building's mansard roofs with the rounded mountaintops rising behind so as to further enhance the scenic Higashiyama vista.[61]

If the Imperial Kyoto Museum had the feel of a storehouse, as the critic suggested, then it was a remarkably palatial storehouse. Although the Meiji emperor never visited this museum, he was assumed to be the symbolic patron of the institution. Several architectural gestures were made to accommodate his presence, from the imperial entryway to a throne room (otherwise the sculpture atrium) (fig. 4.19).[62] In essence, the museum served as an extension of his palace, in symbolic observance of the European

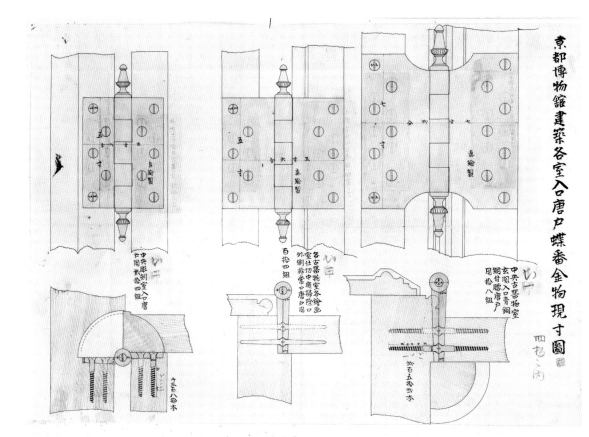

4.20 Katayama Tōkuma, Imperial Kyoto Museum, detail of door hinges and finials. Kyoto National Museum.

monarchs who made their collections open to the public. Expressions of imperial patronage saturate the interior. Katayama, a specialist in the ornamentation and furnishing of palaces (most notably the palace of Prince Arisugawa, the Imperial Palace in Tokyo, and the later Akasaka Detached Palace), injected opulence into every detail, from the ceiling coffering down to the door hinges and finials (fig. 4.20). Among the original drawings, there are even furniture designs, such as those of two state chairs for the emperor and empress (fig. 4.21). While the imperial chrysanthemum conspicuously adorns the exterior pediment, other motifs such as the acorn and cherry, along with trophies, swags, and floral cornucopia, dominate the interior decorative program (fig. 4.22). None, including the chrysanthemum, acted officially as symbols of the Japanese imperial house before the Meiji period. Like the emperor's Prussian-style uniform and horse-drawn carriage, these details became part of the total aesthetic adopted for the modern image of the monarch and his millennial capital.

4.21 Katayama Tōkuma, Imperial Kyoto Museum, design for a state chair for the emperor. Kyoto National Museum.

4.22 Katayama Tōkuma, Imperial Kyoto Museum, detail of segmental pediment above an interior doorway. Kyoto National Museum.

COMPARISON WITH THE HŌŌDEN

The American critic Fenollosa and the Japanese critic Mamizu advocated incorporating tradition with innovation in the architecture of the Imperial Museums, and both stressed the importance of giving expression to the unique cultural lineage that the institution embodied. Yet, beyond this broad formulation, they stopped short of defining a specific approach or model. Katayama's design, however, relied heavily on the visual vocabulary prevalent in Europe at the time. Although the Ueno museum, completed more than a decade earlier, also met the challenge of cultural expression with difficulty, that building was a conscientious, even if somewhat illegible, attempt to bridge the East-West cultural gap. Was Katayama simply working at cross-purposes with his critics, who were looking for a definitive image of Japan, or did his work operate on a different level of legibility? One way to answer these questions is to consider the strategies of cultural self-definition that Japan as a nation attempted to project through this museum and other parallel architectural projects of the time.

If one of Japan's ideological aims in establishing the Imperial Kyoto Museum was to express through visual-material means the cultural and national identity of the nation, then it is necessary to examine the strategies of meaning-making in play. A comparative study of the Imperial Kyoto Museum and the Hōōden (see figs. 4.3–4.5), the Japanese national pavilion at the 1893 World's Columbian Exposition, will prove helpful to understanding Katayama's design as national expression. The visual contrast set up by the two buildings—the cross-cultural imagery of the Kyoto museum versus the nativist imagery of the Hōōden—tends to obscure their important commonalities: both buildings were designed around 1891 to 1892, and they were ideologically related projects supervised by the same set of government administrators and intended to serve the function of Japanese cultural display.

The architect of the Hōōden, Kuru Masamichi (1855–1914), also a student of Josiah Conder's, graduated from the Imperial College of Engineering in 1881, two years after Katayama. Although neither Kuru nor Katayama received training in the history or construction of traditional architecture (the first courses on Japanese architecture at the Imperial College did not begin until 1889), Kuru's Hōōden was an attempt to re-create specific historical structures in material, method, and style. As an architect serving under the Education Ministry, Kuru had designed some of Japan's first modern school buildings and would later draw up plans for the Imperial Library, located just one block west of Conder's museum in Ueno Park. A large number of his designs, like Conder's Ueno museum, were distinguished by their vibrant red brick exteriors. The Hōōden was his initial attempt at conceiving a building in wood, and it is especially notable as an incipient example of a Japanese-style structure designed by a modern, academically trained architect.[63] When Japan participated in previous world's fairs, it

consistently exhibited in structures erected by traditional carpentry methods (with the materials pre-cut and pre-fitted in Japan and assembled on-site by Japanese carpenters). The World's Columbian Exposition was the first occasion for which an architect was commissioned to design the national pavilion, and also the first time the design replicated historically specific models.[64] This building approached Fenollosa's suggested method for architectural development, stated in his final report for the Fine Arts Commission; it exemplified a modern way of developing indigenous architecture by eliciting the participation of the new generation of Western-trained architects who, in Fenollosa's words, "had become proficient in both styles, and who distinctly asserted the possibility and desirability of utilizing their Western scientific knowledge in developing Eastern styles."[65] The Hōōden, Japan's self-representation in Chicago, was an exhibition indigenous in form and material but very much Western-influenced in conception.

According to the official catalog for the Hōōden, authored by Okakura Kakuzō, the entire design was a composite of at least four different historical buildings, identified as the Phoenix Hall (Hōōdō) in Uji, the Kyoto Imperial Palace (Kyōto Gosho), the Silver Pavilion (Ginkakuji) in Kyoto, and Edo Castle (Edojō).[66] The overall exterior form of the Hōōden, as suggested by its name, was modeled primarily after the eleventh-century Phoenix Hall of the Byōdōin temple complex in Uji. The formal massing, a metaphor for the phoenix, consisted of the central block as the body of the bird and the two extensions to the left and the right as its wings. The corridor behind the central portion of the Phoenix Hall, representing the tail, was omitted in the Hōōden. The interior was divided into a tripartite program, each segment architecturally and decoratively modeled after a specific epoch in Japanese art history: the north wing, the Fujiwara period (880–1150); the central hall, the Tokugawa period (1600–1868); and the south wing, the Ashikaga period (1350–1550).[67] The Fujiwara wing, a large open room without partitions, incorporated features such as round pillars, vertical shutters, and door shades (see fig. 4.5). The Ashikaga wing, containing a library and a tea room, featured the distinctive interior elements of square pillars, tatami, a tokonoma, and staggered shelves. In between the Fujiwara and Ashikaga sections was the spacious central hall, partitioned into four rooms—the sitting room (*jōdan no ma*), the anteroom (*tsugi no ma*), the food preparation room (*kon no ma*), and the library (*shosai*)—plus circulation corridors. Paintings and carvings covered every available surface in this suite of rooms, inclusive of walls, ceiling, sliding doors, and transoms.

The architectural models that informed the design of the Hōōden were intended by its designers to span a comprehensive gamut of Japanese art and architecture history from the eleventh to the seventeenth century. The three wings of the building composed a virtual timeline of artistic development of the past millennium. Okakura emphasized this aspect of the Hōōden in the catalog when he described the three wings in chronological order of the historical periods they represented rather than in order of the place

each held in the interior circulation. Furthermore, he introduced each epoch as a component of a linear historical progression, comparing and contrasting characteristic elements with previous and successive time periods. In his description of the Fujiwara wing, he explains round pillars as precursors to square ones, the papered transom as the antecedent to later carved examples, and the use of single cushions on the floor as a practice that preceded the custom of permanently covering the floors of entire rooms with tatami.[68] Also, the Ashikaga style "showed greater elaboration of details and was less gaudy in tone than the preceding [Fujiwara]," while the art of the Tokugawa period "did not differ materially from that which flourished in the days of the Ashikaga . . . but shows decided progress in many respects, owing to the peace and general prosperity enjoyed by the country for nearly three hundred years."[69]

Okakura asserted that the building's eponymous form, the *hōō* (phoenix) motif, had been applied consistently in the art of Japan throughout known history for the bird's mythical status as a "native of Japan" and a zoomorphic symbol of "holiness and mercy." Therefore, the form of the phoenix constantly embellished the noblest objects and buildings of Japan, beginning with decorations for early Shinto shrines and their accoutrements and continuing through the eleventh-century Phoenix Hall, the fourteenth-century Golden Pavilion (Kinkakuji), the fifteenth-century Silver Pavilion, and the recent ornamentation for the "state coach used by His Majesty, the Emperor . . . in 1890."[70] Okakura's elaborate and sweeping symbolic history of the phoenix proffers the Hōōden, not only as the container of the essential artistic lineage of Japan, but also as the ultimate signifier of Japanese art itself.

The stylistic polarity set up by the Imperial Kyoto Museum and the Hōōden is all the more remarkable because of the similar physical and visual functions they performed. They primarily served the purpose of displaying Japanese artworks and artifacts from the pre-Meiji periods.[71] The objects were chosen to illustrate a historical continuum of cultural achievement and excellence, and the buildings unified them under the national heading. It is logical to assume that a similar strategy was at work for both buildings because top members of the Imperial Museum administration—Kuki Ryūichi, Okakura Kakuzō, and Yamataka Nobutsura—headed the temporary Imperial Commission for the World's Columbian Exposition. Kuru, the architect appointed to design the national buildings for this fair, had existing connections to this group. His position as the instructor of architectural decoration at the Tokyo School of Fine Arts very likely gained him the commission, and his work at this school, rather than his training at the Imperial College of Engineering, stimulated his extraordinary and unprecedented approach to reviving traditional architecture. The Imperial Kyoto Museum and the Hōōden were equally part of the master plan for the fine arts being propelled by the original members of the Fine Arts Commission.

Although the museum and national pavilion are related in a number of significant

ways, the differences, lodged in their tangible, visible attributes, tend to outshine the similarities. In addition to construction material and stylistic expression, their building sites and exhibition methods also differed. The Hōōden was a temporary national pavilion sent overseas to a world's fair,[72] while the Imperial Kyoto Museum was a permanent structure in the nation's most important set of museums. The relationship of each building to its respective site—in Chicago, specifically the Wooded Island site within the fairgrounds, and in Kyoto, specifically the historical district of Higashiyama—should be taken into consideration. The way in which each building presented its collection to visitors is also key to an analysis of meaning production and conveyance.

Both buildings were visually striking because of their stylistic deviation from their respective surroundings. Just as the Hōōden stood as the singular small-scale wooden building in an environment of monumental Neo-classical structures (see fig. 4.3),[73] the Imperial Kyoto Museum was the only masonry building in a historical area of Japanese temples and shrines. In a stylistically homogenous environment, deviation ensured visibility. And visibility was crucial for a national pavilion acting as a stand-in for the whole of Japan in a sea of nationalities at the fair.[74] Similarly, the Kyoto museum acted as a stand-in for its agent—the Meiji government and its modernizing policies—within the accumulation of monuments and epitaphs erected by past regimes.

Despite sharing the function of displaying objects that exemplified Japan's historical and artistic accomplishments, the Hōōden and the Imperial Kyoto Museum related to these objects in two distinct ways, in what can be called the contextual mode and the classificatory mode. The Hōōden was composed of three sections, the interior of each constructed in accordance with the principal architectural features of a historical epoch. The furnishing, accoutrements, and paintings featured in each section were appropriate to the period (see fig. 4.5). The curators of the Imperial Museums selected some of the artworks, while the faculty and students of the Tokyo School of Fine Arts furnished the rest by creating replicas of famous works as well as paintings and objects in the style of the specific periods. The building as a whole was the product of a close collaboration between the government-run art school and the nation's museums, and Okakura was the linchpin for this alliance. In the Hōōden catalog, Okakura described the building as three distinct interior vignettes and provided meticulous explanations of the original function and significance of every object and feature in each section. In order to be as faithful to the period interiors as possible, reproductions of historical paintings and furnishings were commissioned to supplement authentic period pieces. The primary objective was to provide total environments for conveying the aesthetic values of particular periods rather than to showcase the individual objects.

In contrast, the interior of the Imperial Kyoto Museum did not provide a setting sympathetic to, or suggestive of, the original spatial or temporal context of the objects. A contextual installation requires the grouping of objects by chronology, in that each

4.23 Katayama Tōkuma, Imperial Kyoto Museum, view of
sculpture displays. *Wandlungen im Kunstleben Japans* (1900).
Courtesy of the Library of Congress.

room houses a collection from one specific time period. The Kyoto collection was classified and exhibited by function, medium, and type—the method of installation imagined by the architect as well as the curators (fig. 4.23). Unlike the Hōōden display, which stressed the effect of the aggregate whole, the Kyoto museum display emphasized the aesthetic individuality of each piece, by physically disengaging one artwork from another and by disrupting chronological uniformity and linearity. This strategy elided the objects' original contexts in order to give equal prominence to each as an isolated visual event. While the Hōōden attempted to locate the pieces in their original contexts of usage and meaning, the Kyoto museum dislocated the pieces from those contexts.

If the Hōōden and the Imperial Kyoto Museum were designed as visual signifiers of the same idea, then how can the two different modes of exhibition be reconciled? One

answer may be that the same strategy of dislocation implemented in the Kyoto museum's architectural and exhibition framework was also at work in the various Japanese national exhibits, including the Hōōden, at the World's Columbian Exposition.[75] A more exacting examination of the Hōōden reveals that, unlike the Kyoto museum, the national pavilion did not establish a separation between the architectural setting and the object display. The architecture and the art coalesced as a *Gesamtkunstwerk*, a total environment with every space and object designed to convey an overarching idea. Visitors to the fair viewed the Hōōden, including the interior and its contents, from behind roped barriers outside the pavilion. Therefore, no point of entry disrupted this spatially and semiotically sealed structure. In this sense, the Hōōden was not an exhibition space detached from the exhibition event, as was the Kyoto museum, but a total exhibition in and of itself.

In comparing the Hōōden and the Imperial Kyoto Museum, the Japanese pavilion set within the organizational layout of the main exposition grounds should be seen as the equivalent of an individual object placed within the architectural framework of the Kyoto museum. In both instances, the traditional Japanese object was set off within a modern, Western Neo-classical environment. The same strategy of visual framing applied to the other Japanese exhibits throughout the exposition (figs. 4.24, 4.25).[76] For example, although *karahafu* gates were erected at the entrance of the Japanese section in the Manufactures and Liberal Arts Building, most of the articles were displayed in glass vitrines. The exhibit in the Woman's Building did include display areas where objects were arranged in original settings for instructional purposes, but these areas were demarcated by velvet ropes and were not accessible. Again, these areas were clearly marked as exhibition events and not as exhibition spaces. No less significant was the contemporary Western dress worn by Japanese officials at the World's Columbian Exposition, much to the disappointment of many exotica-seeking American fairgoers.[77] The exhibition order being set up by the Japanese administrators at the exposition in Chicago and similarly at the museum in Kyoto was that while the exhibited event highlighted traditional Japan, the exhibiting agent, in contrast, was modern and worldly-wise.

NATIONAL EXPRESSION, TRANSNATIONAL STYLE

No less than the official policy in Meiji Japan, acculturation was part and parcel of the larger plan to gain political parity with Western nations. Given the asymmetric nature of the relationship between Japan and the West, Japan's adoption of Western standards was inevitably a double-edged sword. In the colonial context of the late nineteenth century, Japan as a nation trod the fine line between affirming its own unique identity and fulfilling exotic expectations whenever it dressed, literally and figuratively, in native costume. Christine Guth has observed that Okakura was highly sensitive to the politics

4.24 Japanese national display in the Palace of Fine Arts, World's Columbian Exposition, Chicago, 1893. *Rinji Hakurankai Jimukyoku hōkoku fuzokuzu* [Illustrated supplement to the report of the Temporary Exposition Bureau] (1895).

of articulating sameness and difference in his interactions with a Western audience. He understood that, without taking on and mastering the dominant culture—inclusive of dress, language, and etiquette—a Japanese had no voice in which to express his individuality to an international, and most important, Western audience.[78] This idea is encapsulated in his now famous advice to his son: "I suggest you travel abroad in kimono if you think that your English is good enough. But never wear Japanese costume if you talk in broken English."[79]

The implications of such cultural cross-dressing extend beyond the actual garments worn by Japanese individuals; to a certain extent, they also apply to the architectural styles that clothed Japanese buildings. From the start, the Japanese appropriation of foreign architecture had involved more than the need for more advanced technique and technology. To Meiji Japanese officials, European architecture carried a physical and psychological weight that their indigenous architecture could not equal.[80] In spite of the extraordinary expense and consideration the planners devoted to its design, the Hōōden's modest size and materials in contrast to the ostentatious height and applied

4.25 Japanese national display in the Manufactures Building, World's Columbian Exposition, Chicago, 1893. *Rinji Hakurankai Jimukyoku hōkoku fuzokuzu* [Illustrated supplement to the report of the Temporary Exposition Bureau] (1895).

ornamentation on the fair's central architectural group triggered Japanese fears of inadequacy.[81] The pavilion also confirmed the Americans' expectations of a delicate, toylike architecture that fit neatly with the general stereotype they had already formed of Japan. Members of the Imperial Commission attempted to subvert this exotic, infantile image by dressing in Western attire, while the architecture satisfied the ethnic articulation requisite at such an event. Even Josiah Conder, who had fashioned himself as a champion of traditional Japanese architecture, continued to deny Japan architectural parity with the West. In a paper for the World's Congress of Architects held in conjunction with the exposition, he maintained that traditional Japanese architecture, while having high artistic qualities, fell short of the Western definition of architecture because of its "perishability" and "lack of monumental solidity."[82]

While the Hōōden represented a temporary performance of national identity overseas, the Imperial Kyoto Museum represented a permanent fixture of cultural authority

at home. As Conder maintained, "such institutions as colleges, assemblies, museums, hospitals, and numerous other establishments belong entirely to *modern* Japan, and the former vernacular style of building presents no solution for the important problems which the requirements of such institutions impose on the architect."[83] And on this general point, Katayama appears to be in complete agreement with his mentor. However, what did Katayama's use of the Classical style signify in contrast to Conder's use of the Gothic for Japanese museum design?

Katayama's adoption of the Classical idiom was more reflective of modern Japan's overall strategy in emulating Western technology and institutions. When the Meiji government was organizing the nation's new political and social structure, it looked to the nations of Europe and the United States for models, such that, for example, the Japanese constitution was fashioned after that of Prussia, the postal system emulated that of England, the educational administration resembled that of France, and methods of pedagogy were based on those of the United States. In adopting with discriminating precision, the aim was to mold Japan into a vanguard international force and not a duplicate of any one nation. Throughout the Meiji period, the government in general imposed no stylistic preference for its major projects; however, Katayama must have realized, after his extended research trips to Europe and the United States, the singularity of the Victorian Gothic style he had learned under Conder versus the universality of the monumental Classical style. Whereas the mid- to late-nineteenth-century Gothic Revival was marked by its particularism of place and function, turn-of-the-century Classicism was marked by its internationalism, urban bias, and universal applicability to most types of institutional buildings. Henry Russell Hitchcock loosely described Classicism as the international Second Empire mode, a style that "found its inspiration in the grandiose extension of a palace in Paris" but was appropriated for villas and factories alike, especially in non-French nations.[84] Hitchcock singled out the "multiple mansards and pavilioned facades" as the most conspicuous markers of this popular mode that dominated the Western world from around 1852 to well after the end of the Second Empire. More than the Gothic, which had associations of national and regional specificity,[85] Classicism was a shared architectural language of Europe and the nations under its influence in the late nineteenth century. To build in this style was to take part in this international community.

Specifically, Classicism was an appropriate choice for the Imperial Kyoto Museum in that it established a visual link with the style then favored for the architecture of fine arts museums as opposed to the architecture of art and industry museums and natural science museums. Katayama's composition captured many of the stylistic features that had come to be associated with the art museums and art galleries, both urban and provincial, of Europe and the United States. The square dome was an especially prevalent feature of French and German art museums of this time, the majority of them

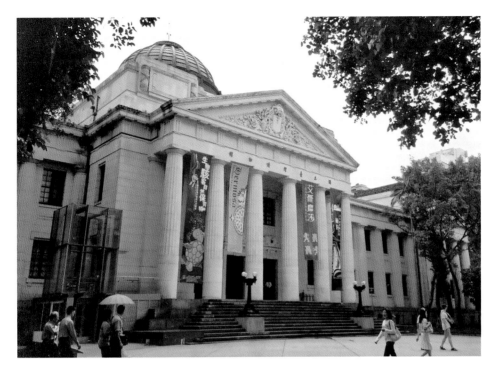

4.26 Nomura Ichirō, Taiwan Government-General Museum (now National Taiwan Museum), Taipei, Taiwan, 1913–15. Photograph by Li Kuo-Cheng.

provincial; some examples include the Musée de Picardie, Amiens (1855–62), the Musée-Bibliothèque Rouen (1876–88), the Musée des Beaux-Arts de Valenciennes (1898–1909), and Josef Zitek's museum proposal for Weimar (1863–69). They share other characteristic features such as grandiose entry porticos, multiple mansard domes, dramatically scaled dormers, and pronounced corner pavilions—all readily intelligible echoes of the model state museum, the Louvre, and its most recent 1850s addition by Hector-Martin Lefuel.

Hitchcock singled out the New Louvre as "the symbol, *par excellence*, of cosmopolitan modernity" of its time, particularly for the New World (in his definition, the United States and Latin America).[86] The Second Empire style had readily expanded beyond its Parisian borders and attained a far-reaching geographical distribution, most visibly through European colonial architecture. Like the Ottoman Empire, which also fell under the pressure of informal cultural colonization, Japan appropriated Western-style architecture as the formal language of authority for its most important institutions. And when Japan as an imperialist power built its first museum in Taiwan in 1915, the building's Doric peristyle and hemispherical dome were its most prominent features (fig. 4.26). At the turn of the twentieth century, Classicism would no longer define only Europe, the geographical and cultural region, but develop as a common language of power, empire,

and political legitimation. The Classical idiom, the universal signifier of modern high style, and now the favored style for art museums, was the expedient thrust into international visual politics that Japan desired.

PROGRESS AND TRADITION

The celebrations that took place in Kyoto in 1895 were well deserved. Because of its long standing as an imperial city and an urban center, Kyoto, in comparison to Tokyo, boasted more sophistication in character and more cultural establishments in fact. Yet to consider Kyoto simply as a custodian of its own eleven-hundred-year legacy, or only as a site of symbol and ritual for the nation, is to deny that it underwent the same dramatic modernizing transformations as did Edo/Tokyo in the Meiji period. Both before and after the Meiji Restoration, Kyoto assumed the dynamism that could be expected of any politically conscious urban city during a time of radical change. At the end of the Tokugawa era, during what is commonly referred to as the *bakumatsu* period (1853–68), Kyoto more than once served as the battleground for physical and ideological contests between pro-shogunate and pro-emperor factions; during one particular clash, even the doors of the imperial palace were shot through with bullets.[87] The city also experienced its fair share of the most prominent forms of social and political disruption during this period—peasant riots,[88] *yonaoshi* uprisings,[89] and *okagemairi* pilgrimages.[90] After the overthrow of the Tokugawa shogunate and the restoration of the imperial institution to political ascendancy, Kyoto suffered the mass departure of government officials, institutions, and the imperial court to Tokyo.[91] The central government in Tokyo, however, funded new and existing industries in Kyoto in order to save the city from economic decline.[92] The emperor himself sent a personal monetary gift in 1877, with instructions for its use toward preserving the city. Consequently, with the combined efforts of the national and local governments, Kyoto became the site of Japan's first electrically operated streetcar, elementary school building, insane asylum, cattle ranch, and textile factory, among other social and industrial institutions. The completion of the Lake Biwa Canal in 1890, under the supervision of the engineer Tanabe Sakurō, was an especially significant technical triumph for this city. One of its features, a hydroelectric power plant, was not only the first in Japan but one of the world's largest at the time. In 1912, as part of the second half of the canal project, Katayama Tōkuma designed the Imperial Pump House, now called the Mount Kujō Water Purification Plant Pump Room, with a main that directly supplied the Imperial Palace expressly for firefighting. Despite the small size and utilitarian nature of the building, it is distinguished by a very formal design comprising a rusticated stone base, a red brick body, and an attached front portico—features that distinctly echo the architectural aesthetic of the Imperial Kyoto Museum.

In the related arenas of exhibitions, museums, and art education, Kyoto paralleled or preceded Tokyo in initiative and implementation.[93] Kyoto, not Tokyo, held the first event in the nation to be called a *hakurankai*, in 1871. Kyoto opened a prefectural museum largely similar in mission to Tokyo's Yamashita Museum in 1875. And Kyoto launched the first public school devoted solely to the fine arts in Japan that offered courses in both Western-style and traditional-style painting, the Kyoto Prefectural School of Painting (Kyōtofu Gagakkō), in 1880.[94] At the same time, local artistic and handicraft industries also modernized to meet and even stimulate new demand from overseas. In the well-known case of Kyoto textiles, which have a history dating back to the founding of the city, the incorporation of technology and equipment from Europe extended the vitality of their production into the Meiji period and beyond.

The central government's concern with Kyoto's physical upkeep and material well-being was closely related to its recognition of the city's symbolic potential for the nation's self-definition. In addition to prioritizing the economic and technological advancement of the nation at large, the government also went to great lengths to construct an official culture, or what historian Takashi Fujitani describes as an official "memoryscape" for Japan during this time of dramatic transformation.[95] The city of Kyoto played an important ideological role in this manufactured time-space. Fujitani proposes that in creating a modern image for the imperial institution, the Meiji oligarchs embarked on two primary and interrelated projects: the promotion of a new visibility for the monarch as the symbol of national totality and the incorporation of the common people into a unified and totalizing culture. The people were to be unified by a common memory, or narrative of the past, with the emperor acting as the mnemonic device. Because of its long history as the nation's imperial capital, Kyoto came to represent, in this ideological configuration, the cradle of the national past and the site of Japan's cultural legitimation.

The concept of Kyoto as the ideological site of Japan's "tradition" in tandem with that of Tokyo as the site of Japan's "progress" was a deliberate modern invention. Fujitani convincingly argues this point. He cites the creation of ancient-looking rituals and pageants and the construction of traditional-style architecture in the Meiji period as visual strategies that enforced the idea of Kyoto as the nation's cultural nucleus. Equally significant but not explored by Fujitani is the role of Western conventions, specifically the museum, in enforcing the same idea. The Imperial Kyoto Museum, as a Western-inspired institution and Western-style architecture, contributed as much to the construction of Kyoto as the cultural capital of Japan as did traditional-style monuments, such as Itō Chūta and Kigo Kiyoyoshi's Heian Shrine, a project completed in the same year (see fig. 4.6).[96] In fact, Kyoto's cultural weight could not be effectively articulated without the interplay between the "modern" and the "traditional" within the same physical and ideological boundaries. Just as Japan as a nation required the ideological pairing of Tokyo and Kyoto to give it full meaning, Kyoto as a city required the juxta-

position of the old and the new (or what represented the old and the new) to achieve semiotic persuasiveness.

The Imperial Kyoto Museum embodied both the present and the past of the nation. This could be understood in more than one way. On the most fundamental level, the organizational structure of the museum was new to Japan, while the building itself housed articles of the nation's past. On the stylistic level, the building's Classicism was a signifier of Western tradition and of Japanese modernity. And on the symbolic level, the museum housed a past that was being rendered visible by the present. The past preserved by the Kyoto museum and emblematized by the city of Kyoto was not only being tangibly defined through the newly invented object category of National Treasure for objects but also being physically sequestered in the museum structure.

In discussing the Meiji period, it is no longer unusual to suggest that the purposeful preservation of a link to the premodern past played a primary role in making modern Japan; after all, the Meiji Restoration had been carried out in the name of upholding traditional values, summarily expressed by the *bakumatsu* slogan "revere the emperor, expel the barbarians" (*sonnō jōi*). This chapter has explored the converse and examined the roles of modernization and Westernization in rendering a cultural past—in this case, in the form of a unique national artistic lineage—visible in the same period. The Western-style architectural and organizational framework of the Imperial Kyoto Museum was a literal manifestation of the Meiji government's participation in the definition and dissemination of this cultural past. The museum as a physical and ideological structure demarcated the present, represented by an emperor-centered government and the implementation of ideas and ideals from the West, from the recent past, represented by a shogun-centered government and national isolation. The Kyoto museum was one of many Meiji monuments that stood as a symbol of modern Japan, no longer saddled with the myopia and provincialism of the old warrior regime and fully participating in the Western-centric world arena. It effectively communicated a new national identity both progressive in means and traditional in meaning.

5 · The Imperial Nara Museum
Administering History and Religion

Art is always wedded to religion. Her greatest achievements have been in the clothing of religious thought. This fact has induced us sometimes to think that the decline of religious activity marks also the decline of artistic effort. The fact is, however, that art has a separated and independent existence outside of religion. Religion is not necessarily conductive to the development of art. It has been antagonistic, in some instances.

—Okakura Kakuzō (1911)

The artist Sugimoto Kenkichi (1905–2004) executed a series of paintings in the 1940s centering on the sites and scenes of Nara. Among the architecture and landscape of the ancient capital, the original building of the Imperial Nara Museum (fig. 5.1) was a recurring subject for Sugimoto.[1] Unlike the temples, streets, and natural topography that he captured through aerial and wide-perspectival views, he depicted the museum building exclusively through cropped views of its interior. Imprints of a lingering, probing eye, the paintings put forth unresolved intimations of the subject under scrutiny: the object on display, the glass case sheathing it, and the architecture enveloping them. The painting *Center of the Museum* (Hakubutsukan chūō) (fig. 5.2), a prize-winning work at the 1942 New Ministry of Education Art Exhibition (Shin Bunten), is a prime example of the ambiguity of meaning Sugimoto's work communicates. The Buddhist statue that occupies the focal point and physical center of the painting is overshadowed rather than illuminated by the formidable display case; the willowy figure stands imperceptible behind the dense lattice of the dark wooden frame and the impermeable opacity of the glass panels. Further eclipsing the display object are the other sections of the museum interior. The furniture, floor, walls, and ceiling, all painted in dark yellows and browns, replicate rather than contrast the color of the statue so that the entire painting reads like a monochromatic composition without a clearly elucidated subject.

In this series of paintings, according to the catalog accompanying Sugimoto's retrospective show in 1994, the artist was apparently interested in the complexities of transparency and visibility the museum display offered: the phenomenology of "the transparency of the glass, the green of the trees reflecting in it, in contrast against the

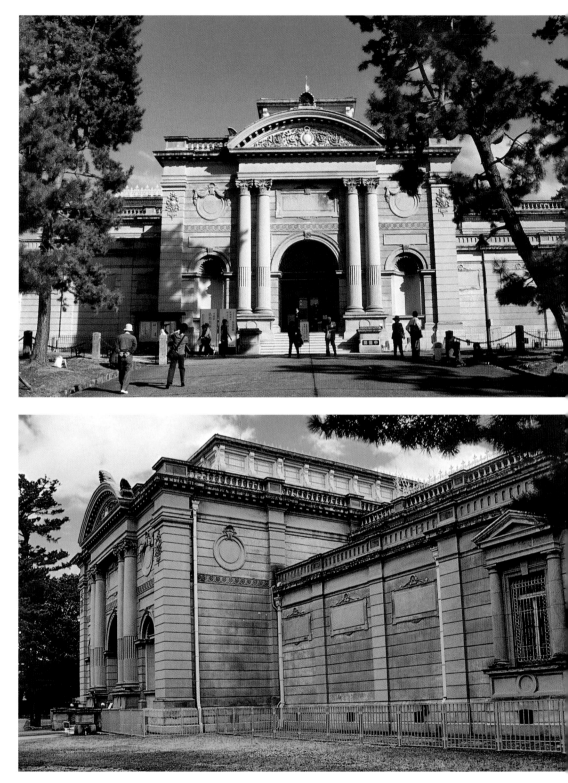

5.1 Katayama Tōkuma, Imperial Nara Museum (now Nara National Museum), Nara, 1892–94. Important Cultural Property. *Top*: view of front; *bottom*: view of side. Photographs by the author.

5.2 Sugimoto Kenkichi, *Center of the Museum*, 1942. Oil
on canvas. Tokyo National Museum, TNM Image Archives.

black of the frame, and the interwoven light caused by the halation of the sun's rays
filtered through the glass."[2] Demonstrating the paradox of the transparent glass obscur-
ing clear vision and the display case obstructing presentation, *Center of the Museum*
and its companion images in the series blur the boundaries between art object, display
case, and museum architecture, giving the viewer no direct visual access to the center
of the painting.

Sugimoto's paintings of the original building of the Imperial Nara Museum serve as
an appropriate entry into the issues attendant to the establishment of this institution,
a modern museum in the ancient capital. These paintings bring to the forefront the
dominant feature of the Nara museum, its exhibition of religious icons in a nonreligious
setting; at the same time, they call into question its innovation, the nature of the new
visibility being granted to such icons. Although existing studies have focused on the dis-
placement of Buddhist icons, or religious objects from non-Western regions in general,

in the Western museum,[3] it is significant to stress here that the transfer of religious objects from temple to museum, even within the same culture, has been no less dramatic or unnatural. This chapter explores the role of architecture in facilitating the physical and psychological shift from religious to museological space and presents two apparently divergent visions for the design of the Imperial Nara Museum, from Ernest Fenollosa, one of the institution's master planners, and Katayama Tōkuma, the imperial architect. It also examines the innovation of exhibiting religious objects and icons outside their home institutions by considering pre-Meiji traditions of visual display such as unveilings (*kaichō*), airings (*mushiboshi*), and sideshows (*misemono*), practices that preceded the Meiji-period government-sponsored exhibitions and museums. An analysis of the museum as a customized space for Nara-area treasures and of its terms of exchange with local temples and shrines calls into question the stakes and ramifications of curating Buddhist art for the nation and for the region.

Historically, Heijō (now the city of Nara) preceded Heian (now the city of Kyoto) as the imperial capital of Japan. The Nara period, a historical division marking the years from 710 to 784 when this city served as the seat of government, was distinguished by the dominating presence of Buddhism, the religion of the court. The proliferation of newly erected temples was accompanied by the energetic production of Buddhist icons and architecture, which would become the lasting legacy and visual symbols of this city. Even after the transfer of the capital to Nagaoka and then to Heian, great Buddhist institutions such as the Kōfukuji and Tōdaiji continued to wield immense power, and the city remained a significant religious and artistic center. Nara became known as the "southern capital" (*nanto*) in relation to the new capitals farther north.

Today the cities of Nara and Kyoto are commonly paired as Japan's cultural epicenters, although the two are separated by one major distinction in the nation's symbolic topography. As the imperial capital, Nara had lasted only about seventy years, while Kyoto prevailed for more than one thousand years. The latter's exceptionally long tenure as the imperial center had activated a rich, wide-ranging series of cultural developments, and, as discussed in chapter 4, Kyoto actively juxtaposed its traditional and progressive faces in the Meiji period. In contrast, the apex of Nara's political and cultural brilliance dated to ancient times, and as such, the antiquarian image served as this city's unique appeal. Additionally, as a result of its lack of success in sustaining specialized industries such as sake and linen production in the early modern period, Nara, beginning in the eighteenth century, became primarily a tourist town, depending more and more on the shrines and temples of the eighth century as its principal attractions.

The preservation of Nara and its historical architecture, artifacts, and sites also occupied a crucial place in the Meiji government's movement to create national heritage sites at the turn of the century. This movement culminated in the promulgation of the Law for the Preservation of Historic, Scenic, and Natural Sites (*Shiseki meishō tennen*

kinenbutsu hozon hō) in 1919. Takagi Hiroshi has explained the motivation for preserving the Kyoto-Nara region as the government's attempt to distill an imperial culture unique to Japan.[4] This was another purposeful aspect of the Japanese imperial institution's self-presentation to the Euro-American world powers. Iwakura Tomomi and Yanagihara Sakimitsu, both top Meiji bureaucrats as well as noblemen by birth, believed that the West would admit Japan as a social equal if Japan adopted (their) common royal protocols as well as maintained its own distinctive cultural roots (so as not to be accused of mindless aping). The physical maintenance of Nara as an unchanged and unchanging symbol of ancient Japan was therefore essential to the elevation of the modern monarchy to the status of "first-class nation" (*ittō koku*). It also presented a major challenge to the development of new architecture in this region.[5]

FROM TEMPLE TO MUSEUM

Before the establishment of the Imperial Museums, the Japanese public had regular access to showings of religious treasures through two major types of events: unveilings and airings, both popular cultural practices in the preceding Edo period. An unveiling was literally the "opening" (*hiraku*) of the "curtain" (*tobari*) of an auspicious image to the public for a limited time period. These events gave believers a chance to form "propitious bonds" (*kechien*) with the unveiled deity. In exchange for facilitating transcendental gain for the worshiper, the temple received material gifts such as votive valuables and monetary offerings. A distinction was made between displaying sacred icons that were part of one's own temple properties, a practice known as *igaichō*, and displaying those on loan from outside institutions (usually from afar), called *degaichō*.[6] This means that a temple did not have to own an icon in order to hold an unveiling, and the ability to display outside icons explains the great number of unveilings held each year that did not involve repeated exposure of the same icons.

A temple's motivation for holding an unveiling was as much religious as financial. Because the Tokugawa *bakufu* maintained a stringent policy on the amount of governmental funding and lay contribution allowed for religious institutions, most temples and shrines had difficulty financing regular maintenance and repairs, not to mention major reconstruction projects after natural disasters such as fires and earthquakes. A temple that sought income in excess of the governmental proviso could request a permit from the *bakufu* to hold an unveiling within its grounds in order to raise funds for repairs. The *Register of Permissions for Unveilings* (Kaichō sashiyurushichō), a document in three volumes (now in the National Diet Library), contains records of the official authorizations given for holding unveilings in the city of Edo during the years 1733 to 1868. In this city alone, the recorded unveiling events numbered as high as fifteen hundred, with "support for repairs" (*shūfuku josei*) the most frequently cited reason. Saitō

Gesshin's chronicle *Chronology of Edo* (Bukō nenpyō), a compendium of significant events in Edo between 1590 and 1873, provides an unofficial tabulation of unveilings that took place in that city; the total number of temple fairs he cites likewise numbered slightly above one thousand between the years 1654 and 1867.[7] Gesshin's records not only confirm the omnipresence and frequency of unveilings but also suggest their roles as essential events in the annual functions of eighteenth- and early-nineteenth-century Japan.

Airings were another type of event regularly held on temple grounds. *Mushiboshi*, the term for this annual late summer practice of airing a religious institution's prized possessions, literally means "drying of insects." A preventive measure against wet- and worm-induced damage, the airings simultaneously afforded the public an opportunity to view highly valued objects—such as paintings, books, utensils, relics—that were usually kept in storage. Travel guidebooks of the time publicized schedules of the airings, each lasting only one day, especially those to be held by prominent Zen monasteries in Kyoto.[8] During the late summer and early fall, therefore, temples and shrines were popular destinations. When an institution scheduled an airing and an unveiling simultaneously, the excitement doubled. The display of secret icons and house treasures attracted the local population as much as out-of-towners, all motivated by religious sentiment, secular curiosity, or a combination of the two.

The transient nature of the showings and the entrée they provided to normally inaccessible objects were integral to the excitement these experiences generated. The short-lived exhibitions have been interpreted as essential facets of the pre-Meiji religious experience as well as unmistakable extensions of purely commercial forms of display known as *misemono,* sideshows that were characteristic urban phenomena of the Edo period.[9] Unlike unveilings and airings, which took place within temple grounds, sideshows hovered around their periphery, typically in makeshift stalls just outside the gates of major religious sites (fig. 5.3). However, these exhibits required no specific site conditions—open-air lots, temple fronts, street corners, and even dry riverbeds served the purpose well. A number of locations in each of the three major cities of Edo, Kyoto, and Osaka gradually evolved as semipermanent centers for such crude, spontaneous street entertainment. The performances and shows that fell under the heading of "sideshow" according to Edo-period usage were variegated and eclectic, defying neat categorization and definition. The historian Furukawa Miki suggests three broad classifications: (1) magic acts, acrobatic feats, dance, martial arts, and other performances; (2) human abnormalities, rare animals, unusual plants and insects, and other natural wonders; and (3) *karakuri* (mechanical) devices, *saiku* (fine craftsmanship) in various media, and *ningyō* (dolls) both static and "living."[10] Enterprising showmen often set up their booths just outside the sites of religious unveilings, offering secular marvels to match the sacred ones.

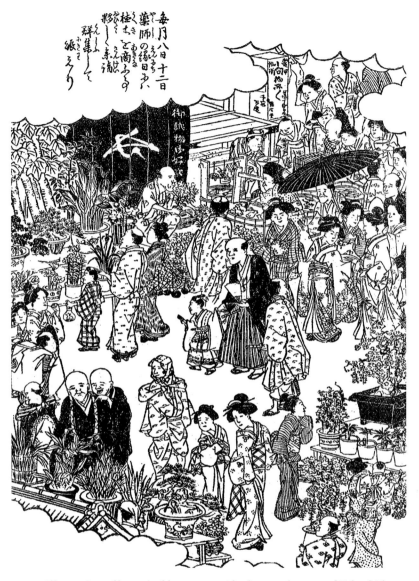

毎月八日十二日、薬師の縁日には、植木と商ふと品物、ましく来備えて、群集しておびただし、賑へり

5.3 Illustration of botanical bazaar outside the temple gates of Yakushidō in Kayabachō, Edo. *Edo meisho zue* [Famous places of Edo] (1834).

In short, the same physical space in and around the temple often served as a central-ized location that provided an elastic gamut of religious, cultural, and recreational gratification for the visitor. As urban historians have pointed out, temples "controlled some of the only publicly accessible open space in Tokugawa era cities where large crowds were allowed to gather,"[11] and areas around some of the larger urban temples such as the Sensōji of Edo developed into thriving popular entertainment districts, or *sakariba*.[12] As Edward Seidensticker succinctly puts it, "Asakusa was more than a religious center

—or rather it was a Japanese sort of religious center, one which welcomed pleasure to the sacred precincts."[13]

On the level of conception and motivation, the world's fairs, museums, and art galleries of Europe and the United States might have been the immediate sources of inspiration for Japan's domestic expositions and national museums. On the level of reception, however, the idea of viewing rare and magnificent objects in a centralized location was not foreign—neither strange nor imported—to the common person. Religious institutions and their icons and artworks, especially in the first half of the nineteenth century, had already formed a strong rapport with the Japanese public through these prevalent, albeit transient, unveilings, airings, and sideshows. The introduction of museums and exhibitions to major cities in the Meiji period did not critically disrupt these existing modes of display. In fact, the historian Yoshimi Shunya cites the presence of sideshow booths lining the path leading to the main gate of the 1877 National Industrial Exhibition in Ueno, identifying the ambiguous boundary both physical and phenomenological between exhibitions and sideshows during this period of visual cultural transition from Edo to Meiji.[14]

Likewise, temple unveilings and airings represent counterpoints to temperature- and light-controlled displays of religious objects in modern museums. The most conspicuous differences are site related: whether the exhibit takes place within institutional grounds or is completely separate from those provenance-generating spaces. Gregory Levine has recently noted that despite the apparent similarities between a visit today to a museum and a temple airing (an ongoing practice)—"we pay a fee to enter, follow a defined route, look intently at art objects, comment in subdued social voices, bump into other visitors, and crane our necks to see better"—the space of the airing, "one with intrinsic ritual functions and iconic configurations and a program of pictorial decoration," exudes an aura of authority and authenticity that is absent in a museum.[15] Even if the specific rooms used for the airings—usually the abbot's quarters—do not regularly or primarily serve the function of worship, they act as phenomenological synecdoches, standing for the spatial whole of the institution.

Several scholars, of art history and religion alike, have recognized the transfer of religious sculptures and paintings from temple altars to museum vitrines as a shift in their legibility and value as objects from the liturgical to the aesthetic sphere—in essence, changing our vision from veneration of the icon to appreciation of its iconography.[16] John Rosenfield asserts that "there is ample evidence from early times that educated persons were fully aware of the beauty of religious art and lavished great resources on it [though] there is no evidence that they removed such objects from ritual settings for purposes of private delectation."[17] Bernard Faure declares that "the notion of animated Buddhist icons has been repressed as a result of the modern and Western values of aestheticization, desacralization, and secularization."[18] While Rosenfield cites

modernization in general—"great stresses of industrialization and the loss of traditional values"—as the catalyst for the shift, Faure pinpoints as the cause the imposition of the Western and Westernized Asian gaze on said objects. Yet it would be difficult to prove that the shift has been irreparable or is in fact complete, for the line between cultic icon and art object might be more porous than hitherto posited. More than one scholar has observed that, even today, "it is not unusual to see people joining their hands and bowing to a particularly famous Buddha image on display at a museum exhibition."[19] Moreover, the National Museums in Nara and Kyoto still follow the customary practice of scheduling their most prominent exhibitions in the late summer and early fall in conjunction with the airings taking place at area temples. Levine also acknowledges that a similar multivalence (his term) of devotion, connoisseurship, and curiosity motivates visitors to airing and museum alike, and that the enforcement of boundaries among sacred, scholarly, and secular dimensions belies the richness of the experience.[20]

In the early Meiji period, several distinct factors came together to spur the physical transfer of objects from temple to museum. Christine Guth has summarized the initial circumstances of cultural preservation as follows:

> Administrative changes as well as conflicting priorities among bureaucrats in different ministries make it difficult to generalize about attitudes towards art during the transitional period between 1868–85 when the Meiji government was under the Dajōkan [Grand Council of State] system. However, by 1871, there was clearly a consensus, albeit for different reasons, that ensuring the protection of cultural relics was in the national interest. This recognition underlay government directives ordering the protection of antiquities (*kohin kyūbutsu hozon fukoku*) and plans to construct a museum of antiquities (*shūkokan*). Although temples and shrines are not specifically mentioned, the list of thirty-one articles covered by the directives ranges from ancient mirrors and swords, such as were often preserved in shrines, to Buddhist images and ritual implements.[21]

This assessment brings out two important points: the immediacy of cultural preservation as an issue of concern to the central government and the centrality to this concern of religious institutions, Shinto and Buddhist, from the very beginning.

In 1872, Machida Hisanari and Ninagawa Noritane of the Museum Bureau led a survey of the temples and shrines of the Kinki region, which includes the cities of Kyoto and Nara.[22] Even Shōsōin, the eighth-century imperial repository, was opened for inventory, notwithstanding the stringent practice of imperial closure, or *chokufū*, that governed each opening and closing of this structure.[23] One direct result of the survey was the 1875 Nara Exhibition (Nara Hakurankai), held in the Great Buddha Hall of the Tōdaiji. The featured objects came from the Shōsōin and the Hōryūji, another Buddhist institution of ancient standing and with imperial ties. The works on display, previously

seen only by the most privileged within the elite classes, were not publicized in the Meiji period as secret, auspicious icons being unveiled to the public for the latter's spiritual benefit but were displayed along with contemporary arts and crafts as possible models for future artistic production. Surveys followed by exhibitions in the Nara area would continue throughout the Meiji period.

While the activities of the Fenollosa group under the Temporary National Treasures Investigation Bureau in the 1880s have drawn the lion's share of historiographical attention, these in actuality constituted one, albeit crucial, phase in a succession of national surveys sponsored by the Meiji government. Moreover, the Fenollosa group's concentration on the contents of temples and shrines was not unique, in that it was following in the fairly recent footsteps of other bureaucrats such as Machida and Ninagawa.[24] The investigation bureau's efforts were unequaled, however, in that the results of its search led directly to the establishment of two museums in Kyoto and Nara, and the original 1871 proposal, cited by Guth, to preserve national antiquities in a building dedicated to this cause appears to have been finally realized, in this case, with two buildings.

As Guth argues, attaining the status of National Treasure was not an inevitable endpoint for religious icons and relics in the modern period. Specific but varied agendas of the central government, such as its supervision of religious institutions and its administration of future art production, fostered the transformation of religious property into works of art "deemed most representative of the national cultural patrimony" that occurred in the period between 1871 and 1897. The latter date marks the enactment of the Law for the Protection of Old Temples and Shrines (*Koshaji hozon hō*) and the inception of the category of National Treasure as the overriding label for objects with disparate functional and symbolic pasts. Ever since, the invented concept of "Buddhist art" has been operating in the art historical domain within the parameters of painting and sculpture, and the museum space has become a naturalized environment for the exhibition of Buddhist imagery.[25] The Imperial Museums at Kyoto and Nara set the precedent for providing this modern armature for the classification and presentation of Buddhist art as such.

The critique and persecution of Buddhism in early Meiji, known as *haibutsu kishaku* (literally, "abolishing Buddhism and destroying [the teachings of] Sakyamuni"), has been commonly cited as the most immediate and urgent catalyst for establishing the museums in Kyoto and Nara, which would act as safe havens for the wealth of sacred icons threatened with destruction or dispersal. In 1868, the new Meiji administration had called for the complete separation of Shinto from Buddhism, or *shinbutsu bunri*, in an attempt to elevate Shinto to the status of state religion. Previously, the great majority of Shinto shrines had existed as a small component of a greater temple-shrine complex, where the Buddhist clergy usually served as administrative leaders. After the separation,

Buddhist temples lost state patronage and the attendant income, and Shinto shrines, gaining institutional independence, removed all vestiges, material and ritualistic, of Buddhism. Incidents of unauthorized destruction and plunder at Buddhist institutions ensued after official orders of *shinbutsu bunri*. Temples that had received support from the previous regime were attacked and their objects demolished in retribution for their roles as mechanisms of control for the Tokugawa *bakufu*. (After the banning of Christianity in 1614, the *bakufu* ordered every Japanese to register with a Buddhist sect, and each family was required to register with a family temple.[26] Buddhist institutions not only received land grants from the government but also profited greatly from their monopoly of funeral and memorial rites.) The government offered several compelling reasons for the demotion of Buddhism in the Meiji period: one being that the religion had grown corrupt and gluttonous under the past regime, and another being that its foreign origin rendered it unsuitable for rallying national spirit. In the first years of the Meiji period, thousands of Buddhist priests were forced to return to lay status; consequently, their temples were left unguarded, and the remaining material holdings—icons, implements, and secular treasures—became vulnerable to every imaginable peril. Some statuary and ritual objects were melted down for cannon production.[27] A former priest of Eikyūji set up an art dealership with the contents of his temple.[28] One distressed institution, the Kōfukuji, sold its five-story pagoda (today designated a National Treasure) to a buyer interested only in salvaging the metal fittings.[29]

History books have a tendency to linger on the sensational episodes of spoiling and looting at Buddhist institutions during the early Meiji period; however, the extremity of injury sustained may not have been as great as claimed.[30] Buddhism recovered quickly from the initial blow it received from the Meiji government. In 1873, the government lifted the ban on Christianity, and Buddhism was once again paired with Shinto as indigenous forces faced with this (even more) alien religion.[31] Furthermore, the juridical separation of Buddhism from Shinto did not effectively weaken the populace's attachment to Buddhism. Much of the anti-Buddhist violence and vandalism was instigated not by angry villagers but by Shinto clergy seeking revenge for their longtime subordination to their Buddhist counterparts.[32] Moreover, temple affiliations were consistently maintained into the Meiji period through funeral services, family burial sites, and ancestral memorial rites. Shinto was unable to fill the void left by the separation; historically, it had been without any true comprehensive organizational structure or doctrinal creed comparable to those of Buddhism. "When the campaign [to promulgate Shinto as the new state religion] proved unable to unite the populace in support of a unified creed . . . Shinto bureaucrats fell from favor, and state support, as measured by bureaucratic rank of priests in government service or by monetary grants to shrines, fell sharply."[33] State support of Shinto declined during the period from 1880 to 1905, and

therefore, when the Temporary National Treasures Investigation Bureau was organized in 1888 to survey the nation's temples and shrines, anti-Buddhist persecutions had most likely all but stopped. Even so, state interest in shepherding the temple objects was approaching a high point.

FENOLLOSA'S PROPOSAL FOR A MUSEUM IN NARA

Ernest Fenollosa's report on the examination of Nara and Kyoto temples and his memorandum outlining specific building guidelines for the Imperial Nara Museum (see appendix) shed some light on the motivation and purpose underlying the investigation bureau's activities in the Kinki region.[34] Although both documents are undated, it is reasonable to assume that the report was written in the end of May 1888 and the memorandum sometime in 1889.[35] The report is significant for Fenollosa's firsthand assessment of temple conditions and his reasoning that a state-administered museum is the logical next place for the "treasures." The memorandum extends this idea by articulating the physical requirements of a custom-built environment for these objects. While Fenollosa's overt condescension toward and condemnation of native Japanese bureaucrats and priests, expressed in this report and memorandum, should not be overlooked, registering his subjectivity encourages awareness of the highly personal prejudices and motivations that propelled this project.

What were the conditions of the temples and their assets according to Fenollosa? The main problems he observed were the lack of thorough and systematic recording of the objects in the temples; the failure of existing provincial listings to make the distinction between objects of artistic merit and objects of antiquarian curiosity; the ambiguous ownership of many items, which belonged to either the temples or the priests; and the intensification of commercial trafficking and dispersal of temple property from the Yamato region. Fenollosa emphasized that he was interested in the objects only as "art treasures" and that he and his group had uncovered many artistic items overlooked by past surveys, which, in his opinion "[took] great care over a few relatively worthless things, while they [were] ignorant or indifferent to many priceless treasures."[36] As his collaborator Okakura states in this chapter's epigraph, it was their belief that art could be separated from religion, even in the case of religious art. Clearly, Fenollosa was positioning himself as the originator of a new paradigm for the evaluation of temple objects, despite the disclosure in his report that Japanese and foreign collectors alike, in behaving as eager and very active buyers, already shared the same discernment. Classifying the icons as art treasures of the nation and at the same time identifying the temples as crumbling repositories and the priests as corrupt guardians, he recommended the logical next step of state intervention—removal of the treasures from temple to

museum: "... *the sooner the Museum openly begins its collection the better*, and ... *the collection cannot begin* until most everything we can hope to get has been identified and catalogued. The importance of haste in collecting rests upon the danger of future sales, fires, and careless treatment by priests. It would be well to get the most difficult things into the custody of Kunaisho [Imperial Household Ministry] before next winter."[37] The clarity and precision of Fenollosa's vision is extraordinary in that he even summarized in the same report the full range of procedures the government might follow with regard to temple property: objects could be taken without compensation to temples that were close to abolishment or total ruin; objects could be taken with annual compensation to temples that needed the custodianship; objects could be purchased outright; or objects could be on temporary loan.

This document contains many overt allegations of priestly cupidity. These accusations are ironic coming from Fenollosa, whose own double-dealing as a private buyer and official agent of the Japanese government is recognized today as an indelible blemish on his otherwise esteemed involvement with Japanese art. In his report, Fenollosa even suggests using his status as a "well-known private collector" to infiltrate the temples and carry out the investigation bureau activities! He was well aware of his duplicity and once expressed his wavering allegiances in a letter to fellow American and collector Edward Morse before he sold his own collection of Japanese art to Charles Goddard Weld:

> Already people here are saying that my collection must be kept here in Japan for the Japanese. I have bought a number of very greatest treasures secretly. The Japanese as yet don't know that I have them. I wish I could see them all safely housed forever in the Boston Art Museum. And yet, if the Emperor or the Mombusho [Education Ministry] should want to buy my collections, wouldn't it be my duty to humanity, all things considered, to let them have it?[38]

In this one instance, many of the conflicting agendas that colored Fenollosa's participation in the treasure surveys come to the surface, namely, private versus state interests, religious versus aesthetic interests, and commercial versus preservational interests.

Although the report did not explicitly suggest that a museum be sited in Nara, it raised some points of concern that affected the eventual decision. Because the objects of interest in Nara were being classified as art treasures, Fenollosa petitioned for a fine arts museum distinct in mission and organization from the existing museum in Ueno Park, which contained an arts (*geijutsu*) but not a fine art (*bijutsu*) department. But rather than set up the new institution in Tokyo, Fenollosa advanced reasons for considering a local museum. There were two major motivations, one pragmatic and one ideological:

(1) to prevent transport-related damage to the ancient and fragile objects and (2) to preserve the nation's existing cultural equilibrium by keeping the objects close to their geographical place of origin.

Fenollosa's memorandum "Conditions under which plans must be drawn for constructing the Building of the Nara Imperial Museum" contains his architectural proposal for a museum in Nara. In it, he outlined twenty-four points of architectural specification, with fairly explicit suggestions for the construction material, room layout, dimensions, lighting system, cost, and decoration of the building. He also laid out a number of key ideas. First, the museum should be a low, sturdy brick building with uninterrupted walls (conditions 1, 2, 3). Second, lighting should be exclusively from the top (conditions 7, 21). Third, the exhibition space should be of two types: a long gallery and individual rooms set in a fixed circulation path (conditions 9, 10). And fourth, the brick walls should be left entirely unadorned on the exterior and interior (conditions 4, 5).

On the one hand, conditions calling for brick of the best and sturdiest quality (conditions 1, 4), a wooden floor impervious to the damp from below (condition 8), and skylights impenetrable by moisture and dust (condition 21) are obvious requisites for durable construction. On the other hand, other conditions, just as exacting, are comparatively inscrutable. For example, condition 17 states that "the walls above all door openings must not be supported by arches of brick, but by lintels of stone." Was Fenollosa asserting an aesthetic or a technical preference? Was he differentiating between brick and stone, or between arch and lintel? Without further clarification, the building defined by Fenollosa is difficult to visualize as a whole. His proposal incorporates several of the storehouse-like characteristics of the 1877 Art Gallery, designed by Hayashi Tadahiro, at the First National Industrial Exhibition (see figs. 2.2, 2.3). But a building of the size Fenollosa is advising—approximately nineteen thousand square feet, six times the size of Hayashi's gallery—with no side windows or applied ornamentation would result in an ineffectually dark interior and an equally austere exterior. Fenollosa's detailed suggestions for the museum's architecture are curious in that the memorandum postdates his 1886–87 survey of Euro-American museums yet shows no obvious imprint of that experience. While he and his colleagues expressed admiration for monumental state projects such as the museums in Berlin and Vienna during the trip, in his Fine Arts Commission reports (see chapter 4), Fenollosa pointedly declared European architecture inappropriate for Japanese emulation, stylistic and technical. However, countering his original dismissal of masonry construction, he did urge that the museum be "made of the best brick, cemented in the strongest manner."[39]

Fenollosa did not have a chance to see through his ideas in person, having left Japan in 1890. It is unclear whether he was expressly asked to contribute to the architectural brainstorming for the Nara museum and whether his outline was ever reviewed by any

member of the museum administration. The executed building designed by Katayama Tōkuma clearly reflects few of Fenollosa's suggestions. But Fenollosa's memorandum is nevertheless significant. The meticulous attention and deliberation with which he drafted it once again confirms architecture's crucial position in the holistic design of the Imperial Museums. Architecture was not envisioned as a separate, unrelated facet of the museum by the Fine Arts Commission as a group or by Fenollosa personally. At the same time, that the architect Katayama's expertise ultimately prevailed over the commission's master concept reveals the multiple agencies involved in *realizing* the museums project. While a singular vision could dominate the earliest planning stages, successful execution demanded a variegated team of experts and approaches.[40]

KATAYAMA'S DESIGN

The Imperial Nara Museum, conceived at the same time as the Imperial Kyoto Museum, but smaller and less expensive, was the first of the two to be completed (fig. 5.4). For the design, Katayama was once again aided by Sō Hyōzō, his junior from the Imperial College of Engineering, and Shibata Shishichi, Maki Osatomi, and Hara Chūji, three engineers from the Bureau of Construction. The general contractor was Shimizu Mannosuke (forerunner to today's Shimizu Corporation).[41] The site was determined in December 1889, and construction took place between July 1892 and December 1894.

The museum was set within the historical district established in 1880 as Nara Park.[42] Like the Kyoto museum, the Nara museum was bordered by some of the best-known temples and shrines in the area: on the east by the Kasuga Shrine, on the west by the Kōfukuji, and on the north by the Tōdaiji. A verdant belt of uninterrupted park grounds buffered the museum structure from the religious institutions immediately surrounding it, but no fencing was erected to demarcate its perimeter. Yet at the same time, being the first thoroughly modern building, both in material and style, in the area, the Nara museum stood as a visually striking addition to this park, a space that the prefectural government was actively cultivating as a national heritage site for its historical and scenic value.

In designing the Museum in Ueno Park, Conder had made stylistic expression a primary issue. Katayama, unfortunately, left behind no personal records of his thoughts on the design of his museums. The popular press affixed the broadest possible stylistic label of *seiyōfū*, or Western style, to the Imperial Nara Museum at the time of its completion. Surprisingly, the building did not elicit special attention from the architectural press even though it was the first bona fide masonry structure with corresponding constructional ornamentation in the Nara region. While the press was not concerned about addressing the specificity of the building's style, the German doctor Erwin Baelz (1849–1913), personal physician to the imperial family, visited in 1904 and made a swift,

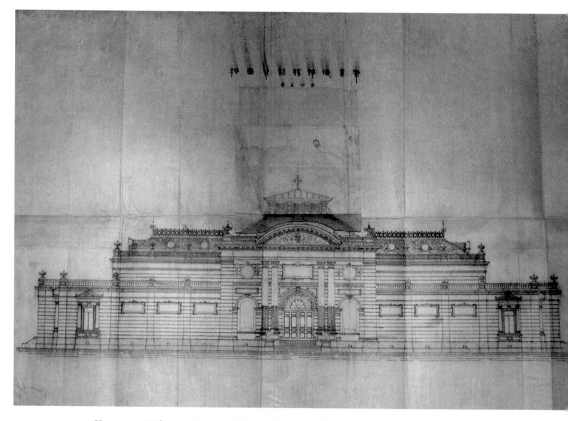

5.4 Katayama Tōkuma, Imperial Nara Museum, front elevation, representing a revised scheme with a raised skylight (note parchment overlay). Nara National Museum.

acerbic diagnosis, pronouncing it "one part Greek temple, one part Renaissance theater" (*nakaba girisha shiki jiin, nakaba runessansu shiki gekijō*).[43] His assignment of archetypal origins to the building detracts from the design's originality by condemning it as both a hybrid and a simulacrum. Provocative and glib (what aspect of a Greek temple could he possibly discover here?), the tone of Baelz's offhand criticism has reverberated throughout later scholarly writings that place undue emphasis on this building as a design derivative.[44]

Style was not the principal concern voiced by the original designers, administrators, or press at the time. Contemporary documents relevant to this project—namely, Fenollosa's memorandum, the extant construction drawings,[45] contemporary reviews in the journals *Kenchiku zasshi* and *Kyōto Bijutsu Kyōkai zasshi*, and the designer Sō Hyōzō's published recollections—all indicate that the building's viability as a display space overshadowed stylistic expression as the primary concern steering the design.

Fenollosa's memorandum expressly calls for no architectural ornamentation (condi-

tion 6) and focuses instead on the physical requirements conducive to exhibiting ancient and religious art. As already discussed, this meant a structure resistant to fire, earthquake, and damp, with the interior space partitioned into six rooms of various proportions laid out linearly, alongside a long gallery; although Fenollosa did not specify, it is reasonable to assume, based on conventional practice of the period, that he envisioned sculpture inside the individual rooms and paintings inside the gallery. An examination of the architect's original drawings for the Imperial Nara Museum reveals that the realized design was a study in structural effectiveness. However, it diverged significantly in layout and decoration from Fenollosa's outline.

The museum, designed in the immediate aftermath of the 1891 Nōbi Earthquake, was a studied attempt at aseismic construction. Moreover, the high cultural value of the works to be housed there compelled the designers to be particularly mindful of the building's structural safety and durability. Sō, the on-site supervisor for the building, said the following about the project in 1927:

> It was right after the Nōbi disaster and a time when practicing quake-resistant construction was taken very seriously. . . . Because the museum was in all likelihood going to house imperial treasures, the building had to be sturdy all around. If it were today, certainly ferro-concrete construction would be the answer, but at the time, there was no better material but brick for the job. Sturdiness was the number one priority, so the walls were made as thick as 4 *shaku* (3.98 feet) [in some places].[46]

Like the Kyoto museum, the Nara museum was limited to one story and built in brick with stone and plaster for facing and ornamentation. The plan was a rectangular block partitioned into thirteen exhibition rooms, augmented by attached front and back porticos (fig. 5.5). Furnished with a minimum of window cutouts and no interior courtyard, the building, seemingly mirroring Fenollosa's conditions, received natural light predominantly from a raised skylight that stretched the entire east-west axis of the building (fig. 5.6). According to the project description published in *Kenchiku zasshi* near the end of construction, it was made to be the "strongest possible structure" (*mottomo kenrō naru kōzō*) to date.[47] In order to anchor the building, the foundation was cast in concrete to a depth of approximately 3 *shaku* (2.98 feet), and the frame was reinforced by load-bearing walls of increasing thicknesses toward the center of the building (five bricks thick for the walls of the central atrium, four bricks thick for those of the sculpture rooms, and three bricks thick for those of the outermost painting rooms) (fig. 5.7). Metal straps that reinforced the intersections of truss members strengthened the roof structure (fig. 5.8). As a fire-prevention measure, sparse plantings but no buildings were allowed in the museum's immediate proximity.

The architects' original plans indicate that the building was organized into thirteen

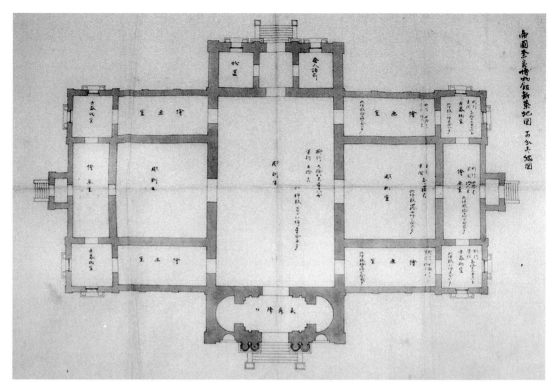

5.5 Katayama Tōkuma, Imperial Nara Museum, plan showing rooms labeled by object medium. Nara National Museum.

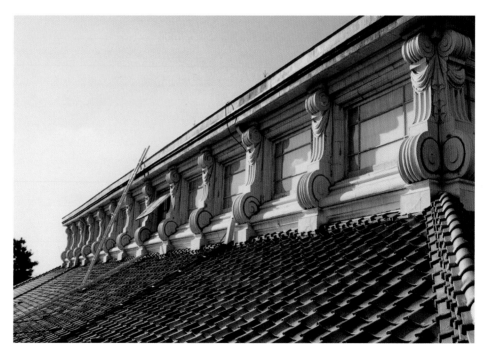

5.6 Katayama Tōkuma, Imperial Nara Museum, detail of raised skylight. Photograph by the author.

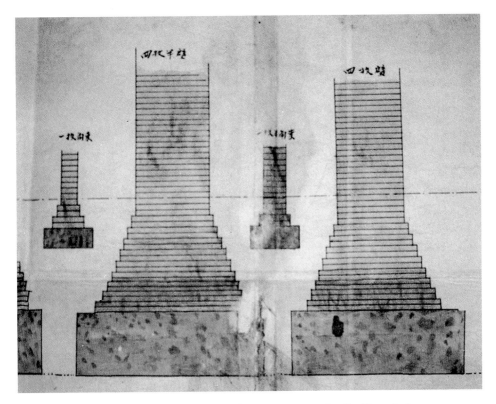

5.7 Katayama Tōkuma, Imperial Nara Museum, detail of foundation, showing footing depths and wall thicknesses. Nara National Museum.

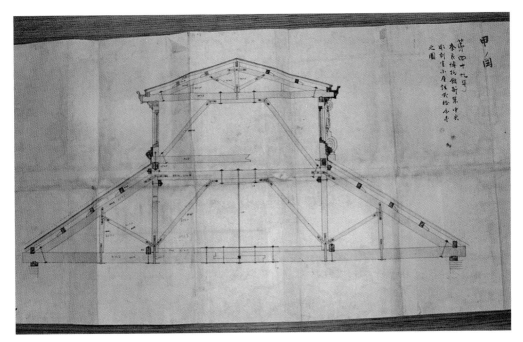

5.8 Katayama Tōkuma, Imperial Nara Museum, section of roof truss, showing framing system with metal reinforcements. Nara National Museum.

exhibition rooms, the size and shape of each corresponding to a type of object to be displayed inside (see fig. 5.5): the four small square rooms were designated for ancient vessels (*kokibutsu*); the six long, rectangular rooms were for painting (*kaiga*); and the two large square rooms and the central atrium were for sculpture (*chōkoku*). Another drawing of the roof plan confirms that the square rooms received no top lighting, only side lighting from the bay windows; the rectangular rooms received top lighting from the roof and elevated lunettes on one side; the two large sculpture rooms received top lighting from the roof; and the central atrium was lit from the rectangular skylight, which provided light directly from the top and diagonally from the side.[48] The layout of the rooms and their illumination suggest that the architect was expecting a collection of mainly three-dimensional sculptural works.

After sturdiness, daylighting presented a major point of deliberation for the designers. The extant drawings show several interpretations of the building differentiated mostly by changes in the number of windows. The distinctive raised skylight, which provided the only source of illumination to the largest room within the museum, did not exist in earlier drawings. A set of elevation drawings vividly illustrates the evolution toward the finalized form by showing the skylight portion as overlays on top of the original scheme (fig. 5.9). The lunettes on all four sides did not figure into the design until the final phase (fig. 5.10).

Circulation through the thirteen rooms is marked in a separate floor plan. A printed guide to the museum published in 1925 confirms the continuous path to be taken through the rooms (fig. 5.11).[49] However, the guide also reveals that the configuration of the collection was not faithful to either Fenollosa's original suggestion or the architect's assignment of function to the rooms. Condition 10 in Fenollosa's architectural outline called for the rooms to be arranged so that the visitor could pass through them in a fixed, linear order.[50] The guide shows that rooms 1, 2, and 3 each contained sculptures grouped by time period (Suiko/Tenpyō, Heian/Fujiwara, and Kamakura); nevertheless, the visitor could not walk through these three rooms in order of chronological development. The objects in rooms 4 through 13, in contrast, were grouped by medium (i.e., ceramics, painting, calligraphy), not time period. Here again, as in the Kyoto museum, the curators apparently preferred to keep objects from the same department in contiguous blocks of rooms even if it meant displaying the artworks in unfavorable lighting.

Both the configuration suggested by the architect and the actual configuration printed in the guidebook indicate that the general visitors entrance was on the east side, while the main, presumably imperial, entrance was on the west. A wooden shed and corridor for checking shoes and coats were appended to the exterior of the eastern entrance for the general public (fig. 5.12).[51] Although erected in less durable material (wood) and embellished with less refinement, the pragmatic extension, visible on the

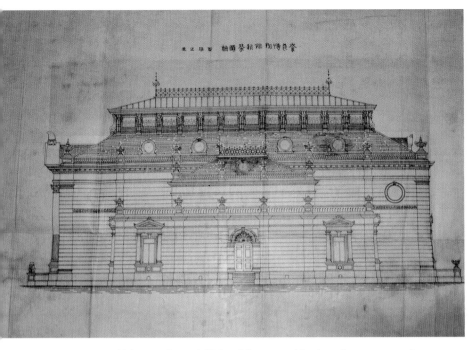

5.9 Katayama Tōkuma, Imperial Nara Museum, side elevation, representing
a revised scheme with a raised skylight (note the parchment overlay).
Nara National Museum.

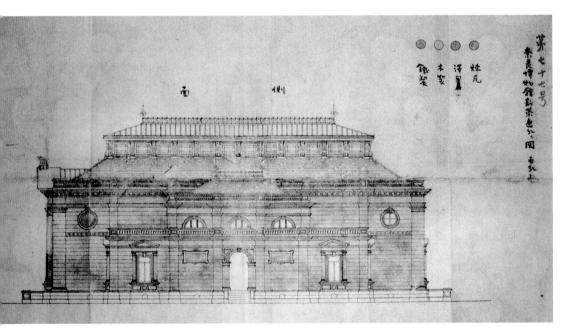

5.10 Katayama Tōkuma, Imperial Nara Museum, side elevation, representing
a revised scheme with lunette windows. Nara National Museum.

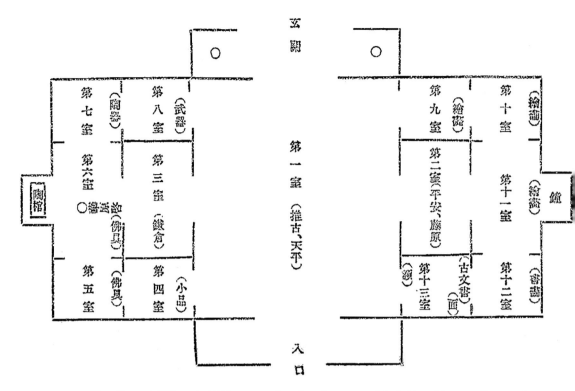

5.11 Nara Imperial Household Museum, plan showing rooms labeled by object medium and period. *Nara Teishitsu Hakubutsukan o miru hito e* [Guide for visitors to the Nara Imperial Household Museum] (1925). Courtesy of the Library of Congress.

original floor plans, constituted part of the overall design.[52] Significantly, the timber structure attempted to echo the masonry detailing of the main structure through the sculpted floral design in the triangular pediment of the gabled top and the stylized anthemia (or palmette) affixed on the edges. Furthermore, the upright posts took the shape of Tuscan columns but were reinforced with diagonal braces.

The most elaborate exterior decoration was reserved for the main facade on the west, which Meiji-period museumgoers would not see at all if they did not make the effort to circumambulate the exterior. Contradicting Fenollosa's appeal for "plain face brick" and "no exterior ornament," the Nara facade is dressed in stonework that is noticeably more lively and ornate than the exterior of the Kyoto museum. It features an arched portal, flanked by full double columns and capped by a segmental pediment (fig. 5.13).[53] The circle and arc motifs are repeated in the spherical crest in the center of the pediment, the arched niches adjacent to the portal (fig, 5.14), the circular cartouches above the niches, and the high lunette windows found on all four sides of the building. A variety of floral forms and swags also proliferate. Overall, abstract and nonspecific motifs embel-

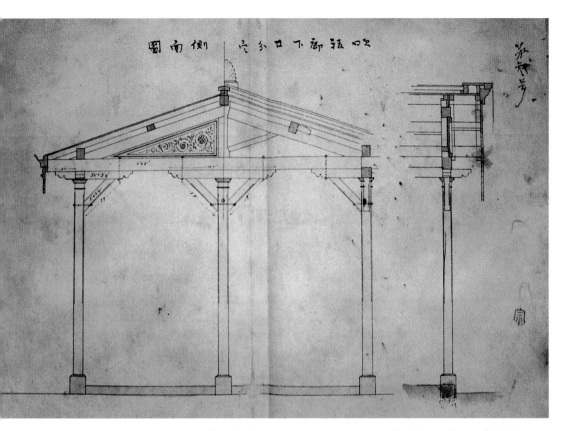

5.12 Katayama Tōkuma, Imperial Nara Museum, extension structure for shoe and coat check (demolished), side elevation. Nara National Museum.

lish the facade. In contrast to the allegorical sculpture, imperial crest, and inscribed museum name embellishing the Imperial Kyoto Museum, the facade ornamentation at Nara does not attempt to communicate the specificity of place or function of the building. And just like Kyoto's, the executed design appears restrained in comparison to earlier sets of drawings (see figs. 5.4, 5.9) that feature several rows of decorative trophies, spherical antefixes (upright roof ornaments), floral-patterned window grilles, and a pair of animal statues guarding the front.

There is no question that the overall style and decoration of the Imperial Nara Museum marked it as a place apart from its neighboring temples and shrines. Although no direct criticism against Katayama's design is documented, the Nara prefectural government apparently urged all other architectural projects that followed the Nara museum to apply elements of traditional Japanese architecture rather than Western architecture in their designs. According to the architect Nagano Uheiji (1867–1913), who designed the Nara Prefectural Office (fig. 5.15), a building completed one year after the

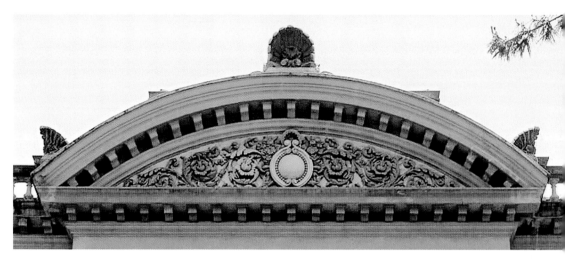

5.13 Katayama Tōkuma, Imperial Nara Museum, detail of facade pediment.
Photograph by the author.

5.14 Katayama Tōkuma, Imperial Nara Museum, detail of facade niche.
Photograph by the author.

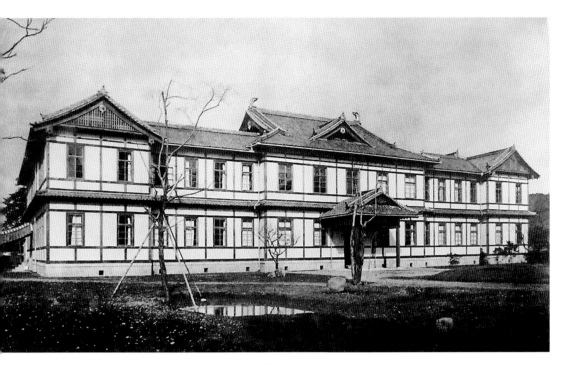

5.15 Nagano Uheiji, Nara Prefectural Office (moved to Tenri City, Nara Prefecture), Nara, 1894–95. *Kenchiku zasshi* (March 1896). Courtesy of Architecture Library, University of Tokyo.

Nara museum, the prefecture explicitly requested that the building "adopt the excellent elements of our nation's architecture" (*honpō kenchiku no yūten o toru*) because the Nara region embodied "the essence [*iki*] of our nation's art and the bastion of ancient architecture."[54] According to Nagano, his prefectural office design was essentially Western in terms of material (concrete, granite, and brick) and construction method (including the timber trusses of the pitched roof).[55] Only the roof tiles and gables made use of "Japanese-style designs" (*nihonfū no shukō*).[56] This building, which assumed Japanese style in the frothiest possible manner, apparently satisfied the prefectural commission. Two subsequent projects, the Prefectural Exhibition Hall for Nara Products, completed in 1902 and executed from the design of Sekino Tadashi (see fig. 2.22), and the Nara Hotel, completed in 1909 and executed from the design of Tatsuno Kingo, fundamentally followed the same strategy: applying cosmetically the roof and facade detailing of traditional temples and shrines to modern, secular buildings so as to harmonize with the Nara landscape.

Without predecessor or successor, the Imperial Nara Museum stood as a stylistic anomaly in Nara Park. Like the Imperial Kyoto Museum, it did not attempt to blend into its immediate surroundings, taking on none of the religious and historical totems

5.16 Poster advertising a baroque concert at the Nara
National Museum, 2001. Collection of the author.

defining its city. The museum also did not allow the collection to blend into itself by
simulating original historical or religious environments in the interior. Even today, the
building maintains its exotic appeal: the Nara National Museum hosts a European
baroque music concert in the central sculpture room every November, which coincides
with the special exhibitions of religious icons taking place in the area at the same time
(fig. 5.16). The architectural positioning of the museum vis-à-vis its neighboring insti-
tutions and host city should be identified not as antithetical but as differentiated.

Both Fenollosa's proposal and Katayama's design emphasized the importance of solid
building for the purpose of safekeeping Nara-area treasures, but neither made reference
to the particular cultural-religious context of Nara. Their understanding of the muse-
um's physical function and their strategies for fulfilling it more or less coincided, but

their concepts of how and what the Nara museum signifies diverged. Looking beyond the city of Nara and beyond Japan, Fenollosa and Katayama seized on principles that transcended geographical, cultural, or national specificity.

When Fenollosa asked for a building free of ornamentation, he was in effect asking for a building free of European-derived ornamentation. His proposal was an exhortation to originate a new architecture, for it was his belief that every epoch including his own is defined by a distinct aesthetic (this being the main thesis of his magnum opus *Epochs of Chinese and Japanese Art*, published posthumously in 1912). To him, the modern age, defined by the palpable intermingling of Japan, Europe, and the United States in the late nineteenth century, could be captured only by an aesthetic that denoted the same. Modern architecture, akin to the newly fashioned Nihonga (Japanese-style painting) that he was also promoting, would therefore need to eschew the historic and cultural specificity of European *and* Japanese classicism in order to express the new condition of cultural and scientific amalgamation. In his words: "in Art, as in civilization generally, the best in both East and West is that which is common to the two, and eloquent of universal social construction."[57] In contrast, Katayama, rather than denying the museum institution's European origins as Fenollosa wished, capitalized on its elite, imperial lineage, not separating the form from the function of the models he investigated in his trips abroad. Like Fenollosa, the architect framed the museum building not as an isolated phenomenon but as one intimately linked to contemporary developments and movements in Europe and the United States. In deliberately asserting contrast to the spatial-temporal particularism of the Nara objects and sites, the two experts, each in his way, sought a more appropriate expression of a modern age that partook of a culture of shared technological, institutional, and aesthetic concerns. After all, the museum, as institution and as architecture, unlike its ancient collection, was a product of this new age.

CURATING BUDDHIST ART: THE STAKES AND THE RAMIFICATIONS

On 1 May 1895, the Osaka *Asahi shinbun* announced the opening of the Imperial Nara Museum: "At last, the [Imperial Nara Museum] opened yesterday. The displayed objects were imperial calligraphy, sculpture, and paintings. Other objects belonged to the departments of Art Industry, History, etc. Important treasures and rarities abound, and an exceedingly large number of visitors were present."[58]

This concise paragraph reveals the classificatory structure in operation at the Nara museum. The collection was subdivided under the headings of imperial properties and the three curatorial departments of history, fine art, and art industry.[59] Although the objects fell under these official categories, they had only recently existed under different groupings, usually as part of a syntactic whole or network of icons at the temple or shrine

of origin. In order to realize the original premise of the museum's establishment, articles from local religious institutions dominated the collection. As a rule, published descriptions identified the proprietor of each work.[60] The museum obtained the right to exhibit such articles through at least three distinct channels—purchase, permanent custody, and temporary loan—under separate sets of terms and conditions. The difficult procedure of acquisition, a major factor in the logistics of establishing the Imperial Museums in Nara and Kyoto, had been given thorough consideration as early as 1888.

The majority of the clergy reacted to the activities of the Temporary National Treasures Investigation Bureau with animosity and mistrust. In Fenollosa's report on Nara temples, he describes the general obstinacy of the priests, some motivated by religious piety and others by personal avarice, in allowing the government representatives to examine their holdings: "as soon as the priests found out what was being done by [the investigation bureau], they shut up all their best things from view."[61] And in January 1895, when the *Kyōto Bijutsu Kyōkai zasshi*, the journal of the Kyoto Art Association (Kyōto Bijutsu Kyōkai), publicized the opening of the Nara Museum, it added the following comment:

> Rumor has it that the director general Kuki pleaded with the temples and shrines throughout the Yamato region to exhibit at the museum the eight-hundred-year-old treasures that they have been safekeeping, but institutions such as the Hōryūji and Tōshōdaiji which possess the largest number of ancient treasures have been stubborn and had to be asked repeatedly. They are afraid that when they exhibit [their treasured possessions] at the museum, the number of people who visit the temples and shrines will naturally decrease, and the offerings of money will be affected.[62]

The article concluded by criticizing the shortsightedness of such fears, for the benefits of depositing the objects in the museum—namely, state protection and subsidy—outweighed the perceived losses. And in time, the temples and shrines were persuaded. The same journal reported a favorable turn in the attitudes of local clergymen by the third year of the Nara museum's opening, and with their cooperation the museum was able to "tower over [*sobadatsu shite*] the Imperial Kyoto Museum in displaying the beauty of the art of [the] nation's ancient ages."[63]

What were the precise terms of exchange for the Imperial Museums and the religious institutions that relinquished objects to them? On 26 January 1895, the Imperial Household Ministry promulgated the Regulations for the Entrustment of House Treasures from Temples and Shrines (*Shaji jūhō shutaku kisoku*).[64] The regulations applied to the Imperial Museum at Kyoto and at Nara alike. Composed of fourteen articles, this document was above all an articulation of the provisos for monetary compensation to the temples and shrines. It can be summarized in the following three main points. First, all

costs incurred from the packing, shipping, and repair of the entrusted object would be paid in full by the museum. Second, all proceeds from museum ticket sales (minus the ticket production and handling expenses) would be distributed among the temples and shrines that entrusted objects to the museum. The amount of ¥1,000 per annum is guaranteed for distribution among the participating institutions. In the event that ticket proceeds alone cannot fulfill this minimum amount, the museum covers the difference as part of its expenses. Third, the exact amount of compensation an institution receives depends on the following variables: the number of object lots entrusted to the museum; the grade the investigation bureau originally gave to the object—"excellent" (*yūtō*), "fair" (*jitō*), or "on reserve" (*hōmotsu sankōbo ni tōroku*); and the number of months the object is on display at the museum. A separate set of regulations, the Regulations for Exhibition at the Imperial Nara Museum (*Teikoku Nara Hakubutsukan shuppin kisoku*), made a clear distinction between objects on display at the museum's request and those on display at the owner's request.[65] The latter class of objects would be packed and shipped at the owner's own expense (article 5), and the owner would be entitled to no compensatory claims in the event of natural disasters (article 6.2). Also, because no mention was made of the issue, no subsidies were likely given to voluntary exhibiters, even when their objects met the value criteria for exhibition at the museum.

Although the two sets of regulations cast the Imperial Museums mainly in a charitable light as the benefactor of Buddhist and Shinto institutions, they also disclosed some of the difficulties and inconveniences of obtaining the government subsidies. For instance, not all house treasures were deemed worthy of museum sponsorship, the deserving ones being those that met the investigation bureau's aesthetic standards and subsequently were invited for exhibition. And although the "entrustment" (*shutaku*) was voluntary, most temples had no alternative offer of financial assistance from the state.[66] In addition, once the object was surrendered, its preservation and display at the museum would supersede its original religious functions; article 12 of the entrustment regulations states that the subsidy will be reduced if an object returns home for more than two consecutive weeks for use in rituals. The entrustment of objects was a clear quid pro quo between the religious institution and the state, with the latter giving aid selectively to temples and shrines based on the aesthetic merit of their holdings, not on their financial need. The survival of insolvent temples, therefore, did not depend on their significance as spiritual centers for the citizenry but their potential as suppliers to the national artistic collection.

The decision to preserve the material holdings of Japan's religious institutions through the erection of the Imperial Museums in Nara and Kyoto was not motivated solely by the need to preserve ancient icons, as the official publications of their successors still maintain today.[67] If preservation had been the primary reason, then the government could conceivably have left the icons in situ and provided the individual

institutions with appropriate funds to exercise extra safekeeping and maintenance measures. Clearly, the symbolic prominence of a state museum that could assemble the prime religious holdings of the nation and present them all under one roof overwhelms practical considerations. More salient issues include the relations between state and religion (both Buddhism and Shinto) and between religion and art.

Nara, more than Kyoto, was dominated by religious collections, and the placement of Buddhist sculptures, paintings, and ritual implements in the Nara museum served at least two ideological ends for the Japanese government: it expressed official disapproval of the willful damage and destruction of temple property, and it initiated a cultural redefinition of Buddhism. Although the promotion of Shinto in the early years of the Meiji period resulted in the demotion of Buddhism, the government had not intended to effect the total eradication or banning of Buddhism in Japan. Even before the Meiji period, beginning as early as the seventeenth century, the school of thought known as National Learning (Kokugaku)—the same school that advocated the promotion of Shinto in the late nineteenth century—had expressed antagonism toward Buddhism as a foreign creed that sullied the "pure" mind-set and worldview of the ancient Japanese. Yet this nativist movement urged the separation of the two religions and an end to Shinto's subordination to Buddhism without overt mention of eradicating Buddhism (as Christianity was so decidedly and rigorously suppressed in Japan until 1873). One reason is that the historical Shinto-Buddhist syncretism of locations and divinities made the physical *and* mental dissociation of one from the other very difficult.[68] Even at the venerable Ise Grand Shrines, where there was a nominal ban on Buddhist rites, "recitation of Buddhist sutras before the altars of the *kami* was a common occurrence."[69] To quash Buddhism in toto was therefore neither feasible nor ever the official governmental stance.[70] The government expropriated temple lands and income, defrocked clergy, and reduced the number of temples but urged that the transactions be executed peaceably. Thus, the implementation of surveys of temples and shrines and the establishment of an institution to protect and preserve sacred Buddhist statues and implements enforced in no uncertain terms the Meiji government's desire to maintain peaceable relations with Buddhism. The surveys also presented a way to salvage the religion without implicating its sacred and devotional dimensions. Buddhism's power was to be reduced, but its history and cultural presence were not to be obliterated.

By placing Buddhist objects in a secular environment, the government was able to accomplish another ideological objective, that of initiating a cultural redefinition of Buddhism. Early-Meiji critics of this religion had seen it as corrupt, decadent, and alien as well as inimical to Japan's need for scientific and technological advancement. There were efforts from within and without the Buddhist community to rehabilitate the religion to suit the Meiji ethos privileging rational reason and pragmatism.[71] Just as Buddhist leaders tried to reconstruct their religion as a universal creed "purified of all supersti-

tious accretions . . . and in full accord with the findings of modern science,"[72] the government re-presented Buddhist objects as works symbolic of Japan's national culture and for the secular gaze. In the pre-Meiji periods, to regard Buddhist relics as purely aesthetic works was considered sacrilegious; the intensity of this shared understanding had prevented even the most avid art collectors from trafficking these items and made their acquisition for secular purposes impossible.[73] After the religion lost the state as its promoter, however, this belief no longer held true. In 1878, the Imperial Household led the way in the secularizing and aestheticizing of Buddhist objects by accepting a group of more than three hundred items from Hōryūji, consisting of religious icons, paintings, sutras, and implements as well as a variety of secular accoutrements; in exchange, it granted the temple ¥10,000 for much-needed repairs.[74] When the museum designed by Josiah Conder was completed in 1882, the Hōryūji treasures were transferred to Ueno Park in Tokyo. Like the Shōsōin treasures, which fell under the management of a series of government ministries after the 1870s, the Hōryūji treasures gained an unprecedented visibility in the public eye after the state offered protection, took possession, and displayed them, always out of their original contexts. The virtual sale and exhibition of Buddhist art eroded the spirituality that once empowered them absolutely, and they took on another layer of meaning as objects of aesthetic, historic, and educational value. In an age that placed a premium on the empirical sciences and industrial technology, the humanizing and rationalizing of Buddhism were requisite tactics for the religion's survival.[75]

A MODERN VISIBILITY

On the space of the museum in general, Eilean Hooper-Greenhill has pointed out the following:

> The primary feature of [museum] display as a mode of transmission is that it is structured on the principle of visibility. Objects are laid out so that they can be seen. . . . The visible features of the objects are the most important and other features of them, their use, their history, how they would look in motion, etc., are all difficult to portray. Display is static and timeless. Time is not a feature of most museum displays, in that the effects of time are minimized, and indeed often disguised or denied. The objects are not perceived in space and time, so that only a very limited experience of them is possible. The visible itself is often only a limited visibility.[76]

The opening of the Imperial Nara Museum created two new values: the encounter with religious objects shaped as a predominantly visual event and the presentation of this event as something entirely new, unrelated to existing traditions. Not only were the

objects in the museum "laid out so that they [could] be seen," but this venue promoted permanence, accessibility, and clarity of vision, in marked contrast to the comparatively transient and secretive displays at the Edo-period unveilings and airings. When not the focus of a special unveiling, icons housed inside temples were constrained by even more conditions inhibiting visibility, such as liturgical and doctrinal specifications. One category of sacred icons known as *hibutsu* (secret buddhas) was by definition on display very rarely or never at all (some famous examples being the Nyoirin Kannon at Kanshinji and the Amida triad at Zenkōji). The physical removal of the icons and treasures from their customary religious environment was accompanied by their metaphorical displacement through the museum's invention of new categories, value criteria, and architectural setting for them. In addition to centralizing disparate properties under one roof, the museum reformed them as a new, unified, national collection. The Nara Museum's distinctively modern, Western architecture prominently signaled its status as a space and an encounter set apart from neighboring religious institutions, even, or especially, those that originally housed the objects.

Yet did the establishment of the Nara museum in effect separate art from belief? Were the religious objects on display presented exclusively as art treasures of the nation, as Fenollosa had evaluated them during the investigation bureau surveys? The museum indeed facilitated a connoisseurial appreciation of the objects by emphasizing their provenance, make, and subject. Unlike the liturgically hierarchic space normally found inside a temple's main hall, where a primary icon, or *honzon*, presided over a room of subsidiary deities emplaced in order to evoke a meaningful schema for the believer, the museum space privileged the historicity and materiality of each buddha, bodhisattva, and guardian king. A diagram of the exhibits in the central hall of the Nara Museum in 1925, for example, shows a roomful of sculptures unified by chronology—the Suiko, Hakuhō, and Nara periods (fig. 5.17).[77] The icons, all Buddhist, originated from various institutions and stood in the museum in unconventional groupings and orientations. All statues were placed along the perimeter of the room, facing in toward the center of the room, as best to facilitate unobstructed views of each statue for visitors. In one corner, placed side by side on the same platform, were Amida, Shaka, Ashuku, and Hōshō, four buddhas not known to exist as a religiously meaningful group; in another corner, also placed side by side in linear fashion, were the Shitennō (Four Guardian Kings), a potent group inside Buddhist halls when each is placed to correspond with the cardinal direction that he protects. A second set of Shitennō, also impotent in single file, stood along another wall of the same room. In addition, statues of two Guardian Kings, Tamonten and Jikokuten, formed part of a miscellany of six icons immediately in front of a complete set of Shitennō. Room 2 held another prominent example of iconic replication, with six different statues of the Jūichimen Kannon (Eleven-headed Kannon) on display.[78] As this brief assessment indicates, the museum's display invited scrutiny and

5.17 Nara Imperial Household Museum, plan of the central hall (room 1), showing layout of exhibition. *Nara Teishitsu Hakubutsukan o miru hito e* [Guide for visitors to the Nara Imperial Household Museum] (1925). Courtesy of the Library of Congress.

comparison of the material evidence of different epochs, different artisans, and different sects of believers. Belief itself was not being facilitated.

But what of Hooper-Greenhill's assertion that "the visible itself is often only a limited visibility" in the space of the museum? As Sugimoto's paintings suggest, the dialectics of visibility emerge in the experience of the Imperial Nara Museum. If visual access is what the museum provides, then why is the Buddhist statue not in clear view? On one level, limited visibility refers to the static state of display, which privileges a particular view as frontal or confines the object within a finite framework (in the case of Sugimoto's *Center of the Museum* [see figure 5.2], the very bars of the display case fragment and obscure the totality of the statue). On another level, the museum denies the object the opportunity to perform its original designated function, it denies the other senses in the visitor's interaction with the object, and it denies the history that has accumulated within and around it. The buddha stands alone in the center of the museum without the smoky fragrance of incense swirling around it, without the company of its divine entourage, and without any overt suggestion of its spiritual potency. The full gamut of its properties, therefore, is not revealed in this limited view.

The modes of presentation at the temples and at the museum were as similar as they were different, and to conceptualize the two as opposing spaces would be positing a false dichotomy. For the 1875 Nara Exhibition, the main icon of Hōryūji, the Yakushi Buddha, was relocated from this institution's Golden Hall (Kondō) to the Great Buddha Hall of the Tōdaiji. For the duration of the secular event, this bronze statue, set alongside nonreligious items, served as an example of ancient bronze casting and an old national artifact.[79] When the Imperial Nara Museum opened its doors for the first time in May 1895, many of the major temples and shrines of Nara—including the museum's immediate neighbors, the Kasuga Shrine, the Tōdaiji, the Kōfukuji, and the Shin Yakushiji—also held viewings of their house treasures in their respective precincts. Organized by their host institutions in conjunction, not in competition, with one another, the collective showings provided a comprehensive visual presentation of the area's cultural riches for the visitor, who the organizers anticipated would go without bias to temples and museum alike. Concurrently, in nearby Kyoto, where display culture was reaching fever pitch at the Fourth National Industrial Exhibition, the temples and shrines also seized the opportunity to present their treasured objects, not just for one day but for the duration of the industrial exhibition. With this coordinated display, museum and temple functioned in unison to create a unique visual culture for the Kinki region.

Thus, the categories of religious icon and art treasure were not necessarily mutually exclusive or irrevocable. Just as "Buddhist icons used as the focus of ritual and devotion . . . had not been the objects of art collectors' interest before the Meiji period" and "commerce in Buddhist art was virtually unknown," the willingness and eagerness of Meiji-period Japanese art collectors to change their attitudes and purchasing habits signaled an existing appreciation of the aesthetic qualities of religiously purposeful objects.[80] Moreover, instances of icons being desacralized and then re-sacralized, passing from temple to museum and back to temple, have also been recorded.[81] The fluidity between the spaces of the temple and the museum reinforced the visibility of the icons as material reality. The icon's transition from temple to museum, as noted earlier, was not necessarily permanent; furthermore, the object did not move far from its original home. (Most recently, an eleven-foot-tall Yakushi Buddha, the main icon of the Tōshōdaiji and a National Treasure of Japan, was the key attraction in the central atrium of the Nara National Museum for six years while awaiting the completion of repairs to the temple's main hall; the statue returned safely home in July 2006.) True to the premise of its establishment, the Nara museum could be distinguished from the museum in Tokyo by this very physical proximity to these icons and their sources. The objects had not been irreparably severed from the ancient and religious aura of the old capital, and to this day they have not lost their identity as Nara-area treasures.

6 · The Hyōkeikan Art Museum

Debating the Permanent Place of Art

That day my father took me to the Hyōkeikan at Ueno. . . . We both entered the upstairs hall.
There hung in succession ten pieces or so by Ōkyo which formed one sequence; the one on the
extreme right represented three cranes, and another on the extreme left, just one crane on
spread wings, and the whole space between, about four or five yards in distance, was filled
with waves.

* "They were stripped off sliding panels and made into hanging scrolls, I gather."*

* My father pointed out to me, on each piece, the worn marks of handling and white spots*
where the catch had been removed. Standing there in the middle of the hall, I learned from
my father for the first time how to admire the Japanese artist of olden times who had created
these magnificent paintings.

<div align="right">

—Natsume Sōseki, *The Wayfarer (Kōjin)* (1912–13)

</div>

The intersection of two previously unrelated events in the year 1900—the marriage of Crown Prince Yoshihito (1879–1926), the eventual Taishō emperor (r. 1912–26), and the reorganization of the Imperial Museums as the Imperial Household Museums—led to the opening of a permanent art museum in Tokyo's Ueno Park. The new building, named the Hyōkeikan (fig. 6.1), literally, "Hall of Celebratory Expression," was conceived in commemoration of the royal nuptials. Upon completion in 1908, it was officially entrusted to the administration of the newly reorganized Tokyo Imperial Household Museum (formerly the Imperial Museum in Tokyo) for use as an exhibition space devoted exclusively to its art collections. While this satisfied the definition of a museum of art on the most fundamental level, it fell short of demands from constituents of the Tokyo art world (administrators, artists, educators, critics, and promoters) that originally propelled the creation of a permanent and exclusive venue for art exhibition. These demands called for an altogether new type of institution—a *bijutsukan* (美術館), or art museum, distinct from the existing *hakubutsukan* (博物館), or museum, model.

Up to the end of the nineteenth century, the label *bijutsukan* referred to spaces for transient exhibitions. Most prominently, a *bijutsukan* stood as the central architectural

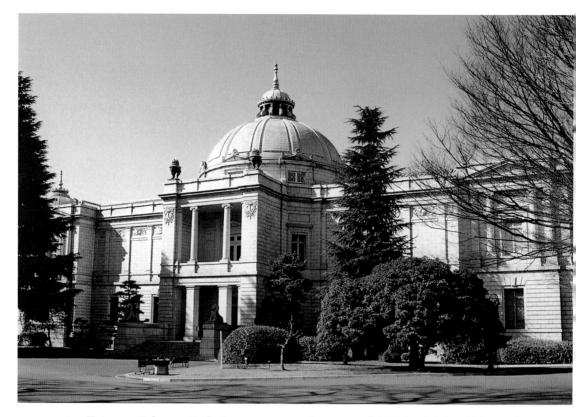

6.1 Katayama Tōkuma, Hyōkeikan art museum (now part of the Tokyo National Museum), Tokyo, 1901–8. Important Cultural Property. Photograph by the author.

feature at each of the National Industrial Exhibitions, acting as the focal point by embodying the ideals of newness and innovation in exhibition learned from the West. In chapter 2, *bijutsukan* is translated as "art gallery," after the original Meiji-period English-language catalogs provided at the National Industrial Exhibitions.[1] The term "gallery" is appropriate for buildings that preceded the Hyōkeikan, especially in light of attempts to shift the meaning of *bijutsukan* from the sense of temporary quarters to that of permanent institution in early-twentieth-century Tokyo. The distinction, put in terms of current English-language usage, corresponds to a shift from art gallery to art museum, from show-and-sell to show-and-tell. Even if no actual money-for-object exchange took place inside the *bijutsukan* at the exhibitions, the objects served as samples destined for future sale. The same did not apply to art museum pieces, which entered the collection to instruct and to be preserved.

The redefinition of *bijutsukan* as "art museum" solidified around the Hyōkeikan's merging with the Tokyo Imperial Household Museum. In attaining stable status, it presented a new construction of a *bijutsukan* that operated closely within the boundaries

and values of the existing museum system. The physical separation of art from the other museum classifications (history, art industry, and natural products) demanded changes to the position it had originally occupied in the larger museum scheme, especially its hitherto tangled relationship to industry.

This chapter examines the role of architecture in demarcating the perimeter of *bijutsu* as a stand-alone classification, by taking into close consideration the specific circumstances surrounding the creation of the Hyōkeikan, the nation's first permanent, purpose-built art museum. Its location adjacent to the main building of the Tokyo Imperial Household Museum deflected its architectural kinship with the crown prince's palace, which was simultaneously under construction and supervised by Katayama Tōkuma, in another part of Tokyo. In many ways, the Hyōkeikan's unofficial status as an extension of the palace overshadowed its obligation to innovate a new type of space exclusively for art display. A perfunctory transfer of the Tokyo Imperial Household Museum's collection, as if the Hyōkeikan were no more than a means of remedying a space shortage, would further deflate the ambition to invent an unprecedented institution, an art museum.

CHANGING DEFINITIONS OF ART

In 2001, the Tokyo National Museum and the National Museum of Modern Art, Tokyo, organized the special exhibition *Reading the Art Museum: Hyōkeikan and the Art of Today*.[2] The accompanying catalog of the same title and the concomitant symposium *From the Perspective of the Hyōkeikan: Art/Exhibition Today* identified the Hyōkeikan as the point of origin for Japan's modern public art museums, it being the first permanent, purpose-built structure for art display in the nation and the oldest extant example of such a space today. In other words, while earlier displays occurred in adapted or makeshift spaces, fixity and singularity of form and function distinguished the Hyōkeikan. Yet, despite conceding its archetypal status, participants and organizers of the 2001 exhibition candidly posited the structure as a problematic model. To them, its ineffectiveness was due to its detachment from its contents and its failure to illuminate art in a distinctive light. In one catalog essay, the author seizes on this incongruity as the paradox of the archetypal art museum of Japan, unceremoniously dubbing it a "shallow" (*hori no asai*) and "nebulous" (*sanman*) space; she implicates the invisibility and impotence of the very thing—art—within its customized setting.[3] While the critique suggests a stable category of objects compromised by the unstable spatial articulations of the building, such a portrayal defies the historical circumstances behind the creation of the Hyōkeikan. In 1900, the terms *bijutsu* and *bijutsukan* were no longer neologisms, yet each was to some extent unfixed in form and meaning. The answers to the questions of what qualified as art and how it should be displayed varied from expert to expert,

depending on his bias as an artist, educator, or administrator. The social function of art, and, by extension, the art museum, was up for debate.

As discussed in chapter 1, the need to facilitate diplomacy and trade with Euro-American nations led Japan to reorganize the arts in correspondence with Western standards. The umbrella term *bijutsu*, covering painting and sculpture, was created to coincide with the European concept of the fine arts, which privileged the expression of noble ideas over mere technical dexterity or usefulness. Such a separation between the fine and the useful arts had not existed in Japan before the Meiji period. According to Satō Dōshin, before the term and concept of *bijutsu* were coined, the majority of artistic pursuits fell under the heading of *kōgei*, or "industry." Both Satō and Kitazawa Noriaki emphasize that unlike the other art-related terms, *kōgei* was not a neologism of the Meiji period but had a much longer history, originating in China as far back as the Tang period (seventh–tenth century).[4] Satō's and Kitazawa's findings on the etymology of the term *kōgei* are essential to an understanding of its symbiotic pairing with the term *bijutsu* in the Meiji period. Before the Meiji period, the category of *kōgei* encompassed a wide range of skilled arts, including painting (*gakō*), carving (*chōkō*), potting (*tōkō*), lacquering (*shikkō*), weaving (*shokkō*), woodworking (*mokkō*), stoneworking (*ishiku*), and metalworking (*kinkō*), each referring to a specialized set of skills, techniques, and materials for artistic production. In the first decade after the Meiji Restoration, painting and carving were extracted from the group to fulfill the new fine art concept of *bijutsu*, leaving the rest to remain under the classification of *kōgei*. It was during this time that the term *kōgei* took on an additional definition, related to industry, when *kōgei* was cited as a major focus in the establishment of the Public Works Ministry in 1870. From then and into the 1880s, the terms *kōgei* (工芸) and *kōgyō* (工業) were used interchangeably, when hand production predominated in the manufacturing industries. The successful implementation of modern mechanized industries in the 1890s effected the separation of the two into our current understanding of the terms: *kōgei* meaning the production of objects individually by hand, and *kōgyō* meaning the mass production of objects by machine.

Kōgei existed as a department or classification in museums, exhibitions, and art schools in the late 1880s. In the Imperial Museums, *bijutsu*, *kōgei*, and *bijutsu kōgei* formed three discrete departments; the museum director Kuki Ryūichi conscientiously affixed the English translation words "fine art," "industry," and "art industry" to these three headings in his 1889 proposal for the museums (Kuki's use of "industry" for *kōgei* is practiced throughout this book). A simultaneous split and re-merger of art and industry were written into this set of terms. The Tokyo School of Fine Arts featured a similar affirmation but distancing of *kōgei* as a discipline by having the three curricular departments of painting, sculpture, and art industry. Not an assorted collection of distinct art and industry objects, the art industry department comprised commercial

manufactures that approximated the aesthetic of finer, unique artworks. Yet art industry objects did not aspire to be fine art, for replicability and marketability were key to their production.

The scholar Hino Eiichi has traced the history of the changing meaning of the term *bijutsu kōgei* in the period between the 1873 Weltausstellung in Vienna and the 1900 Exposition Universelle in Paris.[5] Throughout the three decades, the intersecting efforts of the Agriculture, Home, and Imperial Household Ministries propelled the specialization of the categories *bijutsu* and *kōgei* to better reflect a national advantage for Japan at the international expositions. While Meiji Japan entered the world market through its practical art objects, eliciting much Western interest with the barrage of gold lacquer, porcelain, bronze, ivory, and bamboo wares, its fine art objects, also composed of carved or painted objects, were simultaneously denied entry into the fine arts pavilions of the same expositions. The Japanese were not the only ones undecided on the distinction between art and industry, for these classifications were themselves in flux in the West. No readily available heading captured the unique characteristics of Japanese works, which had previously made no strict differentiation between pure and practical art objects. The compound term *bijutsu kōgei* first appeared in 1885 to draw attention to the high artistic quality of production distinctive to Japan's decorative ceramic, lacquer, and cloisonné wares.

The admittance of both *bijutsu* and *bijutsu kōgei* works into the Palace of Fine Arts at the 1893 World's Columbian Exposition (see fig. 4.24) marked a high point of national achievement for Japan. The Japanese Commission had classified its art-related exhibits for this exposition into three categories: "ordinary commercial objects" (*futsū shōhin*), "art industry objects" (*bijutsu kōgeihin*), and "art objects" (*bijutsuhin*). While the distinction between the objects in the first and second categories were vague, both being functional goods marketable to the West, the third category, art objects, was defined as things "not conforming to popular Western taste" that "represented the unique artistry of our nation."[6] This time, the criteria for differentiating art and industry were uniqueness as well as authentic Japanese taste. Here, art industry could act as the mediating category that channeled the most palatable Japanese motifs into popular production.

The main motivation for disrupting the existing classification system of art and manufactures at Chicago was the desire to capture even more national and commercial publicity.[7] Not only was it a matter of national pride and significance that a group of Japanese artworks be admitted to the Palace of Fine Arts, side by side with the fine arts of England and France, the fact that very little appeared to differentiate the Japanese cloisonné, ceramics, and ivory in here and the those on display at the Manufactures and Liberal Arts Building must have greatly boosted the sale value of those already popular wares, which comprised a large portion of Japanese exports at the time.[8]

The unprecedented bending of international, or Western, rules made a deep impres-

sion on Japanese and American commentators alike. In the words of a reporter for the *Kyōto Bijutsu Kyōkai zasshi*:

> It is not that our nation has no art [*bijutsu*], but that Europeans and Americans operate from the bias that outside of [their] oil painting and sculpture there is no art in other parts of the world. But this time at the request of our representatives at the Chicago exposition, they have made the special exception for our nation to expand their categories so that Japanese artworks could be exhibited at an international exposition for the first time.[9]

In contrast, William Walton, author of a guide to the art and architecture of the exposition, observed that "Exposition authorities abandoned the system of classification which holds good everywhere else and allowed these antipodes [the Japanese] to confound things according to their own ideas." His irreverent tone notwithstanding, the author concedes that the "paintings, sculpture, carvings, ceramics, and textile fabrics, [were] all presented together, with a resulting effect as strange as it is admirable."[10] The recognition of Japanese works of art as on a par with the best specimens of Western works of art did not rely on a reevaluation of the inherent merit of the former. Underlying the statements by the Japanese reporter and the American author was the common sentiment that Japan must be acknowledged as different but equal, as a nation that merited an exception to the existing Western hierarchy. Significantly, the aim was not to condemn that hierarchy or propose an alternative fully independent of it; the Japanese Imperial Commission desired to keep it intact insofar as the nation could benefit from it effectively.

Tateno Gōzō, the Japanese minister to the United States at the time of the fair, also saw his nation's exhibits as a way to give an international audience "a more accurate and complete knowledge of [his] country, its history, its progress and its aspirations."[11] This keen manipulation of art display criteria at Chicago reflected equally the larger effort of the Imperial Commission to sway Americans' perception of Japan for political gain. Japanese exhibits at this fair, as argued by Lisa Langlois, effectively impelled simultaneous petitions for the renegotiation of the unequal treaties originally signed in the 1850s.[12] As Tateno concludes in no uncertain terms in his essay for the *North American Review*, " . . . above all, [my Government and my countrymen] hope that what they will do on this occasion will bring them into closer contact with intelligent, thinking people, and will prove that Japan is a country worthy of full fellowship in the family of nations, no longer deserving to labor under the incubus which circumstances forced upon her."[13] Once again, art was being placed squarely within the political order of the day, as stand-in for the nation and as trope for progress and enlightenment.

SHIFTING PLACES FOR ART

The notion of *bijutsukan* to mean a discrete building type, a space set apart for the display of *bijutsu*, has been introduced in chapter 2, in the discussion of the two structures designed respectively by Hayashi Tadahiro and Josiah Conder for the first two National Industrial Exhibitions, in 1877 and 1881.[14] As a label, the term *bijutsukan* was initially attached to buildings that served the purpose of art exhibition only for the duration of the fairs. Although both buildings remained in service to the Museum in Ueno Park after the fairs, they were no longer identified as *bijutsukan* nor did they display art exclusively. The Hyōkeikan was distinguished from these earlier *bijutsukan* in that it was intended to be a museum of art in perpetuity, in name and in function. As a building, it asserted an unprecedented spatial independence from history, industry, and science. Yet curiously, no corresponding clarity of vision developed regarding the art to be housed, neither at the birth of the project nor at the completion of the building. This conceptual indeterminacy would be the greatest flaw in the creation of the Hyōkeikan.

In the mid- to late-Meiji period, at the turn of the century, *bijutsu* was on display at roughly three types of public venues in Tokyo: the Imperial Museum, the National Industrial Exhibitions, and exhibitions organized by art associations. They converged physically in Ueno Park, the location where art events were frequently scheduled to occur simultaneously. Although all three included displays labeled as *bijutsu*, each in effect presented a distinct body of works.

The Fine Art Department of the Imperial Museum in Tokyo on the whole concentrated on the traditional art forms, secular and religious, made prior to the Meiji Restoration; these objects were at the time generally referred to as "old art" (*kobijutsu*). A breakdown of the department holdings in 1897 shows that more than 80 percent of the fine art collection consisted of paintings; the other four subsections, in descending order of the size of the holdings, were sculpture, "photographs and prints" (*shashin insatsu*), "calligraphy" (*shoseki*), and "architecture" (*kenchiku*).[15] Examples of significant works acquired during this time include Tosa Mitsunobu's portrait of Momonoi Naoaki, Soga Shōhaku's Pine and Crane screens, and copies of pre-Meiji Buddhist icons by Meiji sculptor Takeuchi Kyūichi. The Fine Art Department occupied a suite of connecting rooms on the second floor, with objects grouped by medium or type in each room.[16] Within the building, fine art objects were usually placed in closest proximity to the art industry displays (and farthest away from the fossils and minerals of the Natural Products Department).

At the first three National Industrial Exhibitions, all held in Ueno Park, *bijutsu* was a major classification and each time was housed in its own building.[17] What were con-

6.2 Watanabe Nobukazu, *The Third National Industrial Exhibition*, 1890. Woodblock print. View of interior showing a visit from the imperial family and its entourage. Museum of Fine Arts, Boston, Jean S. and Frederic A. Sharf Collection. Photograph © 2006 Museum of Fine Arts, Boston.

sidered separately as art, art industry, and industry at the Imperial Museum were freely integrated under the *bijutsu* heading at the exhibitions. For example, at the first exhibition, the subdivisions were sculpture, painting, engraving and lithography, photography, industrial and architectural design, and ceramic and vitreous decoration. The second and third exhibitions remained faithful to this order of classification. In line with the aim of promoting industry, the displays were largely new production (not old works, like those in the museum) identified by their place of origin, maker, and sale price. A contemporaneous description provides some insight into the type of objects and their arrangement inside the 1877 Art Gallery: " . . . we perceive that the general arrangement followed has been to cover the walls to quite a hight [*sic*] with paintings, while the vacant spaces of the floor are occupied by glass cases and cabinets, where a precious miscellany of lacquer, bronze, porcelain and classless 'curios' are exhibited, safe from the too

inquisitive."[18] The same reporter saw only a few examples of antique lacquer and textiles, on loan from the museum, and discovered mostly modern, innovative pieces such as hanging scrolls decorated with colored photographs instead of the traditional panels of silk or paper as well as oil and crayon paintings representing Japanese subjects. Woodblock prints by Utagawa Hiroshige III and Watanabe Nobukazu, showing the art displays at the First and Third National Industrial Exhibitions, respectively (see figs. 2.4, 6.2), depict similar jumbles of paintings and pots clustered in the open interiors, with no spatial differentiation to indicate old and new production. In both prints, the profusion and diversity of objects impede a clear view of individual pieces for the visitor—especially in the case of the scrolls left in their furled state inside the vitrine. The showing of national abundance appears to overwhelm the showing of art at these exhibitions.

"Art associations" (*bijutsu dantai*) were another key channel for fostering new art

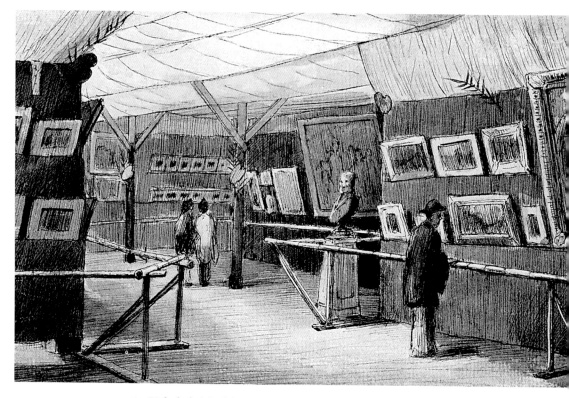

6.3 Hakubakai (White Horse Society) art exhibition, Tokyo, 1898.
Wandlungen im Kunstleben Japans (1900). Courtesy of the Library of Congress.

in late-Meiji Tokyo.[19] As organized societies of practicing artists, art associations were the modern successors to traditional schools of painting, or *ryūha*, which previously structured the interactions of artists of similar training and practice. The Meiji-period art associations organized around two major types of painting, Yōga (commonly translated as "Western-style painting") and Nihonga (commonly translated as "Japanese-style painting").[20] In the main, the category of Yōga referred to Western-influenced oil painting, and Nihonga referred to Sino-Japanese ink painting. By the 1880s and 1890s, subfactions were forming within each main category, and dissenters reorganized as new associations; nonetheless, all major groups, old and new (e.g., Ryūchikai [founded in 1879], Kangakai [1884], Nihon Bijutsu Kyōkai [1887], Meiji Bijutsukai [1889], and Hakubakai [1896]), received the firm backing of a government ministry. The associations held regular exhibitions of their works and included examples of old and foreign works for the purposes of educating and stimulating their members (fig. 6.3). The majority of the meetings and exhibitions convened in Ueno Park, and two buildings in particular were in constant demand as gallery spaces for the art associations.[21] Erected as Building Two and Building Four for the Second National Industrial Exhibition, these structures were reused as

Building Three and Building Five in the Third National Industrial Exhibition in 1890; subsequently, they were saved from demolition in order to fulfill the growing space demands of smaller-scale art shows. Since they were originally intended as transient structures for showcasing the greatest possible assortment of manufactures and industrial products, the two buildings, identical in size and design, were nothing more than wooden sheds with vast, undivided interiors. As gallery spaces available for rent to the art associations, the same quarters served as backdrop, making no special concession to the particular style or scale of the paintings or sculptures being put on display. Each showing by an art association, in contrast to the museum or industrial exhibitions, presented a rare homogeneity of works unified by style and technique.

EARLY PROPOSALS FOR THE DEDICATORY ART MUSEUM

While the term *bijutsu* was a recognized label by 1900, its definition was varied, as were the corresponding exhibition requirements. Tokyo at this time was brimming with ideas for art exhibitions but was short on available spaces. A jumble of diverse interests inside *and* outside the perimeter of the art world appear to have fueled the creation of permanent architecture for *bijutsu*. According to Furuta Ryō's critical examination of the history of the Hyōkeikan, the announcement of the crown prince's engagement in February validated rather than spurred the creation of an art museum. A committee representing the citizens of Tokyo assembled the next month to decide on the type of building to erect in celebration of the imminent royal nuptials, and Furuta does not credit this committee with originating the direction of the project:

> The official report issued by this committee does not make any mention of the reason why an art museum was chosen. According to an article which appeared in *Bijutsu hyōron* [Art Criticism] at that time, there were other ideas such as dedicating a chamber of commerce, a library, or a public hall. The matter was discussed among the committee consisting of fifteen members including Senke Takatomi, governor of Tokyo prefecture; Matsuda Hideo, mayor of Tokyo city; [and] Shibusawa Eiichi, president of the Tokyo Chamber of Commerce ... and the final agreement they reached was to build an art museum. The fact that it took only four days to reach this conclusion shows that there was no conflict of opinion. To put it another way, it could probably be said that rather than thinking of what to do in honor of the imperial engagement, there was already a preceding idea of building a new art museum. . . . It was no longer just a few people in the art world that were dissatisfied with the repetition of a temporary "art museum" emerging whenever a national exhibition was held. Not only the general populace of Tokyo but even the politicians and businessmen recognized the construction of a permanent art museum as an urgent necessity.[22]

The dearth of substantial records on the decision-making process bars a more insightful analysis than what Furuta has provided, yet it is possible to infer that the dedicatory art museum project was generated exclusively in and for the city of Tokyo, where the general mood was in favor of an independent, institutional structure for art. To push the inference further, the project appears to have been predicated on the belief that the structure would legitimize the contents, rather than vice versa. This is an important distinction that marks the project's divergence from the art museums emerging concurrently in other nations, the majority of which were being driven by an existing collection or a firm ideology about the collection to be formed.

After the Imperial Household Ministry sanctioned the proposal on 7 May 1900, and monetary contributions, coming mainly from private citizens, companies, and organizations in Tokyo, reached the target amount of ¥400,000,[23] the committee agreed to the following major resolutions on 27 October: to place the art museum in Ueno Park, to assign the architectural design to Katayama Tōkuma,[24] and to entrust the supervision of the construction to the Imperial Household Museums director general, Matano Migaku. Two months later, the committee determined the exact location of the art museum—on the grounds of the Tokyo Imperial Household Museum, in the space adjacent to the main building designed by Conder. Not until the completion of construction in 1908 was the building formally named the Hyōkeikan and placed under the administration of the Tokyo Imperial Household Museum.

Three major art-related events that occurred in and around Ueno while the Hyōkeikan was under physical construction, between 1900 and 1908, influenced its ideological construction.

First, the reorganization of the Imperial Museums as the Imperial Household Museums in 1900 reinforced the institution's association with the imperial household and at the same time diminished its responsibility to the general public. Unlike the Imperial University, the Imperial Library, and the Imperial Diet, the Imperial Museums did not fall under the jurisdiction of the cabinet government, and the change of name from Imperial Museum to Imperial Household Museum properly registered this difference. The collection narrowed its focus on history and art by abolishing the Industry Department and continuing to maintain its distance from the Natural Products Department, now segregated in its own building.[25] Practical trades and industries of nation building were no longer a direct concern of this museum.[26] Preservation had clearly taken precedence over practical application and education. Even schoolchildren were charged admission for the first time.[27]

Second, the Imperial Museum's compilation of a written history of Japanese art, at the request of the Agriculture and Commerce Ministry, for the 1900 Exposition Universelle in Paris set the precedent for structuring a comprehensive overview of the subject. The French translation, *Histoire de l'Art du Japon*, was published in the original

6.4 Cover, *Histoire de l'Art du Japon* (1900). Courtesy of the
Fine Arts Library, Harvard College Library.

Japanese as *Kōhon Nihon Teikoku bijutsu ryakushi* in 1901. This work covered the full
historical range from the prehistoric to the recent Tokugawa period (fig. 6.4). Yet the
history revolved around objects in the Imperial Museums as well as the findings of the
Temporary National Treasures Investigation Bureau, its antiquarian and religious pref-
erences constituting the umbrella definition of Japanese art. The book confirmed the
museum's art as the nation's art. The international and national reach of this publication
cannot be underestimated, for, in addition to the French and later English translations,
no fewer than four editions, including abridged versions, were printed in Japan within
the last decade of the Meiji period (and continued to be published into the succeeding
Taishō and Shōwa periods).

 Third, the Ministry of Education Art Exhibition (Monbushō Bijutsu Tenrankai), or
Bunten for short, was first held in Ueno Park in 1907, opening an officially sanctioned
forum for the showing of new art. The Japanese answer to the Paris Salons, the Bunten

6.5 Masthead, *Bijutsu shinpō* [Art news] (5 June 1909).

was an annual government-sponsored event open to all artists and assumed the important distinction of being the first exhibition in the Meiji period to reflect the government's new policy of treating art independently from industry.[28] According to Omuka Toshiharu, the establishment of the Bunten "stood as the last phase of modernization and reorganization of the whole art world," a process that began with the establishment of the Imperial Museums and the opening of the Tokyo School of Fine Arts in 1889. After the establishment of the Bunten, Omuka believes, "the whole new system functioned from 1907 as a securely based art establishment."[29] The official exhibition represented the last piece of the master plan for art administration originally envisioned by Kuki, Fenollosa, and Okakura in the mid-1880s. It asserted control over the development of contemporary art through the provision of delimiting categorization (Japanese-style painting, Western-style painting, and sculpture) and influential judging (attended by frequent accusations of favoritism and corruption). As expected, great prestige and controversy surrounded this annual event, which both guarded and steered national art.

These three major occurrences all contributed to the formalization of art in one way or another. As the Hyōkeikan was under construction, thoughts naturally converged around the *type* of permanent space for art that was most urgently needed in the nation's capital. The new art journal *Bijutsu shinpō* (Art news), which had just begun circulation in March 1902, meticulously chronicled the hot topic (fig. 6.5). Some of the most commanding figures in the art world voiced their opinions in the pages of this bimonthly

publication. Their lines of reasoning all conspicuously engaged a mix of art, nation, and diplomacy. Specifically, their propositions were supported by a shared premise, the need to identify several distinct Western art display models for consideration and to select the one most appropriate to current needs. In their essays, published in the period between 1902 and 1906, Masaki Naohiko, Hayashi Tadamasa, and Taki Seiichi presented three major options for consideration.

Masaki Naohiko (1862–1940), at the time the director of the Tokyo School of Fine Arts, penned an essay outlining what he classified as the three existing types of "museums of pure art" (*junsei bijutsu sakuhin no hakubutsukan*) in the West.[30] The first type of museum, like the Louvre of Paris and the National Gallery of London, display authentic works of recognized merit so as to showcase a nation's—or, most commonly, the royal family's—collected treasures; the second type, like a number of metropolitan art museums in the United States, display both originals and copies of masterpieces in order to illustrate the complete historical lineage of artworks; and the third type, like the Luxembourg Museum in Paris, display works by living artists and thereby encourage the creation of new art. Not surprisingly, Masaki, who headed the nation's preeminent art school, believed that the second type of museum, essentially a teaching museum, should be given priority. He argued that it was the most advantageous option for the overall preservation and promotion of art in Japan because it not only would complement the trio of Imperial Household Museums, which already functioned as the first type of museum in showing art treasures, but also would elevate the quality of works exhibited in the third type of museum by providing a fertile, comprehensive resource for educating and inspiring practicing artists. In his mind, some of the distinct advantages of collecting originals as well as copies included the opportunity to present a complete historical sequence, the centralization of a large group of masterpieces that would otherwise be dispersed in disparate locations, and the potential of introducing a collection of Western art. Masaki identified these aspirations as especially beneficial to art scholars and students residing in Tokyo. To him, Tokyo was no match for the Kinki region in terms of concentrated artistic wealth; no longer would they need to make the expensive and time-consuming trip south to study all the greatest works if a visit to the local art museum could offer a comparable experience. Masaki wanted to bring the masterpieces of Kyoto and Nara to Tokyo in the same way that the masterpieces of Europe had been brought to the United States by means of plaster casts and copies.

The art dealer Hayashi Tadamasa (1853–1906), whose strong Parisian connection had recently garnered him the prestigious post of *commissaire général* representing the Japanese government at the 1900 Exposition Universelle,[31] articulated his idea for a permanent art museum in Tokyo in a speech given at a meeting of the art association Nihongakai.[32] Hayashi looked to the contemporary French Salons as the best model for Japan to emulate and testified to the efficacy of the recently constructed buildings, the

PARIS — Le Grand Palais - L. D.

6.6 Postcard of the Grand Palais, Paris. Collection of the author.

Grand Palais and the Petit Palais designed by Charles-Louis Girault (fig. 6.6), as permanent exhibition structures for the art shows.[33] He emphasized the importance of a striking architectural exterior, adequate interior lighting, generous circulation and hanging spaces, and well-located resting areas and refreshment stands. The experience of art, in other words, should be awe-inspiring but comfortable for the visitor. Looking at his home country and specifically the display of important current works in the ungainly temporary structure, Building Five in Ueno Park, Hayashi bluntly criticized the setup as no different from "tossing prized gems into a heap of trash" (*jinai tamari ni suishō no tama o ochita*). Hayashi differed from Masaki in stressing the quality of the presentation of art and not just the quality of the artworks themselves. His argument privileged the framework of exhibition as an important factor in the promotion of contemporary art, which in his opinion deserved a dignified and permanent space of display no less than did masterpieces from the past. Committed to infusing international (mostly Parisian) flair into Japanese exhibits, Hayashi was one of the first to build an extensive collection of contemporary Western art (including works by Claude Monet, Auguste Renoir, Camille Pissarro, and Paul Gauguin) and lend it for display in Tokyo.

The art historian Taki Seiichi (1873–1945), also known as Taki Setsuan, advocated yet

another type of art museum in an essay published in 1906.[34] Son of the Nihonga artist Taki Katei (1832–1901), Taki Seiichi was a lecturer at the Tokyo School of Fine Arts and later a professor specializing in the history of Japanese and "Eastern" (*Tōyō*) art at Tokyo Imperial University. He was also chief editor of the journal *Kokka*, launched in 1889 to highlight traditional Japanese art. His proposition, almost a convergence of Masaki's and Hayashi's ideas, was to establish a national museum of art that would chronicle both ancient and modern art in sequential order, from the seventh century to the present. Taki made use of the now familiar argument that a centralized space for distinguished works of art was essential to the education of the public and the showcasing of Japan's cultural lineage. However, the emphasis on a contiguous Japanese art called attention to the fact that there was not yet a true public national art museum in Japan, a lack that was all the more conspicuous in the aftermath of the renaming of the Imperial Household Museums. In contrast to these museums, a network of institutions over which the ordinary citizenry had no authority, Taki envisioned a new museum for the people, by the people, that would represent the interests of the whole nation rather than those of the imperial institution alone. This museum would be not just for researchers or students of art, like Masaki's museum, or a fancy but empty shell for transient artist shows, like Hayashi's museum, but a permanent place for promoting cultural awareness aimed at the Japanese public and foreign visitors alike.

The proposals of Masaki, Hayashi, and Taki encompassed the exhibition of art old and new, Japanese and potentially Western. They looked to cater to the needs of Tokyo artists specifically and the needs of average citizens generally, without overtly invoking the earlier tropes of strengthening the nation or honoring the emperor. In fact, all three essays made the distinction between the emperor's museum and the people's/nation's museum, positioning the two to serve different functions. The debate over the type of art museum that Tokyo and Japan most needed continued steadily in the pages of the *Bijutsu shinpō* even after the completion of the Hyōkeikan. The critical reaction, voiced in the form of reviews of this new museum, is examined in a later section of this chapter.

PALACE AND MUSEUM: A PRINCELY ENSEMBLE

Arguably the most magnificent architectural monument of the Meiji period and without a doubt the magnum opus of Katayama Tōkuma's architectural oeuvre is the Akasaka Detached Palace for the crown prince (fig. 6.7), located in the Akasaka district of Tokyo.[35] The project was set in motion as early as 1893, several years before the adolescent prince was eligible for marriage and while his matrimonial prospects were under early deliberation. Anticipating the inevitable need for a palace, the government initiated the extensive preparations and planning necessary for realizing a structure of this enormity

6.7 Katayama Tōkuma, Akasaka Detached Palace (now State Guest House), Tokyo, 1898–1908. © Jiji Gahō Sha, Inc.

and importance. Construction commenced in July 1899, just one month prior to the selection of Sadako, the fourth daughter of the nobleman Kujō Michitaka, as the prince's bride. The announcement of the engagement the following year prompted the idea of a dedicatory art museum from the people of Tokyo, as already discussed. The construction of their "Hall of Celebratory Expression," the Hyōkeikan, was completed in 1908, as was the prince's palace.

Existing studies on the Hyōkeikan and the Akasaka Detached Palace have not considered the two buildings as ensemble pieces, even though they were instigated by the same event, designed by the same architects, supervised by the same ministry, and conceived and constructed in roughly the same period. This art museum's place in the chronology of museum designs in the Meiji period is just as significant as its place in the framework of palace building for the imperial household. The latter factor was a major determinant of this building's design and exerted more influence than did the variegated demands of the Tokyo art world.

When Katayama was appointed to the Committee for the Investigation of the Construction for the Palace of the Crown Prince (Tōgū Gosho Gozōei Chōsa Iinkai) in 1896,

the Imperial Museums in Kyoto and Nara had just been completed. He, together with Adachi Hatokichi, an engineer who had assisted him on the two earlier museum projects, and Takayama Kōjirō (1855–1908), who had designed the architecture for the Third National Industrial Exhibition, were immediately sent to Europe and the United States for a thirteen-month research trip on palace architecture.[36] Upon their return to Japan in 1898, the Construction Bureau established for the palace project appointed Katayama as project leader, Takayama as design director, and Adachi as on-site operations director. When construction for the art museum began two years later, Katayama and Takayama were involved in the creation of the two buildings simultaneously. Niinomi Takamasa (1857–1922) joined them as on-site operations director for the Hyōkeikan. At one point in their respective careers, Katayama, Takayama, and Niinomi were all involved in the construction of the Imperial Palace in Tokyo, the earlier of the two major palace architecture projects in the Meiji period that reached completion in 1888. The teams of supervisors for the crown prince's palace and art museum, therefore, were composed of designers and engineers with overlapping experience in the most prominent palace, museum, and exhibition designs of the day.

Katayama undertook three research trips to the West specifically for the design of the Akasaka Detached Palace, and he would pass along to the art museum many of the same material, technical, and aesthetic options implemented for the palace. The Imperial Household Ministry's official order for the first excursion specified a one-year investigation (which actually ran slightly longer, from February 1897 to March 1898) of all architecture and technology of relevance in the following nations: Austria, Belgium, England, France, Germany, Greece, Holland, Italy, and the United States.[37] The order articulated ten specific areas for examination, and the majority of them dealt with technical matters, such as the advantages and disadvantages of steel frame construction and the latest developments in heating, water, and sanitation facilities. With regard to design and aesthetics, the focus was to be on the interior decoration and furnishings of royal palaces—Katayama's specialty. The architect's next two trips, in 1899 to the United States and in 1903 to Europe, involved specific assignments to acquire construction materials and furniture, respectively.

The comprehensive incorporation of Euro-American visual and material culture composed a large part of this building's identity. The intent was to actively pursue the most up-to-date technical innovations available but at the same time to defer to the magnificent imperial styles of the old European past. A resultant ideological split distinguished the ensemble designs of the palace and museum, best described as forward-looking technology clothed in backward-looking dress. Yet as the official imagery of a nation, this was not unique for architecture at the end of the nineteenth century. During Katayama's multiple visits to the West, he no doubt would have seen, if not in person then in print, many prominent buildings, recently built, that exhibited the same simul-

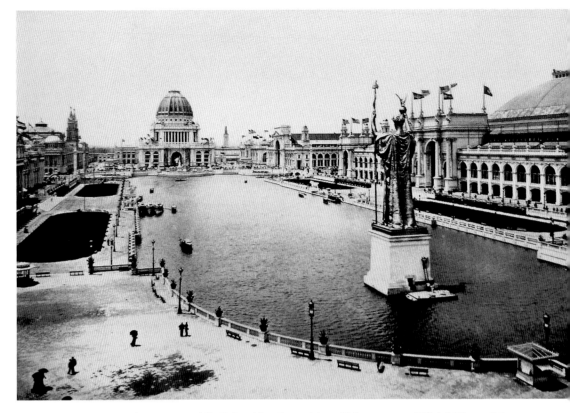

6.8 Court of Honor, World's Columbian Exposition, Chicago, 1893. *Official Views of the World's Columbian Exposition* (1893). Courtesy of the Library of Congress.

taneous endorsement of the old and the new. Major examples were the main group of exhibition structures known as the Court of Honor at the World's Columbian Exposition in Chicago (fig. 6.8), the Grand Palais in Paris (see fig. 6.6), the Monument to Victor Emmanuel in Rome, and the Neue Hofburg in Vienna. Because the new art museum was not intended to be an extension of the adjacent structure designed by Conder, it would assert this difference prominently through its adoption of the current vogue for French Beaux-Arts-style monumental public building.

The use of European stylistic idiom at this time should be read as a gesture not of deference but of equivalence. With national confidence at an all-time high, Japan prided itself as an equal to the Western powers. At the turn of the twentieth century, Japan had just won a war against China and would soon be victorious against Russia in a separate but related military struggle for power over Korea and other strategic zones in Asia. It also secured strong global standing through the Anglo-Japanese alliance of 1902. Because its international worldview originated within the structure of the informal empire the West had established in East Asia during the nineteenth century, Japanese

6.9 Guy Lowell, Museum of Fine Arts, Boston, Huntington Avenue Building,
first section, 1907–9. Photograph by the author.

leaders were conditioned to set standards of success that remained within a framework
of the West's making. This attitude was certainly a distinctive feature of Japanese archi-
tectural modernity in that taking the form of European high architecture invariably
signified a Japanese definition of cultural accomplishment. Like Conder's museum in
Ueno Park, which participated in the latest developments in museum architecture in
the 1870s, the Hyōkeikan assumed similarly visible transnational links by adopting the
fashions of the 1900s.

Once again, the Metropolitan Museum of Art in New York and the Museum of
Fine Arts in Boston present close ideological and architectural parallels to the Japanese
museums under examination in this volume. From the late 1890s to the 1910s, the New
York and Boston museums were each engaged in a second architectural phase, the
former under the design guidance of Richard Morris Hunt and his son Richard Howland
Hunt, after the elder Hunt's sudden death, and the latter under Guy Lowell (fig. 6.9).[38]
Katayama's three museum designs, although much more modest in scale, shared certain
features with the designs of the Hunts and Lowell: a strong axial configuration, sym-
metrical massing, and a ceremoniously grand exterior. The British Victorian Gothic
buildings that marked each institution's architectural beginning in the late 1870s had
unanimously shifted to a noticeably French-inspired, academic classicism.

Both Americans and Japanese shared a sense of cultural inferiority to Europe in the late nineteenth century; with wealth and educational levels increasing among each nation's social elite by the turn of the century, however, private citizens were as capable of remedying the perceived gap as was the government. The fact that private citizens initiated and financed the Hyōkeikan art museum points to the rise of civic consciousness in Tokyo akin to what was driving the rush of museum and library building in New York and Boston. Higher budgets coupled with greater ambitions fueled the desire for monumental expressions comparable to, and perchance even exceeding, the European museological acme—the Louvre of Paris, the Altes Museum of Berlin, the British Museum of London, and the very recent Kunsthistorisches Museum of Vienna (which opened in 1891). The South Kensington Museum model that championed the pragmatics of applying art to industry faded in the fin-de-siècle quest for institutions devoted exclusively to cultural elevation and affirmation.

At an observance of the Hyōkeikan foundation laying in 1903, Matano, the art museum's nominal construction supervisor and director general of the Imperial Household Museums, gave a speech highlighting the work to come. The art museum would be in the Greek style, be composed mainly of granite and brick, and feature copper roofing and eight marble columns; the materials would be of international extraction: Japanese granite and bricks, American steel beams, German steel plates, English wrought iron pipes, and Japanese cypress. The estimated cost was ¥400,000, and the anticipated date of completion was 1907.[39] Many of the same lavish materials were used for the art museum and the palace. The museum's construction time table paralleled that of the Akasaka Detached Palace, for which the architects had recently secured an updated budget of ¥5,000,000 (more than twelve times the cost of the museum). The extravagance of budget and time suggests that the Japanese government had not anticipated the declaration of war on Russia in 1904. The sheer physical immensity of the projects, the disproportionately large quantity of imported and customized materials, and a victorious yet unremunerative war delayed the completion of both buildings to 1908.

Of the major museum buildings erected in the Meiji period, none was more firmly affiliated with the imperial household than the Hyōkeikan. The ontological connection to the crown prince's marriage, the administrative connection to the Imperial Household Museums, and the architectural connection to the new palace all converged in this art museum, which conspicuously manifested its privileged status by setting aside a discrete room within its limited interior space as the imperial family's private respite room (fig. 6.10).[40] Similar gestures had been made in the earlier museums in deference to imperial attendance, although these were less committed in practice. The main museum building in Tokyo by Conder, though not constructed under the aegis of the Imperial Household Ministry, dedicated the central room on the second floor to the

6.10 Katayama Tōkuma, Hyōkeikan art museum,
imperial wing. Photograph by the author.

exhibition of the imperial collection, but only during its decade-long tenure as the
Imperial Museum (1889–99). When the museum debuted at the Second National Indus-
trial Exhibition, the emperor used this room as well as the attached balcony from which
he could look out over the event (see fig. 2.12). The museums in Kyoto and Nara reserved
their main entrances for the emperor. Although the latter designated its central atrium
as the throne room during the emperor's visits (see fig. 4.19), the Meiji emperor never
managed to visit, and the majestic space regularly served as the sculpture room. The
imperial room in the Hyōkeikan, in contrast, remained true to its intended function at
all times, even when not receiving its eponymous visitor.[41]

An examination of the original architectural drawings for the Hyōkeikan reveals
that the design of the imperial room, more than any other section of the building,
including the exhibition rooms, was the source of major deliberation and indecision.

圖 景 配 館 術 美 念 紀 事 慶 御 宮 東

6.11 Katayama Tōkuma, designs for the Dedicatory Art Museum to the Crown Prince.
Above: exterior perspective; *opposite page, top*: plan of upper floor;
opposite page, bottom: plan of ground floor. *Kenchiku zasshi* (May 1900).

Katayama published a design for the art museum (then still known as the Dedicatory Art Museum to the Crown Prince) in the May 1900 issue of *Kenchiku zasshi*, five months before he was officially announced as the project architect (fig. 6.11). This initial set of drawings established all the major features of the realized design: a two-story building with a centralized plan, consisting of a central block with two end pavilions capped by domes as the exterior form, and eight exhibition rooms as the interior program. Like his initial proposals for the museums in Kyoto and Nara, this preliminary design, copiously bedecked with trophies and garlands, columns and niches, proved to be too ornate for the proposed budget. He simplified the design in gradual steps.[42] The extant drawings housed in the archives of the Tokyo National Museum represent two sets of revised plans and elevations for the art museum, one of them largely corresponding to the existing structure (fig. 6.12).[43] Based on the dating on a number of the drawings, it is possible to infer that the two sets date to July 1902 and July 1906, respectively.[44] Another group of three drawings depicts different studies specifically of the imperial room.

The layout of the exhibition rooms remains constant in all three sets of drawings; the plan, identical on the first and second floors, consists of a circular central hall flanked by two linear series of rooms. The four rooms on the bottom floor, which received natural light from side windows, were reserved for the display of sculptures, and the

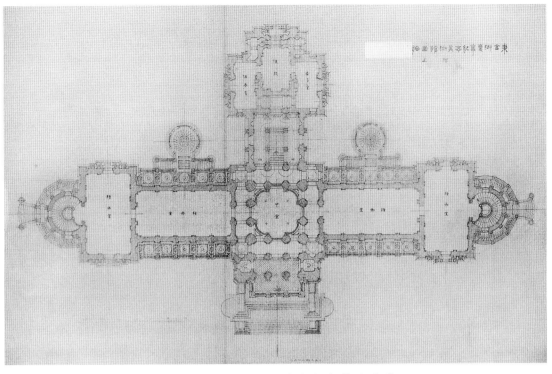

東宮御慶事紀念美術館図面

東宮御慶事紀念美術館平面図 階上

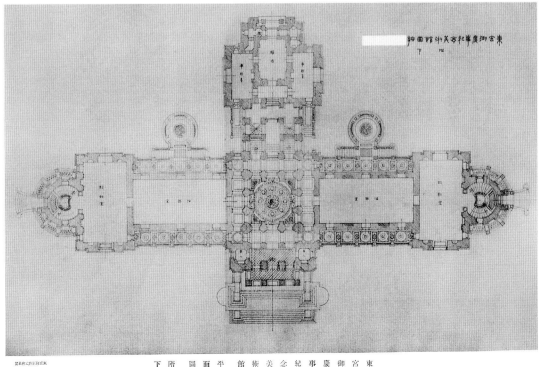

東宮御慶事紀念美術館平面図

東宮御慶事紀念美術館平面図 階下

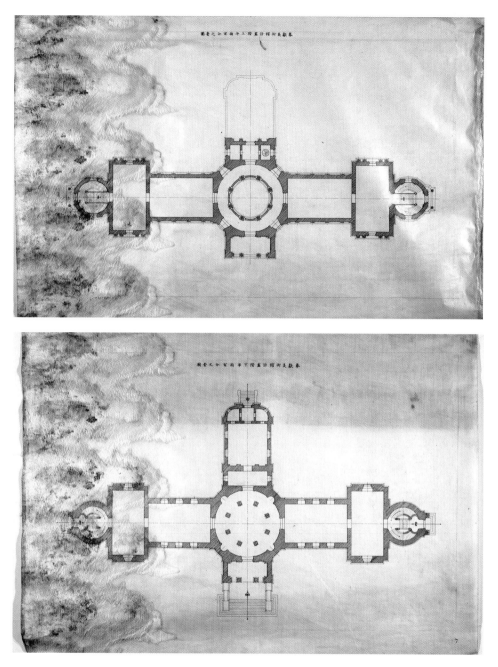

6.12 Katayama Tōkuma, Hyōkeikan art museum, plans of upper floor and ground floor, ca. 1906. Tokyo National Museum, TNM Image Archives.

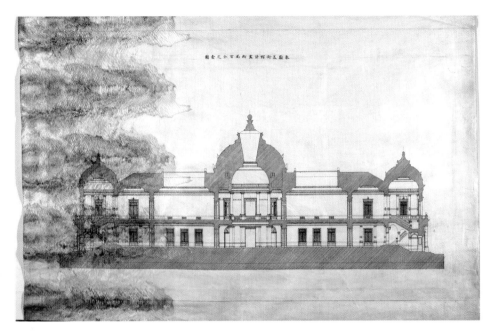

6.13 Katayama Tōkuma, Hyōkeikan art museum, section, ca. 1902.
Tokyo National Museum, TNM Image Archives.

four rooms on the top floor, which received light from the skylight above, were reserved for paintings (fig. 6.13). The placement of side-lit sculpture on the bottom and top-lit painting on the top was a common configuration for a two-story art museum, a standard put in place by Karl Friedrich Schinkel's Altes Museum in Berlin (1830).

The major change that occurs in the three sets of plans is the placement of the imperial room. The art museum, originally a T-shaped building with three wings radiating from the center, contained one wing for administrative offices and other non-exhibition functions. The imperial room was one of three rooms on the second floor, directly above the museum director's office. In the 1902 scheme, the designers had deleted this third wing altogether.[45] And the 1906 version reinstated the third wing, this time only on the ground floor and exclusively for imperial occupancy.[46] In short, the two floors lost their identical form, and the imperial room moved to the ground level.

The archival drawings suggest that at least three different schemes were proposed between 1902 and 1906 before the imperial room reached its finalized state. Three drawings indicate that the architects at first devised the added wing simply as a replication of an exhibition wing, identical to the latter in form and dimensions but partitioned into a highly congested suite of rooms.[47] The final design achieved a better balance in scale and form.[48] Simplified to one main sitting room and three auxiliary

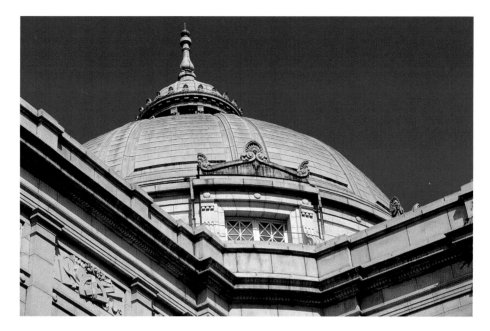

6.14 Katayama Tōkuma, Hyōkeikan art museum, detail of central dome and cornice.
Photograph by the author.

spaces, the imperial wing had been not only reduced in size but, more significantly, refined in form. Harsh edges gave way to elegantly rounded corners that echo the reflected plan of the circular central dome; multiple side windows and a skylight provide more natural light here than in any other section of the building. Overall, the final plan allocated as much space for functions unrelated to exhibition—that is, in the central hall, imperial wing, and side stairwells—as for exhibition. Such an emphasis on the building's ceremonial spaces was unprecedented in Katayama's museum architecture. In striking contrast, every available room in the Kyoto and Nara museums was designed as an exhibition room. No space was allotted for administrative offices, storage, or rest areas. Detached, auxiliary buildings, in much less expensive materials, satisfied these requirements.

Less a stylistic continuation of the earlier museum designs in Kyoto and Nara, the Hyōkeikan was a reflection of the aesthetics and new structural engineering of the crown prince's palace, simultaneously under construction. While vibrant coloring characterized the exterior of the other two Katayama museums, the new art museum eschewed the brick red of Kyoto and the plaster yellow of Nara and donned the same cool granite gray and oxidized copper green combination of the palace (fig. 6.14). The exterior ornamentation on the Hyōkeikan—the attached columns, decorative panels and shields, and window casings—although no less lavish than those of the Kyoto and Nara muse-

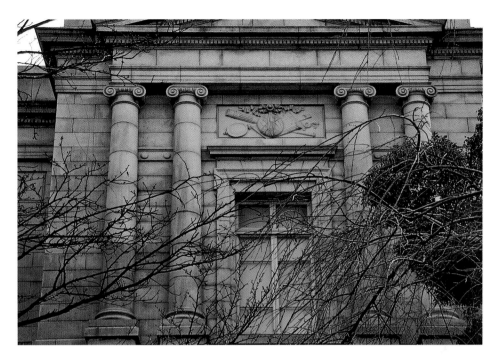

6.15 Katayama Tōkuma, Hyōkeikan art museum, detail of facade on side wing.
Photograph by the author.

ums, merges discreetly with the monochromatic building facade (fig. 6.15). Rather than contrasting colors and materials, this surface is animated by shifting contours, textures, and patterns, and the resultant casting of light and shade. The same tonal and textural palette underlies the exterior ornamentation of the Akasaka Detached Palace, lending both buildings an air of opulent but dignified grandeur. The two buildings even share one feature: the same cupola design crowns the attached side turrets of the palace and the museum (with one small difference, the shape of the finial).[49] In other aspects, the museum suffers in its emulation of the palace. As is to be expected, the scale of the much larger project translated with difficulty in reduction. A conspicuous example is the Hyōkeikan's front central portico, which appears to be a bluntly truncated rendition of the palace's much wider version. The procession of columns on the top floor facade as well as the pilasters on the bottom floor are literally stopped short, leaving straggling half-columns on the ends and two haphazard columns in the center. Both the most attractive and the most awkward features of the Hyōkeikan's exterior design, therefore, are attributable to its intimate association with the palace.

In many senses a miniature of the palace, the art museum effectively shares much of the former's visual and stylistic mode. The interior of the Hyōkeikan, although no match for the extravagance of the ubiquitous marble and gilding that pervades the inside of

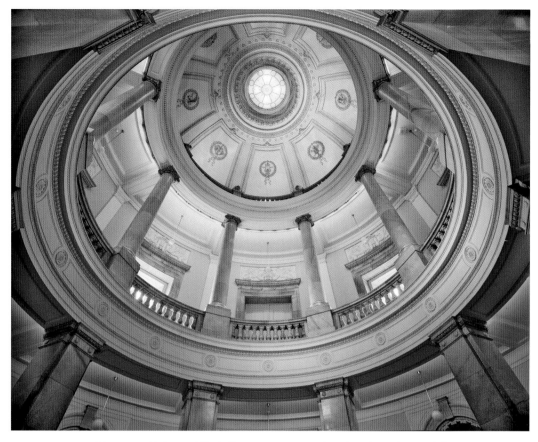

6.16 Katayama Tōkuma, Hyōkeikan art museum, interior view of central dome.
Tokyo National Museum, TNM Image Archives.

the imperial residence,[50] features a lavish double-story central hall enclosed at the top by a semi-spherical dome (fig. 6.16). The most luxurious materials invested in this building are concentrated in this space. On the ground level, the floor of the circular hall is sheathed in a mosaic composed of seven different color varieties of marble from France. Eight freestanding marble pilasters on this level and another set of corresponding Ionic columns on the second level, also marble and accentuated with gold leaf on the capitals and bases, demarcate the double-height space below the dome. A marble balustrade encircles the Ionic columns. Symbolic motifs representing the arts decorate the eight segmental panels on the inside surface of the dome.[51] No other part of the art museum, with the exception of the two side stairwells (fig. 6.17), displays a similar level of compositional extravagance, in material or form. The exhibition rooms, which had been the most important components in the Ueno Park museum by Conder and the Kyoto and Nara museums by Katayama, received almost no embellishment.

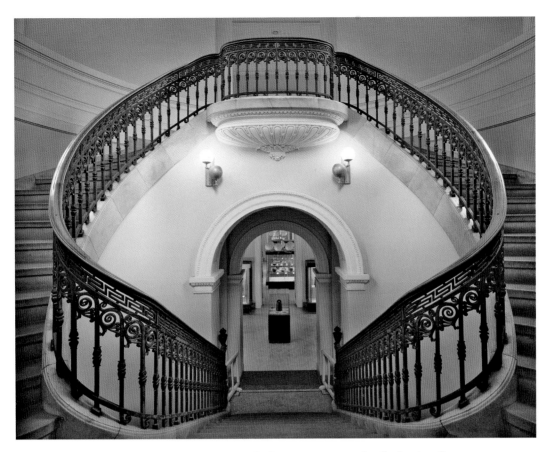

6.17 Katayama Tōkuma, Hyōkeikan art museum, detail of stairwell.
Tokyo National Museum, TNM Image Archives.

The Hyōkeikan was a showcase in many senses, most vividly displaying Katayama's experience and confidence in high design. Compared to the Kyoto and Nara museums, it held no imprint of uninhibited experimentation such as the high-spirited embellishment on the front gates of the Kyoto museum or on the front facade of the Nara museum. Also absent were signs of lingering indecision in regard to lighting (top or side? raised or recessed?) and other particularities of exhibition architecture. With the two other museums successfully completed and the largest commission of his career in progress, the small Hyōkeikan presented an undemanding task, which Katayama fulfilled using straightforward massing and arrangement without sacrificing the opulence its regal status as the prince's wedding gift required. The imposing monochromatic granite shell and multiple domes affirmed its status as a palace of art, distinct from the red-brick laboratory for art, science, and industry next door.

CRITICAL REACTIONS

Long before the formal announcement in November 1908, Tokyo art critics and commentators had already conceded—albeit begrudgingly—that the Hyōkeikan would be overseen by the same administration that directed the adjacent Tokyo Imperial Household Museum. The link between the two structures was literally forged by the addition of an L-shaped connecting passageway (fig. 6.18) and the transfer of the art collection from the older building to the new building.[52]

A committee chaired by the director general of the Imperial Household Museums convened in December 1908 to decide on the contents and method of exhibition for the Hyōkeikan. On the types of objects, committee members voted as follows:

> The objects to be exhibited in this museum will principally be the art of our nation accompanied by excellent examples of Chinese, Korean, Indian, and other Eastern art that inform the organization and development of our nation's art and that encourage its production.
>
> The artworks to be exhibited in this museum will be painting and sculpture executed prior to the Meiji period. However, ancient and modern calligraphy and other works that prove to be instructive to the painting and sculpture hereafter should also be displayed.[53]

In addition, the committee determined that the majority of objects would be drawn from the Tokyo Imperial Household Museum but that it would also petition for the display of objects recently designated National Treasures as well as solicit submissions from elite private citizens, particularly nobles and eminent collectors. Regarding the physical configuration of display, it outlined the very general specifications that sculpture would be on the bottom floor and painting on the top. This last decision is significant in that, for the first time in a Katayama-designed museum, the architect's intention and the actual layout of the collection would correspond.

The committee had merely made widely held speculations official. Criticisms of this uninspired merger with the Tokyo Imperial Household Museum had been launched years before the Hyōkeikan's opening day, and Masaki, Hayashi, and Taki had written their previously mentioned essays fully aware that the museum under construction would not fulfill their expectations. Hayashi expressed this sentiment most candidly by lamenting that the wishes of the art world had been quashed by the need to show ceremonial deference to the crown prince.[54] This essay, like the others, already looked forward to the next art museum project, to be pursued for the sake of art rather than for the imperial household. The Imperial Household Museums did not represent or fulfill the common desires of late-Meiji art practitioners and promoters.

6.18 Katayama Tōkuma, Hyōkeikan art museum, view of connecting passageway to the main building of the Tokyo Imperial Household Museum. Photograph taken in late 1930s during construction of the new main building designed by Watanabe Jin. Tokyo National Museum, TNM Image Archives.

The opening of the Hyōkeikan in May 1909 did nothing to deter the crusade to erect another art museum in Tokyo. The Association for the Resolution to Construct an Art Museum (Bijutsukan Kensetsu Kiseikai) was formed in 1910 to take up, not one, but two developing campaigns: one, supported by the Education Ministry, proposed a permanent exhibition space for art showings and sales, and the other, supported by the governor of Tokyo, proposed a museum of art and art industry.[55] There could not have been a more direct indictment of the inadequacy of the Hyōkeikan, which was the subject of a steady stream of reviews and criticism in the pages of the *Bijutsu shinpō*.

The *Bijutsu shinpō* published its first review of the new art museum on 5 June, shortly after the museum's 10 May opening.[56] Although only one paragraph long, it set the tone for the longer, more detailed reviews that followed. Recognizing the gravity of the

Hyōkeikan's purpose and status as "the only art historical museum of the East" (*Tōyō no yuitsu no rekishiteki bijutsukan*), the piece offered a bluntly negative appraisal of the long-awaited finished product. The architecture, although no worse than the numerous examples of Western-style buildings in Japan, lacked the sense of "dignity" (*seisō*) requisite for showcasing "imprints of the nation's past genius." Perhaps the greater deficiency was in the "installation" (*chinretsu*) and "explanation" (*kaisetsu*) of the art. The piece tersely concludes that there is much room for improvement.

Two months later, an anonymous critic, under the pseudonym Nipporijin (Nippori being the neighborhood just north of Ueno, "Nipporijin" literally means "person from Nippori"), composed a thorough, three-part critique of the Hyōkeikan.[57] The first installment launched a direct attack on the museum's shortcomings. Like other reviewers of the Hyōkeikan, Nipporijin granted a generally favorable appraisal of its architecture. He found the overall effect of the building to be grand but understated.[58] He saw poetry in many of the details—the juxtaposition of the white stone facing to the green lawn, the spiral curvature of the stairwell, and the soft light reflections on the smooth stone floor. Nipporijin unequivocally identified this art museum as a public extension of the prince's private luxury with this generous praise: "I do not know about the Crown Prince's Palace, but the Hyōkeikan is the most magnificent [*sōrei*] Western-style building that the ordinary person can enter in Japan." Moreover, he compared the phenomenology of this Western-style interior to the "strong Eastern feeling" (*tsuyoi Tōyō shumi*) of the ancient temples of Nara and Heian (i.e., Kyoto) and decided that the experience inside the modern museum and the ancient temple were equally enjoyable. This last statement is significant in identifying a link between the two types of places, one characteristically premodern and the other characteristically modern, where art objects were made visible to the common person. As this chapter's epigraph implies, in the twentieth century, a museum was where one went to see art, even art of the "olden times."

The exhibits and their installation, however, did not fare as well as the architecture under Nipporijin's critical eye. Pointing out that "there already exist various complaints and demands from every direction" and that his own opinion reflects the prevailing sentiments, he addressed what he saw as the three most problematic areas. His criticism implicated the classification, labeling, and display vitrines in this art museum; his piece on the whole put forward the notion that a new vision of (and for) pre-Meiji art was vital to this museum's successful functioning.

First, Nipporijin protested the presence of lacquerware in the building, arguing that the inclusion of this medium not only counteracted this art museum's fundamental purpose of housing "pure art" (*junsei bijutsu*) exclusively but also senselessly took up precious space in a small building. Questioning what belongs in an art museum, Nipporijin proffered the answer that art, which he upheld strictly as painting and sculpture, should be a self-contained class, no longer to be presented in the company of other

specimens of ingenuity and industry, as was the practice to date in the main museum building and continued practice in the Kyoto and Nara museums.[59] In fact, in wanting to isolate painting and sculpture from prints, calligraphy, and architecture, the critic was asserting an even narrower definition of art than the extant Imperial Household Museum classification. This selectivity would approximate the fine arts display practice overseas at Euro-American museums and expositions, where the painted and sculpted genres occupied the top of the artistic hierarchy, segregated from all others deemed to be decorative or manufactured arts.

Second, Nipporijin critiqued the ordering and labeling of the exhibits as incomprehensible to the average visitor. Raising the case that experts of pre-Meiji art made up but a small percentage of museumgoers, he contended that "although the saying is that [Japan is] the artistic nation of the Far East, when [Japanese] are asked what that art is, most cannot answer." He suggested systematic arrangements of the exhibits within each type, whether by chronology or by school, and comprehensible labeling with fuller and more accurate descriptions.[60] This emphasis on the didactic—rather than merely the connoisseurial—role that the art museum needed to play was based on the assumptions that only a minority of museum visitors were already familiar with the art, and that even for those experts, the art museum presented an entirely new way of seeing the art of the past. The author gave an example: "The painted scrolls of Japan were originally created to be viewed in sections, but when they are seen as a whole [at the museum,] they have a fresh appeal." Nipporijin also recognized that given the new conditions for displaying and viewing, professional curators with specialized training, rather than wealthy collectors and politically powerful dilettantes, should be steering the direction of art exhibition at the museum.

Third, Nipporijin's encouragement of new ways of seeing the old was developed further through his criticism of the display cases. His main complaint was directed against the use of glass cases for the display of the natural history and fine arts collections alike (fig. 6.19). The horizontal orientation and large dimensions of the majority of folding screens, and the vertical orientation of the hanging scrolls, made for an awkward fit inside the vitrines, which were intended for small, three-dimensional objects. In addition, the reflective glass surface as well as the protracted viewing distance (enforced by the depth of the display box) barred a clear view of the paintings; because of the fixed position of the paintings, the upper registers of the vertical scrolls were especially difficult to see. Nipporijin argued that rather than perfunctorily following existing Western conventions, the Hyōkeikan should introduce an entirely new method of hanging and lighting adapted to the unique properties of Japanese artworks. After all, painted scrolls were created under lighting conditions and for a viewing environment vastly different from those for oil paintings, and it was careless to assume that the same display situation would be adequate for both.

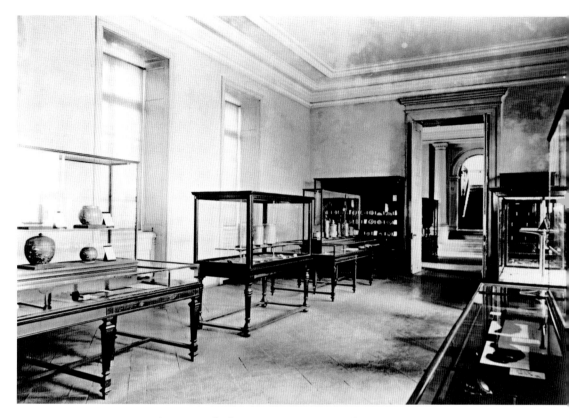

6.19 Katayama Tōkuma, Hyōkeikan art museum, view of art displays on the ground floor.
Tokyo National Museum, TNM Image Archives.

Although the critic did not see this as a problem inherent in the museum architecture, it should be noted that the architect never intended for the paintings to be placed inside vitrines. Katayama had scaled and lit the rooms based on the assumption that paintings would be hung on the walls and would not be behind glass. The same was true for the Kyoto and Nara museums; scaled drawings of custom-designed hooks for hanging the paintings are in the archived drawings for both museums (fig. 6.20). Moreover, Katayama did not design these rooms to accommodate large-scale display cases in addition to the visitors who would circulate through such tight spaces, for the rooms' consistently narrow dimensions betray his understanding that paintings were to be hung flat against the wall. The placement of Japanese paintings inside glass casing was incongruent with both the traditional way of viewing and the architect's proposed way of viewing the artworks—although, understandably, the use of locked glass boxes protected the art from inappropriate touching and theft. Nonetheless, Nipporijin was clear in advocating a total rethinking of the installation in order to fully account for the material specificity of Japanese art. Moreover, he expected the museum to teach its visitors anew what

6.20 Katayama Tōkuma, Imperial Nara Museum, design of hook for picture hanging. Nara National Museum.

Japanese art was, how to understand it, and how to view it. Regardless of the prior knowledge some might have, the Hyōkeikan held the unique responsibility of demarcating what belonged (and did not belong) in an art museum, labeling those that did belong with appropriate information, and enforcing the most favorable layout, orientation, and viewing distance for them. *Bijutsu* as a new word had little value if the space dedicated to it could not uphold its definition.

On the whole, the issues raised by Nipporijin located the Hyōkeikan's inadequacy in its inability to assert a new autonomy for the group of objects it had physically isolated inside its walls. Painting and sculpture forming a stand-alone category required new meaning and purpose after being severed from the other museum categories. And, in his opinion, that new meaning was essentially built into the staging of premodern artworks in the modern museum frame, although the onus was on the museum administration to articulate the purpose of this innovative venture.[61]

In deliberating on the function of the Meiji art museum in relation to pre-Meiji works, it is appropriate to return to the epigraph, an excerpt from *The Wayfarer*, by Natsume

Sōseki, an author celebrated for his portrayal of the emotional and intellectual turmoil brought about by Westernization in the Meiji period. The excerpt comes from a longer passage describing a visit to the Hyōkeikan by a father-son duo, whose generation gap, already exacerbated by the radical cultural transformations of the Meiji period, plays out in front of the objects on display. The father, a retired government official, and his second son Jirō, who works in an architecture firm, represent the typical dichotomy of the stodgy elder and the cheeky youth: the father lectures while the son barely suppresses his boredom. Their encounter with art begins with works of calligraphy on the first floor: "As [my father] came to O-Gishi's writings in the Imperial collection, he was thoroughly impressed, exclaiming 'Yes, indeed.' Whereas I thought them so worthless that I couldn't refrain from commenting, 'Certainly reassuring.' 'Why is that?' cross-questioned my father."[62]

The tension, vividly marked by their polar reactions, uncoils as they progress to the second floor, where they come across paintings by Ōkyo, an eighteenth-century artist: "There hung in succession ten pieces or so by Ōkyo which formed one sequence; the one on the extreme right represented three cranes, and another on the extreme left, just one crane on spread wings, and the whole space between, about four or five yards in distance, was filled with waves." The paintings, unlike the calligraphy, capture Jirō's attention. With uncharacteristic patience, he listens, learns, and appreciates: "I learned from my father for the first time how to admire the Japanese artist of olden times who had created these magnificent paintings."[63] The museum interior isolates the ten pieces, previously glued on sliding panels as decorative elements in a traditional architectural setting, as focal events in their own right. The space also invites the close inspection desired by the connoisseurial eye. The museum display awakens the young man into seeing these old works in a new light.

Without overreading Sōseki's metaphoric formulation of the Hyōkeikan experience, this episode may be seen to stand in deliberate contrast to the one immediately preceding it, when a similar opportunity for an art lesson occurs in the familiarity of Jirō's living room, in front of a hanging scroll in the tokonoma. Despite the work's exalted provenance, Jirō is immune to its artistic value, declaring in unveiled exasperation: "but still my father would not terminate his lecture on the scroll, and insisted on telling me all sorts of wholly uninteresting things—of the Daitokuji Temple, the Obaku sect, and what not."[64] Jirō's conversion in front of the Ōkyo paintings in the Hyōkeikan is all the more precious given this missed chance just pages prior. In many ways, this passage conforms to Nipporijin's decoction of the art museum as a space that facilitates an experience of pure visual deliberation. Painting, not calligraphy, interests Jirō. Visible qualities rather than provenance impress him. Wall decoration reframed as discrete works moves him to see them as art.

Further attempts at restyling the Hyōkeikan into a discrete type of space for Japanese art were curtailed by an unfortunate combination of administrative indecisiveness and exigent historical circumstances. By sheer coincidence, the palace and the museum, the two architectural projects dedicated to the crown prince, both suffered from failure of expectations. With the death of the Meiji emperor in 1912, Yoshihito was enthroned as emperor and did not take up residence in the Akasaka palace. The 1923 earthquake destroyed the main building of the Tokyo Imperial Household Museum, and consequently the Hyōkeikan was reorganized into an all-purpose gallery space for the entire museum collection. Between 1924 and 1938, when the main building reopened, the Hyōkeikan was the only exhibition space in use for the Tokyo Imperial Household Museum. Different assemblages of art—pre-Meiji, post-Meiji, and Western—at times independently, at times in the company of objects from the other departments, circulated through the exhibition rooms of this building. Even the imperial room and the central hall were appropriated as display spaces.[65] After the new main building by Watanabe Jin was completed in 1938, the Hyōkeikan did not return to displaying pre-Meiji painting and sculpture. Instead, it focused on post-Meiji art and, in 1948, added contemporary Western art to its repertoire. In 1956, the contents of the space changed again, this time to archaeological objects.

Criticisms and unfulfilled potential notwithstanding, the Hyōkeikan marked a significant milestone for art in Japan. The project represented an exceptional achievement in that, as the nation's first permanent art museum, it had been envisioned and mobilized by art critics, historians, and artists, with the support of local politicians, rather than implemented from above by the central government, like the majority of the other large-scale Meiji initiatives for art preservation and exhibition. For the first time dissenting voices emerged that were strong enough to challenge the state-administered definition of art as a museum category and as a purposeful political tool, demonstrating that the Imperial Museums did not encapsulate the only construct of art viable in modern Japan.

Conclusion

In two well-known meditations on museums, Asia, or the non-West in general, is rhetorically evoked as the diametrical Other. Compared to modern Europe, Asia is said to be unequipped with either the intellectualism or the materialistic conceit (depending on which author) to originate the idea of placing art in the museological construct. In "The Problem with Museums," Paul Valéry writes:

> I feel sure that Egypt, China, Greece, in their wisdom and refinement, never dreamed of this system of putting together works which simply destroy each other: never arranged units of incompatible pleasure by order of number, and according to abstract principles.[1]

André Malraux made a notably similar claim in *Museum without Walls:*

> The reason the art museum made its appearance in Asia so belatedly (and, even then, only under European influence and patronage) is that, for an Asiatic, and especially the man of the Far East, artistic contemplation and the picture gallery are incompatible. In China, the full enjoyment of works of art necessarily involved ownership, except where religious art was concerned; above all it demanded their isolation. A painting was not exhibited, but unfurled before an art lover in a fitting state of grace; its function was to deepen and enhance his communion with the universe. The practice of confronting works of art with other works of art is an intellectual activity, and diametrically opposed to the mood of relaxation which alone makes contemplation possible. In Asiatic eyes, the museum may be a place of learning and teaching, but considered as anything else it is no more than an absurd concert in which contradictory themes are mingled and confused in an endless succession.[2]

Although Valéry's essay, overall, posits museums as sites encoding cultural decay while Malraux's essay proffers them as sites inciting boundless cultural expansion, the passages above appear to share one idea: if the museum existed outside the geo-cultural boundaries of Europe, it was an unnatural impulse and was, therefore, a precarious graft.

However, this proposal immediately rings false in the face of the larger premise on which both essays rest: the museum was at some point just as unnatural to "European eyes" as to "Asiatic eyes." To Valéry, the museum, despite its being a cultural commonplace for him and his peers, displaces and disorients him, eliciting raw emotions of unease and horror. In his essay, he vividly traces the physical and mental enervation the space of the museum causes, decrying that "only an irrational civilization . . . could have devised such a domain of incoherence." Upon entering the museum, Valéry experiences a plethora of emotions, successively "chilled," "lost," and "smitten with a sacred horror." At the end of the visit, he "[staggers] out of [the] temple of the loftiest pleasures with a splitting head—an extreme fatigue, accompanied sometimes by an almost painful activity of mind."[3] The excesses of his own time, Valéry mourns, had imposed this organized annihilation of the distinct pleasure each artwork of the past could offer. Modern man is to blame for reducing a masterpiece deserving of thorough, undivided attention to but one of many fleeting visual temptations placed cheek by jowl on the busy museum wall.

Malraux, writing two decades after Valéry, shed a more positive light on the museum experience. At the opening of his essay, he conscientiously reminds his reader of the novelty of the museum construct, especially in the presentation of works produced before the establishment of its institution. He cites Cimabue's Madonna and Phidias's Pallas Athene as specific examples of works with original signification before they assumed the status of "picture" and "statue" recognized by the modern viewer. He agrees with Valéry that the museum intellectualizes art, but unlike Valéry, Malraux sees the conglomeration of masterpieces as the catalyst to exciting new ways of seeing hitherto undetected links that bind the expressions of different times and places. The declaration that museums have "imposed on the spectator a wholly new attitude toward the work of art"[4] is applicable to Europe and non-Europe alike.[5] And as Valéry's histrionics attest, a European spectator is not instinctively attuned to the phenomenology of the museum, nor does he necessarily take on that new attitude toward the work of art credulously or completely.

The perceived incongruity of the European museum construct with non-European places is tautological. While analogous practices of collecting, preserving, and exhibiting had existed in Asian cultures, integrating them into a joint purpose was a peculiarly Western-inspired development. Yet to set up Europe and Asia in a Manichean schema by insisting not just difference but absolute polarity, such as claiming materialistic rationality to be the racial monopoly of the "West" and thus denying the "East" of it as Valéry and Malraux do here, is a familiar Orientalist trope. In order to break such an incapacitating conceptualization, it is altogether more revealing to recognize the museum, particularly the state-run museum, as an invention that arose from a particular combination of social and cultural aspirations. In the case of modern Europe,

especially France and England, the convergence of elite aesthetic values and egalitarian ideals fostered the gradual opening of royal and princely collections of fine art to, in due course, all members of the public.[6] It was later, when art production and commerce became vital factors in the international competition for economic and political interests in the nineteenth century, that state art sponsorship began to assume overt nationalist overtones.

Certainly, similar aspirations and conditions spurred the Meiji bureaucracy's installation of the Imperial Museums. Before the 1850s, parallel impulses toward public art exhibitions already existed at the local and private entrepreneurial levels in Japan; the annual temple airings as well as the popular "painting gatherings" (*shogakai*) were both prevalent in major cities in the late Edo period.[7] Once Japan entered into trade relations with Western nations, restored nominal rule to the emperor, and adopted the Western liberal paradigm and its key concepts of rights, liberty, and society, the imperatives of public instruction and national self-fashioning fell under the aegis of the central government.

The Imperial Museums prioritized the education of foreign tourists no less than the education of the local public on Japan's art historical lineage. These museums altered the viewer's engagement with Japanese works of art in an unprecedented way. They accomplished this by showing works hitherto unavailable to the view of the ordinary person and by putting together pieces of disparate function and provenance into entirely new groupings. The context of exhibition—the museum's setting, architecture, and installation—which was so at variance with indigenous architectonic forms and formalities, affirmed the dramatic change taking place. While Japanese museums did not make as belated an appearance as Malraux suggests, having been formed at the same time (the 1870s) as the earliest group of art museums in the United States (i.e., the Metropolitan Museum of Art in New York, the Museum of Fine Arts in Boston, and the Corcoran Gallery of Art in Washington, D.C.), the contrast between the cultural armatures of the pre-Meiji and Meiji periods came into especially sharp focus. This occurred because rather than effecting a visually seamless transition by the adaptive reuse of existing architecture or the simulation of indigenous forms, the constructed nature of the Meiji-period state museums was candidly cast in innovative, Western-inspired forms.

If Andrew McClellan is correct in stating that "there is nothing natural or necessary about the way museums are organized or works of art displayed within them,"[8] then museum architecture served as the most transparent signifier of this reality in late-Meiji Japan. The four buildings examined in this book followed no one obvious or unifying path in forming the nation's collection and its architecture. Even for a set of museums conceived under the same master plan, factors outside the immediate cultural

confines—be they political, economic, social, or religious—were forces of influence that differentiated each specific location and time frame. As official art institutions, the Imperial Museums were also propelled as much by overarching bureaucratic agendas as by the unique visions and decisions of the individuals who made up the bureaucracies. In examining the multifaceted circumstances under which the Imperial Museums came into being in Japan, the staging of Japanese art and its history at this institution may be revealed as but a microcosm of the larger nexus of relationships and ideas guiding the public display of a nation and its identity in the modern era.

Appendix

Ernest Francisco Fenollosa Papers

The following letter and memorandum written by Ernest Fenollosa (referred to in chapter 5) are currently housed in the Houghton Library of Harvard University as part of the Ernest Francisco Fenollosa Papers. The documents have not been published in the original English, whereas Murakata Akiko has translated all three into Japanese and published them in her *Ānesuto F. Fenorosa shiryō: Hāvādo Daigaku Hōton Raiburarī zō*. Although the first two documents have been cataloged separately by the Houghton Library, their content indicates that they are two parts of the same letter. The Houghton Library titled both parts of the letter; the title of the memorandum is by Fenollosa.

"Report on examination of Nara temples"

Dear Sir:

We have now been in Nara, for some days, and have found out enough important facts to warrant us, as we think, in representing the situation directly to you. The facts are as follows:

First, the Osaka Fu office has only a very incomplete list of the treasures kept in old temples; and on this list, even, the things are so inadequately described as to be incapable of identification. For instance, in many cases, the list has mention only of the honzon, although twenty other important statues may be kept in the same temple. This list was made out many years ago, under the old Nara Ken, from hasty notes of a few private investigators; and no thorough exploration was even attempted by Nara Ken, Sakai Ken, or Osaka Fu; as soon as the priests found out what was being done, they shut up all their best things from view, and only a very small portion of things, which they could not hide, were recorded on this list.

Second, the list thus officially made has been considered by the priests from that day to this, so the record of the temples' property, and things not on the list have, in general, been assumed to be the private property of priests. In this way, by far the largest number of the best things have become private property.

An exception to this statement is the case of statues in a few of the larger temples, which, although not on the official list, have been so publicly known as fixtures of the temple from old times, that the priests have not yet cared or dared to claim them.

Third, the property thus claimed as private the priests began to sell at once, and have kept on selling, as their increasing poverty demanded; until now, almost everything in the way of old paintings has disappeared; and even a large number of the smaller statues have been dispersed. Only two or three temples form an exception to this statement, where the priests have

as yet refused to sell. A few of the best things still remain for sale, since the priests hold on in hopes of higher prices. The existence of some of these is unknown to the officers of the Nara Hakuran Kaisha.

Fourth, of the things sold, many have passed in the hands of prominent gentlemen in Osaka Fu and Tokio. A regular exploration of Yamato by curio hunters has been going on for years; and nobody has hesitated to buy these things which have been secretly or falsely claimed by priests. Moreover, the employees and experts of Hakubutsu Kioku, as well as officers of the Nara Hakuran Kaisha have been the regular go-betweens for buying and selling these treasures. In this way, every possible influence has been combined up to this time, to disperse the antiquities and art treasures of Yamato, even that of the very authorities who ought to have been most anxious for their preservation. A few of the things sold have fallen into the hands of good priests, who still retain them as private property.

Fifth, the authorities of the Nara Hakuran Kaisha, who are supposed to know more about remaining Yamato treasures than any one else, appear to have made no thorough and systematic exploration. Moreover, no one here has any appreciation whatever of *artistic excellence* as distinguished from antiquarian curiosity. They thus spend great care over a few relatively worthless things, while they are ignorant or indifferent to many priceless treasures.

The only exception to this is the sculptor Kano Tessai who knows pretty well artistic value, and on his own private account has been making for the last year and a half the first systematic exploration of old temples, and discovered many treasures unknown to the Nara authorities. His willing assistance in our search has already been of great value to us.

Sixth, the priests have now reached such a state of poverty that, in many cases, they have not only exhausted their stock of secreted saleable articles, but are on the point of selling the things on their official list, and substituting imitations in their place.

Seventh, we have already, by searching old go-downs and lofts, discovered many important things, which have not been known to any one before, sometimes unknown even to the present priests when these are found, not being on the list, they become the private property of the priests, who may sell them if they like.

These facts describe the situation, but for convenience, it may be well to classify the art treasures which still remain in temples under the following heads:

a. Things on the official list which, being cared for by the Hakuran Kaisha, are practically unsaleable
b. Things which, though on the list, yet not being known or cared for by the Nara experts, are in danger of being sold secretly
c. Things which, though not on the list, are yet so well known by the public as temple property from old times, that the priests have not claimed them
d. Private property in the hands of the better class of priests who resist all inducements to sell
e. So-called private property in the hands of priests who openly offer it for sale
f. Falsely taken private property in the hands of priests, who conceal it from the authorities, and will sell it secretly as soon as they have a chance (to foreigners by preference, since then there is no danger of after trouble, and they get higher prices)

g. Lately discovered property, as the result of explorations by Tessai and ourselves, which is mostly unknown to the Nara authorities, and which becomes the private property of the priests, who are generally ready to sell it

Such is the situation—and now I beg to be allowed to present for your consideration, some suggestions of what may be done in the immediate future.

Assuming that it is your intention to collect the best of these treasures into a national museum in Tokio, the suggestions may fall under two heads:

(1) Those relating to further exploration

(2) Those relating to the future collecting of treasures

(1) We are making our investigation very thorough, availing ourselves of every help, official and private; we are doing the best that can possibly be done to inform ourselves of the existence of things belonging to the above mentioned seven classes. Of such, we are making careful notes, separating the things of first and second ranks in artistic value, from the common mass. To keep on, however, as thoroughly as we have begun, we shall probably require at least the whole of our four weeks for the temples of Yamato alone. Those of Kawachi, of Yamashiro, of Shiga Ken, and also Koyasan, remain.

(Ca. May 1888. By permission of the Houghton Library, Harvard University, bMS Am 1759.2 [62].)

"On preventing the sale . . ."

In Kioto itself, we have explored the chief temples pretty well in past years. But we need to make a rapid review of things previously seen, as well as make a search in many temples not yet visited. Kawachi and Shiga Ken we have hardly touched in the past. I know that the state of things in Kioto is quite like what it is in Yamato, only the process of selling things on the list has progressed further in Kioto. Since we visited Koyasan two years ago, we *know* that many things have been sold. We have also yet before us the whole question of examining the many private collections in all these places. The first question for decision, then, seems to be, whether our exploring expedition shall be prolonged beyond the originally planned four weeks.

The importance of prolonging it may be summed up in the one comprehensive statement, that *the sooner the Museum openly begins its collection the better,* and that *the collection cannot begin* until most everything we can hope to get has been identified and catalogued. The importance of haste in collecting rests upon the danger of future sales, fires, and careless treatment by priests. It would be well to get the most difficult things into the custody of Kunaisho before next winter. In that case, the open work of collecting and transporting must go on throughout the autumn.

The importance of making a thorough search before revealing its object is, of course, patent. Priests will afterward make every effort to conceal, hastily sell, or pawn their property. As a well-known private collector I now get a chance to see secret things, which otherwise I should not. There seems then no time better than the present to continue our exploration.

As to collecting in future, the question which seems to arise is this, on what terms can the things be taken from the priests; and shall these terms involve our participation in any definite action at present? By examining the list of the seven classes of objects above mentioned, it

appears that classes a, b, and probably c can be claimed as temple property, and be removed to the custody of Kunaisho without special consent on the part of the priests. Class d will very likely be presented by its owners to an Imperial Museum. If not, the things in it (some of the best which exist) might be bought at moderate prices probably. Classes e, f, and g are the dangerous ones, since there is no guarantee against their immediate sale. What is the best thing to do in regard to these? Shall they be bought at once, or shall we take measures to prevent their sale for the present? If the former, shall they be bought by us as private collectors, or through some third party? If the latter, shall we take some third party into our confidence such as the Mayor of Nara, or the managers of Hakuran Kaisha and request them by their personal influence to prevent the sale of such things for the present, if possible. On the whole, it seems to us best to make arrangements for buying such absolutely first class things as are on the point of sale; but, for most of the things, to represent to the priests ourselves, that the government takes interest in the preservation of these things, and does not want them sold. This will not forbid sale, but may have the effect of delaying it until next fall. It will pretty surely prevent the sale of g, will save much of f, and part of e. We await your instructions. In any case, even if things are presented to the Museum, it seems almost indispensable to give the priests a certain present of money, else many will be driven to starvation.

The difficulties in the way of continuing our work *now,* so far as I see, resolve themselves into the one question of my relations to Mombusho and Kunaisho. Please excuse me, then, if I speak about them frankly. If I am to continue my engagement as professor at Dai Gaku, I suppose you can hardly ask the University authorities to allow me more than a month of absence from duty. Moreover, if you are to collect articles for the Museum in the autumn, my presence in this part of the country to help identify and superintend packing will be then required. It appears to us, therefore, that the efficient prosecution of your important plan to save from dispersion the few remaining national treasures at this critical moment will require my active participation from this time onward. In that case, if you had any intention of transferring my sphere of work in future from Dai Gaku to Kunaisho, the above presentation of facts seems to supply reasons why the transference should be done at once. Doubtless there may be difficulties in the way of this, of which I cannot judge. Even if the transference were made at once, I could still return to Tokio in time to conduct the annual examination in the last of June. Your estimate of the importance of this transference will also doubtless depend upon your approval of my suggestions for future work of the Museum. It is perhaps not necessary for me to remind you that the memorandum I submitted to you was no more than a bare outline, the details of all parts of which I have mostly considered, and am prepared to superintend.

There is one further private matter of which I should like to speak. The fact of my having been in the past a large collector of Japanese works of art may prejudice some people against me, as not a fit person to take so responsible a position in connection with the Museum. Whatever considerations on that score that may have occurred, may be cancelled by my telling you what I have not revealed before, that my whole collection was sold last year to go to the Boston Art Museum, where it is to be arranged and exhibited in chronological order. I have only kept some parts of it in Tokio, to be copied for the use of the Mombusho Art Commission. I have now quite ceased to become a purchaser, since my whole object in buying hitherto has been to carry out a definite plan of illustrating Japanese art history, a plan now completed so far as my collection is concerned. Hereafter if you allow me, I propose to devote myself, as I am now doing to the task

of preserving in Japan, and turning to practical and scientific uses, all the ancient art treasures now remaining. If you think best, you may make use of this information.

It will probably be inconvenient to transfer my services to Kunaisho by making any definite final contract during my absence; and I shall be content with any temporary arrangement which appears to your judgment fair and proper.

(Ca. May 1888. By permission of the Houghton Library, Harvard University, bMS Am 1759.2 [70].)

"Conditions under which plans must be drawn for constructing the Building of the Nara Imperial Museum"

1. The building must be made of the best brick, cemented in the strongest manner, with hollow walls
2. All parts of the building must be of one story in height
3. All walls must be unbroken, save by necessary openings for entrance and exit
4. The finish of those parts of the walls which appear externally must be plain face brick of good quality
5. Internally the walls are to be left of ordinary brick unfinished
6. No exterior ornament of the walls is required; and nothing more than pilasters, buttresses, or simple mouldings at top and bottom should in any case be used
7. All lighting must be from above; either from windows in gables, or from windows directly in the roof
8. The floors are to be of wood; and the building must be thoroughly protected from damp from below
9. The apartments for exhibition must consist of six large rooms, and a gallery
10. The six large rooms must be so arranged that they are necessarily passed through in a fixed order from I to VI
11. In each of the four central rooms, that is from Rooms II to V inclusive, two of the walls facing each other, must be left unbroken by door openings

[There is no number 12 on the list.]

13. Rooms II & V must be 45 shaku square inside measurement, and their walls 16 shaku in height above the floor
14. Rooms III & IV must be 60 shaku square inside measurement, and their walls 33 shaku in height above the floor
15. Door openings between these rooms must not be less than 8 nor more than 10 shaku in width, and not less than 12 nor more than 15 shaku in height
16. Between Rooms I & II and rooms V & VI the door openings must be 10x15 shaku, and placed in the centre of one of the longer walls of Rooms I & VI
17. The walls above all door openings must not be supported by arches of brick, but lintels of stone
18. The total length of galleries required is 336 shaku; which may be cut up and disposed of in any convenient manner
19. These galleries must not be less than 18, nor more than 20 shaku in width, and the height of their walls above the floor must be 12 shaku

20. Door openings to enter the galleries must not be less than 6 shaku in width
21. The windows in the roofs must be constructed with special care to prevent the entrance of moisture and dust
23. The total cost of construction must not exceed Yen 60,000

[Number 23 appears twice on the list.]

22. If, in the case of the rooms II, III, IV, & V, windows are inserted in gables, these latter must be set so far back toward the centre of the roof, that their faces shall be at least 5 shaku from the plane of the walls
23. In the fixed order of the six rooms, rooms I & VI must be 30x40 shaku in ground plan, inside measurement; and their walls 25 shaku in height above the floor

(Ca. 1889. By permission of the Houghton Library, Harvard University, bMS Am 1759.2 [61].)

Notes

Introduction

1. Okakura's speech is transcribed in *Nichide shinbun*, 2 September 1888.

2. The Tokyo National Museum, the current manifestation in Tokyo of the Imperial Museum, has been largely responsible for forming this characterization, particularly in the retrospective histories that this institution has published about itself. See also note 3.

3. Kyōto Kokuritsu Hakubutsukan, *Kyōto Kokuritsu Hakubutsukan hyakunenshi* (Kyoto: Kyōto Kokuritsu Hakubutsukan, 1997); Nara Kokuritsu Hakubutsukan, *Nara Kokuritsu Hakubutsukan hyakunen no ayumi* (Nara: Nara Kokuritsu Hakubutsukan, 1995); and Tōkyō Kokuritsu Hakubutsukan, *Tōkyō Kokuritsu Hakubutsukan hyakunenshi*, 2 vols. (Tokyo: Tōkyō Kokuritsu Hakubutsukan, 1973).

4. Both John Rosenfield and Mimi Hall Yiengpruksawan touch on this in their state-of-the-field essays. See John Rosenfield, "Japanese Art Studies in America since 1945," in *The Postwar Development of Japanese Studies in the United States*, ed. Helen Hardacre (Boston: Brill, 1998), 163–67; and Mimi Hall Yiengpruksawan, "Japanese Art History 2001: The State and Stakes of Research," *Art Bulletin* 83 (March 2001): 110–11. The Japanese government's hegemony over the preservation, promotion, and research of art since the Meiji period has been noted by both authors in their assessments as one of the large challenges faced by students of Japanese art history. In Yiengpruksawan's words: "[The Japanese state's] official organs—the Cultural Affairs Agency in the Ministry of Education, the Art Research Institute, the National Museums at Tokyo, Kyoto, and Nara, and the Japan Foundation—supervise access to works of Japanese art and research facilities. . . . The shadow cast by the Cultural Affairs Agency is particularly long and reaches across the Pacific to American museum boardrooms when exhibitions of Japanese art from Japan are contemplated. . . . From an academic standpoint the Cultural Affairs Agency is the guardian and agent abroad of . . . the 'cultural patrimony' of the Japanese art historical canon" (110).

5. The Agency for Cultural Affairs was created in 1968 through a merger of the former Cultural Bureau of the Ministry of Education and the Cultural Properties Protection Commission.

6. Andrew McClellan, *Inventing the Louvre: Art, Politics, and the Origins of the Modern Museum in Eighteenth-Century Paris* (Berkeley: University of California Press, 1999); Patricia Mainardi, *The End of the Salon: Art and the State in the Early Third Republic* (Cambridge: Cambridge University Press, 1993).

7. Mainardi, *End of the Salon*, 4.

8. Official Japanese interest in the international fairs actually started in the 1860s, before the establishment of the Meiji regime. A Japanese envoy visited the 1862 International Exhi-

bition in London, although no official national exhibit was organized. For the 1867 Exposition Universelle in Paris, representatives of the Tokugawa *bakufu*, the Saga domain, and the Satsuma domain all organized displays.

9. The Western-style reform undertaken by the Meiji government involved a complex mélange of motivations and initiatives and was not received without prejudice by all Japanese. Japan's adoption of Western ways was neither an imposition by foreign powers nor an obvious course of action on the part of Japanese leaders. See, for example, W. G. Beasley, *Japan Encounters the Barbarian: Japanese Travellers in America and Europe* (New Haven, Conn.: Yale University Press, 1995); and Andrew Cobbing, *The Japanese Discovery of Victorian Britain: Early Travel Encounters in the Far West* (Richmond, Surrey, U.K.: Japan Library, 1998).

10. Zeynep Çelik, *Displaying the Orient: Architecture of Islam at Nineteenth-Century World's Fairs* (Berkeley: University of California Press, 1992); Patricia Morton, *Hybrid Modernities: Architecture and Representation at the 1931 Colonial Exposition, Paris* (Cambridge, Mass.: MIT Press, 2000).

11. Jeffrey Auerbach, *The Great Exhibition of 1851: A Nation on Display* (New Haven, Conn.: Yale University Press, 1999), 159–89.

12. See the works of Robert Rydell, especially Robert Rydell and Nancy Gwinn, eds., *Fair Representations: World's Fairs and the Modern World* (Amsterdam, Neth.: VU University Press, 1994); and Robert Rydell, *All the World's a Fair: Visions of Empire at American International Expositions, 1876–1916* (Chicago: University of Chicago Press, 1984).

13. Çelik, *Displaying the Orient*, 11.

14. Kitazawa Noriaki, *Me no shinden: "Bijutsu" juyōshi nōto* (Tokyo: Bijutsu Shuppansha, 1989), and Kitazawa, *Kyōkai no bijutsushi: Bijutsu keiseishi nōto* (Tokyo: Seiunsha, 2000); Satō Dōshin, *"Nihon Bijutsu" tanjō: Kindai Nihon no "kotoba" to senryaku* (Tokyo: Kōdansha, 1996), and Satō, *Meiji kokka to kindai bijutsu: Bi no seijigaku* (Tokyo: Yoshikawa Kōbunkan, 1999).

15. See, for example, Elizabeth Mansfield, ed., *Art History and Its Institutions: Foundations of a Discipline* (London: Routledge, 2002). In the past decade, assessments of the state of scholarship in the various subfields of art and architectural history have also been represented in two key journals, the *Art Bulletin* and the *Journal of the Society of Architectural Historians*. Both commissioned series of essays, "The State of Art History," launched in March 2001 in the *Art Bulletin*, and "Teaching the History of Architecture: A Global Inquiry," launched in September 2002 in the *Journal of the Society of Architectural Historians*.

16. See the following by Christine Guth: *Art, Tea, and Industry* (Princeton, N.J.: Princeton University Press, 1993); "Some Reflections on the Formation of the Meiji Artistic Canon," in *New Directions in the Study of Meiji Japan*, ed. Helen Hardacre (Leiden, Neth.: Brill, 1997); and "Kokuhō: From Dynastic to Artistic Treasure," *Cahiers d'Extrême-Asie* 9 (1996–97): 313–22.

17. Carla Yanni, *Nature's Museums: Victorian Science and the Architecture of Display* (Baltimore, Md.: Johns Hopkins University Press, 1999), 3.

18. The museums in Kyoto and Nara were named Important Cultural Properties in 1969, and the Hyōkeikan was given the same status in 1978.

19. The Nara building is the only one that still regularly holds exhibits. Partial sections of the Kyoto building and the Hyōkeikan are open for limited periods each year for special exhibits.

20. Collection histories and building histories have been published separately for the following major museums. For the Victoria and Albert Museum, see Anna Somers Cocks, *The*

Victoria and Albert Museum: The Making of the Collection (London: Windward, 1980); and John Physick, *The Victoria and Albert Museum, the History of Its Building* (Oxford: Phaidon, 1982). For the Louvre, see Andrew McClellan, *Inventing the Louvre*; and Geneviève Bresc-Bautier, *The Louvre: An Architectural History* (New York: Vendome Press, 1995). For the British Museum, see Marjorie Caygill, *The British Museum: 250 Years* (London: British Museum Press, 2003); and J. Mordaunt Crook, *The British Museum: A Case-Study in Architectural Politics* (Harmondsworth, U.K.: Penguin Books, 1973). And for the Metropolitan Museum of Art, New York, see Calvin Tomkins, *Merchants and Masterpieces: The Story of the Metropolitan Museum of Art* (New York: H. Holt, 1989); and Morrison Heckscher, *The Metropolitan Museum of Art: An Architectural History* (New York: Metropolitan Museum of Art, 1995).

21. James Cuno critiques the emergence of the "exciting museum" (a place that offers shopping, dining, and high-tech interfaces in addition to the art exhibition) as the twenty-first-century substitute for art museums (places that should allow and encourage intimate, subjective, and extended experiences with art) in "Against the Discursive Museum," in *The Discursive Museum*, ed. Peter Noever (New York: Distributed Art Publishers, 2001), 44–57. Other writings with telling titles include Franklin Robinson, "No More Buildings! Has the Epidemic of New Buildings Become a Substitute for New Thinking?" *Museum News* (November/December 2002), 28–29; and Suzanne Stephens, "Are Museums Suffering from Architectural Overload?" *Architectural Record* (January 2004), 89–91. A consistent stream of articles has appeared in the *New York Times* with headlines that assert the conflicting coexistence of art and architecture in today's museums: Ann Wilson Lloyd, "If the Museum Itself is an Artwork, What about the Art Inside?" *New York Times*, 25 January 2004; Brenda Goodman, "Atlanta Museum's New Pitch: Come for the Architecture, Stay for the Art," *New York Times*, 12 November 2005; and Randy Kennedy, "When a Museum Building Competes with Art," *New York Times*, 10 January 2006.

22. Carol Duncan and Alan Wallach, "The Universal Survey Museum," *Art History* 3 (December 1980): 448–69.

23. Carol Duncan, *Civilizing Rituals: Inside the Public Art Museums* (London: Routledge, 1995); and Alan Wallach, *Exhibiting Contradiction: Essays on the Art Museum in the United States* (Amherst, Mass.: University of Massachusetts Press, 1998).

24. Jordan Sand, "Japan," *Journal of the Society of Architectural Historians* 57 (June 1998): 231–34.

25. Penelope Mason, *History of Japanese Art*, 1st ed. (New York: Abrams, 1993); William Coaldrake, *Architecture and Authority in Japan* (London: Routledge, 1996). In the second edition of *History of Japanese Art*, revised by Donald Dinwiddie and published in 2005, the seventeen pages devoted to modern architecture in the first edition have been reduced to six pages.

26. While no overarching theme or approach ties together the most recent English-language publications on modern Japanese architecture, each author has broken new ground in reframing an established subject or expanding the canon. Two noteworthy books are Jonathan Reynolds, *Maekawa Kunio and the Emergence of Japanese Modernist Architecture* (Berkeley: University of California Press, 2001); and Jordan Sand, *House and Home in Modern Japan: Architecture, Domestic Space, and Bourgeois Culture, 1880–1930* (Cambridge, Mass.: Harvard University Asia Center, 2003). Essays have mostly focused on the interlinked subjects of architecture, nationalism, and the politics of war: Cherie Wendelken, "Pan-Asianism and the Pure Japanese Thing: Japanese Identity and Architecture in the late 1930s," *Positions* 8 (winter 2000): 819–28; Akiko

Takenaka, "Architecture for Mass-mobilization: The Chūreitō Memorial Construction Movement, 1939–1945," in *The Culture of Japanese Fascism*, ed. Alan Tansman (forthcoming); and Toshio Watanabe, "Japanese Imperial Architecture: From Thomas Roger Smith to Itō Chūta," in *Challenging Past and Present: The Metamorphosis of Nineteenth-Century Japanese Art*, ed. Ellen Conant (Honolulu: University of Hawaii Press, 2006), 240–53. Dallas Finn has written a useful reference book on the subject of Meiji public architecture, *Meiji Revisited: The Sites of Victorian Japan* (New York: Weatherhill, 1995).

27. For publications on Josiah Conder, see chapter 2, note 30; on Katayama Tōkuma, see chapter 4, notes 27 and 41.

28. Carol Gluck, "'Meiji' for Our Time," in *New Directions*, ed. Hardacre, 16.

29. See Helen Hardacre, "Introduction," in *New Directions*, xv–xlii.

1. Encounters and Translations: The Origins of Hakubutsukan *and* Bijutsu

Epigraph: Kume Kunitake, *The Iwakura Embassy, 1871–73: A True Account of the Ambassador Extraordinary and Plenipotentiary's Journeys of Observation through the United States and Europe*, vol. 2, *Britain*, trans. Graham Healey (Princeton, N.J.: Princeton University Press, 2002), 111.

1. Steven Conn, *Museums and American Intellectual Life, 1876–1926* (Chicago: University of Chicago Press, 1998), 3–9.

2. Donald Preziosi, "The Art of Art History," in *The Art of Art History: A Critical Anthology* (Oxford: Oxford University Press, 1998), 513.

3. The International Council of Museums (ICOM) Statutes, Article 2.1 (1995), defines a museum as a "non-profit making, permanent institution in the service of society and of its development, and open to the public, which acquires, conserves, researches, communicates and exhibits, for purposes of study, education and enjoyment, material evidence of people and their environment."

4. On Cole, see Anna Somers Cocks, *The Victoria and Albert Museum: The Making of the Collection* (Leicester, U.K.: Windward, 1980); and on Corcoran, see the chapter "William Corcoran's Failed National Gallery" in Alan Wallach, *Exhibiting Contradiction: Essays on the Art Museum in the United States* (Amherst, Mass.: University of Massachusetts Press, 1998), 22–37.

5. W. G. Beasley, *Japan Encounters the Barbarian: Japanese Travellers in America and Europe* (New Haven, Conn.: Yale University Press, 1995), 207–8.

6. See Shiina Noritaka, *Meiji hakubutsukan kotohajime* (Kyoto: Shibunkaku Shuppan, 1989), 21–25.

7. The term *shūkokan* differs in connotation from the other terms in that it refers specifically to the collection of old objects. This term is still in use today in reference to the museum of the industrialist Okura Kihachirō (1837–1928), the Okura Shūkokan in Tokyo, originally established in 1917 to house the premodern East Asian art treasures Okura had amassed since the Meiji Restoration. The Okura Shūkokan is also notable for being the first private museum in Japan.

8. Douglas Howland, *Translating the West: Language and Political Reason in Nineteenth-Century Japan* (Honolulu: University of Hawaii Press, 2002).

9. On the changing meaning of the term "museum" in Europe, see Paula Findlen, "The

Museum: Its Classical Etymology and Renaissance Genealogy," *Journal of the History of Collections* 1, no. 1 (1989): 59–78.

10. Fukuzawa served as personal servant to the captain of the *Kanrin Maru* in 1860 and as a translator in 1862. The latter group observed the 1862 world's fair while in London.

11. My translation is based on the 1969 reprint of *Seiyō jijō*, in the compilation of Fukuzawa's writings: *Fukuzawa Yukichi*, vol. 33 of *Nihon no meicho* (Tokyo: Chūō Kōronsha, 1969), 376.

12. The Meirokusha, or Meiji Six Society, was a most articulate group of advocates for Western reform. Its publication, the *Meiroku zasshi*, began circulation in 1874. The charter members—Fukuzawa among them—were students of the utilitarianism and positivism of the nineteenth-century West. They believed that a nation's enlightenment and progress was possible through the promotion of "practical studies (*jitsugaku*) [which] explain factual principles through actual observation and verification, such as astronomy, physics, chemistry, medicine, political economy, and philosophy of the modern West." Tsuda Mamichi, "Methods for Advancing Enlightenment," trans. William Reynolds Braisted, in *Meiroku Zasshi, Journal of the Japanese Enlightenment* (Cambridge, Mass.: Harvard University Press, 1976), 38; originally published in Japanese in *Meiroku zasshi*, no. 3, n.d.

13. See Fukuzawa Yukichi, *An Outline of a Theory on Civilization*, trans. David A. Dilworth and G. Cameron Hurst (Tokyo: Sophia University, 1973). Originally published in Japanese as *Bunmeiron no gairyaku* in 1875.

14. It is difficult to decipher the extent to which Kume was expressing his own viewpoint and the extent to which he was faithfully recording the thoughts of the entire group. However, he did distinguish the "fact" sections and the "analysis" sections by means of typographical differentiation.

15. The exceptions being the *hakubutsukan* in Liverpool, Edinburgh, Stockholm, The Hague, and Bern, which, from Kume's description, were exclusively scientific in focus.

16. Kume, *The Iwakura Embassy, 1871–1873*, vol. 4, trans. P. F. Kornicki, 304–7.

17. Ibid., vol. 2, 108.

18. Ibid., vol. 2, 109–10.

19. The exhibition was held from 1 May to 1 November 1873 in Prater Park, Vienna. The Japanese delegation consisted of more than seventy people, a number of whom remained behind in Europe to apprentice in art schools, artisans' workshops, and factories and to attend engineering schools.

20. Gottfried Wagener received a degree in mathematics from the University of Göttingen and in 1868 took employment with an American company that was setting up a soap manufacturing plant in Nagasaki. Later, he entered the services of the Japanese government and became an influential adviser on the preservation of traditional Japanese crafts through the adoption of new techniques and the establishment of a museum. For more on Wagener in Japan, see Muramatsu Teijirō, *Nihon no kindaika to oyatoi gaikokujin* (Tokyo: Hitachi, 1995), 80–85.

21. Both are Japanese translations from original English sources. Sano mentions receiving the originals from Philip Cunliffe-Owen, the director of the South Kensington Museum at the time.

22. While participating in the Weltausstellung, Sano and Wagener also took time to visit the museums in Austria, England, France, and Germany for the purpose of compiling their

respective proposals for a museum in Tokyo. Other than the South Kensington Museum and the Edinburgh Museum of Science and Art (today the National Museum of Scotland), they referenced no other museum by name in their reports.

23. Ōkoku Hakurankai Jimukyoku, *Ōkoku Hakurankai hōkokusho*, vol. 4, *Hakubutsukanbu* (Tokyo: Ōkoku Hakurankai Jimukyoku, 1875), 1.

24. Ibid., 6. Sano used the distinctive expressions *kokka fushoku* (国家富殖), "increasing the wealth of the nation," and *jinbutsu kaimei* (人物開明), "enlightening the people," rather than the familiar Meiji catchphrases *fukoku kyōhei* (富国強兵), "a wealthy nation and a strong army," and *bunmei kaika* (文明開化), "civilization and enlightenment." For a discussion of the advantages of holding exhibitions in Ueno as explained in Sano's report, see Angus Lockyer, "Japan at the Exhibition, 1867–1970" (Ph.D. diss., Stanford University, 2000), 93–95.

25. Sano established the organization as the Philanthropic Society (Hakuaisha) in 1877, and it took the name Japanese Red Cross Society in 1887.

26 From *Fukuzawa Zenshū*, quoted in Carmen Blacker, *The Japanese Enlightenment: A Study of the Writings of Fukuzawa Yukichi* (Cambridge: Cambridge University Press, 1964), 52–53.

27. This is also a main premise in Yoshimi Shunya's *Hakurankai no seijigaku: Manazashi no kindai* (Tokyo: Chūō Kōronsha, 1992).

28. Conn, *Museums and American Intellectual Life*, 11.

29. Quoted in Andrew Cobbing, *The Japanese Discovery of Victorian Britain: Early Travel Encounters in the Far West* (Richmond, Surrey, U.K.: Japan Library, 1998), 173.

30. Tokugawa Western specialists were also known as Dutch scholars because knowledge about the West was acquired primarily through Dutch texts and study with the Dutch at Nagasaki. Western paintings, scientific instruments, and curios as well as books circulated in limited quantities. The extent of Japan's cultural isolation has been the main subject of inquiry for art scholars such as Calvin French, in *Through Closed Doors: Western Influence on Japanese Art, 1639–1853* (Kobe, Japan: Kobe City Museum of Namban Art, 1977), and more recently by Timon Screech, in *The Lens within the Heart: The Western Scientific Gaze and Popular Imagery in Later Edo Japan*, 2nd ed. (Honolulu: University of Hawaii Press, 2002). Both studies, especially the latter, propose that Western ideas and objects began to play an influential role in artistic and popular cultures even before Japan's political opening in the Meiji period.

31. Cobbing, *Japanese Discovery of Victorian Britain*, 185.

32. See, for example, Ralph Nicholson Wornum, "The Exhibition as a Lesson in Taste. An Essay on Ornamental Art as Displayed in the Industrial Exhibition in Hyde Park, in which the Different Styles are Compared with a View to the Improvement of Taste in Home Manufactures," in *The Art Journal Illustrated Catalogue. The Industry of All Nations, 1851* (London: Bradbury and Evans, 1851), i–xxii; and Richard Redgrave, "Report on the Present State of Design Applied to Manufactures, as Shown in the Paris Universal Exhibition," in *Reports on the Paris Universal Exhibition* (London: George E. Eyre and William Spottiswood for HMSO, 1856), vol. 3, 313–410. I would like to thank Elizabeth Pergam for introducing me to these sources.

33. See Satō Dōshin, *"Nihon Bijutsu" tanjō: Kindai Nihon no "kotoba" to senryaku* (Tokyo: Kōdansha, 1996), 44–49, for a concise summary of the origins of each term.

34. See Kitazawa Noriaki, *Me no shinden: "Bijutsu" juyōshi nōto* (Tokyo: Bijutsu Shuppansha, 1989), and Kitazawa, *Kyōkai no bijutsushi: Bijutsu keiseishi nōto* (Tokyo: Seiunsha, 2000);

and Satō Dōshin, *"Nihon Bijutsu" tanjō*, and Satō, *Meiji kokka to kindai bijutsu: Bi no seijigaku* (Tokyo: Yoshikawa Kōbunkan, 1999).

35. Howland, *Translating the West*, 5.

36. Howland emphasizes the second and third steps.

37. Paul Oskar Kristeller, "The Modern System of the Arts: A Study in the History of Aesthetics," part 2, *Journal of the History of Ideas* 13 (January 1952): 43–44.

38. Patricia Mainardi, *Art and Politics of the Second Empire: The Universal Expositions of 1855 and 1867* (New Haven, Conn.: Yale University Press, 1987), 7.

39. "Jury Awards—Class XXX," Report by the Juries on the Subjects in the Thirty Classes into which the Exhibition was Divided (London: William Clowes & Sons, 1852), 684.

40. Mainardi, *Art and Politics*, 24–26.

41. Emile Gallé, "The Salons of 1897: Objets d'Art," in *The Expanding World of Art, 1874–1902*, vol. 1, *Universal Expositions and State-Sponsored Fine Arts Exhibitions*, ed. Elizabeth Gilmore Holt (New Haven, Conn.: Yale University Press, 1988), 376–80. Originally published as *"Les Salons de 1897,"* in *Gazette des Beaux-Arts*, ser. 3, vol. 18 (September 1897): 229–50.

42. "Jury Awards—Class XXX," 684.

43. Although the discussion appears in Kitazawa's earlier work *Me no shinden*, a more thorough analysis appears in his later work *Kyōkai no bijutsushi*, 8–10.

2. The Museum in Ueno Park: Styling the Nation

Epigraph: Josiah Conder, "The Effect of the Recent Earthquake upon Buildings," *Japan Weekly Mail*, 12 December 1891, 725.

1. Kume Kunitake, *The Iwakura Embassy, 1871–73: A True Account of the Ambassador Extraordinary and Plenipotentiary's Journeys of Observation through the United States and Europe*, vol. 2, *Britain*, trans. Graham Healey (Princeton, N.J.: Princeton University Press, 2002), 59–60.

2. Tanaka Akira, "Introduction," in *The Iwakura Embassy, 1871–1873*, by Kume, vol. 1, xix–xx. The Iwakura mission estimated that Japan was about forty years behind Britain and thirty years behind the rest of Europe and the United States.

3. Although here Kume called it the "Kensington exhibition" (*Kenshinton no hakurankai*, in the original Japanese), he was referring to the Great Exhibition of 1851 held in Hyde Park. Throughout this entry on the South Kensington Museum, he emphasizes the momentous nature of the 1851 event, citing it as the catalyst for improvements in the production, quality, and distribution of the goods of major European nations.

4. Machida Hisanari acted as director of Japanese students from the Satsuma domain who were studying in London in the mid-1860s. This stay enabled him to investigate the city's museums, which formed the basis of his recommendation for a museum in Tokyo. For a general study of Machida and his involvement in directing the museum in Ueno, see Seki Hideo, *Hakubutsukan no tanjō: Machida Hisanari to Tōkyō Teishitsu Hakubutsukan* (Tokyo: Iwanami Shoten, 2005).

5. The Education Ministry museum had its share of name changes. It began with Hakubutsukan in 1872; changed to Tōkyō Hakubutsukan in 1875, Kyōiku Hakubutsukan in 1877, and Tōkyō Kyōiku Hakubutsukan in 1881; went back to Tōkyō Hakubutsukan in 1921; changed

to Tōkyō Kagaku Hakubutsukan in 1931; and finally took its current name of Kokuritsu Kagaku Hakubutsukan (National Science Museum) in 1949.

6. Machida first submitted a proposal in June 1873 to the Grand Council of State. For a transcription of the proposal, see Tōkyō Kokuritsu Hakubutsukan, *Tōkyō Kokuritsu Hakubutsukan hyakunenshi* (hereafter *TKHH*) (Tokyo: Tōkyō Kokuritsu Hakubutsukan, 1973), vol. 2, 6–7. On Machida's favorable assessment of the site's features, see ibid., vol. 1, 108–9.

7. See Shiina Noritaka, *Meiji hakubutsukan kotohajime* (Kyoto: Shibunkaku Shuppan, 1989), 103–9.

8. This pedagogical museum was to be modeled after the Educational Museum in Toronto, established in 1853 as the first museum in the world devoted to the improvement and dissemination of pedagogical methods.

9. *TKHH*, vol. 1, 120.

10. Carla Yanni, *Nature's Museums: Victorian Science and the Architecture of Display* (Baltimore, Md.: Johns Hopkins University Press, 1999), 91.

11. *Edinburgh Evening Courant*, 22 May 1866. Cited in Yanni, *Nature's Museums*, 93.

12. Ōkubo's assassination was unrelated to the museum project but rather resulted from his major role in putting down the 1877 rebellion incited by samurai from his former domain of Satsuma.

13. From 1870 to 1883, the Public Works Ministry administered all national government construction, with the exception of school buildings, which fell within the purview of the Education Ministry.

14. An extended discussion of this exhibition can be found in the chapter "Domesticating the Exposition, Tokyo, 1877," in Angus Lockyer, "Japan at the Exhibition, 1867–1970" (Ph.D. diss., Stanford University, 2000), 79–123.

15. For more on the architecture of Hayashi Tadahiro, see Fujimori Terunobu, *Nihon no kindai kenchiku* (Tokyo: Iwanami Shoten, 1993), vol. 1, 97–102.

16. On the architecture of the Centennial Exhibition, see Bruno Giberti, *Designing the Centennial: A History of the 1876 International Exhibition in Philadelphia* (Lexington, Ky.: University Press of Kentucky, 2002).

17. The Pennsylvania Museum and School of Industrial Art opened in Memorial Hall in 1877 after the close of the Centennial Exhibition. Once again, the South Kensington Museum was the inspiration, as is clearly stated in the institution's 1876 charter. Giberti, *Designing the Centennial*, 195.

18. Maeda Ai, "Modern Literature and the World of Printing," trans. Richard Okada, in *Text and the City: Essays on Japanese Modernity*, ed. James Fujii (Durham, N.C.: Duke University Press, 2004), 265.

19. T. Fujitani, *Splendid Monarchy: Power and Pageantry in Modern Japan* (Berkeley: University of California Press, 1996), 48–49.

20. "The Fine Arts Building," *The Tokio Times*, 6 October 1877.

21. Clara Whitney, *Clara's Diary: An American Girl in Meiji Japan*, ed. M. William Steele and Tamiko Ichimata (Tokyo: Kodansha International, 1979), 146.

22. Giberti, *Designing the Centennial*, 33–34.

23. After the Great Exhibition of 1851, ferro-vitreous construction came to be used for permanent exhibition architecture, but more for natural history museums than for art museums.

See Carla Yanni, "The Crystal Palace: A Legacy in Science," *Journal of Prince Albert Studies* 20 (2002): 119–26.

24. Jeffrey Auerbach, *The Great Exhibition of 1851: A Nation on Display* (New Haven, Conn.: Yale University Press, 1999), 41–53.

25. Giberti, *Designing the Centennial*, 191–92.

26. Nishi Amane, "An Essay on Brick Construction," in *Meiroku Zasshi: Journal of the Japanese Enlightenment*, trans. William Reynolds Braisted (Cambridge, Mass.: Harvard University Press, 1976), 52–53. Originally published in Japanese in *Meiroku zasshi*, no. 4 (1874–75).

27. Conder was of the school of thought that conflated the *appearance* of strength with the *reality* of strength in masonry building. At the time, an opposing view suggested that a flexible material such as wood would be better at withstanding earthquakes. For more on this subject, see Gregory Clancey, *Earthquake Nation: The Cultural Politics of Japanese Seismicity, 1868–1930* (Berkeley: University of California Press, 2006).

28. For example, see R. Henry Brunton, "Constructive Art in Japan," parts 1 and 2, *Transactions of the Asiatic Society of Japan* 2 (22 October 1873–15 July 1874): 64–86; 3 (13 January 1875–30 June 1875): 20–30. Also see George Cawley, "Some Remarks on Constructions in Brick and Wood and Their Relative Suitability for Japan," *Transactions of the Asiatic Society of Japan* 6 (1878): 291–317.

29. Muramatsu Teijirō describes Conder as "the Westerner who exerted the most influence on Japanese architecture during the first half of the [nineteenth] century." Muramatsu Teijirō, "Ventures into Western Architecture," in *Dialogue in Art: Japan and the West*, ed. Yamada Chisaburō (Tokyo: Kodansha International, 1976), 128. Suzuki Hiroyuki, Fujimori Terunobu, and Kawahigashi Yoshiyuki have portrayed him in similar terms in their respective writings (see notes 15 and 30).

30. No book-length English-language publication is yet available on Josiah Conder. For articles, see an earlier version of this chapter in my "Styling Japan: The Case of Josiah Conder and the Museum at Ueno, Tokyo," *Journal of the Society of Architectural Historians* 63 (December 2004): 472–97; two essays by Toshio Watanabe, "Josiah Conder's Rokumeikan: Architecture and National Representation in Meiji Japan," *Art Journal* 55 (fall 1996): 21–27, and "Vernacular Expression or Western Style?: Josiah Conder and the Beginning of Modern Architectural Design in Japan," in *Art and the National Dream: The Search for Vernacular Expression in Turn-of-the-Century Design* (Dublin: Irish Academic Press, 1993), 43–52; and J. Mordaunt Crook, "Josiah Conder in England: Education, Training, and Background," in *Rokumeikan no kenchikuka Josaia Kondoru ten*, ed. Kawanabe Kusumi and Suzuki Hiroyuki (Tokyo: Higashi Nihon Tetsudō Bunka Zaidan, 1997), 26–28. Several book- and article-length studies are available in the Japanese language. Only the ones most relevant to this chapter are named here. The catalog *Rokumeikan no kenchikuka Josaia Kondoru ten*, which accompanied the 1997 exhibition of Josiah's Conder's lifework, contains comprehensive treatment of his projects and publications. Conder's existing architectural drawings have been collected in Kawahigashi Yoshiyuki, *Josaia Kondoru kenchiku zumenshū*, 3 vols. (Tokyo: Chūō Kōron Bijutsu Shuppan, 1980–81). The most insightful analysis of the architect's early work are still the two articles written by Suzuki Hiroyuki: "Josaia Kondoru to Eikoku," *Kenchikushi kenkyū* 40 (1976): 1–15, and "Josaia Kondoru no kenchikukan to Nihon," in *Nihon kenchiku no tokushitsu* (Tokyo: Chūō Kōron Bijutsu Shuppan, 1976), 459–507.

31. Louis François Roubiliac was a sculptor of French birth who in the 1730s emigrated to London, where he eventually established a career and a family. He is best known for his portrait statue of George Frideric Handel (Victoria and Albert Museum, London) and bust of William Hogarth (National Portrait Gallery, London). Grandfather Josiah authored the popular thirty-volume series *The Modern Traveller: A Description, Geographical, Historical, and Topographical, of the Various Countries of the Globe*, despite having never once left English soil. The series, published in 1830, covered remarkably exotic destinations for the mid-nineteenth-century traveler, such as Palestine (volume 1), Burmah [*sic*] and Siam (volume 11), and Brazil (volumes 29, 30). The work included China, but not Japan. He was also well known in his day as a composer of hymns.

32. Following in Josiah's footsteps, younger brother Roger Thomas Conder became an architect as well and won the Soane Medallion in 1881. He initially studied with Thomas Roger Smith in London but relocated in 1889 to the Argentine Republic, where he embarked on his design career. In 1905, when he was elected a fellow of the Royal Institute of British Architects, he was still practicing in that country.

33. Information on Conder's education and training are based on his Nomination Papers for admittance as a fellow of the Royal Institute of British Architects (RIBA), 1 March 1884, British Architectural Library, RIBA.

34. J. Mordaunt Crook, *William Burges and the High Victorian Dream* (Chicago: University of Chicago Press, 1981), 27.

35. The Soane Medallion was instituted in 1838, in memory of the eminent architect Sir John Soane (1753–1837), as an annual design competition for rising young designers. As the 1876 winner, Conder received £50 in prize money for travel to the European continent, with the understanding that his sketches from the trip would be exhibited at the RIBA.

36. Mark Girouard, *Sweetness and Light: The "Queen Anne" Movement, 1860–1900* (Oxford: Clarendon Press, 1977), especially 57–63; Michael J. Lewis, *The Gothic Revival* (New York: Thames and Hudson, 2002), 157–84.

37. J. Mordaunt Crook, *The Dilemma of Style: Architectural Ideas from the Picturesque to the Post-Modern* (Chicago: University of Chicago Press, 1987), 98–132.

38. Josiah Conder, "A Lecture Upon Architecture," lecture given at the Imperial College of Engineering, Tokyo, March 1878.

39. William Burges, in *The Church and the World*, ed. O. Shipley (n.p.: 1867), 589.

40. Immediately after his arrival in Tokyo in 1877, Conder became a member of the Asiatic Society of Japan, where he had the opportunity to listen to reports by fellow Western residents on the history, politics, literature, culture, and arts of Japan, and where he eventually presented his own research on Japanese costumes, landscape gardening, and flower arrangement. Also interested in the promotion of Western-style painting in Japan, he in 1889, along with student Tatsuno Kingo, was a founding member of the Meiji Art Society. For more on Conder's involvement with Japanese arts, see Yamaguchi Seiichi, "Kondoru no Nihon kenkyū," in *Rokumeikan no kenchikuka Josaia Kondoru ten*, ed. Kawanabe and Suzuki, 49–52.

41. Conder studied painting with Kyōsai for eight years and was granted the art name Kyōei (曉英)—*kyō* being the first character of the master's name and *ei* being the character for England. For more on the relationship between Conder and Kyōsai, see Kawanabe Kusumi, "Kondoru to gaka Kyōsai no kōryū," in *Rokumeikan no kenchikuka Josaia Kondoru ten*, ed.

Kawanabe and Suzuki, 57–60. For more on Conder's pursuit of Japanese painting, see Suzuki Hiroyuki and Fujimori Terunobu, eds., *Rokumeikan no yume: Kenchikuka Kondoru to eshi Kyōei* (Tokyo: INAX, 2001).

42. See the bibliography for a list of Conder's papers and publications.

43. Before Conder's arrival in 1877, at least three other foreign experts in the Public Works Ministry were responsible for architecture: the Frenchman Charles Alfred Chastel de Boinville (1850–1897), the Italian Giovanni Vincenzo Cappelletti (1841–1887), and the Englishman Thomas James Waters (b. 1842).

44. Crook, *William Burges*, 52–53. See also Nancy B. Wilkinson, "E. W. Godwin and Japonisme in England," in *E.W. Godwin: Aesthetic Movement Architect and Designer*, ed. Susan Weber Soros (New Haven, Conn.: Yale University Press, 1999), 71–91. On Godwin's Anglo-Japanese furniture, see Susan Weber Soros, *The Secular Furniture of E. W. Godwin* (New Haven, Conn.: Yale University Press, 1999), 38–43.

45. Christopher Dresser was a leading promoter of Japanese aesthetics in Britain even before his visit to Japan in 1876–77. He wrote *Japan, its Architecture, Art, and Art Manufactures* after his three-month tour—during which he met a handful of influential art experts and guides, among them, Sano Tsunetami and Machida Hisanari—but it was not published until 1882. Although the book focused primarily on the decorative arts, his discussion of architecture, namely, a brief, one-page explication on the scientific, aseismic construction of an indigenous pagoda structure, sparked a heated four-year debate between Dresser and Conder. On Dresser's involvement with Japan, see chapters 2 and 3 in Widar Halén, *Christopher Dresser: A Pioneer of Modern Design* (London: Phaidon Press, 1993).

46. The set of bound sketches known as the Josiah Conder Sketchbooks consists of four large albums and one small notebook. They have been kept in the Architecture Department of the University of Tokyo since 1966, when the architect's daughter, Mrs. Helen Grut, gifted them to the university. The sketchbooks as well as the sketch segments within them are in no apparent order, chronological or thematic. Inscriptions, dates, and signatures accompany some segments, although most are undated and unsigned. Sketches by hands other than Conder's also appear in these volumes; Conder's Japanese painting teacher, Kawanabe Kyōsai is one of them. The earliest dated sketches are from October 1874, and the latest is from August 1905. There is also a calendar design for January of 1920.

47. Because of the imminent start of his professional appointment in Japan, Conder was unable to complete a proper grand tour of Europe. In a letter addressed to Charles Barry, the president of the RIBA, Conder requested a modification to the traveling portion of the Soane award. Josiah Conder to Charles Barry, 13 October 1876, British Architectural Library, RIBA. He would need to limit his tour to Italy and supplement his studies of Europe with sketches of Japan.

48. *TKHH*, vol. 1, 192–94.

49. Records of the correspondence appear in ibid., vol. 2, 287–90.

50. Kawai Kōzō, who graduated from the Imperial College of Engineering in 1882, recalls Fontanesi as the person who drew the original plan in "Meiji kenchiku zadankai," *Kenchiku zasshi*, no. 566 (January 1933): 154. In contrast, *Meiji kōgyō shi* names Cappelletti as the person responsible (*Meiji kōgyō shi*, vol. 4, *Kenchiku* [Tokyo: Meiji Kōgyōshi Hakkōjo, 1930], 680). Cappelletti is the more likely candidate because he was trained as an architect, taught archi-

tectural drawing at the Technical Fine Arts School, and executed at least two buildings in Japan—the Yūshūkan arms and armor exhibition hall (1881) and the Army Staff Headquarters (1882). Fontanesi had no known training or expertise in architectural design.

51. The building was used as the exhibition's art gallery primarily for cost-cutting reasons. *TKHH*, vol. 1, 195.

52. Only the first floor of the building was used for the 1881 exhibition, and work on the interior continued until the building was completed in 1882. For more, see Onogi Shigekatsu, "Ueno Hakubutsukan no sekkei oyobi kensetsu jijō," *Nihon Kenchiku Gakkai ronbun hōko-kushū*, no. 179 (January 1971): 87–94.

53. Kunaichō, *Meiji Tennō ki*, vol. 5, 670. This speech was also published on the front page of the daily newspaper *Yomiuri shinbun*, 22 March 1882.

54. All members of the public, with the exception of "drunkards" and "insane persons," were allowed into the museum. It was open year-round, except for Mondays and the twenty-day period of December 16 to January 4, for at least seven hours daily. Admission was three *sen* on weekdays, two *sen* on Saturdays, and five *sen* on Sundays (one *sen* being one-hundredth of a *yen*). Just under 175,000 people visited in the museum's first year. *TKHH*, vol. 1, 208–9.

55. All sixty-three sheets of construction drawings are published in Kawahigashi, *Josaia Kondoru kenchiku zumenshū*.

The three presentation drawings were originally submitted in October 1878 to the Grand Council of State as part of Home Minister Itō Hirobumi's request for an increase in the museum's construction budget. They are now part of the *Pictures and Charts Affiliated with the Compiled Records of the Grand Council of State* (Kobun fuzoku no zu), which were designated Important Cultural Properties of Japan in 1998.

56. For instance, see the caption for the building in Kondoru Hakase Kinen Hyōshōkai, *Kondoru Hakase isakushū* (n.p.: Kondoru Hakase Kinen Hyōshōkai, 1931), 13–14.

57. For more on the Japanese designs of Ende and Böckmann, see Jonathan Reynolds, "Japan's Imperial Diet Building: Debate over Construction of a National Identity," *Art Journal* 55 (fall 1996): 38–47; for more on Wright's Imperial Hotel, see Neil Levine, *The Architecture of Frank Lloyd Wright* (Princeton, N.J.: Princeton University Press, 1996), chapter 5.

58. For an overview of the museums built during this period, see Joyce Jones, "Museum and Art Gallery Buildings in England, 1845–1914," parts 1 and 2, *Museums Journal* (London) 65 (December 1965): 230–38; (March 1966): 271–80. On the Trinity College Museum and the Oxford University Museum, see Eve Blau, *Ruskinian Gothic: The Architecture of Deane and Woodward, 1845–1861* (Princeton, N.J.: Princeton University Press, 1982). See also Yanni, *Nature's Museums*, chapter 3, on the Oxford University Museum, and chapter 5, on the Natural History Museum in London.

59. For the early institutional history of the Museum of Fine Arts, Boston, see Walter Muir Whitehill, *Museum of Fine Arts, Boston: A Centennial History*, vol. 1 (Cambridge, Mass.: Belknap Press, 1970). See especially Neil Harris, "The Gilded Age Revisited: Boston and the Museum Movement," *American Quarterly* 14 (winter 1962): 545–66. On the Metropolitan Museum of Art, see Calvin Tomkins, *Merchants and Masterpieces: The Story of the Metropolitan Museum of Art* (New York: H. Holt, 1989).

60. On the architecture of the South Kensington Museum, see John Physick, *The Victoria and Albert Museum: The History of Its Building* (Oxford: Phaidon, 1982). For an overview of

American museum architecture of this period, see Jay Cantor, "Temples of the Arts: Museum Architecture in Nineteenth-Century America," *Metropolitan Museum of Art Bulletin* (April 1970): 331–54; and Ingrid A. Steffensen-Bruce, *Marble Palaces, Temples of Art: Art Museums, Architecture, and American Culture, 1890–1930* (Lewisburg, Pa.: Bucknell University Press, 1998). On the architecture of the Metropolitan Museum of Art, see Morrison Heckscher, *The Metropolitan Museum of Art: An Architectural History* (New York: Metropolitan Museum of Art, 1995). On the Museum of Fine Arts, see Margaret Henderson Floyd, "A Terra-Cotta Cornerstone for Copley Square: Museum of Fine Arts, Boston, 1870–1876, by Sturgis and Brigham," *Journal of the Society of Architectural Historians* 43 (May 1973): 83–103.

61. William Burges, *Art Applied to Industry: A Series of Lectures* (Oxford: John Henry and James Parker, 1865), 7. Conder echoes this point in his 1878 lecture, stating that "the fine arts of painting and sculpture are the off-spring of architecture."

62. Steffenssen-Bruce, *Marble Palaces*, 19–20.

63. Ibid., 17.

64. It is strange that Conder would call it a museum for arts because, at the time he was designing the building, the museum administration did not intend the collection to focus exclusively or even primarily on art. It is likely that Conder, speaking retrospectively in 1920, confused the focus of the museum at that time—which had turned to art and history in 1889, when it became the Imperial Museum—with the original focus on art, industry, and science.

65. Architectural surveys on the museum as a type generally have not distinguished between those built to house art collections and those built to house science collections. This amalgamated approach follows the precedents set by Helmut Seling, "The Genesis of the Museum," *Architectural Review* 141 (February 1967): 103–14; and Nikolaus Pevsner, *A History of Building Types* (Princeton, N.J.: Princeton University Press, 1976), chapter 8. On Yanni's view of their distinct natures, see her *Nature's Museums*, 10–11.

66. This would not have been Conder's fault because he was working with an existing plan.

67. For more on the issue of lighting in nineteenth- and early-twentieth-century museum design, see Michael Compton, "The Architecture of Daylight," in *Palaces of Art: Art Galleries in Britain, 1790–1990*, ed. Giles Waterfield (London: Dulwich Picture Gallery, 1991), 37–47. See also Georges Teyssot, "'The Simple Day and Light of the Sun': Lights and Shadows in the Museum," *Assemblage*, no. 12 (August 1990): 58–83.

68. The catalogs accompanying the exhibition usually name an item by its owner or manufacturer and then its price.

69. See Onogi Shigekatsu, "Ueno Hakubutsukan no shiyōgaki oyobi shuyō kōzō," *Nihon Kenchiku Gakkai ronbun hōkokushū*, no. 185 (July 1971): 79–85.

70. Watanabe, "Josiah Conder's Rokumeikan," 26.

71. The English-language name Institute of Japanese Architects was coined in 1906, and the organization changed this to the current name, Architectural Institute of Japan, in 1947.

72. In a paper given earlier, in 1891, to the Tokyo Elocutionary Society, Conder addressed some concerns about designing in foreign styles in Japan. The Museum was not specifically mentioned, although the paper gave specific reasons for not incorporating indigenous styles in the designs he produced for Meiji Japan. The paper is transcribed in the *Japan Weekly Mail*, 12 December 1891, under the title "The Effects of the Recent Earthquake upon Buildings." See also this chapter's epigraph.

73. The ceremony took place on 18 April 1920, at 5:30 P.M., at the Seiyōken restaurant in Ueno Park. Kenchiku Gakkai, also celebrating its fifteenth anniversary as a judicial body, presented Conder with a pair of bronze vases.

74. Conder's speech is transcribed in *Kenchiku zasshi,* no. 402 (June 1920): 54–55.

75. *Oxford English Dictionary Online*, s.v. "Saracen," http:// dictionary.oed.com/cgi/entry/ 50213340?single=1&query_type=word&queryword=saracen&first=1&max_to_show=10 (accessed 21 July 2006). According to this entry (definition B.a.), an erroneous assertion on the part of Sir Christopher Wren in his 1750 work *Parentalia*, in which he equated the "Gothick manner" with "Saracen Style," also led to the general misapplication of the term in the eighteenth and nineteenth centuries to mean Gothic architecture.

76. Edward Said, *Orientalism* (New York: Vintage Books, 1978).

77. On Chamberlain's scholarship on Japan, see Richard Minear, "Orientalism and the Study of Japan," *The Journal of Asian Studies* 39 (May 1980): 507–17.

78. See Okakura Kakuzō, *The Ideals of the East* (1903) and *The Book of Tea* (1906).

79. Josiah Conder, "Notes on Japanese Architecture," in *Transactions of the Royal Institute of British Architects*, 1877–78. Thomas Roger Smith read the paper on Conder's behalf at a RIBA meeting held on 4 March 1878.

For instance, on the use of wood or stone, Conder writes: "Japanese architecture, until the employment of foreigners within the last few years, has been, with very few exceptions, entirely of wooden construction. In certain parts of the country, where stone lies to hand in boulders or is otherwise naturally exposed, there are a few instances of its use in the construction of the walls of small houses and simple temples." And in the same month, in "A Lecture Upon Architecture," which he delivered to his own students at the Imperial College of Engineering in Tokyo (see note 38), he said, "It seems to me that there is little use of changes in building in your country, if the chief aim is not solidity and strength."

80. Minear, "Orientalism and the Study of Japan," 508.

81. These descriptive terms appear frequently throughout Conder's "Notes on Japanese Architecture."

82. Jonathan Reynolds confirms that "two of the four volumes of the second edition are still preserved in the Architecture Library at the University of Tokyo" (the Department of Architecture being the successor to the Imperial College of Engineering), in "Teaching Architectural History in Japan: Building a Context for Contemporary Practice," *Journal of the Society of Architectural Historians* 61 (December 2002): 531.

83. Conder's syllabus was printed in the sessional *Calendar* of the Imperial College of Engineering for the year 1877. Reprinted in *Meiji bunka zenshū*, supplementary vol. 3, *Nōkōhen* (Tokyo: Nihon Hyōron Shinsha, 1974), 105–99.

84. Conder openly challenged other foreigners' knowledge of Japanese architecture. His own papers presented at the RIBA in the 1880s were written in reaction to the popularity of Christopher Dresser's *Japan: Its Architecture, Art, and Art Manufactures* (1882) and Edward Morse's *Japanese Homes and Their Surroundings* (1885).

85. The show fulfilled a stipulation of the traveling studentship of the Soane award. See notes 35 and 47.

86. Thomas Metcalf, *An Imperial Vision: Indian Architecture and Britain's Raj* (Berkeley: University of California Press, 1989), 250, 75. See also Mark Crinson, *Empire Building: Orientalism and Victorian Architecture* (London: Routledge, 1996).

87. Metcalf, *An Imperial Vision*, 81.

88. *Ecclesiologist*, no. 172 (February 1866): 119; in the same issue, the design was also referred to as "a kind of Orientalizing Pointed style" (244). T. Roger Smith, "On Buildings for European Occupation in Tropical Climates, Especially in India," in *Papers of the Royal Institute of British Architects* (1867–68).

89. Burges completed only one design (unexecuted) for India, while Smith appears to have executed a number of institutional buildings there. The latter left behind two informative papers on British building in India: "On Buildings for European Occupation in Tropical Climates," in *Papers of the Royal Institute of British Architects* (1867–68), and "Architectural Art in India," *Journal of the Society of Arts* 21 (22 November 1872–14 November 1873): 278–86.

90. James Fergusson's *A History of Architecture in All Countries* is divided under the major headings "Ancient Architecture," "Christian Architecture," and "Pagan Architecture." Banister Fletcher's *A History of Architecture* is divided into "Historical Styles" and "Non-Historical Styles." After Conder's presentation "Notes on Japanese Architecture" at the RIBA, R. Phene Spiers and Charles Barry concluded that "with regard to the architecture of Japan, there is no architecture, as we understand it."

91. Minear, "Orientalism and the Study of Japan," 514–15.

92. Benedict Anderson, *Imagined Communities: Reflections on the Origin and Spread of Nationalism*, rev. ed. (London: Verso, 1991), 94–99.

93. Marilyn Ivy, *Discourses of the Vanishing: Modernity, Phantasm, Japan* (Chicago: University of Chicago Press, 1995), 4.

94. G. Alex Bremner, "'Some Imperial Institute': Architecture, Symbolism, and the Ideal of Empire in Late Victorian Britain, 1887–93," *Journal of the Society of Architectural Historians* 62 (March 2003): 50–73.

95. Hamao's speech is transcribed in *Kenchiku zasshi*, no. 402 (June 1920): 57–59.

96. Okakura established the ideology of Japan as the sole repository of the historic wealth of continental Asian culture in his book *The Ideals of the East*.

97. Josiah Conder, "The Condition of Architecture in Japan," in *Proceedings of the Twenty-Seventh Annual Convention of the American Institute of Architects, Supplement: World's Congress of Architects* (1893): 367.

98. "The Imperial Law Courts, Tokio," *The Builder* (15 April 1893): 288.

99. Even if Conder insisted on maintaining structural compatibility—that is, incorporating only those forms originating from stone and not wooden construction—more probable options would have been to refer to the stonework in Buddhist architecture or in Chinese architecture, both of which he could also have discovered in Fergusson's book.

100. The works of three among the first class of graduates—Tatsuno Kingo, Katayama Tōkuma, and Sone Tatsuzō—reveal few stylistic intersections, as they embarked on distinctly different paths immediately after graduating from the Imperial College of Engineering. Tatsuno traveled to London to continue his architectural study; Katayama entered the service of the Public Works Ministry; and Sone stayed at the college to assist in teaching architecture. Tatsuno and Sone eventually each opened his own firm, while Katayama remained a lifelong state architect and became the preeminent designer to the imperial court. The fourth graduate, Satachi Shichijirō, had an unfortunately short career; according to Suzuki Hiroyuki, after Satachi witnessed the deleterious effects of the Nōbi Earthquake in 1891, he appeared to suffer overwhelming mental anxiety over the possibility that buildings would collapse and quit the profession.

101. *TKHH*, vol. 1, 251–52.

102. Okakura Kakuzō to Ernest Fenollosa, 8 December 1888, Ernest Francisco Fenollosa Papers (bMS Am 1759.2: 106–8), Houghton Library, Harvard University.

103. The Imperial Museum administration attempted to do away with the Natural Products Department and the zoological garden during its 1889 organization but did not transfer them to the Education Museum until 1925. Ian Miller points out that the zoo "was often treated as something of a lower-class stepsibling of the more refined museum" by the administration, even though it was an important revenue generator for the museum. For more on the Meiji-period history of the zoo attached to the Museum, refer to Miller's "Didactic Nature: Exhibiting Nation and Empire at the Ueno Zoological Gardens," in *JAPANimals: History and Culture in Japan's Animal Life*, ed. Gregory Pflugfelder and Brett Walker (Ann Arbor, Mich.: Center for Japanese Studies, University of Michigan, 2005), 273–313.

104. Henry Russell Hitchcock, *Architecture: Nineteenth and Twentieth Centuries*, 3rd ed. (Harmondsworth, U.K.: Penguin Books, 1968), 135.

105. Later in his career, Conder sometimes used Islamic decorative motifs in the interior of private architecture. One example is the house for Mitsubishi president Iwasaki Hisaya, also known as the Kayachō Residence, in Tokyo (now an Important Cultural Property), which was completed in 1896.

3. The Age of the Imperial Museum

Epigraph: Sugiura Jūgō, "Nihon kyōiku genron," 1887. Quoted in Donald Shively, "The Japanization of Middle Meiji," in *Tradition and Modernization in Japanese Culture* (Princeton, N.J.: Princeton University Press, 1971), 105–6.

1. The Agriculture and Commerce Ministry was created to integrate responsibilities for agriculture, forestry, commerce, and industry, which had been jointly handled by the Home, Finance, and Public Works Ministries.

2. The other auxiliary building was originally the Machine Gallery for the 1877 National Industrial Exhibition.

3. In 1881, the Natural Products Department held 71,362 objects and the Industry Department 13,830 objects (compared to 1,900 objects in the Arts Department). In 1885, Natural Products had 89,630 objects and Industry 16,544 objects (compared to 1,843 objects in Arts). Tōkyō Kokuritsu Hakubutsukan, *Tōkyō Kokuritsu Hakubutsukan hyakunenshi* (hereafter *TKHH*) (Tokyo: Tōkyō Kokuritsu Hakubutsukan, 1973), vol. 1, 214–15.

4. For more on the power structure within the imperial household, see David Titus, *Palace and Politics in Prewar Japan* (New York: Columbia University Press, 1974).

5. Constitution of the Great Empire of Japan, Article 3.

6. Fukuzawa Yukichi, "Teishitsu ron," 1882. Quoted in Shively, "The Japanization of Middle Meiji," 111–12.

7. Preamble, Constitution of the Great Empire of Japan.

8. The Imperial Museums were established by Order No. 6 of the Imperial Household Ministry, dated 16 May 1889. Although the director general of the Imperial Museums held authority over all three institutions—in Tokyo, Kyoto, and Nara—each museum was responsible for its own administration, finances, and accounting.

9. See Carol Gluck, *Japan's Modern Myths: Ideology in the Late Meiji Period* (Princeton, N.J.: Princeton University Press, 1985), especially chapters 1 and 2.

10. Ibid., 23.

11. *TKHH*, vol. 1, 243–306. See also Matsumiya Hideharu, "Meiji zenki no hakubutsukan seisaku," in *Bakumatsu Meiji ki no kokumin kokka keisei to bunka henyō* (Tokyo: Shinyōsha, 1995), 253–78.

12. For more on the moment of "transition" from pro-foreign to pro-native sentiments in the Meiji period, see Shively, "The Japanization of Middle Meiji," 77–119. For writings that acknowledge the art world's vacillating commitment toward foreign and native modes, see John Rosenfield, "Western-style Painting in the Early Meiji Period and Its Critics," in *Tradition and Modernization in Japanese Culture*, ed. Shively, 181–219; and Marius Jansen, "Cultural Change in Nineteenth-Century Japan," in *Challenging Past and Present: The Metamorphosis of Nineteenth-Century Japanese Art*, ed. Ellen Conant (Honolulu: University of Hawaii Press, 2006), 31–55.

13. Pitting the foreign and indigenous against each other as mutually exclusive values and seeing Meiji-period cultural construction as a zero-sum game (e.g., building in European style, donning European fashion, even drawing in pencil all enervate a uniquely Japanese identity) simply echo the ideologies of Meiji politicians and intellectuals who believed in *kokusui hozon*, "the preservation of a national essence." Interestingly, it also reaffirms the Orientalist reasoning of foreigners such as the Basil Hall Chamberlain, the German doctor Erwin Baelz, and countless other Euro-American experts and visitors who argued against Japan's Westernization for fear of loss of identity (on both sides!).

14. In addition to Fenollosa's own lectures, writings, and letters, two highly laudatory biographies written in the 1960s established the myth of his greatness: Van Wyck Brooks, *Fenollosa and His Circle* (New York: Dutton, 1962); and Lawrence Chisholm, *Fenollosa: The Far East and American Culture* (New Haven, Conn.: Yale University Press, 1963). The most consulted biography of Okakura Kakuzō is by his son, Okakura Kazuo, *Chichi Tenshin o meguru hitobito* (Tokyo: Bunsendō Shobō, 1943). Recent scholarship has begun to disentangle these autobiographical and biographical assessments based mostly on personal letters, recollections, and biases. Fenollosa's and Okakura's contributions to Japanese art have been most rigorously questioned in the work of Ellen Conant; see especially her "Principles and Pragmatism: The *Yatoi* in the Field of Art," in *Foreign Employees in Nineteenth-Century Japan*, ed. Edward Beauchamp and Akira Iriye (Boulder, Colo.: Westview Press, 1990). See also Victoria Weston, *Japanese Painting and National Identity: Okakura Tenshin and His Circle* (Ann Arbor, Mich.: Center for Japanese Studies, University of Michigan, 2004).

15. *Meiji ishin jinmei jiten* (Tokyo: Yoshikawa Kōbunkan, 1981), 1040.

16. On the Ryūchikai, see Satō Dōshin, *Meiji kokka to kindai bijutsu: Bi no seijigaku* (Tokyo: Yoshikawa Kōbunkan, 1999), 22–34.

17. Murakata Akiko, "Fenorosa no hōmotsu chōsa to Teikoku Hakubutsukan no kōsō," *Museum* (Tokyo) (February 1980): 21–36.

18. For Okakura's articulation of East Asian art to the early-twentieth-century Western audience—primarily through his English-language writings and curatorial work in the United States—see Noriko Murai, "Authoring the East: Okakura Kakuzō and the Representations of East Asian Art in the Early Twentieth Century" (Ph.D. diss., Harvard University, 2003).

19. In 1898, Okakura was dismissed from his position with the museum and the art school. A topic of great controversy in its own time as well as now in scholarship, his dismissal was

most likely the result of a combination of shifting priorities in the art world and poor personal decisions. For more on the Okakura scandal, see Weston, *Japanese Painting and National Identity*, 159–62.

20. See Murai, "Authoring the East," chapters 1 and 2.

21. Morse resided in Japan for brief periods, from June to November 1877, from April 1878 to September 1879, and finally from June 1882 to February 1883. His original interest in collecting Japanese shellfish led to the discovery of not just the Ōmori shell mounds but the social and cultural habits of an alien people, which he felt compelled to record in detail. Morse collected artifacts and objects of everyday use in order to comprehend the life of an average Japanese at the outset of the Meiji period. In his quest to capture his Japanese experience, he placed almost no limits on his investigation, which he pursued through a unique interdisciplinary approach that combined archaeology, art, architecture, religion, cuisine, and folklore. He collected every portable object in sight as well as kept a journal, accompanied by descriptive sketches, and took copious photographs. The Morse collection is now divided between two Massachusetts institutions, the Peabody Essex Museum in Salem and the Museum of Fine Arts, Boston.

22. Chisolm, *Fenollosa*, 31.

23. [Notes on a visit to the Centennial], n.d., Ernest Francisco Fenollosa Papers (hereafter Fenollosa Papers), bMS Am 1759.3 (12), Houghton Library, Harvard University.

24. Weston, *Japanese Painting and National Identity*, 6.

25. [Report of the Fine Arts Commission], n.d., Fenollosa Papers, bMS Am 1759.2 (86).

26. For Fenollosa's outline, see [Configuration of Imperial Museum,] n.d., Fenollosa Papers, bMS Am 1759.2 (63). For Kuki's draft and the official museum bylaws promulgated in May 1889, see *TKHH*, vol. 1, 250–52, 254–56.

27. The terms of investigation were outlined in the contract and instructions given to Fenollosa by the Education Ministry. Fenollosa Papers, bMS Am 1759.3 (10.1 and 10.4). The commission visited Austria, England, France, Germany, Italy, Spain, and the United States, although no official record of the institutions visited is extant. After signing a contract with the Education Ministry, Fenollosa signed a codicil agreeing to work with the Imperial Household Ministry "on matters relating to fine arts" in exchange for free housing. Fenollosa Papers, bMS Am 1759.3 (10.2).

28. After the elimination of the bureau, the Imperial Museum continued the surveys for three more years.

29. The 1897 law is the Law for the Protection of Old Temples and Shrines (*Koshaji hozon hō*). See Christine Guth, "Kokuhō: From Dynastic to Artistic Treasure," *Cahiers d'Extrême-Asie* 9 (1996–97): 313–22.

30. Itō Hirobumi to E. F. Fenollosa, 15 September 1886, Fenollosa Papers, bMS Am 1759.3 (5).

31. [The Fine Arts Commission to Europe and America], n.d., Fenollosa Papers, bMS Am 1759.2 (28).

32. Nara served as the capital of Japan from 710 to 784. During this time, Buddhist monasteries multiplied in great numbers and gained immense political influence, so much so that by the end of the eighth century, one of the main reasons for moving the capital to Kyoto was to escape the growing political power of religious leaders.

33. This raises the issue of the degree to which classification of an object as a National Treasure might have been determined by individual taste.

34. Natural Products, the largest of the old departments, was not part of the museum director's master plan for the Imperial Museum. Kuki was clear on his intention not to incorporate this department, and he agreed only to take temporary charge of it before its anticipated move to the education museum. See *TKHH*, vol. 1, 251. Refer also to chapter 2, note 103.

35. The first modern history of Japanese art was compiled by the Imperial Museum and debuted in French as *Histoire de l'Art du Japon* at the 1900 Exposition Universelle in Paris. The original Japanese manuscript, *Kōhon Nihon Teikoku bijutsu ryakushi*, was published in 1901 in Japan, and several abridged editions as well as English translations were subsequently made available. The 1908 edition includes an architecture section authored by Itō Chūta.

36. The school opened in 1889, housed in the original building of the Education Museum. Hamao apparently admired this building and site, which he considered as picturesque as the European art schools he had just visited with the Fine Arts Commission. The decision to oust the Education Museum was secretive and swift, striking the museum at a vulnerable period when its validity was being seriously challenged by the nearby Imperial Museum. For more details, see Kokuritsu Kagaku Hakubutsukan, *Kokuritsu Kagaku Hakubutsukan hyakunenshi* (Tokyo: Kokuritsu Kagaku Hakubutsukan, 1977), 142–47.

37. On *juku* teaching in the modern period, see Sakakibara Yoshio, "*Juku*, the Private Teaching Atelier," in *Nihonga: Transcending the Past: Japanese-Style Painting, 1868–1968*, ed. Ellen Conant (Saint Louis: Saint Louis Art Museum, 1995), 82–83. See also Victoria Weston, "Institutionalizing Talent and the Kano Legacy at the Tokyo School of Fine Arts, 1889–1893," in *Copying the Master and Stealing His Secrets: Talent and Training in Japanese Painting*, ed. Brenda Jordan and Victoria Weston (Honolulu: University of Hawaii Press, 2003), 147–77.

38. In addition to the use of photography, the commissioning of "painted copies" (*mosha*) and "sculpted copies" (*mozō*) was an integral part of the Imperial Museum's original plans for recording and preserving the collection. Modern copies of premodern artworks was the focus of a 2005 exhibition at the Tokyo National Museum and the accompanying catalog, Tōkyō Kokuritsu Hakubutsukan, *Mosha, mozō to Nihon bijutsu: Utsusu, manabu, tsutaeru* (Tokyo: Tōkyō Kokuritsu Hakubutsukan, 2005). For specific discussion of the collaboration between the Imperial Museums and the Tokyo School of Fine Arts, see the essays by Satō Dōshin and Satō Akio in this exhibition catalog. I would like to thank Chelsea Foxwell for bringing the exhibition and catalog to my attention.

39. Nivedita of Ramakrishna-Vivekānanda, in the introduction to Okakura Kakuzō, *The Ideals of the East: With Special Reference to the Art of Japan* (New York: ICG Muse, 2000), x.

40. Guth, "Kokuhō," 322.

4. The Imperial Kyoto Museum: Locating the Past within the Present

Epigraph: Tateno Gōzō, "Foreign Nations at the World's Fair," *North American Review* (January 1893): 35–36.

1. The original plans for the three events were either delayed or accelerated so that they would all occur in 1895. Kyoto was founded as the imperial capital in 794, making 1894 the actual 1100th anniversary year. The National Exhibition had been proposed for 1896. The Imperial Kyoto Museum had suffered through an earthquake and construction complications and anticipated opening no earlier than 1896; October 1895 marked the end of construction, not the opening of the museum, which followed two years later.

2. Some of the leaders in the early Meiji government, such as Inoue Yorikuni and Fukuoka Takachika, did not equate the creation of Tokyo with the demise of Kyoto as Japan's imperial capital. Inoue believed that Japan could have more than one imperial capital, while Fukuoka conceded Tokyo as a mere "temporary court" (*anzaisho*). See T. Fujitani, *Splendid Monarchy: Power and Pageantry in Modern Japan* (Berkeley: University of California Press, 1996), 34–42.

3. Imperial House Law, Article 11.

4. The preamble to the Meiji Constitution begins with the following sentence: "Having, by virtue of the glories of Our Ancestors, ascended to the Throne of a lineal succession unbroken for ages eternal; desiring to promote the welfare of, and to give development to the moral and intellectual faculties of Our beloved subjects, the very same that have been favored with the benevolent care and affectionate vigilance of Our Ancestors; and hoping to maintain the prosperity of the State, in concert with Our people and with their support, We hereby promulgate, in pursuance of Our Imperial Rescript of the 12th day of the 10th month of the 14th year of Meiji, a fundamental law of the State, to exhibit the principles, by which We are guided in Our conduct, and to point out to what Our descendants and Our subjects and their descendants are forever to conform."

5. The academic departments at the Tokyo School of Fine Arts included traditional-style painting, sculpture, and art industry—categories similar to the curatorial departments of the Imperial Museums.

6. For the circumstance and motivations behind the introduction of master carpenter Kigo Kiyoyoshi's lectures on traditional building techniques and construction to the curriculum, see Cherie Wendelken, "The Tectonics of Japanese Style: Architect and Carpenter in the Late Meiji Period," *Art Journal* 55 (fall 1996): 28–37.

7. Kyōto Kokuritsu Hakubutsukan, *Kyōto Kokuritsu Hakubutsukan hyakunenshi* (Kyoto: Kyōto Kokuritsu Hakubutsukan, 1997), 67–68.

8. For more on the religious projects commissioned by Toyotomi Hideyoshi and his clan, see Andrew Watsky, *Chikubushima: Deploying the Sacred Arts in Momoyama Japan* (Seattle: University of Washington Press, 2004).

9. Kyōto Kokuritsu Hakubutsukan, *Kyōto Kokuritsu Hakubutsukan hyakunenshi*, 69–70. The Kyōmyōgū housed the Buddhist relics and implements of the imperial court during the early Meiji period, when Buddhism and Shinto were officially separated by the state. It also included residential facilities for a number of elderly court ladies who did not follow the emperor to Tokyo.

10. [Instructions concerning the mission of Mr. E. F. Fenollosa to Europe], 1 August 1886, Ernest Francisco Fenollosa Papers (hereafter Fenollosa Papers), bMS Am 1759.3 (10), Houghton Library, Harvard University.

11. [The Fine Arts Commission to Europe and America], n.d., Fenollosa Papers, bMS Am 1759.2 (28).

12. Okakura's diary is reproduced in Okakura Kakuzō (Tenshin), *Okakura Tenshin zenshū* (Tokyo: Heibonsha, 1979), vol. 5, 281–385.

13. [Report of the Fine Arts Commission], n.d., Fenollosa Papers, bMS Am 1759.2 (86).

14. In Conder's "Lecture upon Architecture," he remarks: "Books from America are easily and cheaply obtained, but I know of no worse country from which you could take example for the development of your Architectural Art"; on pre-Meiji architecture, he recommended appreciation but not emulation: "You [Japanese] have your monuments too . . . to the appre-

ciation of which I am for ever urging you; and would urge you again that you secure careful drawings of them, and learn all lessons to be gained from each, *before it is gone*" (emphasis mine).

15. [Report of the Fine Arts Commission], n.d., Fenollosa Papers, bMS Am 1759.2 (86).

16. Josiah Conder, "Building in Earthquake Countries," *Japan Weekly Mail*, 22 June 1889, 605.

17. W. S. Worden, "The Earthquake," *Japan Weekly Mail*, 7 November 1891, 556; X. (pseud.), "The Effects of the Earthquake," *Japan Weekly Mail*, 7 November 1891, 556–57; and P.Q. (pseud.), "From Tokyo to the Earthquake District," *Japan Weekly Mail*, 7 November 1891, 558–59.

18. Worden, "The Earthquake," 556.

19. P.Q., "From Tokyo to the Earthquake District," 558–59.

20. Josiah Conder, "An Architect's Note on the Great Earthquake of October 1891," *Seismo-logical Journal of Japan* (1893): 1–91. I would like to thank Gregory Clancey for sharing a copy of this article with me.

21. At least two contemporaneous sources assert that the original design was a three-story structure: *Asahi shinbun* (Osaka), 30 November 1894; and *Kenchiku zasshi*, no. 96 (December 1894): 354.

22. Fenollosa left Japan in 1890. The Education Ministry did not renew its contract with him and no other government agency, including the Imperial Household Ministry and its museums, offered him a permanent position.

23. Drawings 192, 199, and 203 are stamped with the seals "Kakuzō" and "Ryūichi." The greatest difference between this early design and the executed building is the straight slope of the central dome, which is curved in the drawings. In this design, decorative features are applied in greater quantities, including the line of trophies on the cornice and the curlicues on the traceries and balustrades. (The original order of the drawings is not known. In this book, I refer to the drawings using the museum's "new numbering system" [*shinbako bangō*].)

24. Okakura participated in designing the Japanese art display for the Hōōden in Chicago and the Buddhist Room at the Museum of Fine Arts, Boston. On the Buddhist Room, see Noriko Murai, "Authoring the East: Okakura Kakuzō and the Representation of East Asian Art in the Early Twentieth Century" (Ph.D. diss., Harvard University, 2003), 172–82.

25. Mamizu Hideo, "Teikoku Kyōto Hakubutsukan," *Kenchiku zasshi*, no. 143 (1898): 49–51.

26. From 1875 to 1883, Kyoto operated a prefectural museum with a mission largely parallel to that of the Museum in Ueno Park. Its collection included samples of agricultural produc-tion, crafts, and manufactures and was highlighted by local historical and cultural artifacts. Although a site for a freestanding museum building had been selected, the architectural designs were drawn, and construction materials had been acquired, the project was ultimately abandoned. After this prefectural museum closed, more than one thousand objects from its collection were transferred to the Imperial Kyoto Museum.

27. The posthumous retrospective of Katayama's architecture published in *Kenchiku zasshi* provides the most extensive information available about his life and projects: "Katayama Hakushi o tomurau," *Kenchiku zasshi*, no. 372 (1917): 1–22. Not much is known about Kata-yama's private life. He and his wife had no children, and no diaries or sketchbooks have been discovered.

28. Onogi Shigekatsu, *Yōshiki no ishizue*, vol. 2 of *Nihon no kenchiku: Meiji, Taishō, Shōwa* (Tokyo: Sanseidō, 1979), 142.

29. The curriculum of the Imperial College of Engineering for the year 1877 is recorded in the school's *Calendar*. A reprint appears in *Meiji bunka zenshū*, supplement vol. 3, *Nōkō hen* (Tokyo: Nihon Hyōronsha, 1974), 105–99.

30. Of the sixty-three extant drawings for the Ueno museum, eleven bear student signatures. Of the fifty-three extant drawings for the Kaitakushi, thirty-nine bear student signatures. There are no extant drawings for the School for the Blind.

31. The signature was written in English: "Designed by Harada." Harada was Katayama's adoptive name, which he kept throughout his college days. He returned to the name Katayama in his adulthood.

32. For diploma year 1879, students selected one of three proposed design projects and one of three thesis topics. The design project choices were a lunatic asylum, a school of art, or a museum for natural history objects. Instructions for the drawings included the following: "The style selected is left to the student, but the suitability to climate will be taken into account in valuing the designs. The materials are to be either brick and stone, brick and terra-cotta, or entirely stone." For his thesis, Katayama chose to address the following topic: "Considering the climate of this country and the pursuits and habits of the people generally, also bearing in mind the serious destruction of wooden cities by fire, what suggestions would you make for the future domestic architecture of Japan?"

33. Katayama made six drawings: two plans, two elevations, and two details. All six are currently in the archives of the Architecture Department of the University of Tokyo.

34. Conder's comments, written directly on the drawings, were "Design and drawing excellent. Plan good but some rooms rather too small."

35. Katayama's original thesis is stored in the archives of the Architecture Department of the University of Tokyo.

36. *Calendar* (1877; reprint in *Meiji bunka zenshū*, 1974), 112 (page citation to reprint edition).

37. For a compendium of projects by the Bureau of Construction of the Imperial Household Ministry, see Suzuki Hiroyuki, ed., *Kōshitsu kenchiku: Takumiryō no hito to sakuhin* (Tokyo: Kenchiku Gahōsha, 2005).

38. The trade school was founded in part by Katayama and Tatsuno Kingo to train workmen in the construction of Western-style architecture.

39. "Katayama Hakushi o tomurau," 11. Former classmate Tatsuno Kingo also remembered Katayama as a man of great integrity and honesty. Because they were both passionate about architecture, they frequently had fiery exchanges in their college days over matters relating to the profession. Although Katayama disliked public speaking, he apparently excelled at private debates.

40. In 1882, he traveled through England and France, seeking ideas and manufacturers for the interior decoration of Prince Arisugawa's palace, and in 1886, he visited Germany for the interior decoration of the Imperial Palace. Katayama traveled to Europe and the United States for the design of the Akasaka Detached Palace in 1897 and repeated this itinerary in 1902 for the interior decoration of the same palace.

41. Onogi Shigekatsu, *Meiji yōfū kyūtei kenchiku* (Tokyo: Sagami Shobo, 1983), and Onogi, *Yōshiki no ishizue*, 141–67.

42. Onogi, *Yōshiki no ishizue*, 152–58. Professor Onogi generously provided me with a list of books Katayama purchased for the library of the Imperial Household Ministry. More than seven hundred titles are recorded, and they are by no means limited to architecture books. In general, the titles covered the subjects of architecture, fine art, decorative art, and furnishings.

43. This stay coincided with the Fine Arts Commission's travels through Europe. In his diary entry for 13 March 1887, Okakura records meeting with Katayama while in Vienna.

44. Fujimori Terunobu, *Nihon no kindai kenchiku* (Tokyo: Iwanami Shoten, 1993), vol. 1, 248–57.

45. Name seals of all five are visible on the extant set of construction drawings for the Imperial Kyoto Museum.

46. For a history of the Nihon Doboku Kaisha, see Taisei Kensetsu Kabushiki Gaisha, *Taisei Kensetsusha shi* (Tokyo: Taisei Kensetsu Kabushiki Gaisha, 1963).

47. I would like to thank Nakamura Yasushi of the Kyoto National Museum for guiding me through this entire set of drawings and models in October 2001.

48. The sources consistently state that the majority of materials, including the two types of bricks and two types of stone, were all locally produced.

49. *Kyōto Bijutsu Kyōkai zasshi*, no. 47 (1896), 13; *Asahi shinbun* (Osaka), 2 May 1897, 2.

50. Early in his essay, Mamizu groundlessly describes the architectural style as Anglo-Japanese (*anguro japanīsu*) without elaborating on this word choice. Other than the use of red brick in conjunction with light stone and plaster facing (reminiscent of the South Kensington style popular in the 1870s and Conder's Museum in Ueno), nothing in particular overtly alludes to English, especially museum, architecture.

51. Mamizu, "Teikoku Kyōto Hakubutsukan," 50.

52. According to a contemporaneous newspaper article, the Tokyo School of Fine Arts awarded a prize for this design, which was supposed to depict the founding deities of painting and sculpture. Although the article does not name the creator of the winning entry, it identifies the mason Yamazaki Kisaburō as the person who carved the design.

53. In 1924, the inscription changed when the museum was bequeathed to the city of Kyoto and changed again, in 1938, when the institution became the Kyoto National Museum. The inscription now reads "Kyōto Kokuritsu Hakubutsukan" (Kyoto National Museum), in Western manner, from left to right.

54. This space includes a lavatory (with Japanese-style toilet) and provides enough room for full-size furnishings so that a watchman could live comfortably inside.

55. Mamizu, "Teikoku Kyōto Hakubutsukan," 50–51.

56. Drawings 67, 190, and 250 show the exhibition rooms labeled with their prospective object types.

57. Mamizu, "Teikoku Kyōto Hakubutsukan," 51.

58. The importance of safekeeping cannot be overemphasized. Decisions to make the museum low and largely impenetrable should be considered deliberate security measures. See also note 21.

59. The garden has been greatly reduced owing to the addition of another exhibition hall, designed by Morita Keiichi, in 1965 on the north end and a parking lot on the south end. The Morita building will be demolished and replaced by a new building, tentatively named Centennial Hall, designed by Taniguchi Yoshio, which is scheduled to begin construction in 2007.

60. The sloped topography also created the practical challenge of effectively directing and

draining down-flowing rainwater. A large number of construction drawings are devoted to the placement of drainage receptacles and pipes.

61. Nakamura Yasushi, interview by author, Kyoto, 6 August 1999.

62. The Japanese public entered from the back of the building, where there was a place for checking footwear. Apparently, those not wearing Western shoes had to change into soft sandals, or zori. Belongings such as walking sticks and umbrellas could also be checked. At the Imperial Nara Museum, a structural add-on accommodated this purpose.

63. The Hōōden was completed earlier than Itō Chūta and Kigo Kiyoyoshi's 1895 Heian Shrine, a reduced-scale replica of the eighth-century Great Audience Hall (Daigokuden) in the former imperial palace. This seminal project was inspired by Kigo's introduction of the history and preservation of indigenous architecture to the new generation of architects being trained at Tokyo Imperial University.

64. For more on the motivations and factors behind the construction of the Hōōden, see Mishima Masahiro, "1893 nen Shikago bankokuhaku ni okeru Hōōden no kensetsu ikisatsu ni tsuite," *Nihon Kenchiku Gakkai ronbun hōkokushū*, no. 429 (November 1991): 151–63; and idem, "Hōōden no keitai to sono seiritsu yōin ni tsuite," *Nihon Kenchiku Gakkai ronbun hōkokushū*, no. 434 (April 1992): 107–16.

65. [The Fine Arts Commission to Europe and America], n.d., Fenollosa Papers, bMS Am 1759.2 (28).

66. Okakura Kakuzō, *The Hō-ō-den: An Illustrated Description of the Buildings Erected by the Japanese Government at the World's Columbian Exposition* (Tokyo: K. Ogawa, 1893). Also reprinted in *Okakura Kakuzō, Collected English Writings*, vol. 2 (Tokyo: Heibonsha, 1984), 5–29.

67. I am following the period names and dates Okakura used in the official catalog. (See Okakura, *The Hō-ō-den*).

68. Ibid., 14–15.

69. Ibid., 20, 24.

70. Ibid., 9–10, 13.

71. The *Kyōto Bijutsu Kyōkai zasshi* published a complete, room-by-room index of the objects displayed at the 1897 opening of the Imperial Kyoto Museum in six installments, from the July 1897 issue (no. 61) to the February 1898 issue (no. 68). For a complete listing of the objects exhibited in the Hōōden, refer to Okakura's catalog, *The Hō-ō-den*.

72. After the exposition, the Hōōden was gifted to the city of Chicago, which intended to preserve it permanently; however, the wooden pavilion was lost to multiple fires in 1946.

73. The distinctive Neo-classical detailing on the exteriors of these buildings was not cut from stone but made of a lightweight mixture of plaster, cement, and jute fibers. This mixture, called "staff," was invented by the French in the 1860s or 1870s and had already been used in earlier European fairs. At Chicago, these brilliant white exteriors camouflaged the frames of iron and timber underneath. Although imperceptible from the outside, trusses and beams were exposed on the inside. Resembling train sheds more than classical naves or courtyards, these interiors were expressive of the nineteenth-century advancement in iron construction epitomized by the 1851 Crystal Palace, at London's Great Exhibition.

74. American reviewers of the fair took special notice of the Hōōden and documented their impressions in print. For an architectural review of this pavilion, see P. B. Wight, "Japanese Architecture at Chicago," parts 1 and 2, *Inland Architect and News Record* 20 (December 1892): 49–52; (January 1893): 61.

75. For a discussion of the Japanese national displays at the 1893 fair, see Lisa Langlois, "Exhibiting Japan: Gender and National Identity at the World's Columbian Exposition of 1893" (Ph.D. diss., University of Michigan, 2004).

76. For photographs documenting all the Japanese national exhibits at the 1893 fair, see Rinji Hakurankai Jimukyoku, *Rinji Hakurankai Jimukyoku hōkoku fuzokuzu* (Tokyo: Rinji Hakurankai Jimukyoku, 1895).

77. For accounts of Americans' reactions to the Japanese officials and buildings, see Neil Harris, "All the World a Melting Pot? Japan at American Fairs, 1876–1904," in *Mutual Images: Essays in American-Japan Relations*, ed. Akira Iriye (Cambridge, Mass.: Harvard University Press, 1975).

78. Christine Guth, "Charles Longfellow and Okakura Kakuzo: Cultural Cross-Dressing in the Colonial Context," *Positions* 8 (winter 2000): 605–36. See also Murai, "Authoring the East," 76–131.

79. Okakura Kazuo, *Chichi Okakura Tenshin* (Tokyo: Chūō Kōronsha, 1971), 42. Cited in Guth, "Charles Longfellow and Okakura Kakuzo," 623.

80. When the Iwakura mission embarked on its trip to the West, its members did not begin to actively comment on the architecture until they reached Washington, D.C., where they were struck by the monumental scale of the federal architecture. Kume surmised the importance of the structures by visually evaluating their size and weight. For example, the entry for 24 April 1872 includes the following statement: "At eleven o'clock in the morning . . . we visited the Department of the Treasury. This is the government's 'bank vault,' in other words, the finance department. Built of white stone, it is one of the biggest buildings in the city. . . . Although it does not equal the Capitol in size, it uses far more stone. If the whole building were weighed, it would be much heavier than the Capitol." Kume Kunitake, *The Iwakura Embassy, 1871–1873: A True Account of the Ambassador Extraordinary and Plenipotentiary's Journey of Observation through the United States and Europe*, vol. 1, trans. Martin Collcutt (Princeton, N.J.: Princeton University Press, 2002), 235–37.

81. Kuru and the Imperial Commission considered two historical buildings, the Phoenix Hall and the Golden Pavilion, as possible models for the Japanese pavilion, but in the end, neither the architect nor the commission members determined the final design. Instead, the pavilion design had to fit within the overall design scheme for the exposition, conceptualized by Americans Daniel Burnham and Frederick Law Olmsted. As a condition for granting the Japanese government the highly contested Wooded Island site, the exposition planners requested a low building suitable for the setting's lush, natural topography. The three-story Golden Pavilion was thus unsuitable, and the tall, two-story-like proportions of the Phoenix Hall had to be reduced to a comparatively squat one level.

82. Conder could not attend the meeting in person but sent his former student Sone Tatsuzō to read his paper "The Condition of Architecture in Japan" in his place on 5 August 1893. Sone recorded his recollection of the event in "Ōji no kaisō," in *Kenchiku Gakkai sōritsu gojū shūnen kinengō*, a special supplementary issue of *Kenchiku zasshi* (October 1937): 173–76.

83. Josiah Conder, "The Condition of Architecture in Japan," *Proceedings of the Twenty-seventh Annual Convention of the American Institute of Architects* (1893): 368.

84. Henry Russell Hitchcock, *Architecture: Nineteenth and Twentieth Centuries*, 3rd ed. (Harmondworth, U.K.: Penguin Books, 1968), 131.

85. In the early nineteenth century, several major European nations, among them, Eng-

land, France, and Germany, maintained that they had "invented" the Gothic and promoted its use as their national style. See Michael Lewis, *The Gothic Revival* (New York: Thames and Hudson, 2002), 58–80; and Georg Germann, *Gothic Revival in Europe and Britain: Sources, Influences, and Ideas* (London: Lund Humphries with the Architectural Association, 1972).

86. Hitchcock, *Architecture*, 135.

87. In 1864 and 1868, the streets of Kyoto became battlegrounds. In the 1864 incident, a group of pro-emperor samurai attempted to liberate the emperor from Tokugawa control, and conflict ensued with *bakufu* forces in front of the imperial palace doors. A blaze caused by the battle lasted for two nights and destroyed 28,000 houses. In the 1868 battle, the Fushimi district was burned. In both battles, the "imperial army" (*kangun*) consisted of warriors from the Satsuma and Chōshū domains. In the 1868 battle, the imperial army, weakened by lack of funding, fought successfully against the pro-shogunate forces after the wealthy merchant house of Mitsui sent a last-minute supply of money. Mitsui had been secretly collecting information from both factions and eventually decided to support the imperial forces. This course of action did not seem extraordinary to Kyoto townspeople who had been judging the two sides throughout the tumultuous *bakumatsu* period and sided in the end with the pro-court faction.

88. The latter half of the Tokugawa period was marked by an escalation in peasant protests and uprisings. Historians such as Stephen Vlastos and George Wilson have interpreted these events as indicators of the government's weakened state, but not as direct challenges to the existing structure.

89. *Yonaoshi*, or "world renewal," movements occurred mainly during the last decade of the Tokugawa period. Such movements were rooted in the religious belief that world renewal was possible through the valorization of daily life and solidarity of community. Participants wished to relieve the economic hardship experienced by the peasant population during the *bakumatsu* period by attacking well-to-do villagers and merchants who were thought to be hoarding rice.

90. *Okagemairi* were spontaneous mass pilgrimages to the Ise Shrine. There are no historical records available to shed light on the leadership (if any) of such mass movements or the particular motivations behind their occurrence. Because participants numbered in the millions each time, the pilgrimages were characterized by uncontrolled frenzy and a carnival-like atmosphere. Understandably, these events were very disruptive to daily life in that the peasant population abandoned work en masse for up to a month.

91. The Grand Council of State, the government's highest administrative organ, was transferred to Tokyo in April 1869. The Meiji emperor took up permanent residence in the new capital one month later.

92. Gotō Yasushi and Fujitani Toshio, eds., *Kindai Kyōto no ayumi* (Kyoto: Kamogawa Shuppan, 1986), 18–19. The central government cut back taxes in Kyoto and twice granted 50,000 *ryō* to the city, in 1872 and 1873, as capital for funding industrial development.

93. For a summary of the modern history of art in Kyoto, see Hashimoto Kizō, *Kyōto to kindai bijutsu* (Kyoto: Kyōto Shoin, 1982).

94. The Technical Fine Arts School, which opened in 1876, was the first public school in Japan for painting and sculpture but taught exclusively Western-style art. The Tokyo School of Fine Arts, which opened in 1889, taught exclusively Japanese-style art at the time of opening.

95. Fujitani, *Splendid Monarchy*, 18.

96. Interestingly, both the Hōōden and the Heian Shrine made use of the architectural form but not the original function of historical models. While the Great Audience Hall, the eighth-century structure the shrine replicated in smaller scale, had served as a secular building in its time, the Heian Shrine was dedicated as a religious memorial to the spirit of Emperor Kanmu, the city founder.

5. The Imperial Nara Museum: Administering History and Religion

Epigraph: Okakura Kakuzō, "Religions in East Asiatic Art," in *Okakura Kakuzō, Collected English Writings* (Tokyo: Heibonsha, 1984), vol. 2, 133.

1. By this time, the museum had been renamed the Nara Imperial Household Museum (Nara Teishitsu Hakubutsukan).

2. Sakashita Takehiko, "Koto o kaku," in *Sugimoto Kenkichi ten: Gagyō shichijūnen no ayumi,* by Aichi Ken Bijutsukan (Nagoya: Aichi Ken Bijutsukan, 1994), xv.

3. See, for example, the two-part series "The Problematics of Collecting and Display," published in the *Art Bulletin* in 1995, in which at least two essays directly address this issue: Janet Catherine Berlo and Ruth B. Phillips, "Our (Museum) World Turned Upside Down: Representing Native American Arts," *Art Bulletin* 77 (March 1995): 6–10; and Vishakha D. Desai, "Re-Visioning Asian Arts in the 1990s: Reflections of a Museum Professional," *Art Bulletin* 77 (June 1995): 169–74. A particularly graphic episode of the aggressive removal of a Buddhist statue from a Japanese temple by a European collector is described in Ting Chang, "Collecting Asia: Théodore Duret's *Voyage en Asie* and Henri Cernuschi's Museum," *Oxford Art Journal* 25, no. 1 (2002): 23–25, 33. In 1871, despite the frantic protests of local residents, the Europeans Théodore Duret and Henri Cernuschi purchased and removed a four-meter-tall bronze buddha from Meguro, then an area in the outskirts of Tokyo. After shipping the buddha along with more than nine hundred crates of Asian art objects back to Paris, Cernuschi commissioned an architect to design a house-museum to accommodate this collection. Lavish dinners and parties were held so that the guests could mingle amid the Asian objects, including the Meguro buddha.

4. Takagi Hiroshi, *Kindai tennōsei no bunkashiteki kenkyū* (Tokyo: Azekura Shobō, 1997).

5. This is not to say that Nara did not modernize its facilities and institutions as Kyoto and Tokyo did during the Meiji period. But unlike the other two cities, Nara did not develop particularly strong industries in the modern period and even today continues to rely primarily on tourism for economic viability, with the majority of the city's businesses—hotels, restaurants, souvenir shops—catering to tourist needs.

6. For studies on unveilings, see Hiruma Hisashi, *Edo no kaichō* (Tokyo: Yoshikawa Kōbunkan, 1980); and Kitamura Gyōon, *Kinsei kaichō no kenkyū* (Tokyo: Meicho Shuppan, 1989).

7. Saitō Gesshin, *Bukō nenpyō,* 2 vols. (Tokyo: Heibonsha, 1968).

8. For an extended discussion of Edo-period airings at Daitokuji, see Gregory Levine, *Daitokuji: The Visual Cultures of a Zen Monastery* (Seattle: University of Washington Press, 2005), chapters 10 and 11.

9. For a thorough overview of Edo-period sideshows, see Furukawa Miki, *Misemono no rekishi* (Tokyo: Yūzankaku Shuppan, 1970). For an English-language account, see Andrew Markus, "The Carnival of Edo: *Misemono* Spectacles from Contemporary Accounts," *Harvard*

Journal of Asiatic Studies 45 (December 1985): 499–541. For a study on urban spectacles in the face of Meiji-period changes, see Kinoshita Naoyuki, *Bijutsu to iu misemono: Aburae chaya no jidai* (Tokyo: Heibonsha, 1993).

10. Furukawa, *Misemono no rekishi*, 18.

11. André Sorensen, *The Making of Urban Japan: Cities and Planning from Edo to the Twenty-first Century* (London: Routledge, 2002), 30–33. See also Hidenobu Jinnai, "The Spatial Structure of Edo," in *Tokugawa Japan: The Social and Economic Antecedents of Modern Japan*, ed. Chie Nakane and Shizaburō Ōishi (Tokyo: University of Tokyo Press, 1990), 132–33.

12. The intermingling of religion and entertainment at the Sensōji in the late Edo period is the focus of Nam-lin Hur's *Prayer and Play in Late Tokugawa Japan: Asakusa Sensōji and Edo Society* (Cambridge, Mass.: Harvard University Asia Center, 2000).

13. Edward Seidensticker, *Low City, High City: Tokyo from Edo to the Earthquake* (Cambridge, Mass.: Harvard University Press, 1991), 207.

14. Yoshimi Shunya, *Hakurankai no seijigaku: Manazashi no kindai* (Tokyo: Chūō Kōron-sha, 1992), 133–35.

15. Levine, *Daitokuji*, 263, 268.

16. See John Rosenfield, "Japanese Buddhist Art: Alive in the Modern Age," in *Buddhist Treasures from Nara*, by Michael Cunningham (Cleveland, Ohio: Cleveland Museum of Art, 1998), 232–44; Robert Sharf, "Prolegomenon to the Study of Japanese Buddhist Icons," in *Living Images: Japanese Buddhist Icons in Context*, ed. Robert Sharf and Elizabeth Horton Sharf (Stanford, Calif.: Stanford University Press, 2001), 1–18; Bernard Faure, "The Buddhist Icon and the Modern Gaze," *Critical Inquiry* 24 (spring 1998): 768–813; and Donald Lopez, Jr., ed., *Curators of the Buddha: The Study of Buddhism under Colonialism* (Chicago: University of Chicago Press, 1995).

17. Rosenfield, "Japanese Buddhist Art," 233.

18. Faure, "The Buddhist Icon," 769.

19. See Fabio Rambelli, "Secret Buddhas: The Limits of Buddhist Representation," *Monumenta Nipponica* 57 (autumn 2003): 280. Christine Guth makes a similar observation in "Kokuhō: From Dynastic to Artistic Treasure," *Cahiers d'Extrême-Asie* 9 (1996–97): 321.

20. Levine, *Daitokuji*, 268–70.

21. Guth, "Kokuhō," 315.

22. Yokoyama Matsusaburō documented their findings in photographs, which are reproduced in Tōkyō To Shashin Bijutsukan, *Utsusareta Kokuhō: Nihon ni okeru bunkazai shashin no keihu* (Tokyo: Benridō, 2000).

23. Yoshimizu Tsuneo, "The Shōsōin: An Open and Shut Case," *Asian Cultural Studies* 17 (March 1989): 37–38. For a description of the excitement that attended this 1872 opening, see Stefan Tanaka, "Discoveries of the Hōryūji," in *Constructing Nationhood in Modern East Asia*, ed. Kai-wing Chow et al. (Ann Arbor, Mich.: University of Michigan Press, 2001), 122–24.

24. The surveys of the 1880s, especially those conducted around Kyoto and Nara, have left a strong impression on art historians because of the vivid descriptions recorded by Fenollosa in *Epochs of Chinese and Japanese Art* (1913) and by Okakura in *Nihon bijutsushi* (reprint 1980).

25. Today, some temples even operate separate museum annexes for the exhibition of house treasures and icons. Two examples are the Hōryūji, which opened the Daihōzōden in 1998, and the Byōdōin in Uji, which opened the Hōshōkan in 2001. The new facilities are different from the original temple buildings for maintaining and displaying objects under controlled

air and lighting conditions. For example, the statues of the worshiping bodhisattvas, which used to be suspended on the frieze inside the Phoenix Hall, the central building of the Byōdōin temple complex, are now a permanent exhibit inside the Hōshōkan, where visitors can examine them at much closer range and under better lighting.

26. The surveys of religious affiliation, known as *shūmon aratame*, later combined with the census registers and became the "emended temple and population registers" (*shūmon ninbetsu aratamechō*), which villages compiled every spring.

27. Beyond the immediate practical gain, the melting down of icons representative of past regimes was no doubt a political demonstration of the new authority.

28. Christine Guth, *Art, Tea, and Industry* (Princeton, N.J.: Princeton University Press, 1993), 103–4.

29. See Tanaka, "Discoveries of the Hōryūji," 119–20; and Rosenfield, "Japanese Buddhist Art," 235.

30. On the number of Buddhist and Shinto images lost, Guth agrees that the extent of the damage might have been exaggerated. She suggests that some were hidden or diverted to more remote branch temples for safekeeping. Guth, *Art, Tea, and Industry*, 103.

31. Murakami Shigeyoshi, *Japanese Religion in the Modern Century*, trans. H. Byron Earhart (Tokyo: University of Tokyo Press, 1980), 33.

32. Helen Hardacre, "Creating State Shinto: The Great Promulgation Campaign and the New Religions," *Journal of Japanese Studies* 12 (winter 1986): 33, 42.

33. Helen Hardacre, *Shintō and the State, 1868–1988* (Princeton, N.J.: Princeton University Press, 1989), 22.

34. The archives have numbered these two documents separately, but the contents cohere logically as two parts of the same report: [Report on examination of Nara temples], n.d., Ernest Francisco Fenollosa Papers, bMS Am 1759.2 (62), Houghton Library, Harvard University; and [On preventing the sale . . .], n.d., Ernest Francisco Fenollosa Papers (hereafter Fenollosa Papers), bMS Am 1759.2 (70). Memorandum, "Conditions under which plans must be drawn for constructing the Building of the Nara Imperial Museum," n.d., Fenollosa Papers, bMS Am 1759.2 (61).

35. As for the report, Fenollosa begins by stating that his group had been in Nara for some days. According to the investigation bureau's official report, the survey group was in Nara between 25 May and 25 June 1888. This would mean that Fenollosa's report was written at around the end of May. As for the memorandum, Akiko Murakata suggests the more precise time frame of March 1889 in her "Ānesuto F. Fenorosa no kenchiku ni kan suru tekō," *Kenchiku zasshi*, no. 1135 (May 1978): 87–89. Because I have found no evidence specifically dating this memo to March, my own conjecture is that Fenollosa wrote it in 1889 after his survey of Nara and before his departure from Japan in July 1890.

36. Fenollosa Papers, bMS Am 1759.2 (70).

37. Ibid.

38. Ernest Fenollosa to Edward Morse, fall 1884. Cited in Walter Muir Whitehill, *Museum of Fine Arts, Boston: A Centennial History* (Cambridge, Mass.: Belknap Press, 1970), vol. 1, 113.

39. Fenollosa Papers, bMS Am 1759.2 (61).

40. The different architectural visions of Fenollosa and Katayama also recall the clash between Fenollosa and Conder (Katayama's mentor) over the use of brick in Japan (see chapter 4). Conder was not one to bow to the opinions of persons who were not trained in architecture

(hence the public rebuttals addressed to Fenollosa, Dresser, and Morse, among other Western non-architects who voiced criticisms of modern masonry design in Japan), and Katayama likely held a similar confidence in his own architectural training and expert knowledge.

41. This corporation was established in 1804 under Shimizu Kisuke I. For more on its history, see Shimizu Kensetsu Kabushiki Gaisha, *Shimizu Kensetsu hyakuhachijūnen* (Tokyo: Shimizu Kensetsu, 1984).

42. For the early history of Nara Park, see Nara Kōenshi Henshū Jinkai, *Nara Kōenshi* (Nara: Nara ken, 1982), 93–106.

43. Erwin Baelz, *Berutsu no nikki*, ed. Toku Baelz, trans. Suganuma Ryūtarō, vol. 2, part 1 (Tokyo: Iwanami Shoten, 1953), 65. Erwin Baelz's diary was originally edited and published in German in 1931 by his son Toku Baelz under the title *Das Leben eines deutschen Arztes im erwachenden Japan*. An English-language translation, *Awakening Japan: The Diary of a German Doctor*, was published in 1932. The passage quoted here is not in the original German- or English-language publication. According to the Japanese translator Suganuma, the Japanese edition translated the Baelz manuscript unabridged, unlike the German edition, which cut out portions thought to be of little interest to the German reader, reducing the length by approximately a third. The English-language edition is a direct translation of the German edition. Suganuma, preface to *Berutsu no nikki*, 3–6.

44. Many architectural historians today continue to seek the stylistic origins of the Imperial Nara Museum. Onogi Shigekatsu, Fujimori Terunobu, Fujioka Hiroyasu, and David Stewart have all put forth highly specific stylistic labels for the architecture, offering vastly different conjectures on the exact attribution for this museum—"Renaissance," "Baroque," "Neo-Baroque," "Second Empire." Their descriptions have filtered into popular descriptions of this building today, and even the Nara National Museum describes it as the "French Renaissance style" in its official literature.

45. A large set of the original preparatory and construction drawings for the Imperial Nara Museum are currently in the archives of the Nara National Museum. There are 249 sheets of drawings and at least two wooden scale models. The drawings are in no known original order. The museum has devised an informal numbering system based on the order in which the drawings were found in the four original Meiji-period boxes.

46. "Sō Hyōzō no sakuhin to kaikyūdan," *Shinkenchiku* (March 1927): 3. Sō's name seal appears most frequently on the construction drawings. For more on Sō Hyōzō, see Sakamoto Katsuhiko, *Shōto no dezain*, vol. 5 of *Nihon no kenchiku: Meiji, Taishō, Shōwa* (Tokyo: Sanseidō, 1980), 162–65.

47. "Teikoku Nara Hakubutsukan setsumei," *Kenchiku zasshi*, no. 93 (September 1894): 276.

48. Michael Compton describes the lantern, or monitor, type of top lighting as "a structure built onto the roof well within the margins of the walls on which pictures were to be hung, with vertical or slightly inclined glazing on its sides and an opaque top." Michael Compton, "The Architecture of Daylight," in *Palaces of Art: Art Galleries in Britain, 1790–1990*, ed. Giles Waterfield (London: Dulwich Picture Gallery, 1991), 40. In the case of the Imperial Nara Museum, the lantern was also punctured by a skylight.

49. Kojima Teiichi, *Nara Teishitsu Hakubutsukan o miru hito e* (Nara: Kihara Bunshindō, 1925), 24.

50. The spatial linearity would correspond to the teleological development that Fenollosa delineated as Japanese art history.

51. There is now an updated glass structure on the east side, although visitors may enter from the front or the back.

52. A set of nine drawings shows the elevations and plan for this extension.

53. The columns are placed flush against the facade and are not load bearing. They are half fluted, raised on bases, and different in design from the column capitals on the facade of the Kyoto museum.

54. Nagano Uheiji, "Shinchiku Nara kenchō zumen setsumei," *Kenchiku zasshi*, no. 111 (March 1896): 61.

55. For more on Meiji-period Western-style wood construction, see Eguchi Toshihiko, *Yōfū mokuzō kenchiku* (Tokyo: Rikō Gakusha, 1996).

56. Nagano, "Shinchiku Nara kenchō zumen setsumei," 62.

57. Ernest Fenollosa, *Epochs of Chinese and Japanese Art* (Tokyo: ICG Muse, 2000), 2.

58. "Teikoku Nara Hakubutsukan," *Asahi shinbun* (Osaka), 1 May 1895, 1.

59. The exact breakdown of the collection that debuted is as follows: eleven items of "imperial property" (*gyobutsu*); twenty-two items of "imperial calligraphy" (*shinkan*); thirty-eight items from the History Department; ninety-one items from the Fine Art Department; and ninety-one items from the Art Industry Department. Nara Kokuritsu Hakubutsukan, *Nara Kokuritsu Hakubutsukan hyakunen no ayumi* (Nara: Nara Kokuritsu Hakubutsukan, 1995), 11.

60. Ownership is identified both in the official catalogs published by the museum and in lists published in newspapers and journals.

61. Fenollosa Papers, bMS Am 1759.2 (62).

62. "Teikoku Nara Hakubutsukan," *Kyōto Bijutsu Kyōkai zasshi* (hereafter *KBKZ*), no. 32 (January 1895): 32–33.

63. "Teikoku Nara Hakubutsukan," *KBKZ*, no. 66 (December 1897): 11–12. The suggestion of competition between the two institutions is also worth noting.

64. Established by Order No. 1 of the Imperial Household Ministry, dated 26 January 1895. The order is printed in *KBKZ*, no. 33 (February 1895): 33–36.

65. Reprinted in *KBKZ*, no. 34 (March 1895): 29–31. The regulations were reprinted with an amendment in *KBKZ*, no. 36 (May 1895): 30.

66. Even Fenollosa noticed the dire state of affairs: " . . . even if things are presented to the Museum, it seems almost indispensable to give the priests a certain present of money, else many will be driven to starvation." Fenollosa Papers, bMS Am 1759.2 (70).

67. For example, see Kyōto Kokuritsu Hakubutsukan, *Kyōto Kokuritsu Hakubutsukan shichijūnenshi* (Kyoto: Kyōto Kokuritsu Hakubutsukan, 1967), 18–22; and Tōkyō Kokuritsu Hakubutsukan, *Tōkyō Kokuritsu Hakubutsukan hyakunenshi* (Tokyo: Tōkyō Kokuritsu Hakubutsukan, 1973), vol. 1, 253–64. Some scholars also echo the sentiment, for example, Shiina Noritaka, *Zukai hakubutsukanshi* (Tokyo: Yūzankaku Shuppan, 1993), 90–94.

68. Allan Grapard, "Japan's Ignored Cultural Revolution: The Separation of Shintō and Buddhist Divinities in Meiji (*shimbutsu bunri*) and a Case Study: Tōnomine," *History of Religions* 23 (February 1984): 241–42.

69. Hardacre, "Creating State Shinto," 32.

70. Murakami, *Japanese Religion in the Modern Century*, 25.

71. For one account of how Japanese Buddhism reconstructed itself in the modern period as a universal creed (i.e., not simply applicable to India, its place of origin), see Judith Snodgrass, *Presenting Japanese Buddhism to the West: Orientalism, Occidentalism, and the Columbian Exposition* (Chapel Hill, N.C.: University of North Carolina Press, 2003). While most accounts of Buddhism's reformation focus on encounters with Europe and the United States, Richard Jaffe has written on the significance of pan-Asian travels and contacts; see his "Seeking Sakyamuni: Travel and the Reconstruction of Japanese Buddhism," *Journal of Japanese Studies* (winter 2004): 65–96.

72. Robert Sharf, "The Zen of Japanese Nationalism," in *Curators of the Buddha*, ed. Lopez, 110.

73. Rosenfield, "Japanese Buddhist Art," 233.

74. *Tōkyō Kokuritsu Hakubutsukan hyakunenshi*, vol. 1, 159–60. See also Tanaka, "Discoveries of the Hōryūji," 126–27.

75. See Rosenfield, "Japanese Buddhist Art," 234–38. See also Robert Sharf, "Prolegomenon," 6.

76. Eilean Hooper-Greenhill, "The Space of the Museum," *Continuum* (Australia) 3, no. 1 (1990): 63.

77. Kojima, *Nara Teishitsu Hakubutsukan o miru hito e*, 26.

78. Ibid., 47.

79. Tanaka, "Discoveries of the Hōryūji," 125.

80. Guth, *Art, Tea, and Industry*, 100, 101. Rambelli further argues that even the replicability of an icon, such as its recurring exposure in art books, museum catalogs, magazines, and tourist guidebooks, could strengthen the privileged status of the original.

81. Rambelli, "Secret Buddhas," 296–97.

6. The Hyōkeikan Art Museum: Debating the Permanent Place of Art

Epigraph: Natsume Sōseki, *The Wayfarer*, trans. Beongcheon Yu (Tokyo: Charles E. Tuttle, 1967), 243–44. Originally published serially in Japanese as *Kōjin* from 1912 to 1913.

1. Copies of the following catalogs are available at the National Diet Library, Japan: *Official Catalogue of the National Exhibition of Japan* (Tokyo: Exhibition Bureau, 1877); *Official Catalogue of the Second National Exhibition of Japanese Empire* (Tokyo: Exhibition Department, 1881); *Guide to Visitors for National Exhibition (Second Term)* (Tokyo: Siuyeisha, 1881); *Official Catalogue of the Third Industrial National Exhibition, 1890* (Yokohama: Japan Mail Office, 1890).

2. The special exhibition *Bijutsukan o yomitoku: Hyōkeikan to gendai no bijutsu* [Reading the art museum: Hyōkeikan and the art of today] was held at the Hyōkeikan of the Tokyo National Museum from 23 January to 11 March 2001. The symposium *Hyōkeikan kara no enkinhō: Bijutsu/tenji no genzai* [From the perspective of the Hyōkeikan: Art/exhibition today] took place at the Tokyo National University of Fine Arts and Music on 3 February 2001.

3. Kuraya Mika, "Chūkū no bijutsukan," in *Bijutsukan o yomitoku: Hyōkeikan to gendai no bijutsu*, by Tōkyō Kokuritsu Kindai Bijutsukan (Tokyo: Tōkyō Kokuritsu Kindai Bijutsukan, 2001), 10–21.

4. Satō Dōshin, *"Nihon Bijutsu" tanjō: Kindai Nihon no "kotoba" to senryaku* (Tokyo: Kōdansha, 1996), 54–66. Kitazawa Noriaki, *Kyōkai no bijutsushi: Bijutsu keiseishi nōto* (Tokyo: Seiunsha, 2000), 218–41.

5. Hino Eiichi, "Bankoku hakurankai to Nihon no 'bijutsu kōgei,'" in *Bankoku hakurankai no kenkyū*, ed. Yoshida Mitsukuni (Kyoto: Shibunkaku, 1986), 21–43.

6. Furuta Ryō, "Koronbusu sekai hakurankai hitori annai," in *Umi o watatta Meiji no bijutsu*, by Tōkyō Kokuritsu Hakubutsukan (Tokyo: Tōkyō Kokuritsu Hakubutsukan, 1997), 91.

7. Ibid., 90–91.

8. According to the Japanese Imperial Commission's own report *History of the Empire of Japan*, published for the occasion of the World's Columbian Exposition, art manufactures including ceramics, lacquer, and metalwork brought in around ¥8,000,000 annually. Langlois, "Exhibiting Japan: Gender and National Identity at the World's Columbian Exposition of 1893" (Ph.D. diss., University of Michigan, 2004), 8.

9. Miscellanea in the *Kyōto Bijutsu Kyōkai zasshi*, no. 3 (August 1892).

10. William Walton, *Art and Architecture* (Philadelphia: G. Barrie, 1893), 87, 88.

11. Tateno Gōzō, "Foreign Nations at the World's Fair," *North American Review* (January 1893): 34–35.

12. Langlois, "Exhibiting Japan," 96–133.

13. Tateno, "Foreign Nations at the World's Fair," 42–43.

14. The Third and Fourth National Industrial Exhibitions, which were held in 1890 and 1895, also preceded the construction of the Hyōkeikan. Each event also included a freestanding *bijutsukan*, intended to function only for the duration of the fair.

15. Tōkyō Kokuritsu Hakubutsukan, *Tōkyō Kokuritsu Hakubutsukan hyakunenshi* (hereafter *TKHH*) (Tokyo: Tōkyō Kokuritsu Hakubutsukan, 1973), vol. 1, 278. Within the three Imperial Museums, the fine art collection consisted predominantly of painting in Tokyo, of sculpture in Nara, and a balance of the two in Kyoto.

16. See layout of the rooms in *TKHH*, vol. 1, 266, 279.

17. For a catalog of the *bijutsu* exhibits at all five National Industrial Exhibitions, see Tōkyō Kokuritsu Bunkazai Kenkyūjo, *Naikoku Kangyō Hakurankai bijutsuhin shuppin mokuroku* (Tokyo: Tōkyō Kokuritsu Bunkazai Kenkyūjo, 1996).

18. *The Tokio Times*, 6 October 1877.

19. On the creation and configuration of Meiji-period art associations, see Satō, *"Nihon bijutsu" tanjō*, 189–205.

20. For a catalog of the exhibitions sponsored by five major Meiji-period groups, see Tōkyō Kokuritsu Bunkazai Kenkyūjo Bijutsubu, *Meiji ki bijutsu tenrankai shuppin mokuroku* (Tokyo: Chūō Kōron Bijutsu Shuppan, 1994).

21. Both buildings were demolished in 1906 and replaced by a building popularly known as the Takenodai Chinretsukan.

22. Furuta Ryō, "Hyōkeikan shōshi," in *Bijutsukan o yomitoku*, by Tōkyō Kokuritsu Kindai Bijutsukan, 61–71 (also in English as "A Brief History of the Hyōkeikan," in ibid., 102–11).

23. Contributions also came from other prefectures, overseas residents, and even foreigners. For a breakdown of the contributions arranged by geographical districts, see *TKHH*, vol. 2, 334–35.

24. Katayama must have been chosen much earlier because he published a set of drawings for the museum as early as May 1900 in *Kenchiku zasshi*.

25. While all other auxiliary exhibition buildings were physically connected to the main building, only Museum Building Four, which housed the natural products collection, was left unattached.

26. See *TKHH*, vol. 1, 310–13, for the petition letter originally written by the museum director general on the reason for the name change.

27. *TKHH*, vol. 1, 364–65.

28. Kojima Kaoru, "Introduction," in *Bunten no meisaku, 1907–1918*, by Tōkyō Kokuritsu Kindai Bijutsukan (Tokyo: Tōkyō Kokuritsu Kindai Bijutsukan, 1990), 11–15.

29. Omuka Toshiharu, "The Formation of the Audiences for Modern Art in Japan," in *Being Modern in Japan: Culture and Society from the 1910s to the 1930s*, ed. Elise K. Tipton and John Clark (Honolulu: University of Hawaii Press, 2000), 50.

30. Masaki Naohiko, "Bijutsukan no shurui ni tuite," *Bijutsu shinpō* 1 (5 April 1902): 2–3.

31. Because of his French-language ability, Hayashi was hired by a private Japanese company responsible for arranging the Japanese national displays at the 1878 Exposition Universelle in Paris. He remained in Paris after the exposition and eventually opened an art dealership specializing in Japanese prints. For more on his role in the promotion of Japanese art in France, see Segi Shinichi, "Hayashi Tadamasa: Bridge between the Fine Arts of East and West," in *Japonisme in Art, An International Symposium*, ed. Yamada Chisaburō (Tokyo: Committee for the Year 2001, 1980), 167–72; and Kigi Yasuko, *Hayashi Tadamasa to sono jidai: Seikimatsu no Pari to Japonisumu* (Tokyo: Chikuma Shobō, 1987).

32. For a transcription of his speech, see Hayashi Tadamasa, "Bijutsukan kensetsu ni tuite," *Bijutsu shinpō* 4 (20 June 1905): 2.

33. Ironically, the state-sponsored annual Salon no longer existed in France at the time of Hayashi's writing; it was abandoned after 1880. Thereafter, a number of annual exhibitions organized by artist societies replaced the official Salon for displaying new art. Three major ones were the Salon des Artistes Français, the Salon des Indépendants, and the Salon de la Nationale des Beaux-Arts. See Patricia Mainardi, *The End of the Salon: Art and the State in the Early Third Republic* (Cambridge: Cambridge University Press, 1993), especially chapter 6.

34. Taki Setsuan, "Kokuritsu bijutsukan setchi no hitsuyō," *Bijutsu shinpō* 5 (5 April 1906): 2.

35. From December 1968 to March 1974, the Akasaka Detached Palace underwent a period of renovation to ready it for its current role as the State Guest House (Geihinkan) for foreign dignitaries. The architect Murano Tōgo supervised the renovation, and Taniguchi Yoshirō designed a new Japanese-style annex, also completed in March 1974. The two architects later published a richly illustrated monograph, *Geihinkan: Akasaka Rikyū* (Tokyo: Mainichi Shinbunsha, 1975).

36. It is unclear which examples of "palace" architecture they examined in the United States.

37. From the Imperial Household Ministry archives, reproduced in Onogi Shigekatsu, *Meiji yōfū kyūtei kenchiku* (Tokyo: Sagami Shobō, 1983), 257.

38. Ingrid Steffenssen-Bruce, *Marble Palaces, Temples of Art: Art Museums, Architecture, and American Culture, 1890–1930* (Lewisburg, Pa.: Bucknell University Press, 1998), 30–47; Morrison Heckscher, *The Metropolitan Museum of Art: An Architectural History* (New York: Metropolitan Museum of Art, 1995), 30–38; Walter Muir Whitehill, *Museum of Fine Arts, Boston: A Centennial History* (Cambridge, Mass.: Belknap Press, 1970), vol. 1, 218–45.

39. *Kenchiku zasshi*, no. 197 (May 1903): 190.

40. Later large-scale institutional architecture such as the Tokyo Station (1905) and the National Diet Building (1936) followed the practice of having an imperial entrance and a sitting room separate from those used by the public.

41. Although this room had direct access to the outside, given the modesty of the size and

decoration of the doorway, it most likely served as a discreet outlet rather than a ceremonial imperial entry.

42. It is possible to think of the first designs as Katayama's ideal designs, developed when cost, site, and materials were not considerations.

43. Currently, there are twenty-six sheets of original architectural drawings in the archives of the Tokyo National Museum (reference numbers 3400–3425). About half are heavily discolored by water and mold damage. They appear to be presentation drawings rather than construction documents (which constitute the majority of extant drawings for Conder's Ueno museum and the museums at Kyoto and Nara).

44. The two dated drawings—drawing 3405, signed Seto and Murai and dated "Meiji 35 July," and drawing 3421, signed Tōkuma and dated "Meiji 39 July"—are each one from a larger set of drawings.

45. Drawings 3404, 3405.

46. Drawings 3401, 3402.

47. Drawings 3406, 3410, 3411.

48. Drawing 3409.

49. An earlier set of drawings shows the Hyōkeikan cupolas with round finials similar to those executed for the Akasaka Detached Palace.

50. The often-cited anecdote about this building is that Emperor Meiji, upon seeing a photograph album of the completed Akasaka Detached Palace, disapprovingly exclaimed, "Zeitaku da!" (Such extravagance!). The comment supposedly struck a fatal blow to the architect Katayama's self-esteem, and, according to the dramatic recounting of Fujimori Terunobu, "[the preeminent architect] for long lay in bed due to the shock, and even after getting back on his feet relinquished all of his projects to his underlings. He shut himself in the greenhouse of his home, tending to his orchids til his death." Fujimori Terunobu, *Nihon no kindai kenchiku* (Tokyo: Iwanami Shoten, 1993), vol. 1, 256–57. However, Onogi Shigekatsu tells a more probable story. In addition to the high pressure of overseeing the gargantuan palace project, the architect was handling a full load of additional imperial commissions. His health failed more likely because of stress and overwork rather than heartbreak. Onogi Shigekatsu, *Yōshiki no ishizue*, vol. 2 of *Nihon no kenchiku: Meiji, Taishō, Shōwa* (Tokyo: Sanseidō, 1979), 149.

51. There are no records extant that can clarify which system or group of the arts is being depicted. Clearly, "architecture," "music," and "painting" are represented, while the other panels are more difficult to decipher. Similar motifs on the cartouches on the exterior front facade depict the different trades of nation building. The artists who designed these two groups were not named in the original documents or contemporary journals. With regard to other exterior decorative features, Sano Akira (1866–1955) designed the large pair of urns, and Ōkuma Ujihiro (1856–1934) designed the lions. Both were sculptors who had studied in Paris.

52. The first budget allowance for the connecting passage between the main museum building and the Hyōkeikan was allotted in 1907. Construction started in fall 1909, and the building was completed in December 1911. The Imperial Household Ministry selected Katayama and Niinomi to design and oversee the work because the agency desired a design that would match the art museum in style and quality. This connector was torn down when the main building of the Tokyo Imperial Household Museum was reconstructed after the 1923 earthquake. For more, see *TKHH*, vol. 1, 396–97; vol. 2, 345–51.

53. Reprinted in *TKHH*, vol. 1, 341.

54. Hayashi, "Bijutsukan kensetsu ni tuite," 2.

55. "Bijutsukan setsuritsu no yōkyū," *Bijutsu shinpō* 9 (1 July 1910): 1; "Bijutsukan setsuritsu mondai," *Bijutsu shinpō* 9 (1 August 1910): 1.

56. "Hyōkeikan no rakusei," *Bijutsu shinpō* 8 (5 June 1909): 1.

57. Nipporijin, "Hyōkeikan o miru," part 1, *Bijutsu shinpō* 8 (5 August 1909): 3; part 2 (20 August 1909): 3; part 3 (20 September 1909): 4.

58. Although Nipporijin considered the scale of the building to be smaller than ideal and the interior to be less imposing than that of the Kyoto museum, he attributed these qualities to the limited budget.

59. Although the Industry Department was abolished in Kyoto and Nara, the Art Industry Department survived in both places.

60. After its reorganization as the Imperial Household Museum, the museum began to use labels written in both Japanese and English. The labels named the artwork's title, media, artist, school, year, and owner.

61. The following spring, Taki Seiichi contributed an essay to a different journal regarding the difficulty of exhibiting pre-Meiji art but without explicitly mentioning the Hyōkeikan: "Exhibitions and Japanese Art," *Kokka* 20 (May 1910): 337–40. He offered an apologia for the incongruence of pre-Meiji art to public exhibition, citing the original intent of these works as "household decoration" to account for their small scale and simple coloring.

62. *The Wayfarer*, 243–44.

63. Ibid., 244.

64. Ibid., 243.

65. Diagrams of the layout of a 1937 exhibition show such use of the two spaces. See Tōkyō Teishitsu Hakubutsukan, *A Brief Guide to the Imperial Household Museum* (Tokyo: World Conference Committee of the Japanese Education Association, 1937).

Conclusion

1. Paul Valéry, "The Problem of Museums," in *Degas, Manet, Morisot*, vol. 12 of *The Collected Works of Paul Valéry*, trans. David Paul (New York: Pantheon Books, 1960), 204. Originally published as "Le Problème des musées" in 1923.

2. André Malraux, *Museum without Walls*, trans. Stuart Gilbert and Francis Price (Garden City, N.Y.: Doubleday, 1967), 10. Originally published as "Le Musée imaginaire" in 1947.

3. Valéry, "The Problem of Museums," 203, 205.

4. Malraux, *Museum without Walls*, 9.

5. This is a subject of discussion in Donald Preziosi, "The Art of Art History," in *The Art of Art History: A Critical Anthology* (Oxford: Oxford University Press, 1998), 507–25.

6. Andrew McClellan, "A Brief History of the Art Museum Public," in *Art and Its Publics: Museum Studies at the Millennium* (Malden, Mass.: Blackwell Publishing, 2003), 2–16.

7. For more on *shogakai*, see Andrew Markus, "Shogakai: Celebrity Banquets of the Late Edo Period," *Harvard Journal of Asiatic Studies* 53 (June 1993): 135–67.

8. Andrew McClellan, *Inventing the Louvre: Art, Politics, and the Origins of the Modern Museum in Eighteenth-Century Paris* (Berkeley: University of California Press, 1999), 12.

Glossary

Akasaka Rikyū 赤坂離宮

bakufu 幕府
bakumatsu 幕末
bijutsu 美術
bijutsu dantai 美術団体
bijutsu kōgei 美術工芸
Bijutsu shinpō 美術新報
Bijutsu Torishirabe 美術取調
bijutsukan 美術館
Bishu Katsuma 毘首羯摩
Bukō nenpyō 武江年表
Bunkachō 文化庁

chōkoku 彫刻

Dainippon Teikoku Kenpō 大日本帝国憲法
Dajōkan 太政官
Dokuritsu Gyōsei Hōjin Kokuritsu Haku-
 butsukan 独立行政法人国立博物館

Eizenkyoku 営繕局

Fukuzawa Yukichi 福沢諭吉

geijutsu 芸術
Gigei Tennyo 技芸天女

hakubutsukan 博物館
Hakubutsukyoku 博物局
hakurankai 博覧会
Hakurankai Jimukyoku 博覧会事務局
Hamao Arata 浜尾新

Hayashi Tadahiro 林忠恕
Hayashi Tadamasa 林忠正
Heian Jingū 平安神宮
Hōōden 鳳凰殿
Hōōdō 鳳凰堂
Hōryūji 法隆寺

Itō Hirobumi 伊藤博文

Jūyō Bunkazai 重要文化財

kaichō 開帳
Kaichō sashiyurushichō 開帳差免帳
kaiga 絵画
Katayama Tōkuma 片山東熊
Kawanabe Kyōsai 河鍋暁斎
Kenchiku Gakkai 建築学会
Kenchiku zasshi 建築雑誌
Kinki chihō 近畿地方
kobijutsu 古美術
Kōbu Bijutsu Gakkō 工部美術学校
Kōbu Daigakkō 工部大学校
Kōbushō 工部省
kōgei 工芸
kōgyō 工業
Kōhon Nihon Teikoku bijutsu ryakushi 稿本日
 本帝国美術略史
kokibutsu 古器物
Kokka 国華
Kokuhō 国宝
Kokuritsu Kagaku Hakubutsukan 国立科学
 博物館
Koshaji hozon hō 古社寺保存法

Kuki Ryūichi 九鬼隆一
Kume Kunitake 久米邦武
Kunaishō 宮内省
Kuru Masamichi 久留正道
Kyōto Bijutsu Kyōkai 京都美術協会
Kyōto Bijutsu Kyōkai zasshi 京都美術協会雑誌
Kyōto Kokuritsu Hakubutsukan 京都国立博物館
Kyōto Teishitsu Hakubutsukan 京都帝室博物館
Kyōtofu Gagakkō 京都府画学校

Machida Hisanari 町田久成
Masaki Naohiko 正木直彦
Meiji Bijutsukai 明治美術会
misemono 見世物
Monbushō 文部省
Monbushō Bijutsu Tenrankai 文部省美術展覧会
mushiboshi 虫干

Naikoku Kangyō Hakurankai 内国勧業博覧会
Naimushō 内務省
Nara Kokuritsu Hakubutsukan 奈良国立博物館
Nara Teishitsu Hakubutsukan 奈良帝室博物館
Nihonga 日本画
Nōshōmushō 農商務省

Okakura Kakuzō (Tenshin) 岡倉覚三 (天心)
Ōkoku Hakurankai hōkokusho 澳国博覧会報告書
Ōkoku Hakurankai Jimukyoku 澳国博覧会事務局

Rinji Zenkoku Hōmotsu Torishirabe-kyoku 臨時全国宝物取調局

Sano Tsunetami 佐野常民
Seiyō jijō 西洋事情

Shaji jūhō shutaku kisoku 社寺什寶受託規則
Shiseki meishō tennen kinenbutsu hozon hō 史跡名勝天然記念物保存法
Shōsōin 正倉院

Taki Seiichi 瀧清一
Takumi no Kami 内匠頭
Takumiryō 内匠寮
Teikoku Hakubutsukan 帝国博物館
Teikoku Kyōto Hakubutsukan 帝国京都博物館
Teikoku Nara Hakubutsukan 帝国奈良博物館
Teikoku Nara Hakubutsukan shuppin kisoku 帝国奈良博物館出品規則
tensan 天産
Tōdaiji 東大寺
Tokumei zenken taishi: Beiō kairan jikki 特命全権大使米欧回覧実記
Tōkyō Bijutsu Gakkō 東京美術学校
Tōkyō Kokuritsu Hakubutsukan 東京国立博物館
Tōkyō Teishitsu Hakubutsukan 東京帝室博物館
Tōgū Gosho 東宮御所
Tōgū Gosho Gozōei Chōsa Iinkai 東宮御所御造営調査委員会
Tōyō 東洋

Ueno 上野

Yamashita Hakubutsukan 山下博物館
Yamataka Nobutsura 山高信離
yōfū 洋風
Yōga 洋画

Zōka Gakkai 造家学会

Bibliography

Archival Sources and Drawings

Conder, Josiah. Letters. Royal Institute of British Architects Archives.

———. Nomination papers. Royal Institute of British Architects Archives.

Conder, Roger. Letters. Royal Institute of British Architects Archives.

Ernest Francisco Fenollosa Papers (bMS Am 1759–1759.4). Houghton Library, Harvard University.

Harada (Katayama) Tōkuma. Graduation design, 1879. Archives of the Architecture Department, University of Tokyo.

———. Graduation thesis, 1879. Archives of the Architecture Department, University of Tokyo.

Josiah Conder Sketchbooks. Architectural History Laboratory, Architecture Department, University of Tokyo.

Kyoto National Museum. Drawings of the Imperial Kyoto Museum. Kyoto National Museum Archives.

———. Models of the Imperial Kyoto Museum. Kyoto National Museum Archives.

Nara National Museum. Drawings of the Imperial Nara Museum. Nara National Museum Archives.

———. Models of the Imperial Nara Museum. Nara National Museum Archives.

Tokyo National Museum. Drawings of the Hyōkeikan. Tokyo National Museum Archives.

———. Drawings of the Museum at Ueno Park, former Main Building. Tokyo National Museum Archives.

Newspapers and Periodicals

Asahi shinbun (Osaka), 1891, 1895–97.

Bijutsu shinpō, 1902–10.

The Builder, 1878–79, 1884, 1886–87, 1893.

The Building News, 1876, 1878–79, 1886–87.

The Far East (Yokohama), 1872–73.

Kenchiku zasshi, 1887–1920.

Kōgakkaishi, 1893.

Kyōto Bijutsu Kyōkai zasshi, 1895–99.

The Tokio Times, 1877.

Yomiuri shinbun (Tokyo), 1882.

Major Lectures, Papers, and Publications by Josiah Conder (in chronological order)

"Notes on Japanese Architecture." *Transactions of the Royal Institute of British Architects* (1877–78): 179–92. Paper read on 4 March 1878 on behalf of Conder by T(homas). Roger Smith.

"A Few Remarks upon Architecture." Lecture given at the Imperial College of Engineering, Tokyo, March 1878.

"Theatres in Japan." *The Builder* (5 April 1879): 368–76.

"The History of Japanese Costume—Court Dress." *Transactions of the Asiatic Society of Japan* 8 (1880): 333–68. Paper read on 11 May 1880.

"The History of Japanese Costume II—Armour." *Transactions of the Asiatic Society of Japan* 9 (1881): 254–80. Paper read on 28 June 1881; dated in error as 20 June 1881 in *Transactions*.

"Further Notes on Japanese Architecture." *Transactions of the Royal Institute of British Architects* (1885–86): 185–209. Paper read on 31 May 1886 on behalf of Conder by R(oger). T(homas). Conder.

"The Art of Landscape Gardening in Japan." *Transactions of the Asiatic Society of Japan* 14 (1886): 119–75. Paper read on 5 May 1886.

"Domestic Architecture in Japan." *Transactions of the Royal Institute of British Architects* (1886–87): 103–27. Paper read on 28 February 1887.

"Zōka hikkei." Lectures by Josiah Conder transcribed in Japanese by Matsuda Shūji and Sone Tatsuzō, 1886.

"Theory of Japanese Flower Arrangements." *Transactions of the Asiatic Society of Japan* 17 (1889): 1–96. Paper read on 13 March 1889.

"Obituary of Kawanabe Kyōsai." *Japan Weekly Mail* (18 May 1889): 477–79.

"Meiji Art Society." *Japan Weekly Mail* (14 December 1889): 555–57. Lecture given on 7 December 1889.

The Flowers of Japan and the Art of Floral Arrangement. Tokyo: Hakubunsha, Kelly and Walsh, 1891. Revised edition, *The Floral Art of Japan*, 1899.

"The Effects of the Recent Earthquake upon Buildings." *Japan Weekly Mail* (12 December 1891): 725–26. Paper read before the Tōkyō Nōbengakkai (Tokyo Elocutionary Society), 6 December 1891.

"An Architect's Note on the Great Earthquake of October 1891." *Seismological Journal of Japan* (1893): 1–91.

"Earthquakes versus Buildings." *Japan Weekly Mail* (30 January 1892): 153–55. Paper read before the Society of Japanese Architects, 27 January 1892.

Landscape Gardening in Japan. Tokyo: Kelly and Walsh, 1893. Revised editions 1912, 1964.

Supplement to Landscape Gardening in Japan. Tokyo: Kelly and Walsh, 1893. Revised editions 1912, 1964.

"The Condition of Architecture in Japan." *Proceedings of the Twenty-seventh Annual Convention of the American Institute of Architects* (1893): 365–81. Paper read at the World's Congress of Architects, World's Columbian Exposition, Chicago, on 5 August 1893, on behalf of Conder by Sone Tatsuzō.

Paintings and Studies by Kawanabe Kyōsai. Tokyo: Maruzen, Kelly and Walsh, 1911.

The Theory of Japanese Flower Arrangements. Kobe, Japan: J. L. Thompson & Co., 1935. Posthumous reprint of the paper "Theory of Japanese Flower Arrangements," read on 13 March 1889 at the Asiatic Society of Japan.

Publications by Katayama Tōkuma (in chronological order)

"Renga kō." *Kenchiku zasshi*, no. 27 (March 1889).

"Haideruberuhi Daigaku fuzoku shinbyōin kenchiku tekiyō." *Kenchiku zasshi*, no. 33 (September 1889).

"Kando ōuchi no sei." *Kenchiku zasshi*, no. 43 (July 1890).

Books and Articles

Western-Language Sources

Adorno, Theodor. "Valéry Proust Museum." In *Prisms*, translated by Samuel and Shierry Weber. Cambridge, Mass.: MIT Press, 1967.

Anderson, Benedict. *Imagined Communities: Reflections on the Origin and Spread of Nationalism*. Revised edition. London: Verso, 1991.

Art Bulletin. "The Problematics of Collecting and Display, Part 1." *Art Bulletin* 77 (March 1995): 6–24.

———. "The Problematics of Collecting and Display, Part 2." *Art Bulletin* 77 (June 1995): 166–85.

Art Journal. "Japan 1868–1945: Art, Architecture, and National Identity." *Art Journal* 55 (fall 1996).

Auerbach, Jeffrey. *The Great Exhibition of 1851: A Nation on Display*. New Haven, Conn.: Yale University Press, 1999.

Baker, Malcolm, and Brenda Richardson, eds. *A Grand Design: The Art of the Victoria and Albert Museum*. New York: Harry N. Abrams; Baltimore, Md.: Baltimore Museum of Art, 1997.

Bal, Mieke. "Telling, Showing, Showing Off." *Critical Inquiry* 18 (spring 1992): 556–94.

Baxandall, Michael. "Exhibiting Intention: Some Preconditions of the Visual Display of Culturally Purposeful Objects." In *Exhibiting Cultures: The Poetics and Politics of Museum Display*, edited by Ivan Karp and Steven Lavine. Washington, D.C.: Smithsonian Institution, 1991.

Bazin, Germain. *The Museum Age*. New York: Universe Books, 1967.

Beasley, W. G. *Japan Encounters the Barbarian: Japanese Travellers in America and Europe*. New Haven, Conn.: Yale University Press, 1995.

———. *Japanese Imperialism, 1894–1945*. Oxford: Clarendon Press, 1987.

Beauchamp, Edward, and Akira Iriye, eds. *Foreign Employees in Nineteenth-Century Japan*. Boulder, Colo.: Westview Press, 1990.

Bennett, Tony. *The Birth of the Museum*. London: Routledge, 1995.

Bergdoll, Barry. *European Architecture, 1750–1890*. Oxford: Oxford University Press, 2000.

———. *Karl Friedrich Schinkel: An Architecture for Prussia*. New York: Rizzoli, 1994.

Bhabha, Homi. "Culture's in Between." *Artforum International* 32 (September 1993): 167–68, 211–12, 214.

———. "Of Mimicry and Man: The Ambivalence of Colonial Discourse." *October* 28 (spring 1984): 125–33.

Blacker, Carmen. *The Japanese Enlightenment: A Study of the Writings of Fukuzawa Yukichi*. Cambridge: Cambridge University Press, 1964.

Boswell, David, and Jessica Evans, eds. *Representing the Nation: A Reader: Histories, Heritage and Museums.* London: Routledge, 1999.

Braisted, William Reynolds, trans. *Meiroku Zasshi: Journal of the Japanese Enlightenment.* Cambridge, Mass.: Harvard University Press, 1976.

Bremner, G. Alex. "'Some Imperial Institute': Architecture, Symbolism, and the Ideal of Empire in Late Victorian Britain, 1887–93." *Journal of the Society of Architectural Historians* 62 (March 2003): 50–73.

Bresc-Bautier, Genevieve. *The Louvre: An Architectural History.* New York: Vendome Press, 1995.

Brooks, Van Wyck. *Fenollosa and His Circle.* New York: Dutton, 1962.

Brownlee, David. *Building the City Beautiful: The Benjamin Franklin Parkway and the Philadelphia Museum of Art.* Philadelphia: Philadelphia Museum of Art, 1989.

Brunton, R. Henry. "Constructive Art in Japan." Parts 1 and 2. *Transactions of the Asiatic Society of Japan* 2 (22 October 1873–15 July 1874): 64–86; 3 (13 January 1875–30 June 1875): 20–30.

Burges, William. *Art Applied to Industry: A Series of Lectures.* Oxford: John Henry and James Parker, 1865.

Burks, Ardath, ed. *The Modernizers: Overseas Students, Foreign Employees, and Meiji Japan.* Boulder, Colo.: Westview Press, 1985.

Burt, Nathaniel. *Palaces for the People: A Social History of the American Art Museum.* Boston: Little Brown, 1977.

Cawley, George. "Some Remarks on Constructions in Brick and Wood and Their Relative Suitability for Japan." *Transactions of the Asiatic Society of Japan* 6 (1878): 291–317.

Caygill, Marjorie. *The British Museum: 250 Years.* London: British Museum Press, 2003.

Çelik, Zeynep. *Displaying the Orient: Architecture of Islam at Nineteenth-Century World's Fairs.* Berkeley: University of California Press, 1992.

Çelik, Zeynep, and Leila Kinney. "Ethnography and Exhibitionism at the Expositions Universelles." *Assemblage*, no. 13 (December 1990): 35–59.

Chang, Ting. "Collecting Asia: Theodore Duret's *Voyage en Asie* and Henri Cernuschi's Museum." *Oxford Art Journal* 25, no. 1 (2002): 17–34.

Chisholm, Lawrence. *Fenollosa: The Far East and American Culture.* New Haven, Conn.: Yale University Press, 1963.

Clancey, Gregory. *Earthquake Nation: The Cultural Politics of Japanese Seismicity, 1868–1930.* Berkeley: University of California Press, 2006.

Clark, John. *Japanese Exchanges in Art, 1850s to 1930s, with Britain, Continental Europe, and the USA.* Sydney, Australia: Power Publications, 2001.

Cobbing, Andrew. *The Japanese Discovery of Victorian Britain: Early Travel Encounters in the Far West.* Richmond, Surrey, U.K.: Japan Library, 1998.

———. *The Satsuma Students in Britain: Japan's Early Search for the "Essence of the West."* Richmond, Surrey, U.K.: Japan Library, 2000.

Cocks, Anna Somers. *The Victoria and Albert Museum: The Making of the Collection.* Leicester, U.K.: Windward, 1980.

Compton, Michael. "The Architecture of Daylight." In *Palaces of Art: Art Galleries in Britain, 1790–1990*, edited by Giles Waterfield. London: Dulwich Picture Gallery, 1991.

Conant, Ellen. *Nihonga: Transcending the Past: Japanese-Style Painting, 1868–1968.* Saint Louis: Saint Louis Art Museum, 1995.

———. "Principles and Pragmatism: The *Yatoi* in the Field of Art." In *Foreign Employees in Nineteenth-Century Japan*, edited by Edward Beauchamp and Akira Iriye. Boulder, Colo.: Westview Press, 1990.

———, ed. *Challenging Past and Present: The Metamophosis of Nineteenth-Century Japanese Art.* Honolulu: University of Hawaii Press, 2006.

Conn, Steven. *Museums and American Intellectual Life, 1876–1926.* Chicago: University of Chicago Press, 1998.

Crinson, Mark. *Empire Building: Orientalism and Victorian Architecture.* London: Routledge, 1996.

Crook, J. Mordaunt. *The British Museum: A Case Study in Architectural Politics.* Harmondsworth, U.K.: Penguin Books, 1973.

———. *The Dilemma of Style: Architectural Ideas from the Picturesque to the Post-Modern.* Chicago: University of Chicago Press, 1987.

———. *William Burges and the High Victorian Dream.* Chicago: University of Chicago Press, 1981.

Cunningham, Michael. *Buddhist Treasures from Nara.* Cleveland, Ohio: Cleveland Museum of Art, 1998.

Cuno, James. "Against the Discursive Museum." In *The Discursive Museum*, edited by Peter Noever. New York: Distributed Art Publishers, 2001.

Dresser, Christopher. *Japan: Its Architecture, Art, and Art Manufactures.* London: Longmans, Green, and Company, 1882.

Duncan, Carol. *Civilizing Rituals: Inside Public Art Museums.* London: Routledge, 1995.

Duncan, Carol, and Alan Wallach. "The Universal Survey Museum." *Art History* 3 (December 1980): 448–69.

Dyer, Henry. *Dai Nippon, the Britain of the East: A Study in National Evolution.* London: Blackie and Son, 1904.

Earle, Joe. *Splendors of Imperial Japan: Arts of the Meiji Period from the Khalili Collection.* London: Khalili Family Trust, 2002.

Evett, Elisa. *The Critical Reception of Japanese Art in Late Nineteenth Century Europe.* Ann Arbor, Mich.: UMI Research Press, 1982.

Faure, Bernard. "The Buddhist Icon and the Modern Gaze." *Critical Inquiry* 24 (spring 1998): 768–813.

Fenollosa, Ernest. *Epochs of Chinese and Japanese Art.* Tokyo: ICG Muse, 2000.

Fiévé, Nicolas, and Paul Waley, eds. *Japanese Capitals in Historical Perspective: Place, Power, and Memory in Kyoto, Edo, and Tokyo.* London: RoutledgeCurzon, 2003.

Findlen, Paula. "The Museum: Its Classical Etymology and Renaissance Genealogy." *Journal of the History of Collections* 1, no. 1 (1989): 59–78.

Fischer, Adolf. *Wandlungen im kunstleben Japans.* Berlin: B. Behrs Verlag, 1900.

Floyd, Margaret Henderson. "A Terra-Cotta Cornerstone for Copley Square: Museum of Fine Arts, Boston, 1870–1876, by Sturgis and Brigham." *Journal of the Society of Architectural Historians* 43 (May 1973): 83–103.

French, Calvin. *Through Closed Doors: Western Influence on Japanese Art, 1639–1853.* Kobe, Japan: Kobe City Museum of Namban Art, 1977.

Fujita, Haruhiko. "Notomi Kaijiro: An Industrial Art Pioneer and the First Design Educator of Modern Japan." *Design Issues* 17 (spring 2001): 17–31.

Fujitani, T. *Splendid Monarchy: Power and Pageantry in Modern Japan.* Berkeley: University of California Press, 1996.

Fukuzawa Yukichi. *An Outline of a Theory on Civilization.* Translated by David A. Dilworth and G. Cameron Hurst. Tokyo: Sophia University, 1973.

Germann, Georg. *Gothic Revival in Europe and Britain: Sources, Influences, and Ideas.* Translated by Gerald Onn. London: Lund Humphries for the Architectural Association, 1972.

Giberti, Bruno. *Designing the Centennial: A History of the 1876 International Exhibition in Philadelphia.* Lexington, Ky.: University Press of Kentucky, 2002.

Girouard, Mark. *Alfred Waterhouse and the Natural History Museum.* New Haven, Conn.: Yale University Press, 1981.

———. *Sweetness and Light: The "Queen Anne" Movement, 1860–1900.* Oxford: Clarendon Press, 1977.

Gluck, Carol. *Japan's Modern Myths: Ideology in the Late Meiji Period.* Princeton, N.J.: Princeton University Press, 1985.

———. "'Meiji' for Our Time." In *New Directions in the Study of Meiji Japan*, edited by Helen Hardacre. Leiden, Neth.: Brill, 1997.

Gordon, Andrew. *A Modern History of Japan: From Tokugawa Times to the Present.* Oxford: Oxford University Press, 2003.

Grapard, Allan. "Japan's Ignored Cultural Revolution: The Separation of Shintō and Buddhist Divinities in Meiji (*shimbutsu bunri*) and a Case Study: Tōnomine." *History of Religion* 23 (February 1984): 240–65.

Guide to Visitors for National Exhibition (Second Term). Tokyo: Siuyeisha, 1881.

Guth, Christine. *Art, Tea, and Industry.* Princeton, N.J.: Princeton University Press, 1993.

———. "Charles Longfellow and Okakura Kakuzo: Cultural Cross-Dressing in the Colonial Context." *Positions* 8 (winter 2000): 605–36.

———. "Kokuhō: From Dynastic to Artistic Treasure." *Cahiers d'Extrême-Asie* 9 (1996–97): 313–22.

———. "Some Reflections on the Formation of the Meiji Artistic Canon." In *New Directions in the Study of Meiji Japan*, edited by Helen Hardacre. Leiden, Neth.: Brill, 1997.

Halén, Widar. *Christopher Dresser: A Pioneer of Modern Design.* London: Phaidon Press, 1993.

———. "Christopher Dresser (1834–1904) and the Cult of Japan." Ph.D. diss., Wadham College, University of Oxford, 1988.

Hardacre, Helen. "Creating State Shinto: The Great Promulgation Campaign and the New Religions." *Journal of Japanese Studies* 12 (winter 1986): 29–63.

———. *Shintō and the State, 1868–1988.* Princeton, N.J.: Princeton University Press, 1989.

———, ed. *New Directions in the Study of Meiji Japan.* Leiden, Neth.: Brill, 1997.

Harris, Neil. "All the World a Melting Pot? Japan at the American Fairs, 1876–1904." In *Mutual Images: Essays in American-Japan Relations*, edited by Akira Iriye. Cambridge, Mass.: Harvard University Press, 1975.

———. "The Gilded Age Revisited: Boston and the Museum Movement." *American Quarterly* 14 (winter 1962): 545–66.

Heckscher, Morrison. *The Metropolitan Museum of Art: An Architectural History.* New York: Metropolitan Museum of Art, 1995.

Hidenobu Jinnai. "The Spatial Structure of Edo." In *Tokugawa Japan: The Social and Economic Antecedents of Modern Japan*, edited by Chie Nakane and Shinzaburō Ōishi. Tokyo: University of Tokyo Press, 1990.

Hitchcock, Henry Russell. *Architecture: Nineteenth and Twentieth Centuries.* 3rd edition. Harmondsworth, U.K.: Penguin Books, 1968.

Holt, Elizabeth Gilmore, ed. *The Expanding World of Art, 1874–1902.* New Haven, Conn.: Yale University Press, 1988.

Hooper-Greenhill, Eilean. "The Space of the Museum." *Continuum* 3, no. 1 (1990): 56–69.

Howland, Douglas. *Translating the West: Language and Political Reason in Nineteenth-Century Japan.* Honolulu: University of Hawaii Press, 2002.

Hur, Nam-lin. *Prayer and Play in Late Tokugawa Japan: Asakusa Sensōji and Edo Society.* Cambridge, Mass: Harvard University Asia Center, 2000.

Ivy, Marilyn. *Discourses of the Vanishing: Modernity, Phantasm, Japan.* Chicago: University of Chicago Press, 1995.

Jaffe, Richard. "Seeking Sakyamuni: Travel and the Reconstruction of Japanese Buddhism." *Journal of Japanese Studies* (winter 2004): 65–96.

Jansen, Marius. "Cultural Change in Nineteenth-Century Japan." In *Challenging Past and Present: The Metamorphosis of Nineteenth-Century Japanese Art*, edited by Ellen Conant. Honolulu: University of Hawaii Press, 2006.

———. *The Making of Modern Japan.* Cambridge, Mass.: Belknap Press of Harvard University Press, 2000.

———, ed. *The Nineteenth Century.* Vol. 5 of *The Cambridge History of Japan.* Cambridge: Cambridge University Press, 1989.

Jones, Joyce. "Museum and Art Gallery Buildings in England—1845–1914." Parts 1 and 2. *Museums Journal* (London) 65 (December 1965): 230–38; (March 1966): 271–80.

Jordan, Brenda, and Victoria Weston, eds. *Copying the Master and Stealing His Secrets: Talent and Training in Japanese Painting.* Honolulu: University of Hawaii Press, 2003.

Karatani Kōjin. "Japan as Museum: Okakura Tenshin and Ernest Fenollosa." In *Japanese Art after 1945: Scream against the Sky*, edited by Alexandra Munroe. New York: H. N. Abrams, 1994.

Karp, Ivan, and Steven Lavine, eds. *Exhibiting Cultures: The Poetics and Politics of Museum Display.* Washington, D.C.: Smithsonian Institution Press, 1991.

Keene, Donald. *Emperor of Japan: Meiji and His World, 1852–1912.* New York: Columbia University Press, 2002.

Kornicki, P. F. "Public Display and Changing Values: Early Meiji Exhibitions and Their Precursors." *Monumenta Nipponica* 49 (summer 1994): 167–96.

Kristeller, Paul Oskar. "The Modern System of the Arts: A Study in the History of Aesthetics." Parts 1 and 2. *Journal of the History of Ideas* 12 (October 1951): 496–527; 13 (January 1952): 17–46.

Kume Kunitake. *The Iwakura Embassy, 1871–1873: A True Account of the Ambassador Extraordinary and Plenipotentiary's Journey of Observation through the United States and Europe.* Edited by Graham Healey and Chushichi Tsuzuki. 5 volumes. Princeton, N.J.: Princeton University Press, 2002.

Langlois, Lisa. "Exhibiting Japan: Gender and National Identity at the World's Columbian Exposition of 1893." Ph.D. diss., University of Michigan, 2004.

Levine, Gregory. *Daitokuji: The Visual Cultures of a Zen Monastery.* Seattle: University of Washington Press, 2005.

Lewis, Michael. *The Gothic Revival.* New York: Thames and Hudson, 2002.

Lockyer, Angus. "Japan at the Exhibition, 1867–1970." Ph.D. diss., Stanford University, 2000.

Lopez, Donald, Jr., ed. *Curators of the Buddha: The Study of Buddhism under Colonialism.* Chicago: University of Chicago Press, 1995.

Maeda Ai. *Text and the City: Essays on Japanese Modernity.* Edited by James Fujii. Durham, N.C.: Duke University Press, 2004.

Mainardi, Patricia. *Art and Politics of the Second Empire: The Universal Expositions of 1855 and 1867.* New Haven, Conn.: Yale University Press, 1987.

———. *The End of the Salon: Art and the State in the Early Third Republic.* Cambridge: Cambridge University Press, 1993.

Mallgrave, Harry. *Gottfried Semper: Architect of the Nineteenth Century.* New Haven, Conn.: Yale University Press, 1996.

Malraux, André. *Museum without Walls.* Translated by Stuart Gilbert and Francis Price. Garden City, N.Y.: Doubleday, 1967.

Mansfield, Elizabeth, ed. *Art History and Its Institutions: Foundations of a Discipline.* London: Routledge, 2002.

Markus, Andrew. "The Carnival of Edo: *Misemono* Spectacles from Contemporary Accounts." *Harvard Journal of Asiatic Studies* 45 (December 1985): 499–541.

———. "Shogakai: Celebrity Banquets of the Late Edo Period." *Harvard Journal of Asiatic Studies* 53 (June 1993): 135–67.

McClellan, Andrew. "From Boullée to Bilbao: The Museum as Utopian Space." In *Art History and Its Institutions: Foundations of a Discipline*, edited by Elizabeth Mansfield. London: Routledge, 2002.

———. *Inventing the Louvre: Art, Politics, and the Origins of the Modern Museum in Eighteenth-Century Paris.* Berkeley: University of California Press, 1999.

———, ed. *Art and Its Publics: Museum Studies at the Millennium.* Malden, Mass.: Blackwell Publishers, 2003.

Metcalf, Thomas. *An Imperial Vision: Indian Architecture and Britain's Raj.* Berkeley: University of California Press, 1989.

Miller, Ian. "Didactic Nature: Exhibiting Nation and Empire at the Ueno Zoological Gardens." In *JAPANimals: History and Culture in Japan's Animal Life*, edited by Gregory Pflugfelder and Brett Walker. Ann Arbor, Mich.: Center for Japanese Studies, University of Michigan, 2005.

Minear, Richard. "Orientalism and the Study of Japan." *The Journal of Asian Studies* 39 (May 1980): 507–17.

Miyoshi, Masao. *As We Saw Them: The First Japanese Embassy to the United States (1860).* Berkeley: University of California Press, 1979.

Morse, Edward. *Japan Day by Day.* Boston: Houghton Mifflin, 1917.

———. *Japanese Homes and Their Surroundings.* New York: Harper, 1885.

Morton, Patricia. *Hybrid Modernities: Architecture and Representation at the 1931 Colonial Exposition, Paris.* Cambridge, Mass.: MIT Press, 2000.

Murai, Noriko. "Authoring the East: Okakura Kakuzō and the Representation of East Asian Art in the Early Twentieth Century." Ph.D. diss., Harvard University, 2003.

Murakami Shigeyoshi. *Japanese Religion in the Modern Century.* Translated by H. Byron Earhart. Tokyo: University of Tokyo Press, 1980.

Muramatsu Teijirō. "Ventures into Western Architecture." In *Dialogue in Art: Japan and the West*, edited by Chisaburoh Yamada. Tokyo: Kodansha International, 1976.

Museum of Fine Arts, Boston. *Japan at the Dawn of the Modern Age: Woodblock Prints from the Meiji Era, 1868–1912.* Boston: MFA Publications, 2001.

Nish, Ian. *The Anglo-Japanese Alliance: The Diplomacy of Two Island Empires, 1894–1907.* London: Athlone Press, 1966.

———, ed. *The Iwakura Mission in America and Europe: A New Assessment.* Richmond, Surrey, U.K.: Japan Library, 1998.

Official Catalogue of the National Exhibition of Japan. Tokyo: Exhibition Bureau, 1877.

Official Catalogue of the Second National Exhibition of Japanese Empire. Tokyo: Exhibition Department, 1881.

Official Catalogue of the Third Industrial National Exhibition, 1890. Yokohama: Japan Mail Office, 1890.

Okakura Kakuzō. *The Hō-ō-den: An Illustrated Description of the Buildings Erected by the Japanese Government at the World's Columbian Exposition.* Tokyo: K. Ogawa, 1893.

———. *The Ideals of the East: With Special Reference to the Art of Japan.* New York: ICG Muse, 2000.

———. *Okakura Kakuzō, Collected English Writings.* 3 volumes. Tokyo: Heibonsha, 1984.

Omuka Toshiharu. "The Formation of the Audiences for Modern Art in Japan." In *Being Modern in Japan: Culture and Society from the 1910s to the 1930s*, edited by Elise K. Tipton and John Clark. Honolulu: University of Hawaii Press, 2000.

Pevsner, Nikolaus. *A History of Building Types.* Princeton, N.J.: Princeton University Press, 1976.

Physick, John. *The Victoria and Albert Museum: The History of Its Building.* Oxford: Phaidon, 1982.

Plagemann, Volker. *Das deutsche Kunstmuseum, 1790–1870: Lage, Baukörper, Raumorganisation, Bildprogramm.* Munich: Prestel-Verlag, 1967.

Pointon, Marcia, ed. *Art Apart: Art Institutions and Ideology Across England and North America.* Manchester, U.K.: Manchester University Press, 1994.

Preziosi, Donald, ed. *The Art of Art History: A Critical Anthology.* Oxford: Oxford University Press, 1998.

Rambelli, Fabio. "Secret Buddhas: The Limits of Buddhist Representation." *Monumenta Nipponica* 57 (autumn 2002): 271–307.

Reynolds, Jonathan. "Japan's Imperial Diet Building: Debate over Construction of a National Identity." *Art Journal* 55 (fall 1996): 38–47.

———. "Teaching Architectural History in Japan: Building a Context for Contemporary Practice." *Journal of the Society of Architectural Historians* 61 (December 2002): 530–36.

Rosenfield, John. "Japanese Art Studies in America since 1945." In *The Postwar Development of Japanese Studies in the United States*, edited by Helen Hardacre. Boston: Brill, 1998.

———. "Japanese Buddhist Art: Alive in the Modern Age." In *Buddhist Treasures from Nara*, by Michael Cunningham. Cleveland, Ohio: Cleveland Museum of Art, 1998.

———. "Western-style Painting in the Early Meiji Period and Its Critics." In *Tradition and*

Modernization in Japanese Culture, edited by Donald H. Shively. Princeton, N.J.: Princeton University Press, 1971.

Rydell, Robert. *All the World's a Fair: Visions of Empire at American International Expositions, 1876–1916*. Chicago: University of Chicago Press, 1984.

Rydell, Robert, and Nancy Gwinn, eds. *Fair Representations: World's Fairs and the Modern World*. Amsterdam, Neth.: VU University Press, 1994.

Said, Edward. *Culture and Imperialism*. New York: Knopf, 1993.

———. *Orientalism*. New York: Vintage Books, 1978.

Sand, Jordan. "Japan." *Journal of the Society of Architectural Historians* 57 (June 1998): 231–34.

Sato, Tomoko, and Toshio Watanabe, eds. *Japan and Britain: An Aesthetic Dialogue 1850–1930*. London: Lund Humphries, 1991.

Scott, Gertrude. "Village Performances: Villages at the Chicago World's Columbian Exposition 1893." Ph.D. diss., New York University, 1991.

Screech, Timon. *The Lens within the Heart: The Western Scientific Gaze and Popular Imagery in Later Edo Japan*. 2nd edition. Honolulu: University of Hawaii Press, 2002.

Segi Shinichi. "Hayashi Tadamasa: Bridge between the Fine Arts of East and West." In *Japonisme in Art: An International Symposium*, edited by Yamada Chisaburō. Tokyo: Committee for the Year 2001, 1980.

Seidensticker, Edward. *Low City, High City: Tokyo from Edo to the Earthquake*. Cambridge, Mass.: Harvard University Press, 1991.

Seling, Helmut. "The Genesis of the Museum." *Architectural Review* 141 (February 1967): 103–14.

Sharf, Robert, and Elizabeth Horton Sharf, eds. *Living Images: Japanese Buddhist Icons in Context*. Stanford, Calif.: Stanford University Press, 2001.

Shelley, Henry. *The British Museum: Its History and Treasures*. Boston: L.C. Page & Company, 1911.

Sherman, Daniel. *Worthy Monuments: Art Museums and the Politics of Culture in Nineteenth-Century France*. Cambridge, Mass.: Harvard University Press, 1989.

Shimizu, Yoshiaki. "Japan in American Museums—But Which Japan?" *Art Bulletin* 83 (March 2001): 123–34.

Shively, Donald. "The Japanization of the Middle Meiji." In *Tradition and Modernization in Japanese Culture*, edited by Donald Shively. Princeton, N.J.: Princeton University Press, 1971.

Snodgrass, Judith. *Presenting Japanese Buddhism to the West: Orientalism, Occidentalism, and the Columbian Exposition*. Chapel Hill, N.C.: University of North Carolina Press, 2003.

Sorensen, André. *The Making of Urban Japan: Cities and Planning from Edo to the Twenty-first Century*. London: Routledge, 2002.

Soros, Susan Weber, ed. *E. W. Godwin: Aesthetic Movement Architect and Designer*. New Haven, Conn.: Yale University Press, 1999.

———. *The Secular Furniture of E. W. Godwin*. New Haven, Conn.: Yale University Press, 1999.

Steegman, John. *Victorian Taste: A Study of the Arts and Architecture from 1830 to 1870*. Cambridge, Mass.: MIT Press, 1970.

Steffensen-Bruce, Ingrid. *Marble Palaces, Temples of Art: Art Museums, Architecture, and American Culture, 1890–1930*. Lewisburg, Pa.: Bucknell University Press, 1998.

Tanaka, Stefan. "Discoveries of the Hōryūji." In *Constructing Nationhood in Modern East*

Asia, edited by Kai-wing Chow et al. Ann Arbor, Mich.: University of Michigan Press, 2001.

Tateno Gōzō. "Foreign Nations at the World's Fair." *North American Review* (January 1893): 34–43.

Teyssot, Georges. "'The Simple Day and Light of the Sun': Lights and Shadows in the Museum." *Assemblage*, no. 12 (August 1990): 58–83.

Tipton, Elise, and John Clark, eds. *Being Modern in Japan: Culture and Society from the 1910s to 1930s*. Honolulu: University of Hawaii Press, 2000.

Titus, David. *Palace and Politics in Prewar Japan*. New York: Columbia University Press, 1974.

Tōkyō Teishitsu Hakubutsukan. *A Brief Guide to the Imperial Household Museum*. Tokyo: World Conference Committee of the Japanese Education Association, 1937.

Tomkins, Calvin. *Merchants and Masterpieces: The Story of the Metropolitan Museum of Art*. New York: H. Holt, 1989.

Tseng, Alice. "Styling Japan: The Case of Josiah Conder and the Museum at Ueno, Tokyo." *Journal of the Society of Architectural Historians* 63 (December 2004): 472–97.

Valéry, Paul. "The Problem of Museums." In *Degas, Manet, Morisot*. Volume 12 of *The Collected Works of Paul Valéry*, translated by David Paul. New York: Pantheon Books, 1960.

Varley, H. Paul. *Japanese Culture*. 3rd edition. Honolulu: University of Hawaii Press, 1984.

Wallach, Alan. *Exhibiting Contradiction: Essays on the Art Museum in the United States*. Amherst, Mass.: University of Massachusetts Press, 1998.

Walton, William. *Art and Architecture*. Philadelphia: G. Barrie, 1893.

Watanabe, Toshio. "Japanese Imperial Architecture: From Thomas Roger Smith to Itō Chūta." In *Challenging Past and Present: The Metamorphosis of Nineteenth-Century Japanese Art*, edited by Ellen Conant. Honolulu: University of Hawaii Press, 2006.

———. "Josiah Conder's Rokumeikan." *Art Journal* 55 (fall 1996): 21–27.

———. "Vernacular Expression or Western Style?: Josiah Conder and the Beginning of the Modern Architectural Design in Japan." In *Art and the National Dream: The Search for Vernacular Expression in Turn of the Century Design*, edited by Nicola Gordon Bowe. Dublin: Irish Academic Press, 1993.

Weisenfeld, Gennifer, ed. "Visual Cultures of Japanese Imperialism." *Positions* 8 (winter 2000).

Wendelken, Cherie. "The Tectonics of Japanese Style: Architect and Carpenter in the Late Meiji Period." *Art Journal* 55 (fall 1996): 28–37.

Weston, Victoria. "Institutionalizing Talent and the Kano Legacy at the Tokyo School of Fine Arts, 1889–1893." In *Copying the Master and Stealing His Secrets: Talent and Training in Japanese Painting*, edited by Brenda Jordan and Victoria Weston. Honolulu: University of Hawaii Press, 2003.

———. *Japanese Painting and National Identity: Okakura Tenshin and His Circle*. Ann Arbor, Mich.: Center for Japanese Studies, University of Michigan, 2004.

Whitehill, Walter Muir. *Museum of Fine Arts, Boston: A Centennial History*. 2 volumes. Cambridge, Mass.: Belknap Press, 1970.

Whitney, Clara. *Clara's Diary: An American Girl in Meiji Japan*. Edited by M. William Steele and Tamiko Ichimata. Tokyo: Kodansha International, 1979.

Wight, P. B. "Japanese Architecture at Chicago." Parts 1 and 2. *Inland Architect and News Record* 20 (December 1892): 49–52; (January 1893): 61.

Wright, Gwendolyn, ed. *The Formation of National Collections of Art and Archaeology.* Washington, D.C.: National Gallery of Art, 1996.

Yanni, Carla. "The Crystal Palace: A Legacy in Science." *Journal of Prince Albert Studies* 20 (2002): 119–26.

———. *Nature's Museums: Victorian Science and the Architecture of Display.* Baltimore, Md.: Johns Hopkins University Press, 1999.

Yiengpruksawan, Mimi Hall. "Japanese Art History 2001: The State and Stakes of Research." *Art Bulletin* 83 (March 2001): 105–22.

———. "The Legacy of Buddhist Art at Nara." In *Buddhist Treasures from Nara*, by Michael Cunningham. Cleveland, Ohio: Cleveland Museum of Art, 1998.

Yokoyama, Toshio. *Japan in the Victorian Mind: A Study of Stereotyped Images of a Nation, 1850–80.* London: Macmillan, 1987.

Yoshimizu Tsuneo. "The Shōsōin: An Open and Shut Case." *Asian Cultural Studies* 17 (March 1989): 15–44.

Zatlin, Linda Gertner. *Beardsley, Japonisme, and the Perversion of the Victorian Ideal.* Cambridge: Cambridge University Press, 1997.

Japanese-Language Sources

Aichi Ken Bijutsukan. *Sugimoto Kenkichi ten: Gagyō shichijūnen no ayumi.* Nagoya: Aichi Ken Bijutsukan, 1994.

Arisugawa no Miya, Taruhito. *Taruhito Shinnō nikki.* Revised edition. 6 volumes. Tokyo: Tōkyō Daigaku Shuppankai, 1976.

Eguchi Toshihiko. *Yōfū mokuzō kenchiku.* Tokyo: Rikō Gakusha, 1996.

Fujimori Terunobu. *Nihon no kindai kenchiku.* 2 volumes. Tokyo: Iwanami Shoten, 1993.

Fukuzawa Yukichi. *Seiyō jijō.* In *Fukuzawa Yukichi.* Volume 33 of *Nihon no meicho.* Tokyo: Chūō Kōronsha, 1969.

Furukawa Miki. *Misemono no rekishi.* Tokyo: Yuzankaku Shuppan, 1970.

Furuta Ryō. "Koronbusu sekai hakurankai hitori annai." In *Umi o watatta Meiji no bijutsu*, by Tōkyō Kokuritsu Hakubutsukan. Tokyo: Tōkyō Kokuritsu Hakubutsukan, 1997.

———. "Nihon no bijutsu tenrankai: Sono kigen to hattatsu." *Museum* (Tokyo) (December 1996): 29–56.

Geijutsu Kenkyū Shinkō Zaidan. *Tōkyō Geijutsu Daigaku hyakunenshi.* Volume 1, *Tōkyō Bijutsu Gakkō hen.* Tokyo: Gyōsei, 1987.

Gotō Yasushi and Fujitani Toshio, eds. *Kindai Kyōto no ayumi.* Kyoto: Kamogawa Shuppan, 1986.

Hashimoto Kizō. *Kyōto to kindai bijutsu.* Kyoto: Kyōto Shoin, 1982.

Hatsuda Tōru. *Toshi no Meiji.* Tokyo: Chikuma Shobō, 1994.

Hayashi Tadasu. *Arisugawa Nihon Shinnō Ōbei junyū nikki.* Tokyo: Kaishundō, 1883.

Hino Eiichi. "Bankoku hakurankai to Nihon no 'bijutsu kōgei.'" In *Bankoku hakurankai no kenkyū*, edited by Yoshida Mitsukuni. Kyoto: Shibunkaku, 1986.

Hiruma Hisashi. *Edo no kaichō.* Tokyo: Yoshikawa Kōbunkan, 1980.

Inagaki Eizō. *Nihon no kindai kenchiku.* 2 volumes. Tokyo: Kajima Shuppankai, 1979.

Ishii Kendō. *Meiji jibutsu kigen.* Tokyo: Shunyōdō Shoten, 1926.

"Katayama Hakushi o tomurau." *Kenchiku zasshi*, no. 372 (1917): 1–22.

Kawahigashi Yoshiyuki. *Josaia Kondoru kenchiku zumenshū*. 3 volumes. Tokyo: Chūō Kōron Bijutsu Shuppan, 1980–81.

Kawanabe Kusumi and Suzuki Hiroyuki, eds. *Rokumeikan no kenchikuka Josaia Kondoru ten*. Tokyo: Higashi Nihon Tetsudō Bunka Zaidan, 1997.

Kigi Yasuko. *Hayashi Tadamasa to sono jidai: Seikimatsu no Pari to Japonisumu*. Tokyo: Chikuma Shobō, 1987.

Kinoshita Naoyuki. *Bijutsu to iu misemono: Aburae chaya no jidai*. Tokyo: Heibonsha, 1993.

Kirishiki Shinjirō. *Meiji no kenchiku*. Revised edition. Tokyo: Honnotomosha, 2001.

Kitamura Gyōon. *Kinsei kaichō no kenkyū*. Tokyo: Meicho Shuppan, 1989.

Kitazawa Noriaki. *Kyōkai no bijutsushi: Bijutsu keiseishi nōto*. Tokyo: Seiunsha, 2000.

———. *Me no shinden: "Bijutsu" juyōshi nōto*. Tokyo: Bijutsu Shuppansha, 1989.

Kobayashi Yasushige. *Ueno Kōen*. Tokyo: Tōkyō to Kōen Kyōkai, 1980.

Kōbu Daigakkō. *Kōbu Bijutsu Gakkō shokisoku*. Tokyo: Kōbu Daigakkō, 1877.

Kojima Teiichi. *Nara Teishitsu Hakubutsukan o miru hito e*. Nara: Kihara Bunshindō, 1925.

Kokuritsu Kagaku Hakubutsukan. *Kokuritsu Kagaku Hakubutsukan hyakunenshi*. Tokyo: Kokuritsu Kagaku Hakubutsukan, 1977.

Kokuritsu Shiryōkan. *Meiji kaikaki no nishikie*. Tokyo: Tōkyō Daigaku Shuppankai, 1989.

Kondoru Hakase Kinen Hyōshōkai. *Kondoru Hakase isakushū*. N.p.: Kondoru Hakase Kinen Hyōshōkai, 1931.

Kumamoto Kenjirō. *Bijutsu*. Volume 16 of *Oyatoi Gaikokujin*. Tokyo: Kajima Kenkyūjo Shuppansha, 1976.

Kume Kunitake. *Tokumei zenken taishi: Beiō kairan jikki*. Iwanami Bunko. 5 volumes. 1977–82.

Kunaichō. *Meiji Tennō ki*. 12 volumes. Tokyo: Yoshikawa Kōbunkan, 1968–77.

Kyōto Furitsu Sōgō Shiritsukan. *Kyōto fu hyakunen no nenpyō*. Volume 7, *Kensetsu, kōtsū, tsūshin hen*. Kyoto: Kyōto fu, 1970.

———. *Kyōto fu hyakunen no nenpyō*. Volume 8, *Bijutsu kōgei hen*. Kyoto: Kyōto fu, 1970.

Kyōto Kokuritsu Hakubutsukan. *Kyōto Kokuritsu Hakubutsukan hyakunenshi*. Kyoto: Kyōto Kokuritsu Hakubutsukan, 1997.

———. *Kyōto Kokuritsu Hakubutsukan shichijūnenshi*. Kyoto: Kyōto Kokuritsu Hakubutsukan, 1967.

Kyōto Teishitsu Hakubutsukan. *Kyōto Teishitsu Hakubutsukan reppin mokuroku*. 2 volumes. Kyoto: Kyōto Teishitsu Hakubutsukan, 1901–3.

Kyū Kōbu Daigakkō Shiryō Hensankai. *Kyū Kōbu Daigakkō shiryō*. Tokyo: Toranomon Kai, 1931.

Mae Hisao. *Kyōto no akarenga: Kindaika no isan*. Kyoto: Kyōto Shinbunsha, 1997.

———. "Kyū Teikoku Kyōto Hakubutsukan kōji zumen ni tuite." *Nihon Kenchiku Gakkai Kinki Shibu kenkyū hōkokushū* (May 1979): 437–40.

———. "Kyū Teikoku Kyōto Hakubutsukan kōji zumen ni tuite." *Nihon Kenchiku Gakkai taikai gakujutsu kōen kōgaishū* (September 1979): 2135–36.

Mamizu Hideo. "Teikoku Kyōto Hakubutsukan." *Kenchiku zasshi*, no. 143 (1898): 49–51.

Matsumiya Hideharu. "Meiji zenki no hakubutsukan seisaku." In *Bakumatsu Meiji ki no kokumin kokka keisei to bunka henyō*, edited by Nishikawa Nagao and Matsumiya Hideharu. Tokyo: Shinyōsha, 1995.

Meiji Bunka Kenkyūkai. *Meiji bunka zenshū*. 36 volumes. Tokyo: Nihon Kōron Shinsha, 1955–68.

Mishima Masahiro. "1893 nen Shikago bankokuhaku ni okeru Hōōden no kensetsu ikisatsu ni tsuite." *Nihon Kenchiku Gakkai ronbun hōkokushū*, no. 429 (November 1991): 151–63.

———. "Hōōden no keitai to sono seiritsu yōin ni tsuite." *Nihon Kenchiku Gakkai ronbun hōkokushū*, no. 434 (April 1992): 107–16.

Murakata Akiko. "Ānesuto F. Fenorosa no kenchiku ni kan suru tekō." *Kenchiku zasshi*, no. 1135 (1978): 87–89.

———. "Fenorosa no hōmotsu chōsa to Teikoku Hakubutsukan no kōsō." *Museum* (Tokyo) (February 1980): 21–36.

———, ed. *Ānesuto F. Fenorosa shiryō: Hāvādo Daigaku Hōton Raiburarī zō*. Tokyo: Myūjiamu Shuppan, 1982.

Muramatsu Teijirō. *Kenchiku, doboku*. Volume 15 of *Oyatoi Gaikokujin*. Tokyo: Kajima Kenkyūjo Shuppansha, 1976.

———. *Nihon kindai kenchiku no rekishi*. Tokyo: NHK Bukkusu, 1977.

———. *Nihon no kindaika to oyatoi gaikokujin*. Tokyo: Hitachi, 1995.

Nagano Uheiji. "Shinchiku Nara kenchō zumen setsumei." *Kenchiku zasshi*, no. 111 (March 1896): 61–63.

Nagoya Bosuton Bijutsukan. *Okakura Tenshin to Bosuton Bijutsukan*. Nagoya: Nagoya Bosuton Bijutsukan, 1999.

Naikoku Kangyō Hakurankai Jimukyoku. *Dainikai Naikoku Kangyō Hakurankai shuppin mokuroku*. Tokyo: Naikoku Kangyō Hakurankai Jimukyoku, 1881.

———. *Daisankai Naikoku Kangyō Hakurankai shuppin mokuroku*. Tokyo: Naikoku Kangyō Hakurankai Jimukyoku, 1890.

———. *Daiyonkai Naikoku Kangyō Hakurankai jimu hōkoku*. Tokyo: Daiyonkai Naikoku Kangyō Hakurankai Jimukyoku, 1896.

———. *Daiyonkai Naikoku Kangyō Hakurankai shuppin mokuroku: Bijutsu oyobi bijutsu kōgei*. Kyoto: Daiyonkai Naikoku Kangyō Hakurankai Jimukyoku, 1895.

———. *Meiji jūnen Naikoku Kangyō Hakurankai hōkokusho*. Tokyo: Naikoku Kangyō Hakurankai Jimukyoku, 1878.

———. *Meiji jūnen Naikoku Kangyō Hakurankai shuppin kaisetsu*. Tokyo: Naikoku Kangyō Hakurankai Jimukyoku, 1878.

Nakatani Norihito. *Kokka, Meiji, kenchikuka: Kindai "Nihonkoku" kenchiku no keifu o megutte*. Tokyo: Ikki Shuppan, 1993.

Nara Kenshi Henshū Iinkai. *Nara kenshi*. Volume 8, *Kenchiku*. Tokyo: Meicho Shuppan, 1998.

Nara Kōenshi Henshū Jinkai. *Nara Kōenshi*. 2 volumes. Nara: Nara ken, 1982.

Nara Kokuritsu Hakubutsukan. *Nara Kokuritsu Hakubutsukan hyakunen no ayumi*. Nara: Nara Kokuritsu Hakubutsukan, 1995.

Nara Shishi Henshū Shingikai. *Nara shishi: Bijutsu hen*. Tokyo: Yoshikawa Kōbunkan, 1974.

———. *Nara shishi: Kenchiku hen*. Tokyo: Yoshikawa Kōbunkan, 1976.

Nara Teishitsu Hakubutsukan. *Nara Teishitsu Hakubutsukan reppin mokuroku*. Nara: Nara Teishitsu Hakubutsukan, 1902.

Nihon Bijutsuin Hyakunenshi Hensanshitsu. *Nihon Bijutsuin hyakunenshi*. 18 volumes. Tokyo: Nihon Bijutsuin, 1989–99.

Nihon Kenchiku Gakkai. *Kindai Nihon kenchikugaku hattatsushi*. Tokyo: Maruzen, 1992.

———. *Nihon Kenchiku Gakkai hyakunenshi, 1886–1985*. Tokyo: Nihon Kenchiku Gakkai, 1990.

Nihon Kōgakkai. *Meiji kōgyōshi: Kenchiku hen.* Tokyo: Kōgakkai, 1930.

Nishikawa Nagao and Matsumiya Hideharu, eds. *"Beiō kairan jikki" o yomu: 1870–nendai no sekai to Nihon.* Kyoto: Hōritsu Bunkasha, 1995.

Okakura Kazuo. *Chichi Tenshin o meguro hitobito.* Tokyo: Bunsendō Shobō, 1943.

Okakura Kakuzō (Tenshin). *Okakura Tenshin zenshū.* 8 volumes. Tokyo: Heibonsha, 1979.

Ōkoku Hakurankai Jimukyoku. *Ōkoku Hakurankai hōkokusho.* Volumes 4–6 of *Hakubutsu-kanbu.* Tokyo: Ōkoku Hakurankai Jimukyoku, 1875.

Onogi Shigekatsu. *Meiji yōfū kyūtei kenchiku.* Tokyo: Sagami Shobō, 1983.

———. "Ueno Hakubutsukan no saibu ishō." *Nihon Kenchiku Gakkai ronbun hōkokushū*, no. 184 (June 1971): 113–20.

———. "Ueno Hakubutsukan no sekkei oyobi kensetsu jijō." *Nihon Kenchiku Gakkai ronbun hōkokushū*, no. 179 (January 1971): 87–94.

———. "Ueno Hakubutsukan no sekki oyobi gaibu ishō." *Nihon Kenchiku Gakkai ronbun hōkokushū*, no. 181 (March 1971): 67–73.

———. "Ueno Hakubutsukan no shiyōgaki oyobi shuyō kōzō." *Nihon Kenchiku Gakkai ronbun hōkokushū*, no. 185 (July 1971): 79–85.

———. *Yōshiki no ishizue.* Volume 2 of *Nihon no kenchiku: Meiji, Taishō, Shōwa.* Tokyo: Sanseidō, 1979.

Pari Bankoku Hakurankai Rinji Hakurankai Jimukyoku. *Senkyūhyakunen Pari Bankoku Hakurankai Rinji Hakurankai Jimukyoku hōkoku.* Tokyo: Nōshōmushō, 1902.

Rinji Hakurankai Jimukyoku. *Rinji Hakurankai Jimukyoku hōkoku.* Tokyo: Rinji Hakurankai Jimukyoku, 1895.

———. *Rinji Hakurankai Jimukyoku hōkoku fuzokuzu.* Tokyo: Rinji Hakurankai Jimukyoku, 1895.

Sakamoto Katsuhiko. *Shōto no dezain.* Volume 5 of *Nihon no kenchiku: Meiji, Taishō, Shōwa.* Tokyo: Sanseidō, 1980.

Satō Dōshin. *Meiji kokka to kindai bijutsu: Bi no seijigaku.* Tokyo: Yoshikawa Kōbunkan, 1999.

———. *"Nihon Bijutsu" tanjō: Kindai Nihon no "kotoba" to senryaku.* Tokyo: Kōdansha, 1996.

Seki Hideo. *Hakubutsukan no tanjō: Machida Hisanari to Tōkyō Teishitsu Hakubutsukan.* Tokyo: Iwanami Shoten, 2005.

Shiina Noritaka. *Meiji hakubutsukan kotohajime.* Kyoto: Shibunkaku Shuppan, 1989.

———. *Nihon hakubutsukan hattatsushi.* Tokyo: Yūzankaku Shuppan, 1988.

———. *Zukai hakubutsukanshi.* Tokyo: Yūzankaku Shuppan, 1993.

"Sō Hyōzō sakuhin to kaikyūdan." *Shinkenchiku* (March 1927): 2–13.

Suzuki Hiroyuki. "Josaia Kondoru no kenchikukan to Nihon." In *Nihon kenchiku no toku-shitsu.* Tokyo: Chūō Kōron Bijutsu Shuppan, 1976.

———. "Josaia Kondoru to Eikoku." *Kenchikushi kenkyū* 40 (1976): 1–15.

———. *Vikutorian goshikku no hōkai.* Tokyo: Chūō Kōron Bijutsu Shuppansha, 1996.

———, ed. *Kōshitsu kenchiku: Takumiryō no hito to sakuhin.* Tokyo: Kenchiku Gahōsha, 2005.

Suzuki Hiroyuki and Fujimori Terunobu, eds. *Rokumeikan no yume: Kenchikuka Kondoru to eshi Kyōei.* Tokyo: INAX, 2001.

Takagi Hiroshi. *Kindai tennōsei no bunkashiteki kenkyū.* Tokyo: Azekura Shobō, 1997.

Taki Teizō. *Nihon kindai bijutsu jiken shi.* Osaka: Tōhō Shuppan, 1993.

Tōkyō Geijutsu Daigaku. *Tōkyō Geijutsu Daigaku hyakunenshi*. Volume 1, *Bijutsu gakkō*. Tokyo: Ongaku no Tomosha, 1987.

Tōkyō Kokuritsu Bunkazai Kenkyūjo. *Naikoku Kangyō Hakurankai bijutsuhin shuppin mokuroku*. Tokyo: Tōkyō Kokuritsu Bunkazai Kenkyūjo, 1996.

Tōkyō Kokuritsu Bunkazai Kenkyūjo Bijutsubu. *Meiji bijutsu kizo shiryōshū: Naikoku Kangyō Hakurankai, Naikoku Kaiga Kyōshinkai (dai ichi-ni kai hen)*. Tokyo: Tōkyō Kokuritsu Bunkazai Kenkyūjo, 1975.

———. *Meiji ki bijutsu tenrankai shuppin mokuroku*. Tokyo: Chūō Kōron Bijutsu Shuppan, 1994.

Tōkyō Kokuritsu Hakubutsukan. *Me de miru 120 nen*. Tokyo: Tōkyō Kokuritsu Hakubutsukan, 1992.

———. *Mosha, mozō to Nihon bijutsu: Utsutsu, manabu, tsutaeru*. Tokyo: Tōkyō Kokuritsu Hakubutsukan, 2005.

———. *Tōkyō Kokuritsu Hakubutsukan hyakunenshi*. 2 volumes. Tokyo: Tōkyō Kokuritsu Hakubutsukan, 1973.

———. *Umi o watatta Meiji no bijutsu*. Tokyo: Tōkyō Kokuritsu Hakubutsukan, 1997.

———, ed. *Seiki no saiten bankoku hakurankai no bijutsu: Pari, Vin, Shikago banpaku ni miru tōzai no meihin*. Tokyo: NHK Puromōshon, 2004.

Tōkyō Kokuritsu Kindai Bijutsukan. *Bijutsukan o yomitoku: Hyōkeikan to gendai no bijutsu*. Tokyo: Tōkyō Kokuritsu Kindai Bijutsukan, 2001.

———. *Bunten no meisaku, 1907–1918*. Tokyo: Tōkyō Kokuritsu Kindai Bijutsukan, 1990.

Tōkyō To Shashin Bijutsukan. *Utsusareta Kokuhō: Nihon ni okeru bunkazai shashin no keifu*. Tokyo: Benridō, 2000.

Watanabe Toshio. "Nihon kindai kenchiku kyōiku no akebono." In *Gakumon no arukeoroji*. Tokyo: Tōkyō Daigaku Shuppankai, 1997.

Yoshida Mitsukuni, ed. *Bankoku hakurankai no kenkyū*. Kyoto: Shibunkaku, 1986.

———. *Bankokuhaku no Nihonkan*. Tokyo: INAX, 1990.

———. *Sangyō*. Volume 2 of *Oyatoi Gaikokujin*. Tokyo: Kajima Kenkyūjo Shuppansha, 1968.

Yoshimi Shunya. *Hakurankai no seijigaku: Manazashi no kindai*. Tokyo: Chūō Kōronsha, 1992.

Index

Note: page numbers in *italics* refer to illustrations; those followed by "n" or "nn" indicate an endnote or endnotes, respectively.